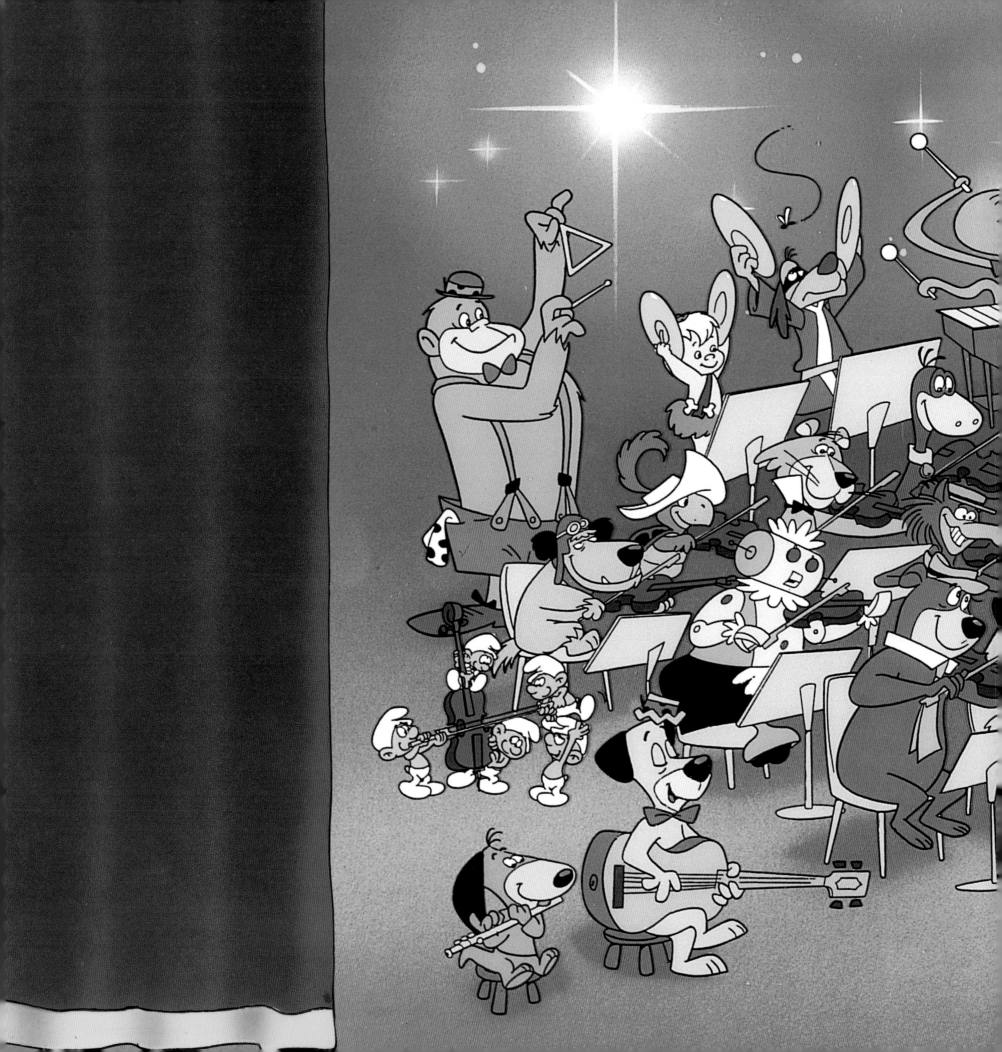

Symphony of the Stars

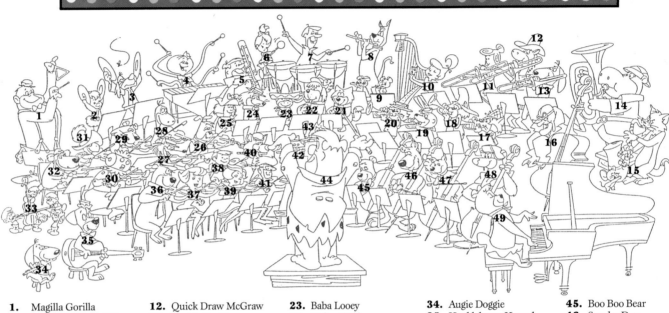

1. Magilla Gorilla	**12.** Quick Draw McGraw	**23.** Baba Looey	**34.** Augie Doggie
2. Bamm Bamm Rubble	**13.** Doggie Daddy	**24.** Hokey Wolf	**35.** Huckleberry Hound
3. Hong Kong Phooey	**14.** Peter Potamus	**25.** Winsome Witch	**36.** Yogi Bear
4. Squiddly Diddly	**15.** Tom and Jerry	**26.** Ruff	**37.** Betty Rubble
5. Barney Rubble	**16.** Dick Dastardly	**27.** Mildew Wolf	**38.** Elroy Jetson
6. Pebbles Flintstone	**17.** Snooper	**28.** Dino Boy	**39.** Jane Jetson
7. George Jetson	**18.** Punkin Puss	**29.** Snagglepuss	**40.** Ding-a-Ling
8. Astro	**19.** Sneezly	**30.** Rosie	**41.** Fluid Man
9. Pixie and Dixie	**20.** Top Cat	**31.** Touché Turtle	**42.** Secret Squirrel
10. Judy Jetson	**21.** Fancy Fancy	**32.** Muttley	**43.** Choo Choo
11. Wilma Flintstone	**22.** Dum Dum	**33.** Smurfs	**44.** Fred Flintstone

45. Boo Boo Bear	
46. Scooby-Doo	
47. Scrappy-Doo	
48. Breezly	
49. Cindy Bear	
	Opening the curtain:
	Freddy Flintstone

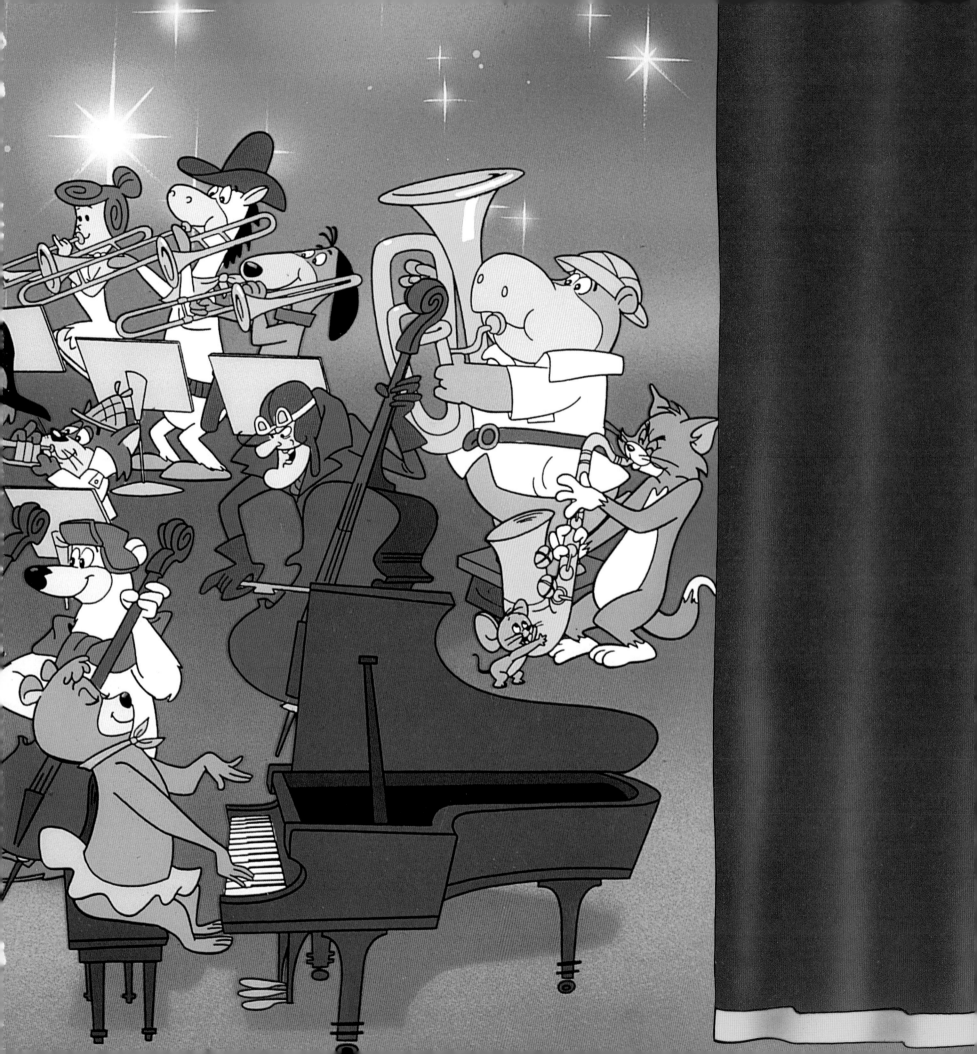

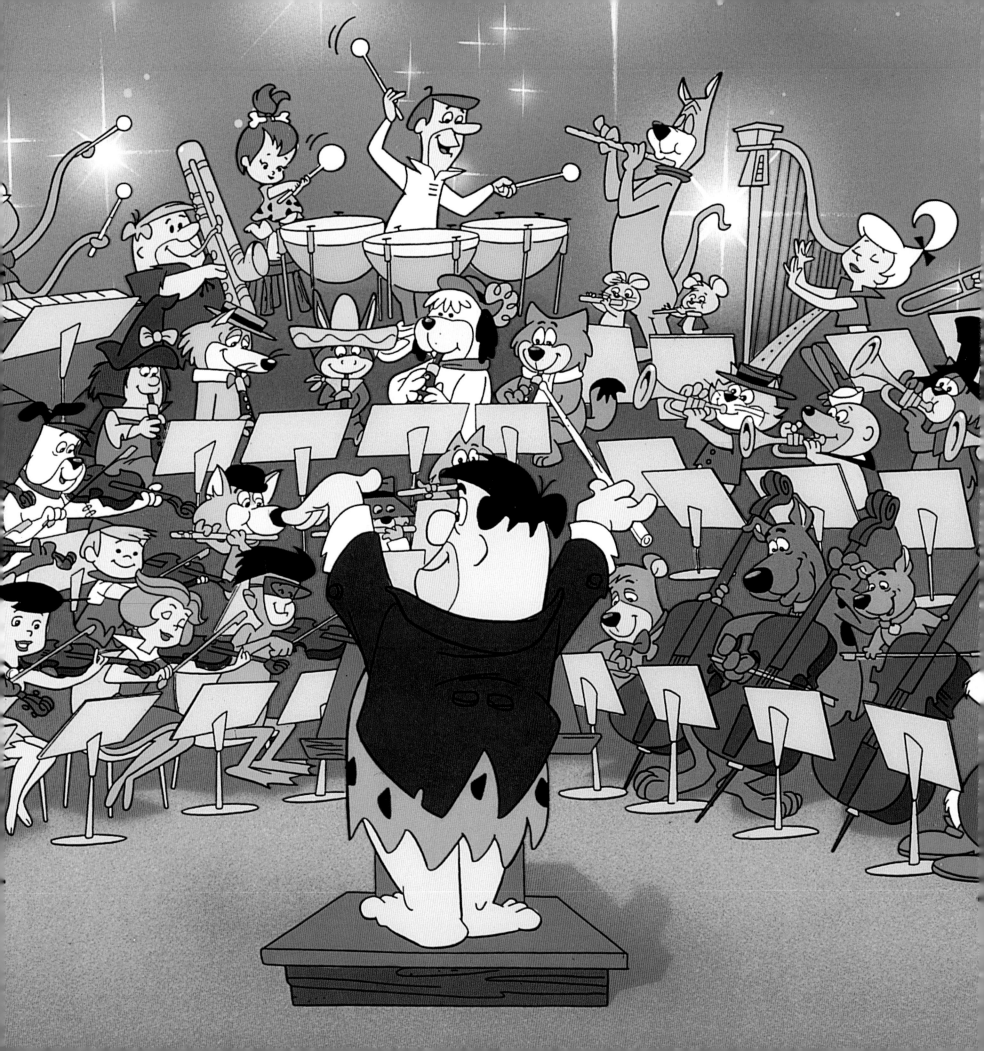

ALSO BY TED SENNETT

Warner Brothers Presents

Lunatics and Lovers

Your Show of Shows

Masters of Menace: Greenstreet and Lorre

Hollywood Musicals

Great Hollywood Movies

Great Movie Directors

The Art of Hanna-Barbera

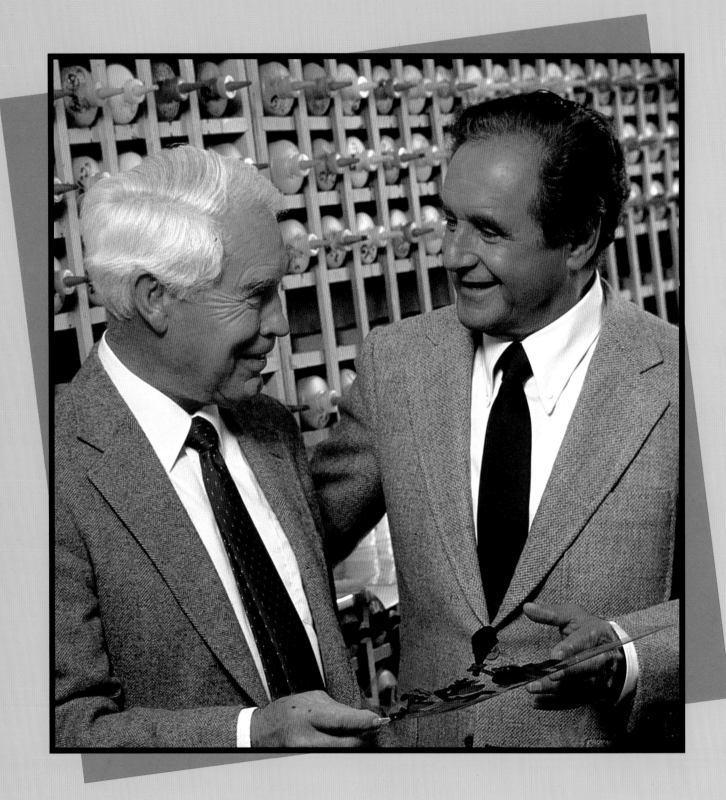

The Art of Hanna-Barbera

Fifty Years of Creativity

Ted Sennett

Design by Amy Hill

VIKING STUDIO BOOKS

VIKING STUDIO BOOKS
Published by the Penguin Group
Viking Penguin, a division of Penguin Books USA Inc., 40 West 23rd Street,
New York, New York 10010, U.S.A.
Penguin Books Ltd, 27 Wrights Lane, London W8 5TZ, England
Penguin Books Australia Ltd, Ringwood, Victoria, Australia
Penguin Books Canada Ltd, 2801 John Street, Markham, Ontario, Canada L3R 1B4
Penguin Books (N.Z.) Ltd, 182–190 Wairau Road, Auckland 10, New Zealand

Penguin Books Ltd, Registered Offices: Harmondsworth, Middlesex, England

First published in 1989 by Viking Penguin, a division of Penguin Books USA Inc.

1 3 5 7 9 10 8 6 4 2

Grateful acknowledgment is made for permission to reproduce the following:
"The Dukes," © 1982 Hanna-Barbera Productions, Inc. "The Dukes of Hazzard," © Warner
Bros., Inc. "Fonz and the Happy Days Gang," © 1980 Hanna-Barbera Productions, Inc.
"Fonz and Happy Days," characters © Paramount Pictures Corp. "Foofur," © 1986 Hanna-
Barbera Productions, Inc., and Sepp S.A. "Gobots," © 1985 Hanna-Barbera Productions,
Inc., and Tonka Corporation. "Godzilla," © 1978 Hanna-Barbera Productions, Inc.; the
character "Godzilla," © Toho Co. Ltd and Benedict Pictures Corporation. "Josie and the
Pussycats," © 1970 Hanna-Barbera Productions, Inc., and Archie Comic Publications, Inc.
"Little Rascals," © 1982 Hanna-Barbera Productions, Inc., and King World Productions, Inc.
"Monchichis," © 1983 Hanna-Barbera Productions, Inc.; characters © Sekiguchi Ltd and
Mattel, Inc. Other character names and trademarks of Sekiguchi Co. Ltd used with
permission. "Mork and Mindy," © 1982 Hanna-Barbera Productions, Inc. "Mork and Mindy"
characters, © Paramount Pictures Corp. "Pac-Man," © 1982 Hanna-Barbera Productions,
Inc. "Pac-Man" characters are trademarks of Namco, Ltd. "Partridge Family: 2200 A.D.," © 1974
Hanna-Barbera Productions, Inc. "Pound Puppies," © 1986 Hanna-Barbera Productions, Inc.,
and Tonka Corporation. "Smurfs," © 1981 Hanna-Barbera Productions, Inc., and Sepp S.A.
"Snorks," © 1984 Hanna-Barbera Productions, Inc., and Sepp S.A. "Tom & Jerry," Copyright
1940 Loew's Incorporated; renewed 1967 Metro-Goldwyn-Mayer, Inc. All other artwork and
characters reproduced in this book are the property of Hanna-Barbera Productions, Inc.
Photograph on page 242 Kirk McKoy/Los Angeles Times.

LIBRARY OF CONGRESS CATALOGING IN PUBLICATION DATA
Hanna, William, 1910–
The art of Hanna-Barbera / William Hanna & Joseph Barbera with Ted
Sennett.
p. cm.
Includes index.
ISBN 0-670-82978-1
ISBN 0-670-83071-2 (Limited Edition)
1. Hanna, William, 1910– — Themes, motives. 2. Barbera, Joseph —
Themes, motives. 3. Animated films — United States. I. Barbera,
Joseph. II. Sennett, Ted. III. Title.
NC1766.U52H3634 1989
741.5'0922 — dc20 88-40627

Printed in Japan
Set in ITC Esprit, Ariston Extra Bold, and Leamington Black

In
memory of
Daws Butler,
whose many inimitable voices
were so important to
Hanna-Barbera

Acknowledgments

There are a great many people I should like to thank for their help in writing this book.

Above all, I want to express my gratitude to William Hanna and Joseph Barbera for their generosity in taking time from their busy schedules to speak with me about their personal lives and about their extraordinary fifty years in animation. I also want to offer my special thanks to Hanna-Barbera's art director Iraj Paran, whose help was indispensable and who gave me so much of his time with warm affability.

I spoke with so many people who have been—or still are—associated with Hanna and Barbera in one capacity or another over the years that I can only list their names in alphabetical order. A deep, low bow to them all: Jayne Barbera, Neal Barbera, Mel Blanc, Lucille Bliss, the late Daws Butler, Lefty Callahan, Hoyt Curtin, Hillary Dunchak, Sam Ewing, Friz Freleng, Gordon Hunt, Chuck Jones, Michael Lah, Shirley Lief, Harry Love, Alex Lovy, Don Messick, the late John Mitchell, Charles A. Nichols, Frank Paiker, Ray Patterson, Maggie Roberts, Ginger Robertson, Andrea Romano, Art Scott, Jeff Siegel, Richard Sigler, Fred Silverman, Kenneth Spears, Irven Spence, Arnold Stang, John Stephenson, Alex Toth, Carl Urbano, Jean Vander Pyl, Janet Waldo, Frank Welker, Doug Wildey, and Tom Wogatzke.

I also thank Sarah Baisley of Taft Entertainment, and Tom Devlin, Robert Denney, and Mimi Wunderlich of Worldvision (Home Video Inc.). Thanks as well to my editor, Michael Fragnito, and to Amy Hill, Emily Kuenstler, and Larry Nevins, all of Viking Penguin Inc., and to my ever-diligent powerhouse of an agent, Peter Miller.

As always, my final words of gratitude go to my wife, Roxane, whose devotion and support never fail to carry me over the rough spots.

—Ted Sennett

William Hanna and Joseph Barbera would like to express their personal gratitude to Iraj Paran for his tireless efforts on their behalf in the preparation of this book.

Contents

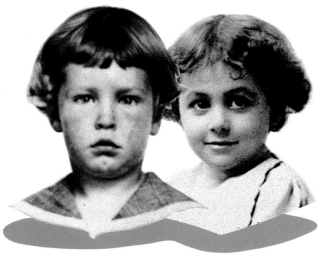

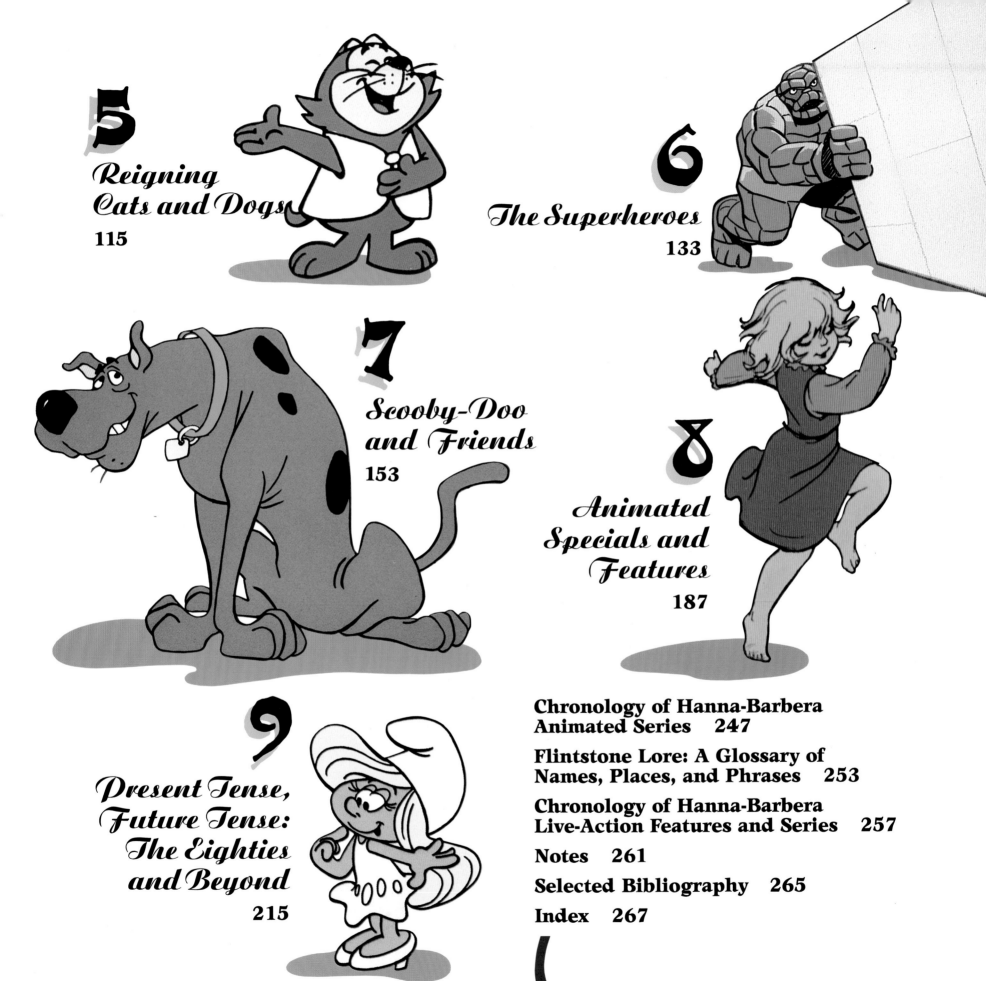

Introduction

For most of us, the world of animation continues to exist in memory. No matter how many years may pass, we can still recall vividly those magical moments when animated figures took on lives of their own. It may have been in a darkened theater, crowded with our noisy, rambunctious friends who cheered when the mouse clobbered the cat or who watched, wide-eyed, when the heroes and heroines of fairytale kingdoms danced before our eyes. It may have been in our living rooms, where we exploded with laughter when a resourceful bear in a pork-pie hat filched another "pic-a-nic" basket, or when a portly suburbanite in a leopard skin bellowed at yet another aborted scheme. Don't tell us that these figures are merely drawings and sketches. They may spring from the imagination of an army of writers, layout men, animators, actors, and directors, but they reside in a corner of our minds, as real as our next-door neighbors.

For half a century, William Hanna and Joseph Barbera have lived side by side in this world of animation. Their

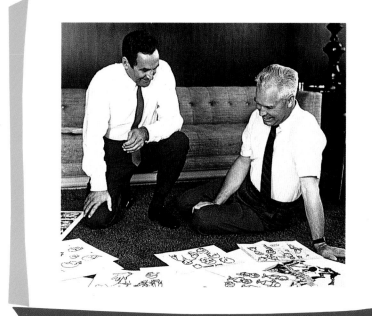

deep and abiding love for animation may have had its roots in their earliest years, but together they forged a dream into an empire. Two men of vastly different styles and temperaments, they succeeded in joining their aspirations and their talents, first to create two decades of classic "Tom and Jerry" cartoons, and then to build an animated domain for television that extends to the farthest corners of the globe. Through changing trends, business reversals, and media upheavals, they persisted and endured, holding fast to the dream. Ultimately, Joe Barbera, an energetic New York artist with a quick-and-ready pen, and Bill Hanna, a quiet-spoken midwesterner with prodigious skills as an organizer, merged into Hanna-Barbera Productions, a company that *60 Minutes*, the CBS newsmagazine, has called "the General Motors of Animation."

Apart from their astonishing longevity as a team, Hanna and Barbera have earned their status as an American success story in other ways. At a time when ani-

Above: Joe Barbera (left) and Bill Hanna
at the studio, about 1964.

mation for television was considered unrealistic and unprofitable, they developed and perfected the techniques of limited animation that made it possible to turn out a large number of cartoons every week. If, as they would be the first to admit, these techniques were far removed from the richly detailed and expressive animation of Disney and "Tom and Jerry," they also opened the door to a host of animated characters who have become a lasting part of American folklore. Several generations of young people from the sixties onward share affection and enthusiasm for a dauntless bear from Jellystone Park, a prehistoric blowhard from Bedrock, and many other endearing creations. It is no exaggeration to state that Bill Hanna and Joe Barbera permanently changed the face of American television.

In adapting animation to the demands of television, Hanna and Barbera also evolved a new form of humor that suited the less patient, more knowing young viewers of the television generation. Swift, basic, and unadorned, it replaced the subtleties of full animation with broad satire and a barrage of gags, both verbal and physical. Hanna and Barbera sensed that youngsters (and their parents) who watched "Huckleberry Hound" would respond appreciatively to its send-up of basic movie and television genres, and that those who fancied "Quick Draw McGraw" would recognize its cheerful burlesque of every Western plot line conceived by filmmakers. Audiences of all ages found much to laugh at in the bumbling antics of Stone Age suburbanites Fred Flintstone and his pal Barney Rubble, whose lives, not so coincidentally, mirrored their own in the twentieth century. While venturing into new areas of animated adventure and live action, Hanna and Barbera have managed to retain the brash, lightly irreverent, and explosively funny animation that characterized their early years.

In their fifty years together, Hanna and Barbera created an enormous international operation that today is the largest animation company in the world. This book ranges across those momentous years, from the two exhilarating decades at MGM to today's worldwide enterprises. My intention has been to rekindle the memories of all the Hanna-Barbera programs and characters that have been a part of so many lives. I have sought to describe the origins of their work, and to pay tribute to all the gifted and dedicated people who helped them and worked with them along the way.

Tom and Jerry. Huckleberry. Yogi. Fred and Barney. Top Cat. Magilla Gorilla. Scooby-Doo. These are only a few of the lifelong friends that Hanna-Barbera has given us over the years. They are the best of friends: they rarely wear out their welcome, they make us laugh, and they bring us pleasure. Those of us who have always kept one small part of ourselves in that world of animation will be forever grateful.

Right: Joe Barbera (left) and Bill Hanna in a publicity shot, 1988.

The Art of Hanna-Barbera

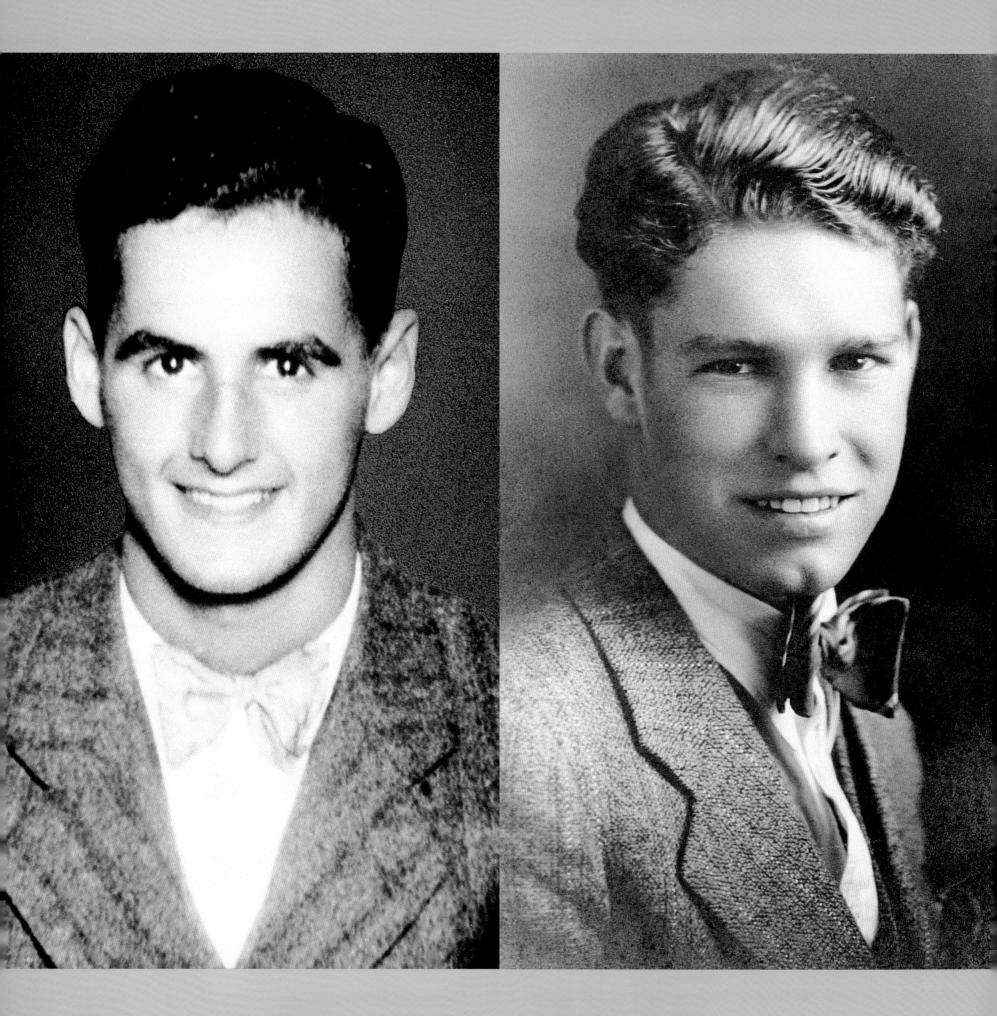

The Beginnings

When did the magic begin? At what point in time did these two men from totally different backgrounds initiate a creative partnership that has survived for half a century? From their own accounts, no spark ignited, no flare illuminated the skies, when they met for the first time in 1937 at MGM's new Cartoon Department. There was mutual respect and admiration, but no immediate signs of the deep rapport that would bind them together. Yet, within a year's time, seated at facing desks, they had meshed their separate talents to conceive of the conflict between a ferocious but hapless cat named Tom and a tiny but resourceful mouse named Jerry. The rest is animation history—and animated magic that extended two decades later into a cartoon world inhabited by characters named Huckleberry, Yogi, and Fred.

Whatever the source of inspiration that turned Joseph Barbera and William Hanna into Hanna-Barbera, it is undeniably true that the seeds of their association were planted long before they met, in their earliest years. For

> **An important thing in life is getting the breaks. It's being somewhere at a certain time and a certain thing happens.**
>
> **—Joe Barbera**

Joe Barbera, it all began in the bleak years of the Depression, when millions of Americans struggled to find their way out of a maze of hunger and joblessness. Born in 1911 on New York City's Lower East Side of an Italian immigrant family, Barbera was brought to the Flatbush section of Brooklyn while still in swaddling clothes. Within a few years, his father, an elegantly attired, cigar-smoking man who loved to play the horses, owned three barber shops and beauty parlors. Growing up in Brooklyn's teeming streets, Barbera learned resourcefulness, the ability to survive, and the strength provided by a warm, closely knit family. On rainy days, he would lie on the floor, copying drawings or illustrations out of magazines. At Holy Innocents Catholic School, his skill at drawing was quickly noticed, and he was soon assigned to trace simple religious scenes onto the blackboard.

After two years at Public School 139 on Cortelyou Road in Brooklyn, Barbera spent four more years at Erasmus Hall High School, where his writing ability was nurtured

Far left: Joe Barbera as a high school student, 1926.
Left: Bill Hanna, 1927.

for the first time. An English teacher encouraged him to write an original story — "It was about Cossacks attacking a village, and it was all seen through the eyes of a wounded soldier," Barbera recalls — and the story so impressed the teacher that he had him read it to the class. About this time, Barbera also began to cultivate his interest in drawing and acting — he appeared in a school production of *H.M.S. Pinafore* at the Brooklyn Academy of Music. A taste of the theater led to Barbera's lifelong devotion to the stage. He remembers the thrill of seeing his first Broadway show, Rodgers and Hart's *A Connecticut Yankee*. "I walked out of the theater about two feet in the air," Barbera recalls. "From then on, I was seeing one after another, whatever came out." The theater became one of his lifelong passions, and in later years he wrote several plays.

Graduating from Erasmus, Barbera found himself jobless in the midst of the Depression. Not much past sixteen (he was a young graduate), he finally found work in a bank, completing and filing income tax returns for the Irving Trust Company on Manhattan's Wall Street, across the street from Trinity Churchyard. His inability to add even simple figures ("To this day they must be looking for my mistakes") made his job not only precarious but less than rewarding. He would spend his happiest time reading books like *Of Human Bondage* in a nearby park. Still, it was work in a difficult time, and he could continue to harbor the dream that had started when he saw a Disney cartoon, "The Skeleton Dance," at the Roxy Theater. With a swift pen and an agile imagination, he could draw figures and characters that, perhaps one day, would take on animated lives of their own.

While working at the bank during the day, Barbera spent most of his nights drawing cartoons for the magazines. Once a week, at lunchtime, he would race uptown in the subway, to leave his cartoons at *Redbook*, *Collier's*, *The New Yorker*, *The Saturday Evening Post*, or a humor magazine called *Judge*, and to pick up the rejected cartoons of the previous week. On some nights, he would attend the Art Students League in Manhattan, where he practiced drawing figures from life and sharpening his skills. One day a letter came from *Collier's* with a $25 check enclosed, and Barbera nearly fainted with joy. He sold a few more cartoons to *Collier's*, but the prospects for a career seemed dim. He began taking courses at the Pratt Institute, while holding on to his despised bank job.

What seemed at first like a golden opportunity came along when he left the bank to work at painting and inking cels* for the Fleischer Studios, where modest, self-effacing Max Fleischer and his more energetic brother Dave originated "Betty Boop" and "Popeye the Sailor." (Barbera was also paid a dollar for every gag used in the "Popeye" strip.) After only four days with Fleischer, watching a man in his thirties who had been inking cels for three years at $35 a week, Barbera decided that there was scant opportunity here for an ambitious nineteen-year-old would-be artist and he quit to return to the bank. By this time, however, the entire financial district was in deep trouble, and his old job at the bank was no longer available. Barbera suddenly found himself out of work, and he imagined himself as an

*A common term for *celluloid*, the transparent sheet on which characters are inked and painted.

Above: Joe Barbera (right) with his brother Larry about 1915.
Right: An early drawing (about 1921) by Joe Barbera.

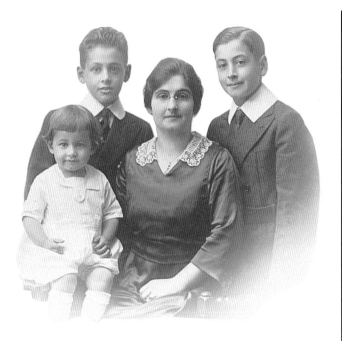

A family photograph taken about 1923, with Joe Barbera (second from left), brother Ted, mother Frances, and brother Larry.

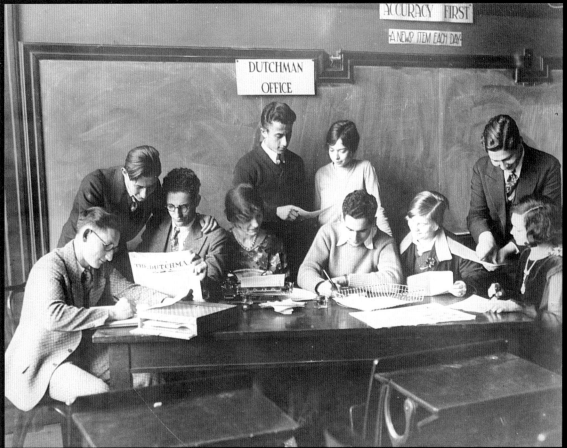

Joe Barbera (seated at desk, wearing sweater) working on Erasmus Hall's school paper, *Dutchman*, in 1926.

Joe Barbera's son Neal, about 1970.

Joe Barbera with daughters Lynn and Jayne in the late sixties.

Joe Barbera with his wife, Sheila, and Yogi Bear at a Christmas parade in Huntington Beach, 1982.

Joe Barbera with his uncle Jim in 1938.

3

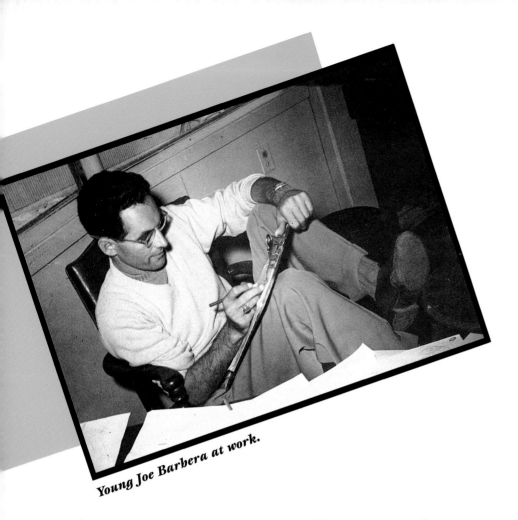

Young Joe Barbera at work.

artist in a cheerless Greenwich Village cold-water flat. He tried to put the best possible face on his dilemma ("I'm a free man!"), but prospects were bleak in 1931, and he had no money to give to his mother.

Fate interceded when he met a friend (a fraternity brother from Erasmus) who told him about a job as an animator at the Van Beuren Studio, located across the street from the Fleischer Studios in Manhattan. An extension of Paul Terry's studio, which had produced "Aesop's Fables," a series of popular silent cartoons, in the twenties, Van Beuren was struggling to find its own identity in the early years of sound. (Terry had left in 1929 to form his own studio.) One of its primitive series was built around two loose-limbed, Mutt-and-Jeff–like men named Tom and Jerry, no relation to the later cat and mouse. In the year before it closed, the studio had its greatest success with "The Toonerville Trolley," based on the comic strip that featured such eccentric characters as the Powerful Katrinka and the Terrible-Tempered Mr. Bang.

Despite its lack of substantial credits, Van Beuren seemed an appropriate place for Barbera to hone his craft. Although he had only a sketchy knowledge of animation—he had been a painter and inker for only four days—Barbera applied for the job and won it. Working day and night for six months, he learned to be an animator—a number of points came from an animator named Tom Goodson—and eventually he added story writing to his cartooning skills. Many of the animators at Van Beuren, including Jack Zander, Dan Gordon, and Alex Lovy, would later become well known in the field.

One afternoon in 1936, Van Beuren's man in charge watched a newsreel segment that announced that RKO Pictures, which was distributing the Van Beuren product, had signed a contract with Walt Disney to make cartoons. Suddenly Van Beuren was out of business—and Barbera was again out of a job. Disney's studio was rapidly becoming the sole province for animation, and Barbera began to feel that there was nowhere else to go. (Several years earlier, he had written to Disney on a whim, enclosing a sketch of Mickey Mouse, and Disney had replied with the promise of a meeting in New York, which never materialized—to Barbera's eternal gratitude.)

Visiting a friend at Paul Terry's cartoon studio in New Rochelle to tell him that he was leaving for California to apply for a job with Disney, Barbera met Terry himself, a large, imposing man who was never without a cigar clenched in his teeth. (Barbera recalls, "There seemed to be a little dent in his lower lip where the cigar would sit.") Terry had been producing his likable Terrytoons since the early thirties and would later create such characters as Mighty Mouse and Heckle and Jeckle. Hating Walt Disney because he persisted in stealing his best animators, Terry offered Barbera a job to keep him from going over to his arch enemy. Barbera accepted gratefully and began animating and ultimately writing cartoons, traveling an hour and a half each way from his Brooklyn home to Terry's studio in New Rochelle.

Right: Two Collier's cartoons drawn by Joe Barbera in 1931.

4

"Every night he sends me flowers and sits in the first row"

For William Hanna, a career in animation also started in the dark period of the Depression. Born in Melrose, New Mexico, in 1910, Hanna moved a number of times in his first years — his father was superintendent of construction for the early Santa Fe railway stations, and his family would move from one train stop to another as his work demanded. Other members of Hanna's family were writers — his mother wrote poetry, his sister published short stories, and an aunt wrote country Westerns for radio. By the time Hanna was three years old, they were living in Baker, Oregon, where his father, in a new phase of his construction work, was assigned to build a local dam. Hanna retains warm memories of his life in Baker; he recalls visiting the dam site and watching the people lifting trout with their hands out of the small puddles that were left when the stream was diverted to accommodate the dam. He even remembers an early experiment in design when, with his younger sister, he broke every window in the barn because the splintered glass formed interesting patterns.

By the time Hanna had started school, his family had moved to Logan, Utah, where the bitter winters brought many hardships but also happy times when he would go sleigh riding in the deep snow, or when the teacher would remove shoes from frostbitten feet and rub the students' feet next to the hot iron stove. In 1917, when Hanna was seven years old, the family moved to San Pedro, California, where they remained for about two years. During this relatively stable period, when his father was finally at home for a while, Hanna recalls stopping near a fort to watch soldiers practice their marksmanship, or visiting the wharves where Oriental fishermen had built their houses over the harbor.

Late in 1919 the Hannas settled in Los Angeles where Bill, at age twelve, became an eager Boy Scout; today, he is still active in scouting. He also began his lifelong interest in music, taking lessons on an alto saxophone and playing with a group of children organized by someone who, Hanna claims, may have been the original music man. Recalled by Hanna as "a great musician, a good teacher, and a lovable character," this wizard sold band instruments to ingenuous parents and gave music lessons to the children. He vanished after the group had made a single appearance at the local theater, but to this day Hanna vividly remembers the weeks on end in which they practiced "Alexander's Ragtime Band" and that final, glorious moment when twenty-three starry-eyed children played on and off key for parents and relatives. In later years, Hanna studied piano, composition, and harmony.

Hanna's high school years were spent in Compton, California, where his favorite subjects were journalism and mathematics, and where he was active in sports. Following graduation, he went on to major in journalism and engineering at Compton Junior College. With the collapse of the economy in 1929, he left college to find work, finally taking a job with the engineers who were building the Pantages Theater on Hollywood Boulevard. After completing this job, he decided that the life of a structural engineer was not for him, and that it was time to move in a new direction. Through his brother-in-law Jack Stevens, who worked for Pacific Title, a Hollywood art studio that created titles and artwork for film companies, Hanna learned about a newly formed animation cartoon company called Harman-Ising Studios. Financed by Pacific's owner Leon Schlesinger, the company was run

Above: Bill Hanna with his sister Norma in Baker, Oregon.

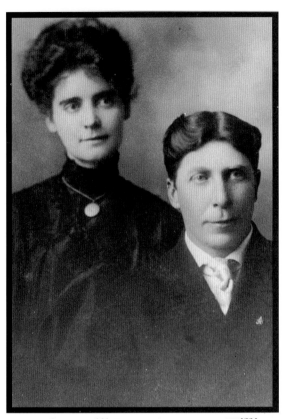

Above: Bill Hanna's parents, William John and Avice Joyce Hanna.

Below: Bill Hanna with his father in Los Angeles about 1931.

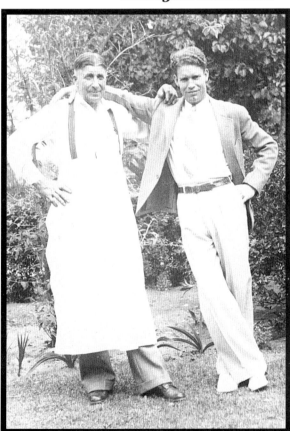

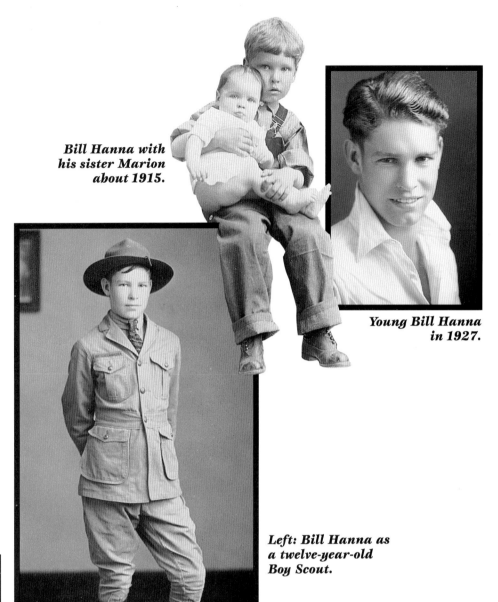

Bill Hanna with his sister Marion about 1915.

Young Bill Hanna in 1927.

Left: Bill Hanna as a twelve-year-old Boy Scout.

Bill Hanna with his wife, Violet, and son David, 1940.

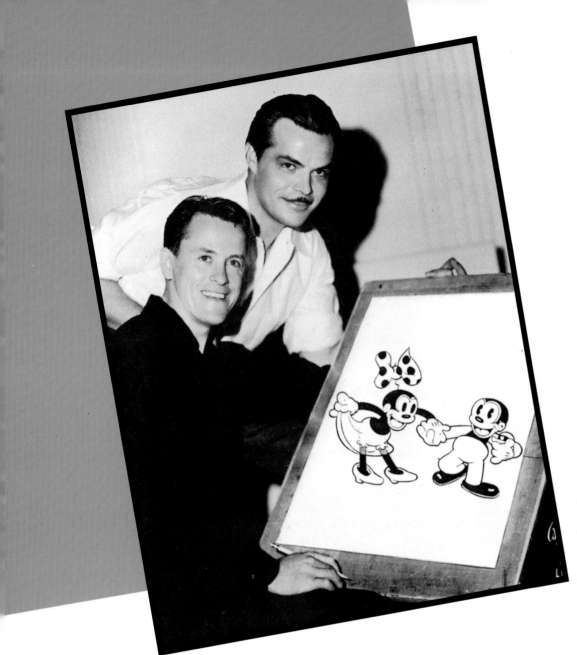

Hugh Harman (left) and Rudy Ising with characters Honey and Bosko.

by two talented young artists, Hugh Harman and Rudolf Ising, who had worked with Walt Disney in Kansas City. In a small studio over a dress shop, Harman and Ising had started production on the first "Looney Tunes" and "Merrie Melodies."

Hanna went to work for Harman-Ising, charged with painting cels and punching animation paper. As the company expanded, so did Hanna's duties, and before the end of his first year he was head of the tracing and painting department, earning $37.50 a week, a considerable sum for the Depression years. During that year, Hanna noticed that

Rudy Ising would arrive close to lunchtime and work virtually every evening until nearly midnight. Encouraged by Ising to join him in these nighttime sessions, Hanna began contributing story material and gags for the early "Looney Tunes" and "Merrie Melodies." Soon he was also writing music and lyrics for the cartoons produced by Hugh Harman.

As time passed, Hanna learned a great deal from Hugh Harman and Rudy Ising. Dynamic and ebullient, Harman brought his superior drawing ability and a touch of sophistication to the cartoons; animator Carl Urbano, who worked

with Harman-Ising and who later contributed to the first "Tom and Jerry" cartoons at MGM, says that for Harman "the sky was always full of pie." Ising was a different sort: a talented artist and a quiet, unassuming young man who was known affectionately as "the Sleepy Bear." The gallons of coffee he consumed as he worked late into the night seemed to fuel his creativity — he was adept at choosing good material and putting it together.

Work on the "Looney Tunes" and "Merrie Melodies" continued happily at Harman-Ising until mid-1933, when, for reasons never revealed, Harman and Ising severed their

relationship with Leon Schlesinger. Schlesinger went on to organize his own production company, where he continued to produce the "Looney Tunes" and "Merrie Melodies." A number of Harman-Ising's staff members went with him, including Isador (Friz) Freleng, one of their top animators. Freleng would later become one of the best-known and most talented producers in the cartoon industry, responsible for many beloved cartoon characters, including Porky Pig.

Hanna elected to stay with Harman-Ising, and when the studio signed a new contract with Metro-Goldwyn-Mayer, it became a time of burgeoning creative activity for the team

Above: The Harman-Ising group: Hugh Harman (second row, left), Rudy Ising (right), and Bill Hanna (back), about 1935.

and their staff. Over the next four years they produced many outstanding cartoons, such as "Honeyland" and "The Old Mill Pond," and they introduced new ongoing characters, including Little Cheeser and a pair of Playful Pups. During this time, Hanna joined the writing staff, while continuing to write lyrics and music where they were needed. Combining these skills, he joined an artist named Paul Fennell in forming a unit at Harman-Ising to produce cartoon musicals. Their first effort, "Ode to Spring," won high praise from MGM executives.

Hanna continued writing and directing at Harman-Ising until 1937, when lightning struck again. For various reasons, MGM decided to start its own cartoon studio. As head of the studio, MGM placed Fred Quimby, who had been in charge of the studio's short-feature department since 1926. Basically an entrepreneur who always dressed immaculately in a double-breasted suit, Quimby was an astute organizer and able administrator who had one disadvantage for the job: he knew little about the art or skill of animation. Bill Hanna describes him as "more of a businessman than a creative person," and animator Irven Spence, who worked at MGM for many years, characterizes him as "a man of a different era," one who seemed older than his years. (He was then in his early fifties.)

Quimby's first job was to bring together an in-house animation staff, and he began by hiring many of Harman and Ising's people. One of the first people he approached was Bill Hanna, who went to work for MGM as a writer and director. Quimby also began to seek out as many talented New York animators and story men as possible, calling on former colleague Jack Zander, who was working for Paul Terry in New Rochelle, to help him in the search. Within a short time, Zander and other co-workers at the Terry studio, including Joe Barbera, had accepted contracts to move out to the West Coast to work in MGM's new cartoon department under a year's contract calling for $87.50 a week. Quimby also hired Friz Freleng away from Leon Schlesinger's studio, where he had made ani-

mation history by creating the character of Porky Pig. Barbera had been hired as an animator, but within a few weeks he became one of Freleng's story men. At the same time he continued to exercise his singular talent for sketching and drawing.

Almost immediately there was trouble at MGM's new cartoon division. Different in every conceivable way, from life-style to work style, the newly arrived eastern staff members clashed with the entrenched western people. One by one, the eastern contingent returned to New York, until only Joe Barbera was left. Serious creative problems marred the operation as well. Quimby had decided that the first major MGM cartoon series would be "The Captain and the Kids," based on the comic strip that had been popular for many years. Although attractively animated in black and white (with a sepia tone over the released version), the series suffered from a variety of handicaps that someone as astute as Friz Freleng could easily recognize.

Many years later Freleng recalled telling Fred Quimby, "It won't work. In the first place, they're humans, and the only cartoons that seem to be successful have animal characters. A guy like Elmer Fudd is only an abstraction. Besides, they speak with a heavy German accent. And those kids aren't even lovable." Quimby insisted on moving ahead, with dire results. (Only one cartoon, "Mama's New Hat," was favorably received.) To salvage this ill-conceived venture, MGM hired the comic artist Milt Gross, who worked on several "Captain and the Kids" episodes, created two more cartoons using his inimitably zany characters, and then left the studio. To make matters worse, the studio also hired newspaper cartoonist Harry Hershfield, placing him above Quimby. Hershfield, a fast-talking man who apparently had little knowledge of — or interest in — animation, could achieve no appreciable results.

In desperation, MGM turned back to Hugh Harman and Rudy Ising for help in keeping the Cartoon Department afloat, and soon the two men were working beside many of their former employees, creating some notable

cartoons over the next few years. (About this same time Friz Freleng returned to Warners, where he remained until they closed in 1963.) Rudy Ising's principal creation, a good-natured animal named Barney Bear, made his debut in "The Bear That Wouldn't Sleep," then appeared in a number of early forties cartoons. Laid back and amiable, whatever the circumstances, Barney was clearly modeled on MGM's star Wallace Beery, whose burly, rough-hewn style was then popular with movie audiences. Some say Barney resembled Ising himself. Harman, on the other hand, was attempting to create loftier animated films, with more sophisticated content; he even tried to animate a version of Gray's "Elegy Written in a Country Churchyard." His most notable work was a 1939 release called "Peace on Earth," in which an antiwar theme was carried out with exquisite animation. The cartoon graphically depicted mankind destroyed by war and the world in ruins, until the animals discover a book in a bombed-out church that urges them to rebuild everything. A happy new world rises out of the debris, leading to a joyous celebration of Christmas. (Nominated for an Academy Award and cited by the Nobel Peace Prize committee, "Peace on Earth" was remade, scene by scene, by Hanna and Barbera in a 1955 CinemaScope version called "Good Will to Men.") Rudy Ising continued to make Barney the Bear cartoons for MGM, along with an occasional one-shot film such as "The Milky Way," which, in 1949, took an Oscar away from Disney for the first time in seven years.

Although MGM's Cartoon Department had somehow weathered the storm of its first years, the atmosphere was far from calm or reassuring. Nor had the department yet made any significant contribution to the history and art of animation. That contribution would soon be forthcoming from two of its employees, who would send an antagonistic cat and an ingenious mouse hurtling merrily into immortality.

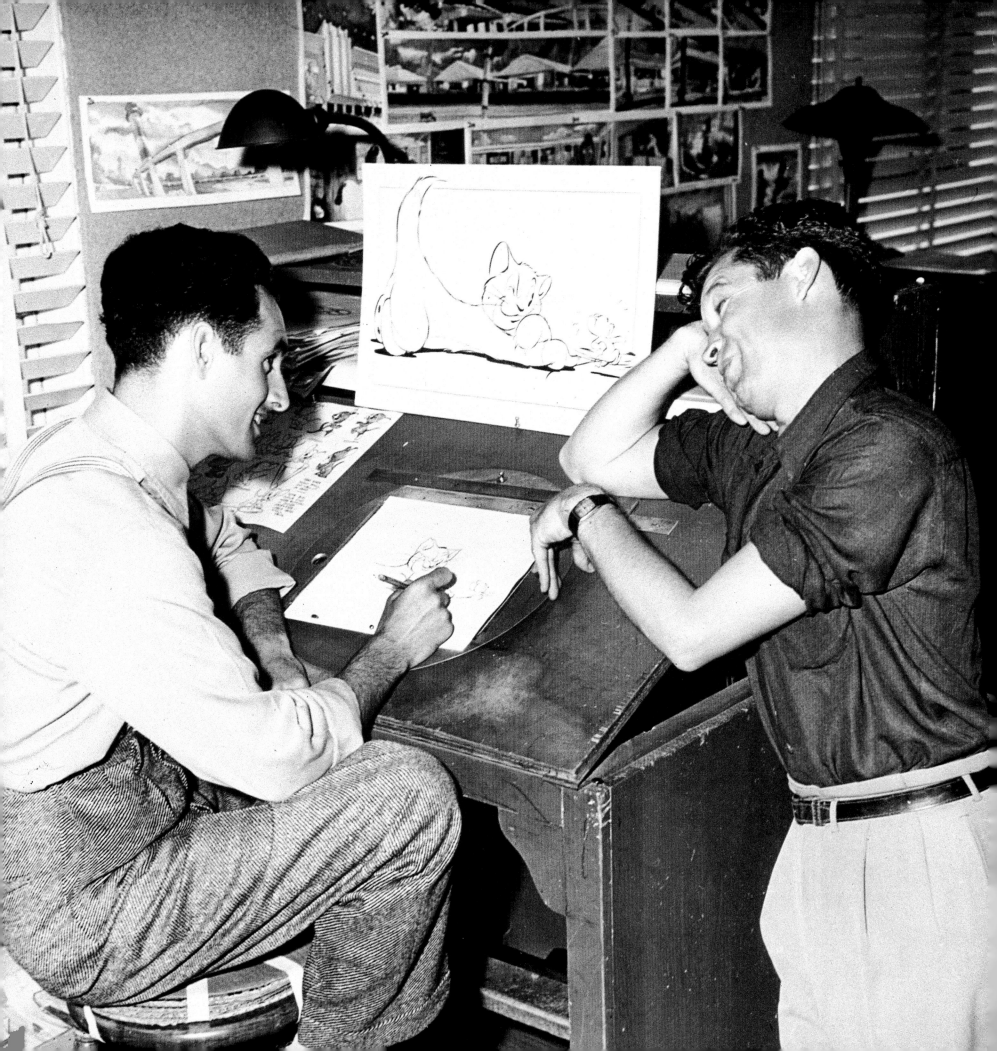

The Tom and Jerry Years

The film is "Trap Happy" (1946), and the chase is on! The cat named Tom madly pursues the mouse named Jerry, his yellow eyes and baleful eyebrows expressing feline fury. He traps Jerry under a chair, only to have the mouse suddenly smack him from behind with a two-by-four. Undaunted, he places a lighted firecracker in Jerry's mousehole, but the unfazed mouse reappears, to place an even bigger firecracker next to Tom, which explodes noisily. Tom comes at Jerry with a shovel, which the mouse sidesteps deftly. Jerry pulls at the shovel, until it catapults into Tom's face. And the chase continues, with cat and mouse locked in a succession of ploys, tricks, and countermoves.

The ingenuity, the imagination, and the creative skill that went into the creation of animated scenes like this originated in the spring of 1938, soon after Bill Hanna and Joe Barbera met for the first time. Cordial from the start, they came to recognize the special rapport between them — the

Left: Together for the first time, Joe Barbera and Bill Hanna at MGM in 1939.

Producing **"Tom and Jerry" cartoons at MGM for twenty years was for me one continuous labor of love.**

—**Bill Hanna**

combination of individual abilities that made them stronger as a team than by themselves. Working together at MGM, they began to understand that Hanna's razor-sharp sense of comedy timing and his organizational skill blended perfectly with Barbera's comic inventiveness and superior drawing ability. "He was the best cartoonist I'd ever seen," Hanna recalls. "I had a lot of respect for his artistic ability, and I knew how much he contributed to the stories." Barbera, similarly, was drawn to Hanna's talents. As the Cartoon Department struggled to find its identity, they decided that it was an ideal time to test the waters, as a team, on their own time.

The overriding question was this: Who would be the central characters of their first cartoon? Ultimately, after some false starts, they settled on two universally recognized antagonists: the cat and the mouse. In a conflict that spanned millennia, the cat had pursued the mouse, and often caught him. Of course the conflict provided count-

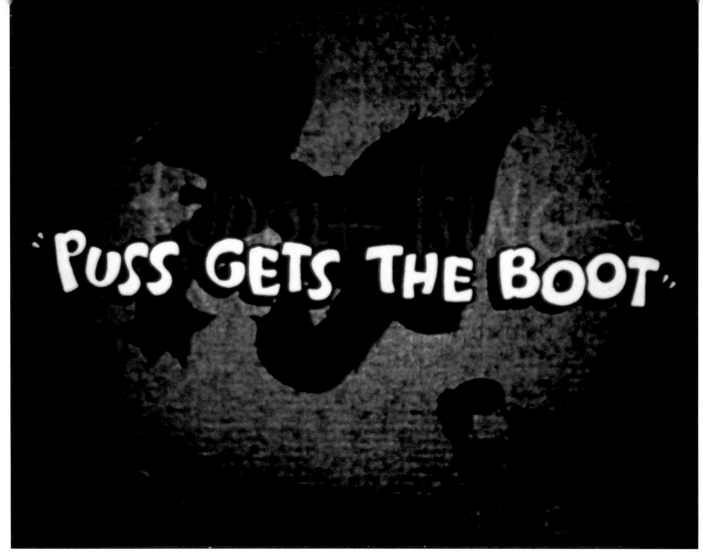

less opportunities for wild chases, hair-breadth escapes by the mouse, humiliation and frustration for the cat — and the kind of all-out slapstick that had provoked audiences to laugh since the first images flickered on a screen. It was the age-old struggle of the weak versus the strong, with the weak not as helpless as one might think and the strong not as all-powerful as he believed. Working long hours into the night, with Barbera rapidly spinning sketches from his fingertips and Hanna timing and directing the action with uncanny precision, the two men created "Puss Gets the Boot."

As an innovation that would influence later cartoon-making, Hanna and Barbera prepared a demonstration film of "Puss Gets the Boot," using only about 1,200 to 1,800 drawings to show every major scene in the film, including the actual close-ups, long shots, and character movements. The drawings were then placed on an exposure sheet — an animator's blueprint — that indicated the action frame by frame so that the camera could shoot them to length. The resulting film was as long as a standard cartoon, but without the infinitely larger number of drawings that were usually required.

"Puss Gets the Boot" showed a Tom (here called Jasper) quite different from the familiar cat of later years. Covered with bandages from previous warfare, he looked rather mangy and disreputable. Given three eyebrows that expressed degrees of cunning or indignation, he also seemed much more ferocious than the Tom who could manage an occasional evil smile. The unnamed mouse resembled the later Jerry, except that he was skinnier and not as cuddly, with a large black nose and matted hair on his head. The situation, however, was basically the same instinctive an-

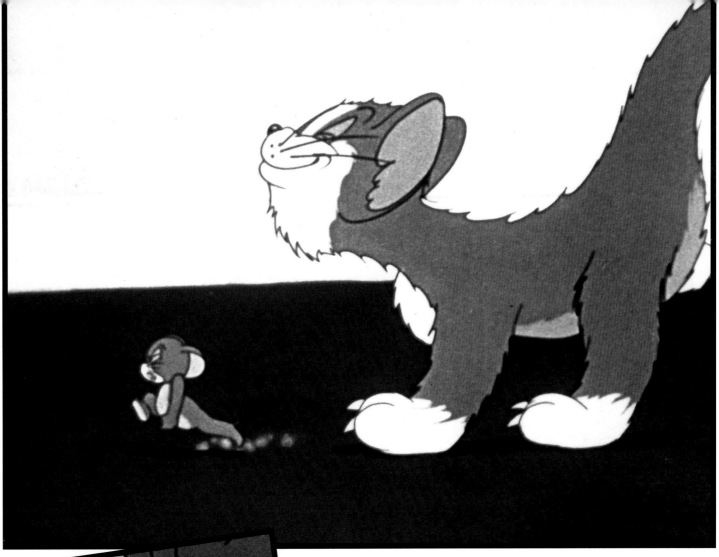

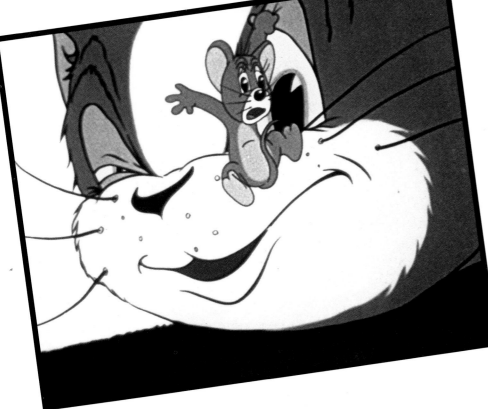

tagonism that would carry them through the next twenty years: cat stalks and chases mouse in a frenzy of mayhem and slapstick violence. In this instance, the "mammy" housekeeper warns Jasper not to break anything more in the house or he would risk being tossed out into the street. This gives the wickedly gleeful mouse the chance for revenge, as he threatens the relentlessly pursuing Jasper with breakage at every turn. The cartoon ends with the cat's ejection and the mouse's placing a "HOME SWEET HOME" sampler above his tiny mousehole.

When the demonstration film of "Puss Gets the Boot" was run for MGM's executives, laughter filled the projection room. Yet the completed cartoon, released without much fanfare early in 1940, received only an indifferent reaction from Fred Quimby and other studio personnel, who felt that the subject of cat versus mouse was tired and

Following pages: The changing faces of Tom and Jerry:
as they appeared in "Puss Gets the Boot," left, and the
familiar antagonists in their signature opening, right.

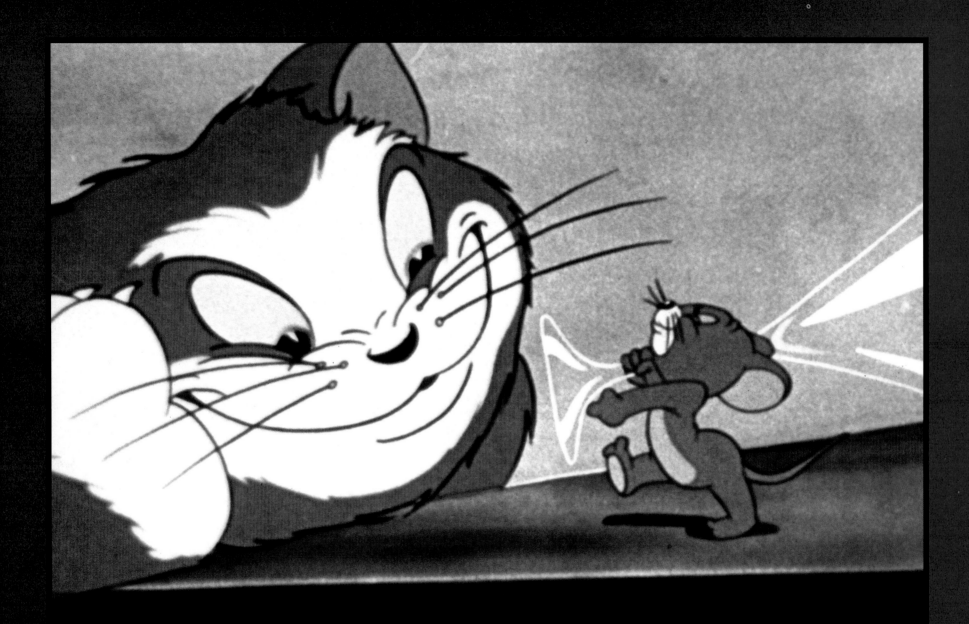

old hat. Luckily, an enthusiastic letter from a major exhibitor turned their opinion around, and Hanna and Barbera were instructed to make more cat-and-mouse cartoons. As icing on the cake, "Puss Gets the Boot" was not only enormously popular in the theaters (it ran for many weeks at a theater on Wilshire Boulevard), but it was also nominated for an Academy Award. Curiously, although they created the material, Hanna and Barbera did not receive screen credit for the film. Sole producer credit went to Rudy Ising, who was soon to leave MGM. Hanna and Barbera continued to make the "Tom and Jerry" cartoons for seventeen years ("we breathed, ate, slept cartoons"), establishing the cat and mouse in the pantheon of animated characters. Although both were deeply involved in the creative process, Barbera would concentrate on sketching the material, while Hanna was concerned with timing and directing the action. The names Tom and Jerry came out of the batch of names that was tossed into a hat by MGM personnel. The $50 prize went to a New York animator named Jack Carr. Today Barbera admits, "No-

body was really inspired by the names Tom and Jerry. But we've since learned that the simpler the name, the easier it is to remember."

The Tom that followed "Puss Gets the Boot," and which eventually became the accepted model, differed markedly in appearance. By 1943 Tom had become much less disreputable, although his thick black eyebrows and yellow eyes still gave him the look of the predator on the loose. A little plumper than the mouse in "Puss Gets the Boot," Jerry retained his tiny stature and large, innocent-seeming eyes, but events proved, over and over again, that he was more than a match for Tom. Both Tom and Jerry appeared to be in constant motion, their thick legs spinning madly during chases and their equally thick tails swishing as they dashed off the screen. Their appearance may have been refined, but the situation seldom changed: in any time (from seventeenth-century France to the present) or place (from a suburban living room to a concert hall), an irritated, furious, or humiliated Tom pursues and attempts to destroy the bemused, unflappable, and diabolically ingenious Jerry.

If the situation remained the same, the range of moods and expressions was amazingly varied over the two-decade history of Tom and Jerry. Through full animation techniques, Hanna and Barbera were able to suggest a great many emotions. Tom, in particular, was able to convey his shifting feelings about his tiny prey: sheer nastiness (his mouth twisted into an evil grin) when he thought of a particularly vicious gambit; puzzlement when he failed to decipher one of Jerry's ruses; rage when yet another trap backfired, and total astonishment when, as often happened, he was completely demolished by one of Jerry's counterattacks. Add an occasional smile of satisfaction when he believed he had triumphed over Jerry, or a look of unbridled terror when he was close to falling into the clutches of Spike the bulldog, and you had a many-sided animated character, with a genuine personality.

Right: Tom's amazing range of emotions (clockwise from top left): bemused, triumphant, terrified, irritated.

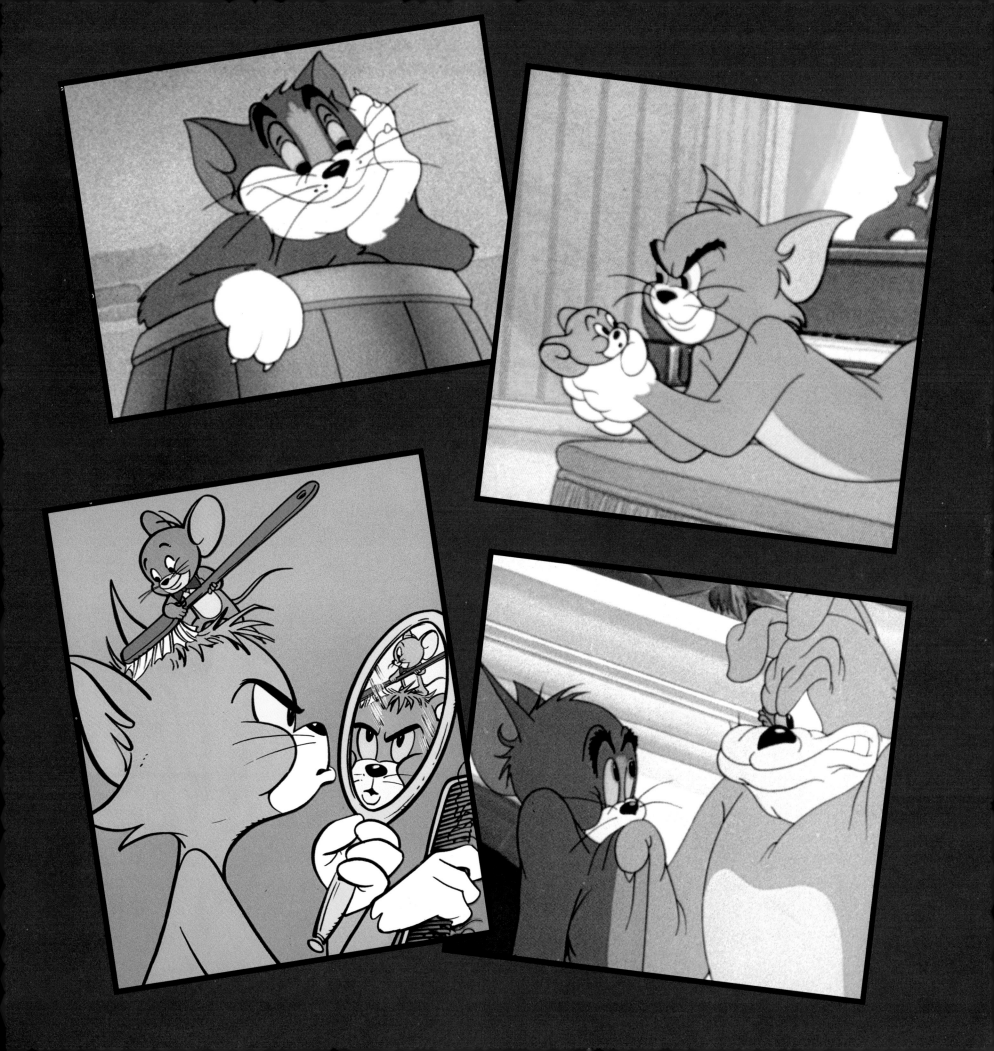

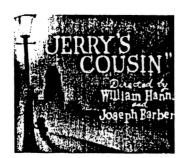

(4) JERRY'S COUSIN

MUSCLES INTO SC.
PICKS LETTER OUT OF CAN

MUSCLES (O.S.) READS
LETTER

GOES IN HOLE -- A
BEAT -- COMES OUT
WITH SUIT CASE

MUSCLES:Listen Pussy cat
don't let me catch you
picking on my little cousin

While I'm around!
You understand?
Now beat it!

CRASHES INTO WALL

DROPS DOWN INTO VASE

SPITS O.S.

HITS VASE - BREAKS

(T) SHAPE OF INSIDE
OF VASE

RUNNING ON PAN

(T) CATCHES (J)

MUSCLES OPENS DOOR.
THROWS BALL ALA
BOWLING BALL

BALL HIT (T) KNOCK HIM
UP IN AIR OUT OF SC.

TEN PIN (T)S DOWN
INTO SC.

MUSCLES IN DETERMINED
RUN

TEN PIN (T)S REACT
RUSH TOGETHER TO
FORM SHAPE OF (T)

(T) INTO TAKE RUNS
OUT OF SC.

AROUND CORNER
ADN OUT OF SC.

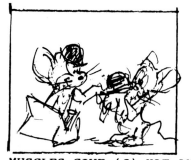

MUSCLES GIVE (J) HAT AND
SWEATER OUT OF HIS BAG
MUSCLES: An' remember

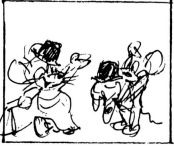

all you have to do is
just whistle. Well so
long cousin.

(J) WIGGLES INTO
SWEATER

PUTS HAT ON COCKS
IT TO ONE SIDE

(J) WHISTLES

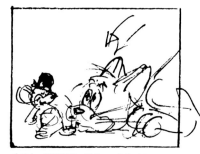

(T) INTO SC. BOWS
KISSES (J) FOOT

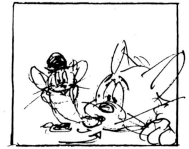

(J) PUTS OTHER FOOT OUT
LOOKS AT CAMERA BIG SMILE

IRIS OUT ON (J)

Despite the ongoing antagonism, the unstated regard that Tom and Jerry had for each other surely contributed to the series' longevity. Viewers sensed that Tom was not *really* interested in destroying little Jerry. In the Oscar-nominated "The Night Before Christmas" (1941), a smugly content Tom suddenly begins to worry about poor Jerry outside in the freezing cold. When Tom contracts amnesia in "Nit Witty Kitty" (1951), Jerry works mightily to restore Tom to his normal cat state — after all, what is life without the pursuing Tom? In "Just Ducky" (1953), Jerry even spoons hot soup into the drenched and shivering Tom, who has been rescued from drowning by the little duckling he was chasing. In reality, their territory — the house — belongs to them both, and in such cartoons as "Dog Trouble" (1942) and "Old Rockin' Chair Tom" (1948), they join forces to rid themselves of any intruder.

Whatever the source of Tom and Jerry's continuing popularity, the creation of the cartoons remained a joyful experience for Hanna, Barbera, and their talented staff, which, over the years, included layout men Harvey Eisenberg and Dick Bickenbach, musical director Scott Bradley,

and animators Irven Spence, Ray Patterson, Ken Muse, and Ed Barge. From first step to last Hanna and Barbera would be closely and intimately involved in a procedure that differed drastically from the much more fragmented procedure followed in today's animation. After the story and gags were developed, and a flood of thumbnail sketches had poured forth from the fertile mind of Joe Barbera, the material would move to Bill Hanna for the timing and animation direction. Irven Spence recalls, "Hanna would act out every scene, every gag and expression. After a while, I knew exactly what he wanted." A pencil test — a one-reel version of the cartoon containing about six or seven hundred feet of animation on negative film — was meticulously polished and sharpened by Hanna and Barbera before the final version was completed. Often a minimum number of changes were required because of Hanna's immaculate timing. Each six- or seven-minute cartoon took about six weeks of diligent effort, at a cost of up to $30,000 per cartoon.

The total absorption of Hanna and Barbera in every phase of a cartoon's production can surely account, at least

Left and above: Part of the storyboard for "Jerry's Cousin," 1951.

in part, for the consistently high quality of the "Tom and Jerry" series. Barbera recalls, "We were the people who were putting it down on paper. We were the people who were translating the gags. I was actually, physically drawing them. I was able to get the gag down on paper, and I was able to interpret it exactly the way it was going to work, and Bill would time it exactly as it should be timed." Today, he feels, the procedure is splintered into too many parts, involving too many hands: "The script leaves the studio and goes to a storyboard man, who has to interpret what the writer has on his mind. Now somewhere down the line, the writer happens to see the storyboard. And he goes crazy, shouting, 'This isn't what I had in mind!' This happens all the time." Another crucial difference from the "Tom and Jerry" period is the input of the network's Standards and Practices people, who approve the original story but then balk at some aspect of the completed material. "With Tom and Jerry," Barbera says, "nobody saw the cartoon until it was finished and ready for screening." Often, after a cartoon was released, the team would converge on the theater, to listen to the audience reaction. Irven Spence remembers, "The gags brought laughs from beginning to end. That was the big payoff. That was our reward."

Rewards also came in the camaraderie and good cheer that apparently pervaded the "Tom and Jerry" unit. The grueling work was not infrequently punctuated with practical jokes. Spence recalls, "Joe Barbera loved to play gags on me. I had a desk next to the wall, with Joe and Bill's office on the other side. One day Joe drilled a hole through the wall, right about where my head would be on the other side. He ran a soda straw through the hole and when he knew I was sitting at my desk, he filled his mouth with water and squirted it through the hole onto my head. But I had my revenge. Joe had a desk where he would stand to make the sketches for 'Tom and Jerry.' I rigged one of the big film cans with water and placed it on a shelf above his desk. Then I fastened a string to a stick underneath the can and attached the string to an electric fan. When he came back to his desk and turned on his light, the fan started and wound up the string, which upset the can. Joe heard the noise of the winding string, stepped back, and the water splashed onto his desk." Animator Ray Patterson sums it up when he remarks, "The whole business was fun. It was hard work, but it was fun."

Despite the occasional high jinks, the group worked assiduously, and the results were usually splendid. Watching the "Tom and Jerry" cartoons created by Hanna, Barbera, and their team between 1940 and 1957, a viewer is continually astonished by the richness of the animation. Ray Patterson recalls the infinite care that was taken with each cartoon: "We fully animated almost every drawing. We put personality into the characters, instead of just having them blink their eyes or move their mouths." Also evident throughout the series is the first-rate combination of story, characterization, and gags. "The Night Before Christmas," for example, brims with holiday charm and inventive gags as Tom appears to interrupt Jerry's joyful holiday and give chase. Toys are used throughout as imaginative props — Jerry pretends to be a tree ornament, hides himself in a troop of marching wooden soldiers, and rides a toy train. Standing under the mistletoe, Jerry coyly asks Tom to kiss him, and when a softened Tom bestows a kiss on his cheek, Jerry rewards him with a kick. The cartoon closes with Jerry using Tom's gift of a peppermint stick to extract cheese from a mousetrap.

Although the pattern of cat chases mouse remained consistent, the series

managed a remarkable number of variations. In a 1944 entry, "The Million Dollar Cat," the newly rich Tom is told he will lose his inheritance if he harms Jerry in any way. His frustration and rage mount with every one of Jerry's well-executed ploys, until he becomes a furry fury ready to take up the chase. "I'm blowing away a million dollars," he exclaims, adding, "but I'm happy!" Oscar nominee "Dr. Jekyll and Mr. Mouse" (1947) has a diabolical Tom inventing a secret formula that temporarily turns Jerry into a phenomenally strong mouse, then deflates him into an ant-size mouse. Jerry retaliates with a potion that changes Tom into a mouse-size cat, whom he pursues with a fly swatter. In "Polka-Dot Puss" (1949), Jerry convinces Tom he has measles by painting the cat's face with

Jerry and his protector, Spike, with watchful Tom in the background.

dots, and then uses an arsenal of medical devices and remedies to "cure" him: he sounds an alarm into a stethoscope, smashes Tom's knee with a hammer, buries him in ice cubes, and then bastes him in a hot oven. The cartoon closes with both cat and mouse quarantined together with genuine measles.

Many of the funniest cartoons involved Tom's luckless encounters with other creatures while engaged in his unceasing pursuit of Jerry. In "Jerry's Cousin" (1951), Tom has the misfortune to come up against Muscles, Jerry's hard-boiled relative, who pulverizes the cat at every opportunity; even Tom's gang of mean, coin-flipping cat thugs is clobbered by Muscles. The recurring character of the surly bulldog Spike sends Tom into a frenzy of terror — in "The Bodyguard" (1944). Tom, fearing that Jerry's shrill whistle

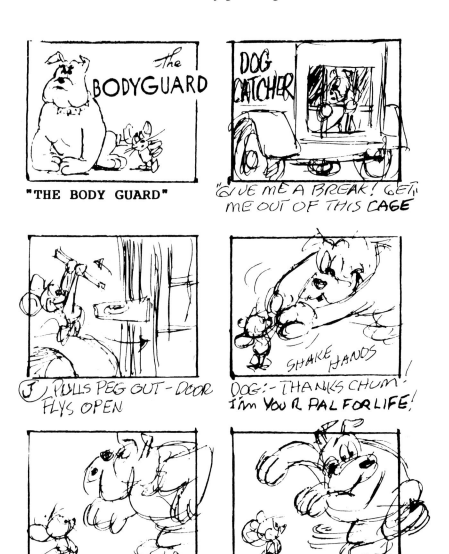

Left: A section of the storyboard for "The Bodyguard," 1944.

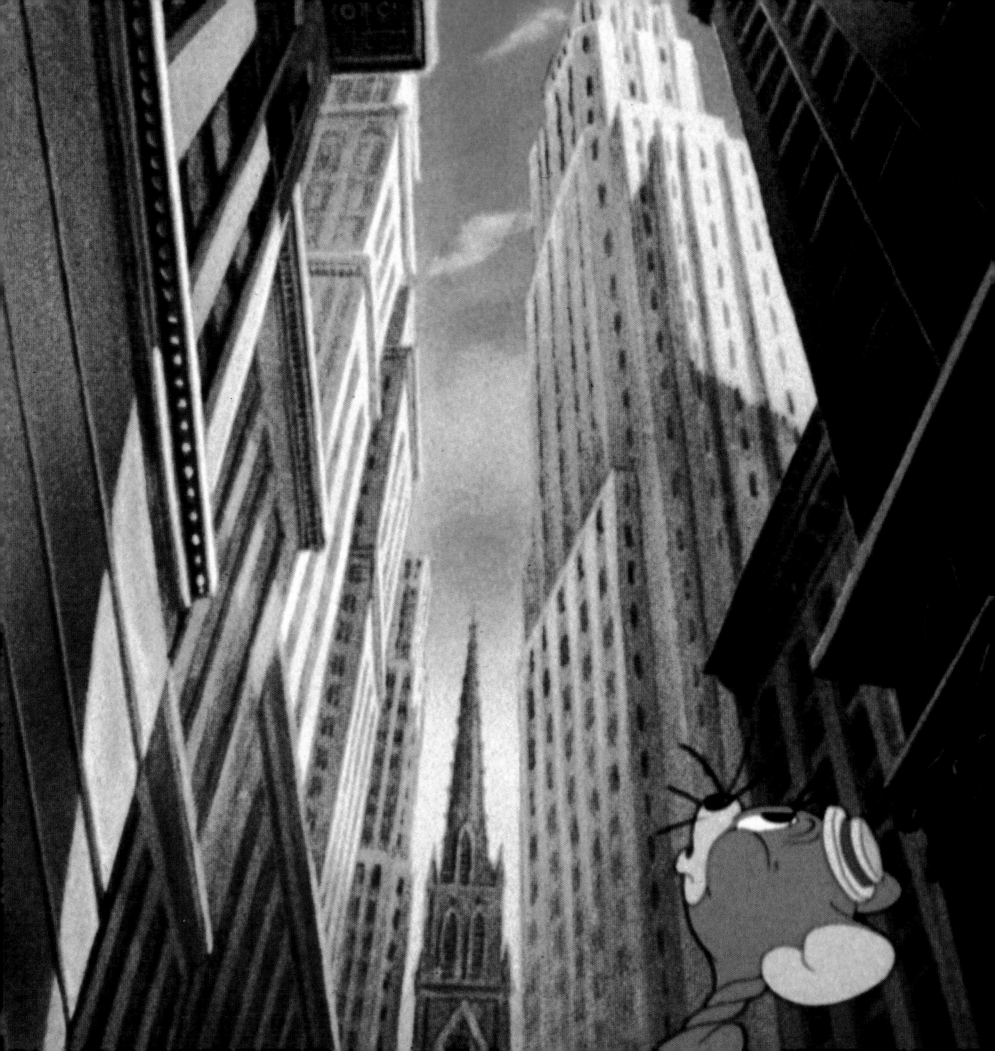

will summon his new bodyguard Spike, becomes completely unglued. He pleads for Jerry's mercy, places a tombstone on a quickly dug grave, and stretches out with a flower in his paw, then hastily scribbles his Last Will and Testament. In "Hic-cup Pup" (1954), a hilarious moment occurs when Tom, wearing the horns that Jerry has strategically placed on his feet, tries frantically to tiptoe away from Spike's onslaught.

One uproarious episode, "The Flying Cat" (1951), finds Tom changing his target to a small bird who proves to be exceptionally adept at besting cats. With Jerry's help, the bird sends Tom crashing to earth with a 2,000-pound weight in his paws and sets fire to the ladder Tom is using to get up into a tree, leaving both cat and ladder in ashes. In an ingeniously devised sequence, Tom pole-vaults in the bird's direction, only to skid on a roller skate placed in his path by Jerry. Landing on a clothesline, he becomes caught in the stays of a girdle. With quick thinking, he fashions the girdle into an improvised "airplane" and soars delightedly through the air — until it plummets into a letter box. Restored in an instant, of course, he undergoes further mishaps until he finally chases Jerry into a tunnel. A train comes roaring through, leaving a terrified Tom dangling from a bridge.

Occasionally, a "Tom and Jerry" cartoon included moments of purely charming animation, with no relation to the broad slapstick of the cat-and-mouse chase. "The Cat and the Mermouse" (1949), a lovely piece of animation, has Tom waking up underwater and deftly imitating the movements of the fish and the turtle he sees. In "Mice Follies" (1954), Jerry and his friends make their own ice rink by releasing and then freezing water from every faucet in the basement. Caught in a spotlight, an enchanted Jerry skates on the ice with a small mouse. "Mouse in Manhattan" (1944), one of the most beautifully animated cartoons in the series, offered stunning vistas of New York City as bored little Jerry seeks excitement in the metropolis. He arrives in the middle of Grand Central

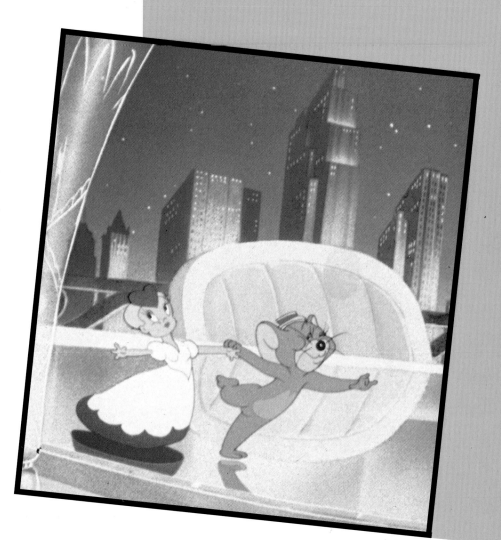

Terminal, awed by its vastness and by the sunlight streaming through the windows. Amazed by the tall buildings, he stumbles into a series of adventures. He finds himself floating down a sewer on a hairbrush and then riding a queasy-making elevator to a hotel powder room from which he emerges blushing. He discovers a swank rooftop restaurant where, in an exquisite moment, he comes upon the paper girls on place cards and dances with them, Astaire and Rogers style, in this magical setting. Eventually he is chased by a scroungy cat into a jewelry store window, only to be pursued by the police. Fleeing across a bridge, he rushes home, tears up his farewell note to Tom, and kisses the bewildered cat profusely. He places a HOME SWEET HOME sign on his mousehole. Throughout this cartoon, the images are rendered in vivid, imaginative strokes, with an extraordinary number of precise details.

Above: Jerry skates happily against Manhattan's winter background in "Mouse in Manhattan," 1944.

Left: Jerry is awed by Manhattan's buildings in "Mouse in Manhattan.

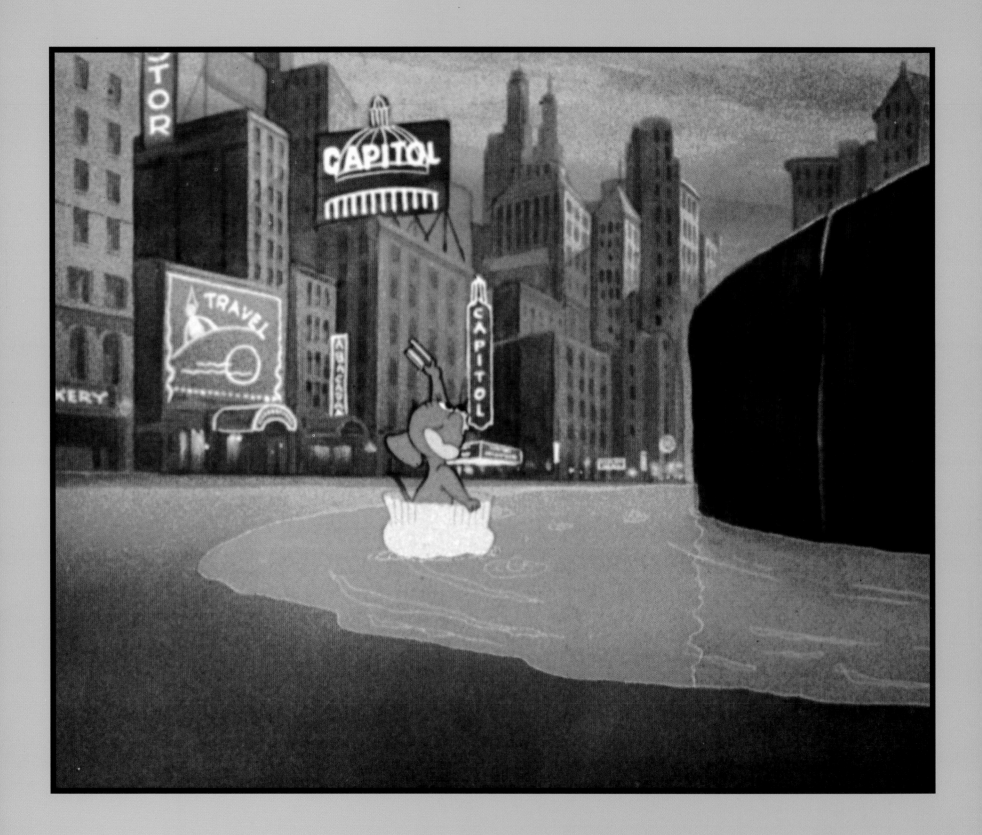

Over the years the high quality and the inventiveness of the stories and animation for "Tom and Jerry" did not go unrewarded, and an unprecedented seven of the cartoons were presented with Academy Awards. Four others were nominated but failed to win. "The Yankee Doodle Mouse," the winning cartoon for 1943, involved Tom and Jerry in a pitched battle that cleverly used ordinary household items as objects of war. Lieutenant Jerry Mouse, scurrying to his cat-raid shelter or firing off communiqués ("Sighted cat—sank same!"), lobs eggs ("hen-grenades") at Tom's head, turns corks from wine bottles into guided missiles, and makes a convenient smoke screen out of flour. "Mouse Trouble," the Oscar-winning entry for 1944, had Tom slavishly following a book entitled *How to Catch a Mouse*, only to have each suggestion fail disastrously. He

Left: Jerry floats down Broadway in "Mouse in Manhattan."

A scene from the Academy Award—winning cartoon "The Yankee Doodle Mouse," 1943.

The MGM animation team (left to right): Ed Barge, Irven Spence, Dick Bickenbach, Joe Barbera, Bill Hanna, and Ken Muse.

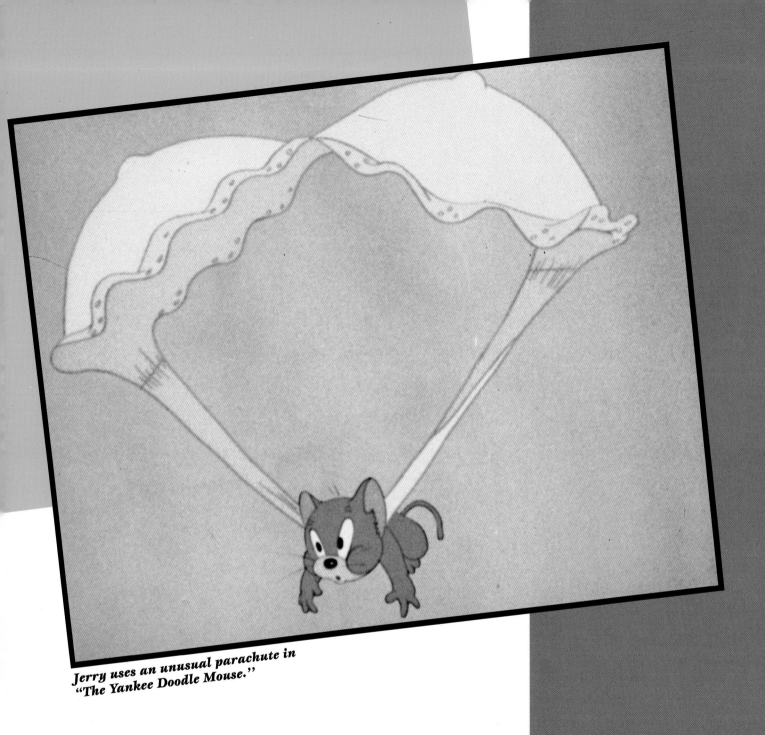

Jerry uses an unusual parachute in "The Yankee Doodle Mouse."

Right: A tense moment for Tom in "The Yankee Doodle Mouse."

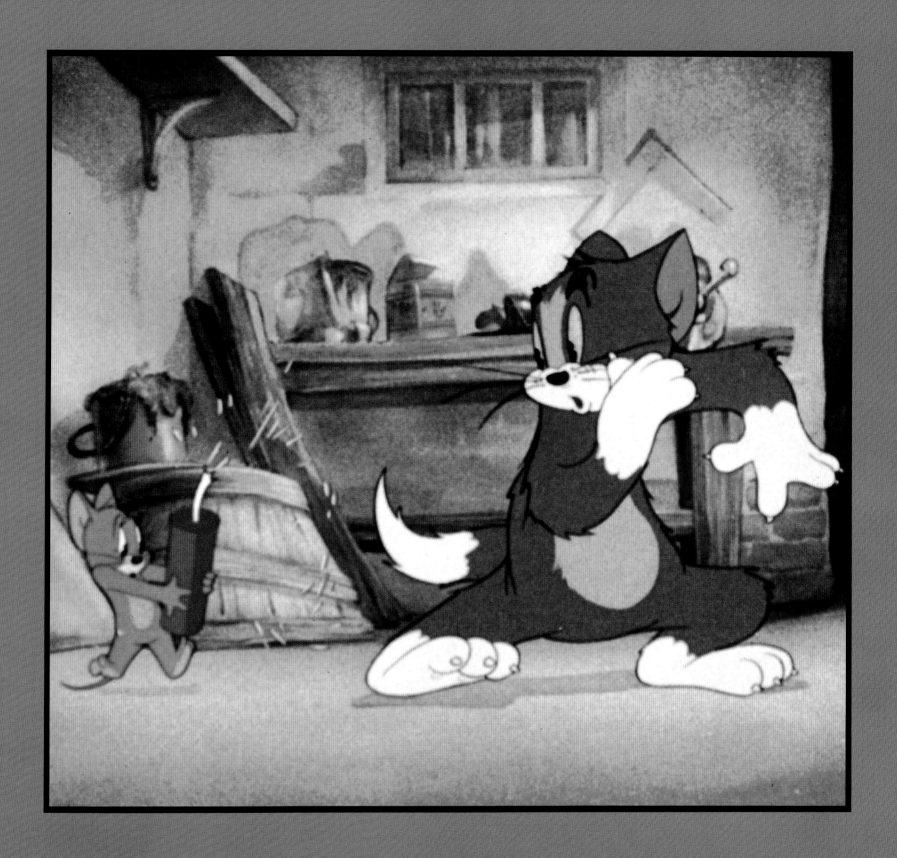

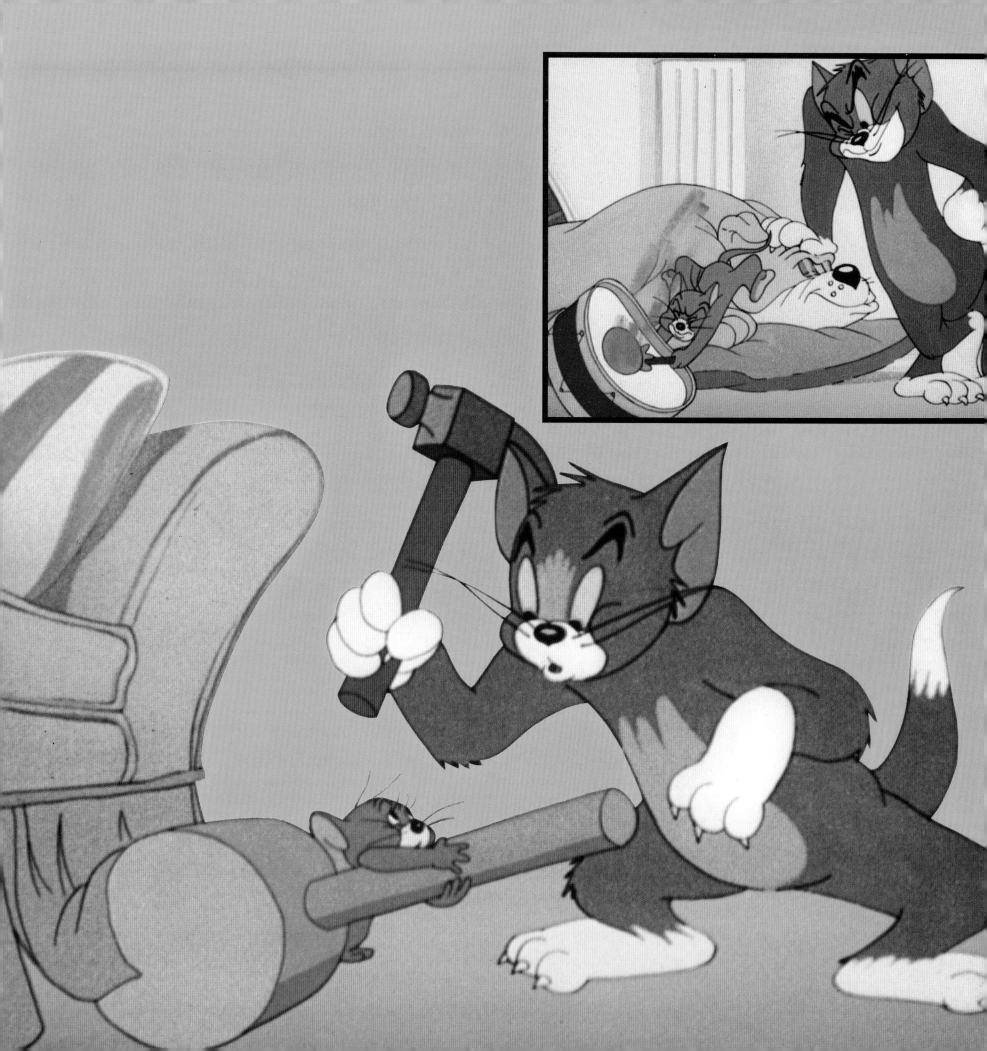

**READS NOTE LEFT
WITH ORPHAN**

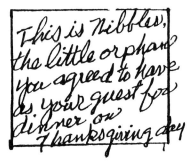

This is Nibbles, the little orphan you agreed to have as your guest for dinner on Thanksgiving day

thank you, Bid-a-Wee Mouse House P.S. He's always Hungry

**ORPHAN TRYS TO EAT
ORANGE**

**SWALLOW$WHOLE
ORANGE**

**(J) INTO SC. TRYS
TO GET ORANGE OUT
OF ORPHAN**

**HITS ORANGE WITH
FLAT OF KNIFE
ORPHAN OUT OF ORANGE**

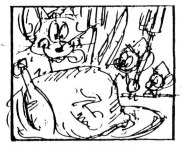

**TRIO ANTICIPATES
EATING TURKEY**

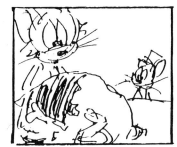

**ORPHAN ZIPS INSIDE
TURKEY - EATS MEAT
LEAVES BONES**

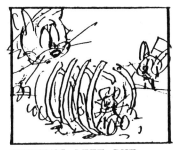

**NOTHING LEFT BUT
SKELETON - BONES
FALL DOWN**

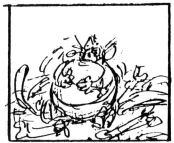

**ORPHAN LICKS CHOPS
PATS TUMMY**

falls into his own traps (a snare trap sends him whirling into space), gets caught in the blast of his own gun, and blows himself up with assorted bombs. "Quiet, Please," honored in 1945, introduced the bulldog Spike, who became Tom's nemesis in a number of cartoons, while "The Little Orphan," the 1948 winner, concerned Jerry's adventure with an orphan mouse aptly named Nibbles, who is insatiably hungry and who tangles inevitably with the predatory Tom. The cartoon is most notable for the ingenuity with which it uses the familiar trappings of Thanksgiving — the foods, dishes, and cutlery assembled for a holiday dinner are used as projectiles.

Left: Tom and Jerry in a pause during combat, and, above, with Spike in the Oscar winner "Quiet, Please," 1945.

Left and above: A portion of the storyboard for Oscar winner "The Little Orphan," 1948.

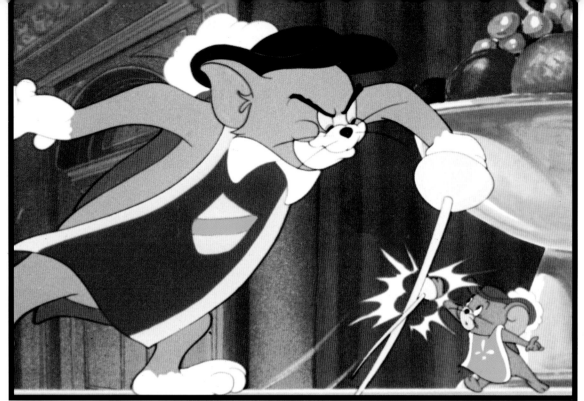

Right: The Mouseketeers try to elude Tom by hiding among the lamb chops decorated for the king's banquet.

Academy Award winner "The Two Mouseketeers," 1951, was one of the finest in the series.

"The Two Mouseketeers," the Oscar-winning entry in 1951, marked a high point in "Tom and Jerry" animation. Funny and clever from start to finish, the cartoon cast the beleaguered Tom as a French guard in the seventeenth century, assigned to protect the king's banquet table from the mischievous Mouseketeers. Failure means the guillotine. Enter the Mouseketeers—Jerry and the tiny mouse called Nibbles or Tuffy—who proceed to tangle with Tom in a barrage of brilliantly animated incidents. Forced to constantly rescue his bold but adorable little friend from Tom's clutches, Jerry must engage in a duel with the cat or pelt him with objects from the banquet table. In one splendid moment, he tosses tomatoes, mushrooms, and chunks of meat at Tom, who impales them on his sword. Delighted when he realizes that he now has a tasty shish kebab, he proceeds to heat it in the flame of the candles, only to be jabbed in the rear by the sword of little Nibbles, who has scurried inside his robe. ("Touché, poussycat!") Surprisingly, the cartoon ends with Tom's beheading (off screen, of course) and little Nibbles's remark, "Pauvre, pauvre poussycat!" followed, after the slightest of pauses, by "C'est la guerre!" (Nibbles's lines were actually spoken by a six-year-old French girl.)

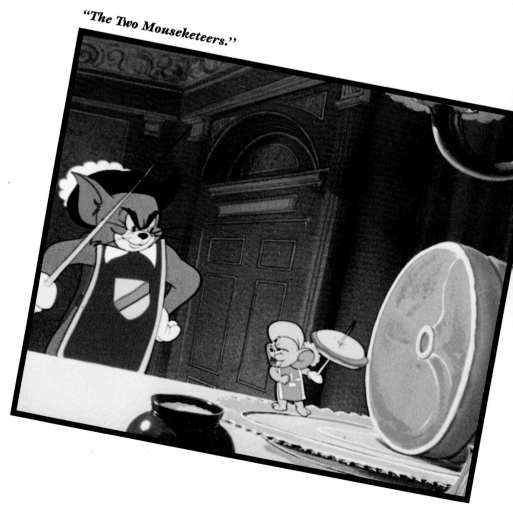

"The Two Mouseketeers."

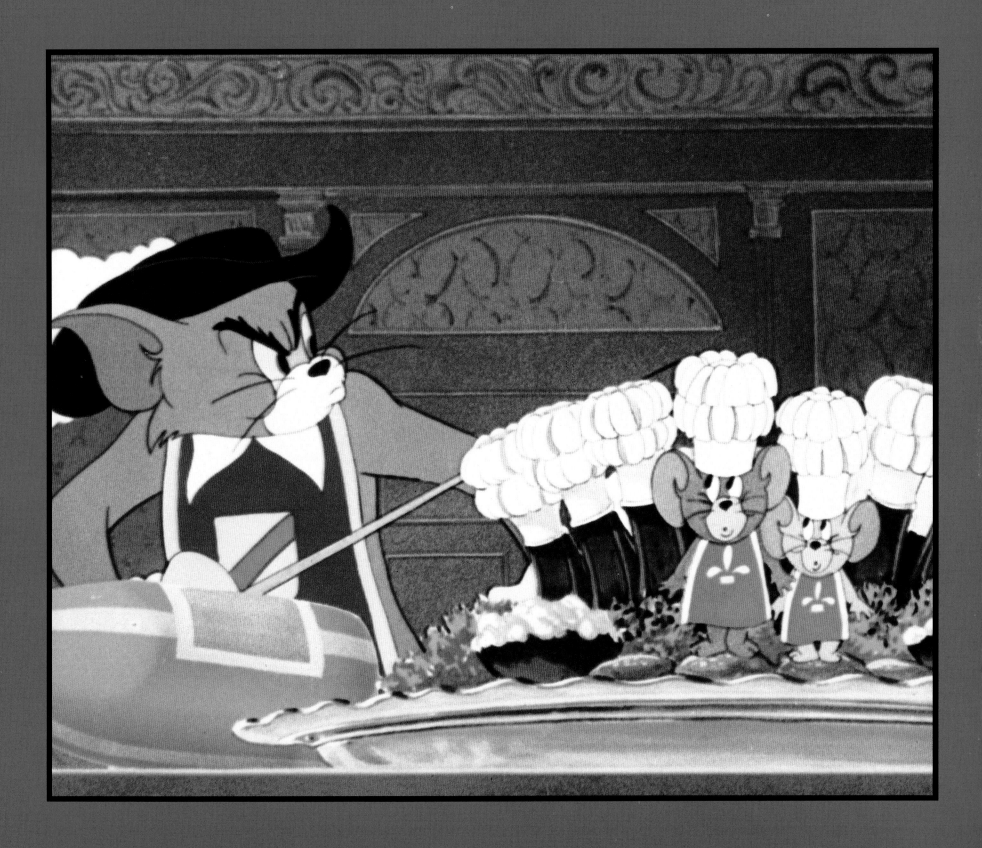

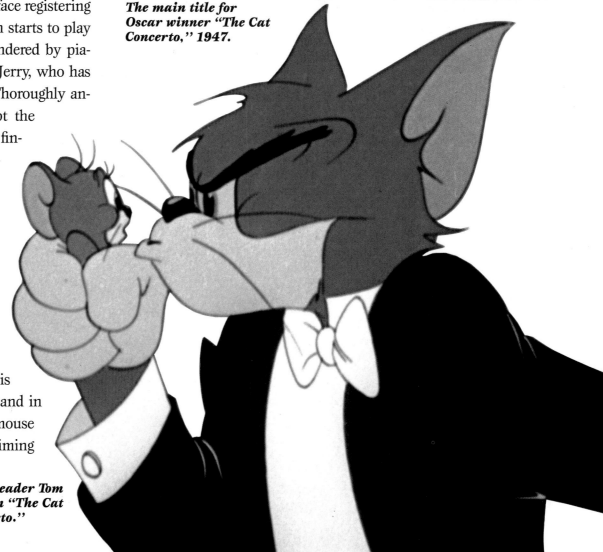

The main title for Oscar winner "The Cat Concerto," 1947.

Two of the Oscar-winning cartoons, both masterpieces of animation, took place in the world of music. "The Cat Concerto" (1947), a delightful parody of the rituals and pretensions of classical music concerts, has Tom as the piano soloist at such a concert. (Ken Muse was especially adept at animating the piano playing.) His face registering the lofty superiority of the great artist, Tom starts to play Liszt's "Hungarian Rhapsody," actually rendered by pianist Jakob Gimpel, only to awaken mouse Jerry, who has been sleeping blissfully inside the piano. Thoroughly annoyed, Jerry begins a campaign to disrupt the concert. He slams the piano cover on Tom's fingers, flattening them completely. (Tom registers a moment of pain, then continues playing with his flattened fingers.) Jerry replaces two keys with a mousetrap and of course Tom obligingly plays the notes. The mouse even takes over the piano at one point, playing a snappy version of MGM's hit song "On the Atchinson, Topeka, and the Santa Fe." Through all the intrusions, Tom fights to keep his concert on course, even playing with his feet at one point. Finally, he catches Jerry and in a deftly animated sequence he tosses the mouse among the piano hammers in perfect timing

Angry orchestra leader Tom clutches Jerry in "The Cat Concerto."

34

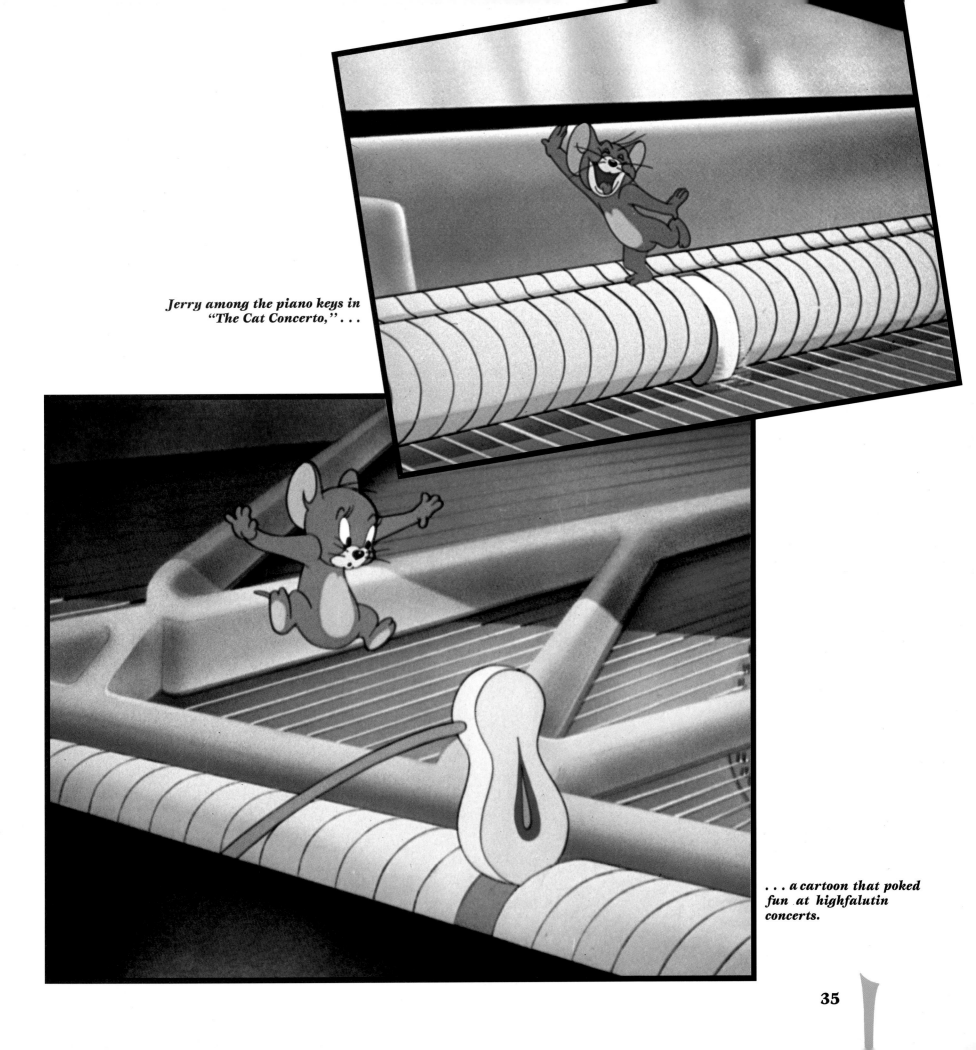

Jerry among the piano keys in "The Cat Concerto," . . .

. . . a cartoon that poked fun at highfalutin concerts.

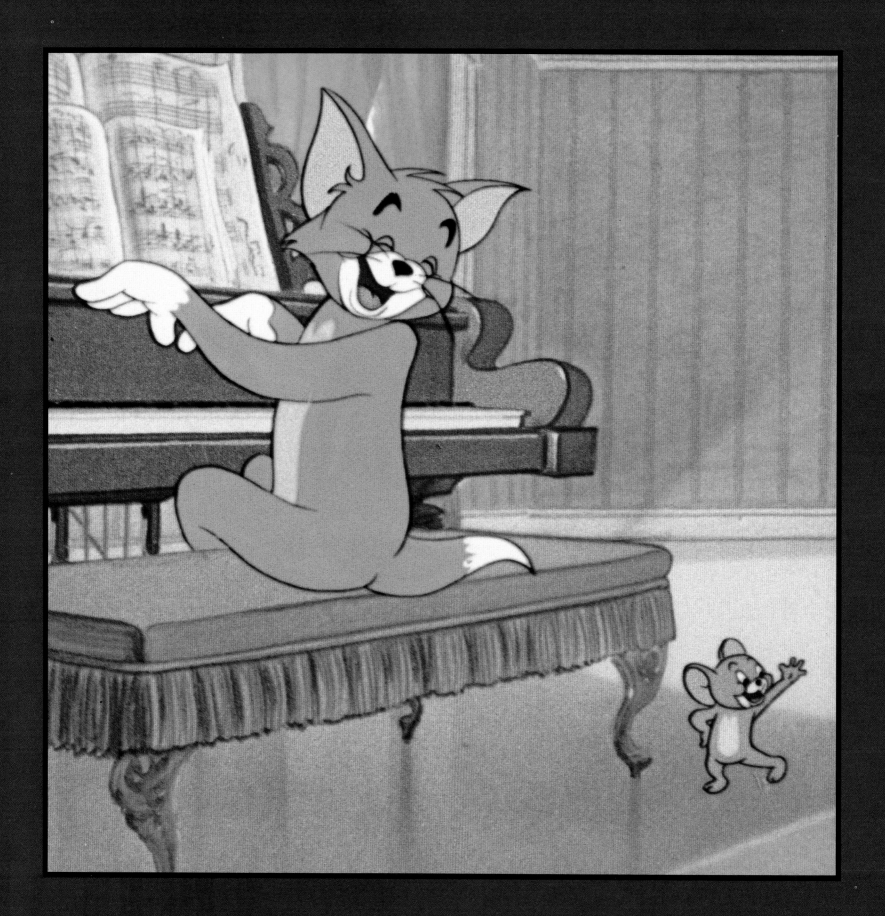

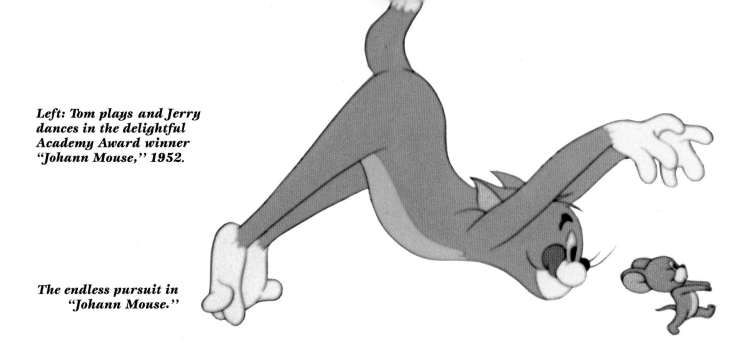

Left: Tom plays and Jerry dances in the delightful Academy Award winner "Johann Mouse," 1952.

The endless pursuit in "Johann Mouse."

with the music. Jerry perseveres, and at the end a totally unraveled Tom collapses on the keys while Jerry takes a bow to ringing cheers and applause. A model of full animation techniques, "The Cat Concerto" combines satire and slapstick with memorable results.

The 1952 Oscar winner, "Johann Mouse," was equally memorable. Narrated by Hans Conreid, this enchanting cartoon has Jerry as a musical-minded mouse living in the home of the Waltz King, Johann Strauss. Unable to resist the lilting strains of the master's music, the little mouse leaves his hole to waltz, entranced, about the room. Each day Tom waits for him to appear, and each day he fails to catch his prey. When the master of the house leaves on a journey, Tom decides to learn to play the piano in order to keep the mouse dancing obliviously. Soon he has become a virtuoso, playing the "Blue Danube" waltz with éclat. (The piano music was again provided by Jakob Gimpel.) When the servants behold a mouse waltzing to piano music played by a cat, the phenomenon reaches the ears of the Emperor, who insists on a command performance. Tom and the mouse perform triumphantly as a team — but when the music stops the chase resumes.

"Johann Mouse" impresses throughout with the perfectly sustained tone of a humorous fable. Funny and engaging moments abound: the mouse transported as he whirls about the lavish music room; Tom learning to play the "Blue Danube" waltz, note by note; a desperate Tom at the keyboard, playing with his rear paws as he lunges at the mouse with his front paws; the cat and mouse at the command performance, haughtily acknowledging the applause of the crowd, or enjoying themselves immensely as the mouse dances atop the piano with Tom's paw.

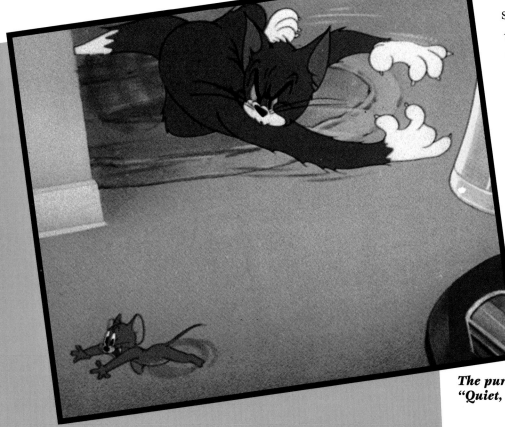

The pursuit continues in "Quiet, Please."

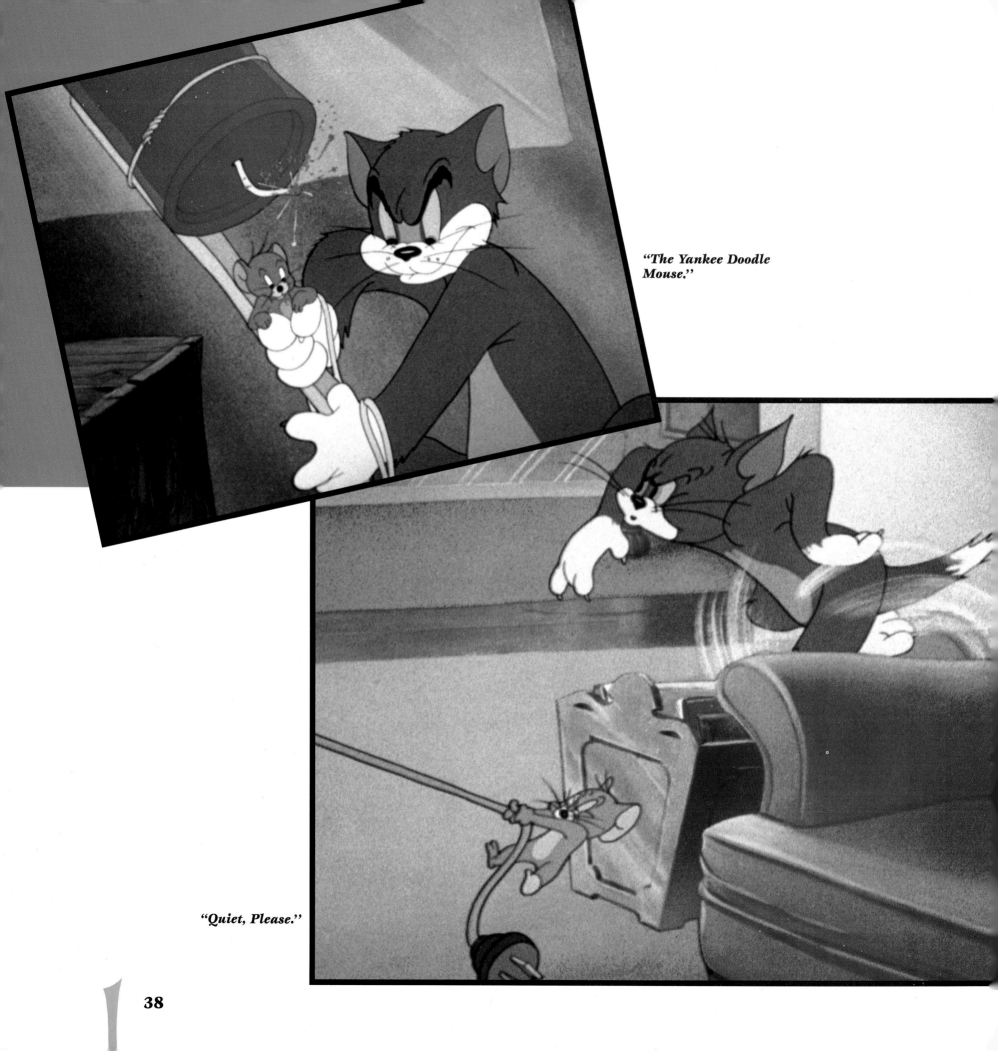

"The Yankee Doodle Mouse."

"Quiet, Please."

What are the basic reasons for the long-standing appeal and success of the "Tom and Jerry" cartoons? In *The American Animated Cartoon*, Bill Hanna attributed their durability to their fundamental good guy–bad guy approach, to audience pleasure at seeing the winsome little mouse triumphing over the predatory cat: "The bad guy always gets it in the end. He gets the comeuppance he deserves. These films . . . follow a basic formula: Tom and Jerry struggle, and Tom loses."[1] For Joe Barbera, the "Tom and Jerry" cartoons have distinctive virtues that place them in the top rank of animation. For one thing, the stories are solidly constructed, built around a single theme and studded with well-realized gags. "I run into people today," he notes, "who can tell me the stories of their favorite 'Tom and Jerry' cartoons. They say, 'I loved it when Jerry was Johann Mouse. Or when Tom finds Jerry sleeping in the pocket of a pool table in 'Cueball Cat.' " Yet undeniably, the single greatest virtue of the cartoons lies in their impeccable artwork, the myriad details of character expressions and backgrounds that remain impressive after so many years. Barbera remarks, "Even today I don't believe there are any writers in our business who can write a funny cartoon script. By that I mean: the humor in animation must come out of the artwork. The artwork will cue your next gag. And it's very difficult to transform a written gag into a piece of art."

A puzzled Tom and a contented Jerry.

Tom bones up on life with Jerry, while a wary Jerry looks on.

In addition to acknowledging the consistently high quality of the artwork in the "Tom and Jerry" cartoons, animation experts have admired the boldness with which the gags were conceived. Friz Freleng says, "Most of our cartoons were chases, but Bill and Joe did them a little more violently than anyone else dared, and I guess that's what made them as popular as they were. After they did one cartoon that was extreme, they did another that was even *more* extreme. Even when Tom and Jerry ran, they ran twice as hard and as fast as any other characters." Freleng contrasts Tom and Jerry with his own creations of Sylvester the Cat and Tweety Bird, who were also involved in a perennial chase situation. "Our gags were violent, but not as violent as Tom and Jerry. Tweety never did anything to Sylvester. The cat schemed continually, but it all backfired on him. Tweety had that 'innocent baby' look but you felt that way back in his mind he was a little rascal. But he never showed it." Mouse Jerry, on the other hand, clearly indicated that he was no innocent victim in his endless war with Tom.

The famous animator Chuck Jones, who worked with Friz Freleng in creating celebrated cartoon figures at

Warners, also offers a contrast between Tom and Jerry and his characters of Wile E. Coyote and the Road Runner, who appeared about the same time. "One major difference," he says, "is that a cat always chases a mouse, but a road runner is not normally chased by a coyote. The road runner is not necessarily a logical adversary. My feeling was that somewhere in the past, there'd been a drought or a famine in the desert, and the only thing around to eat was the road runner. So the coyote went after him. When the drought ended and the other animals came back, other food was available, but the coyote had forgotten what his original intention was. I felt sorry for him, but he had the advantage of being able to stop at any time. The cat didn't have any choice."

Like Friz Freleng, Chuck Jones has enormous admiration for the "Tom and Jerry" cartoons. He says, "To me they were successful because they were beautifully done. They were very funny, and Jerry was a very endearing character. Tom was too, some of the time. They were believable. Hanna and Barbera did beautiful things. And they had some great animators working with them." In the sixties, Jones tried to revive Tom and Jerry for MGM, admittedly without success. Today he says, "I tried my best to make good pictures, but I couldn't make them as well as they did. Nobody could ever do that. The originators are the only ones who know them inside out. You can't compete with the masters."

In addition to the artwork, another indisputable factor in the success of the "Tom and Jerry" cartoons was their expert and artful use of music. Musical director Scott Bradley, who had worked for Harman-Ising in 1934, was skilled at selecting songs from the MGM music library ("Broadway Rhythm," "All God's Chillun Got Rhythm") or from standard songs ("Sleepytime Gal," "Darktown Strutters' Ball") that would augment or comment on the animated action. "The Trolley Song" from *Meet Me in St. Louis* was a recurring favorite, used in "Cat Fishing," "Old Rockin' Chair Tom," and other cartoons. Drawing on his superior musicianship, Bradley was able to apply a wide range of musical ideas to the background of every "Tom and Jerry" cartoon; there was wit and sometimes a touch of sly satire in his use of tunes or musical instruments. Dialogue in the "Tom and Jerry" cartoons was virtually non-existent, and in contrast to Disney's films, where the piping voice of Mickey Mouse or the angry squawks of Donald Duck could make a comic point, Hanna and Barbera had to rely heavily on visual gags and on aural substitutions, including music, to strengthen the humor.

Also vital to the cartoons were the sound effects that punctuated every episode. Often they provoked audience laughter by their very sound alone: the odd sound (something like a ricocheting bullet) when Tom streaked out of a frame at breakneck speed in pursuit of Jerry, the crashing noise as one heavy object after another came down on Tom's head, or the single, unearthly shriek with which Tom registered pain or fright. (This shriek was delivered

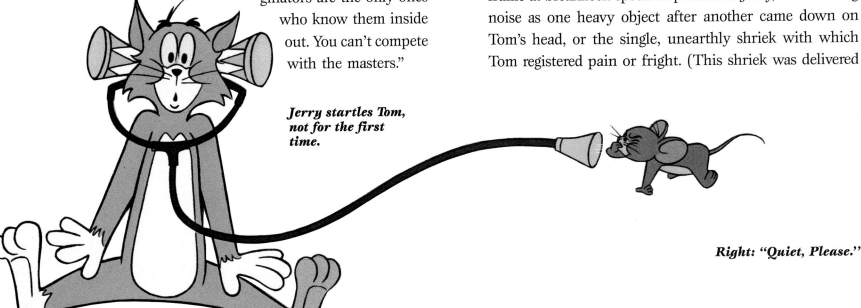

Jerry startles Tom, not for the first time.

Right: "Quiet, Please."

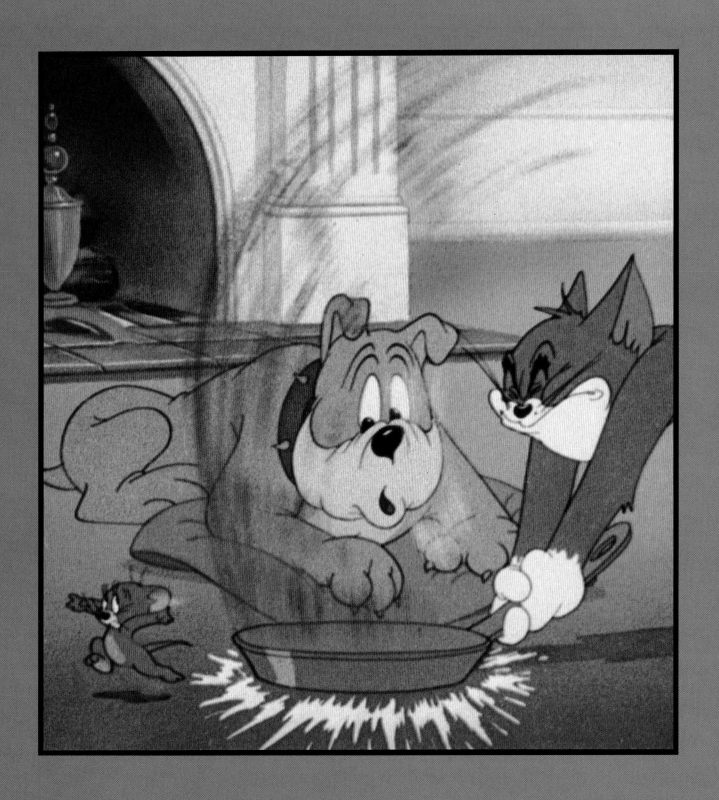

by Bill Hanna, who knew how to make it just long enough to be funny rather than pitiable.)

For all their achievements, and all the pleasure they have provided audiences, the "Tom and Jerry" cartoons have been repeatedly criticized as not merely violent but excessively violent. (Tom endures — or inflicts — all sorts of pain and torture, including countless batterings, headlong collisions, and explosions.) Over the years, Hanna and Barbera have responded to these comments evenhandedly. "My argument against our critics," Barbera has said, "is that there are two kinds of violence. There is violence just for violence sake, presented in a realistic form, and there is fantasy violence, done in comedy form. I agree with critics who say that imitative violence is bad. Now the psychologists and program practices people are easing up on us because they have come to realize that our type of fantasy violence is just for fun and is not imitative."[2]

In an interview for the *New York Times*, Hanna also commented, "We as a studio have always been specialists in comedy and satire. . . . The hits in Tom and Jerry were played for comedy. The harder the cat got hit, the harder they laughed and laughed. The way it was staged was for comedy. It's the spirit in which it was done that made it non-violent. Immediately preceding the hit, Tom would have done something that made him deserve it — so that the audience delights in seeing the mouse triumph because he's such a small, defenseless character."[3]

Watching the "Tom and Jerry" cartoons, one is strongly inclined to agree with Hanna on this issue. In essence, the slapstick violence is not much different than the violence found in the films of Laurel and Hardy, Abbott and Costello, and the Three Stooges, or the silent antics of Charlie Chaplin and Buster Keaton. In fact, it could be said that the smashings and pummelings inflicted on and by Tom and Jerry are more tolerable — and certainly funnier — than those inflicted on real-life people. Tom and Jerry, after all, have no basis in reality — when Tom splinters

into pieces after an assault, he becomes intact in the very next frame, and perhaps only the smallest child would harmfully consider this sort of sudden "reconstruction" possible. "Fantasy violence" induces laughter, not pain — does anyone object when a house crushes the sister of the Wicked Witch or the Scarecrow is torn to pieces in *The Wizard of Oz?*

By the mid-forties, Hanna and Barbera's work on the "Tom and Jerry" cartoons had already established them as leaders in the field of animation. Still, when Gene Kelly, acting on the idea of assistant choreographer Stanley Donen, wanted to do a dance routine with a cartoon character, he turned first not to his MGM colleagues but to Walt Disney. When Disney rejected the assignment, he went to Fred Quimby, who also turned down the idea; he said it would take too much time away from the regular cartoons. A major, and also firm-minded, star at MGM, Kelly persisted — without Quimby's knowledge, he would turn up at Hanna and Barbera's office to press his case until the two were assigned to prepare a sequence for George Sidney's sprightly musical *Anchors Aweigh* (1945). Taking two months to film and requiring over ten thousand frames, the

Jerry dances with Gene Kelly in George Sidney's **Anchors Aweigh, 1945.**

A scene from Invitation to the Dance, 1957, *with Gene Kelly and David Kasday.*

sequence centers on a sad mouse king (played by mouse Jerry), who refuses to allow music in his kingdom. Along comes Kelly, a sailor in the "Pomeranian" Navy, who makes a striking figure in his striped shirt and jaunty beret. He teaches the king to dance, and they join in a joyful dance around the throne room. In one exhilarating moment, Kelly whirls in space on one leg as the mouse leaps deftly around Kelly's outstretched other leg.

The execution of this innovative sequence required extensive work. After a detailed storyboard was completed, Kelly's dance was filmed, with both the performer and the cameraman behaving as if the mouse king were in the scene. The sequence was then rotoscoped, using the device patented by Max Fleischer that permits an animator to trace over live-action filmed movement frame by frame. Kelly was traced onto animation paper so that the frame-by-frame movement of Jerry could be matched to Kelly's dance movements. It called for a precise and fastidious effort on the part of the animators, but the result was enchanting. Its success — and critics agreed that it was the highlight of the movie — prompted the use of animated segments in other MGM musicals. Hanna and Barbera

provided animated opening credits for George Sidney's *Holiday in Mexico* (1946) and later animated a sequence for Charles Walters's *Dangerous When Wet* (1953), in which Tom and Jerry join Esther Williams in an underwater ballet. The latter movie created special problems, since it was filmed in CinemaScope, which picked up every error and every flaw.

Hanna and Barbera's most ambitious assignment in combining animation with live action came when Gene Kelly decided to do an entire segment of his multi-part dance film *Invitation to the Dance* (1953) in which he performed against cartoon backgrounds. This sequence, called "Sinbad the Sailor," has Kelly arriving in Baghdad, where he buys an old lamp. A little genie (David Kasday) emerges from the lamp, and the two embark on an Arabian Nights adventure. In an animated world, Kelly dances with two scimitar-bearing guards, a harem girl, and a slinky serpent. Ahead of its time, the film baffled moviegoers, and no doubt studio executives, who expected a conventional story line and who were not used to story-through-dance. Held for release until 1958, *Invitation to the Dance* drew scant audiences at the box office.

Still, for Hanna and Barbera the sequence marked a commendable achievement, demanding prodigious effort by their staff of animators. Irven Spence, who worked on the sequence, recalls, "Gene Kelly did the dancing, of course. Then we used a system that was different from the earlier system of tracing the dance movements with a rotoscope. We blew up every other frame of Kelly's dance film to animation paper size, ending with a large stack of numbered eight-by-ten-inch photographic prints of the dance. And we would use these prints to do the animation. If a scene was, say, twenty feet long, we would have a lot of photographs. When we had to animate Kelly dancing with the guards, we had his actual footsteps to work with." Sometimes it was extremely difficult to animate a dancer's movements, especially if the dancer was a serpent. Michael Lah, who worked extensively on the segment with the serpent, remembers that, although dancer Carol Haney imitated the serpent as a general reference, its dance movements had to be created entirely by the animators. The serpent had no arms, legs, or shoulders, yet they had to meet the challenge of making the creature move in time with Gene Kelly.

At roughly the same time that Hanna and Barbera were creating their "Tom and Jerry" cartoons, an alumnus from Warners named Tex Avery was heading another unit at MGM. At Warners since the mid-thirties, Avery, working with, and strongly influencing, such top animators as Friz Freleng, Chuck Jones, Bob Clampett, and Frank Tashlin, had much to do with developing the studio's most famous animated characters, including Bugs Bunny, Porky Pig, and Daffy Duck. Today Chuck Jones is still enthusiastic about Tex Avery: "He did the most incredible things. He was extending the graphics of animation." Brought to MGM in the early forties, Avery had developed an animation style that was his very own, highlighted by a headlong pace that never slackened and a series of outlandish, outrageous, and often hilariously funny gags. He delighted in spoofing the conventions of animated cartoons (characters would wander into the wrong movie or slide off the edge of a frame), and he enjoyed inserting visual puns. (When a character says that the drinks are on the house, we see that the drinks are literally *on the house*.) Avery also caused a stir with his creation of an extremely sexy Girl who, in a series of cartoons ("Red Hot Riding Hood," "Wild and Wolfy," etc.) arouses the lascivious Wolf to a comic frenzy. He pounds himself on the head with a sledgehammer, lights his nose instead of his cigarette, and in general behaves like a demented fool.

Inevitably, Avery's irreverent humor and exaggerated style had its effect on Hanna and Barbera. Many years later, Hanna acknowledged Avery's major contribution to everyone in animation, including himself. "He was one of the greatest, most creative cartoonists in our industry," Hanna recalled. "He was a great gag man, a great story man, and he was very innovative. He was also a kind, generous man who shared his talents with everyone." Barbera also has the highest praise for Avery: "His sense of timing and his originality were brilliant. I also admired his daring, his non-conformity. He created a Riding Hood with short legs and sexy-looking eyes, but she never did anything lewd. Fred Quimby was horrified at first but then he got on the bandwagon." The accelerated pace and increasingly hard-hitting gags that characterized the "Tom and Jerry" cartoons in the mid-forties probably resulted from Avery's influence.

"The Two Mouseketeers."

By the late fifties, Hanna and Barbera would seem to have earned a secure place at MGM. Although the output had doubled by this time, from eight to sixteen cartoons a year, the creative quality had never declined. Moreover, after Fred Quimby's departure in 1955 for reasons of health, Hanna and Barbera were named production heads. Barbera recalls, "We were entirely confident of our success and how solid we were at the studio." Then suddenly, early in 1957, the ax fell. With the entire film industry in dire straits due to, among other things, the deepening inroads of television, and with the animation industry virtually closed down, MGM determined that the hugely popular old "Tom and Jerry" cartoons could be reissued on a regular basis and do ninety percent of the business of new cartoons. By doing this, the studio could stop spending money on new cartoons, and the cash would come in without additional expenses. MGM decided, without warning, to shut down its cartoon studio.[4]

Joe Barbera remembers what happened: "It was a fateful day. Here we are thinking that we're at the top of the heap. Producing, writing, directing, and taking care of the full program. And our department on the MGM lot is successful. We didn't know what was going on. Without a hint, the phone rings — not to us but to an accountant, a bookkeeper. 'Close the studio! Lay everybody off! Finish the few pictures you're doing. And then we're not doing any more cartoons.' And you said, 'What's this? This is a catastrophe!' "

For Hanna and Barbera, this was indeed a dire period. "A whole career had disappeared," Barbera recalls. "We build this supposedly impregnable monument to success, and suddenly we are *out*. . . . We had the dreadful feeling that we had to start all over again in another business. I remember watching my young son playing Little League baseball and wondering, 'How am I going to support this kid?' It was a very tough thing to face. Believe me, Bill and I went to every agency, every studio. And they said, 'We aren't doing any more cartoons. Too expensive.' So we either had to find something in our field or leave the business entirely and sell insurance or open a chicken stand or wash cars. We weren't kids, you know. We'd been through a career."

Out of catastrophe came persistence and a determination to turn their lives around. "We were down but we were a long way from out," Bill Hanna remembers. "Having worked with Joe for twenty years and knowing what he could do, and knowing what I felt I could do, I really did think that we could come up with a good product. As soon as the bomb exploded, we went to work immediately on two new characters. We started developing and drawing ideas and concepts. It was all in our heads. We had no deal." Eventually, the characters evolved into a dog named Ruff and a cat named Reddy. And Hanna and Barbera, leading Ruff and Reddy into the fray, were ready to launch an extraordinary new career.

The signature ending for the "Tom and Jerry" cartoons.

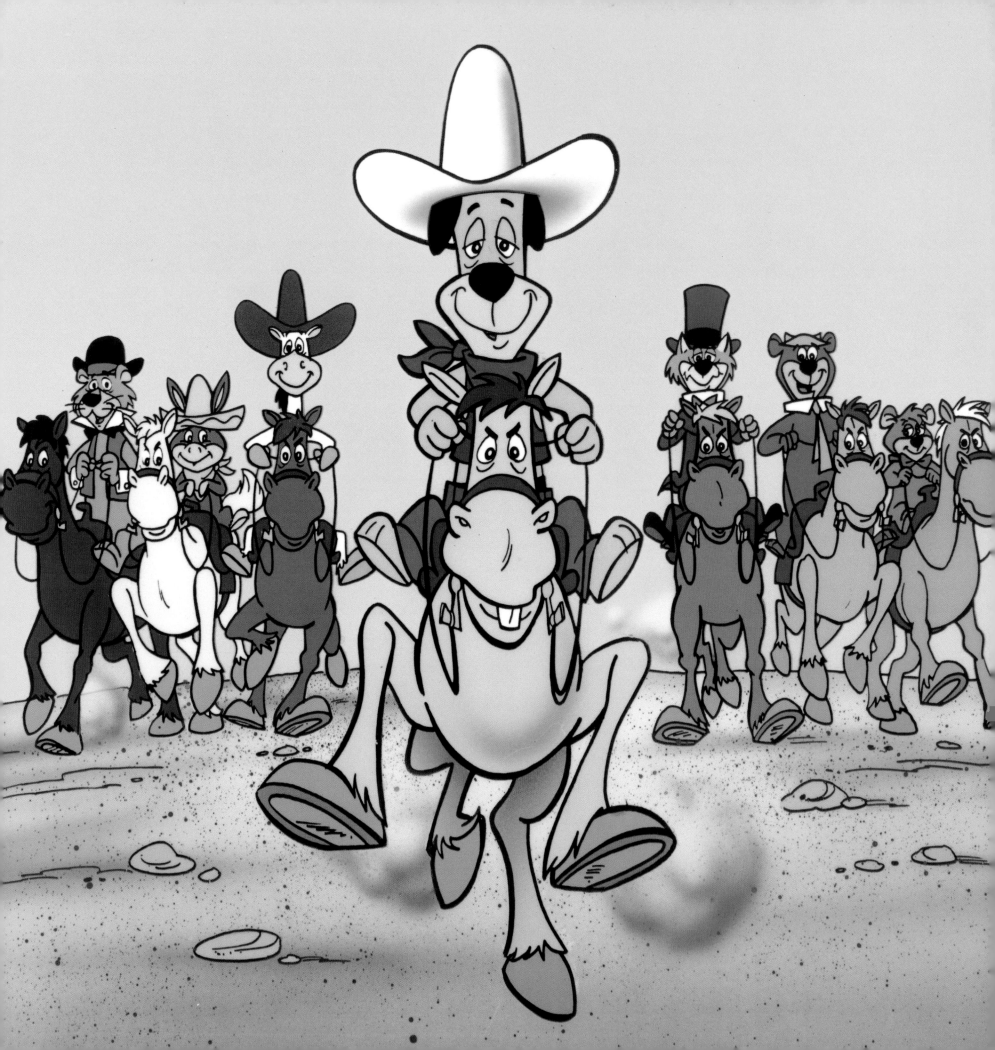

Enter Huckleberry, Quick Draw, Yogi, and Friends

The birth of Ruff and Reddy, Hanna and Barbera's first animated characters for television, took place against what seemed like insurmountable odds. In the bleak months after MGM joined other studios by closing its Cartoon Department, skeptics had warned them that the cost of making cartoons for television would be as prohibitive as the cost of making theatrical cartoons. Every studio, every agency insisted that it was simply not a feasible idea. At MGM, nobody was even permitted to mention the dread word *television*. Undaunted, Hanna and Barbera went to work, creating two new characters in an amiable but slow-thinking dog named Ruff and a smart-talking cat named Reddy. Barbera prepared a storyboard, using his young daughter Jayne to color the drawings. Time and again, the project was turned down as unworkable and uneconomical.

Then, as often happens, fate interceded on behalf of Hanna and Barbera. A man named John Mitchell, who was head of sales for Screen Gems, Columbia's television

In a San Francisco bar, they had a sign: NO TINKLING OF GLASSES OR NOISE DURING THE HUCKLEBERRY HOUND SHOW.
—Joe Barbera

arm, had come to believe that animation *could* be handled feasibly on television. He felt that there should be a place for cartoons amidst the flood of anthologies, sitcoms, and variety shows. "Those were the days," Mitchell recalled, "in which you could get ideas and hopefully, if you were smart or lucky, you could make them work." He proposed to studio head Harry Cohn that they market the old theatrical cartoons that were gathering dust on their shelves, using new cartoons as "bookends" for each package. To create these cartoons, Mitchell turned to Hanna and Barbera, widely known and admired as the creators of "Tom and Jerry." Fortuitously, they had walked in with the completed storyboard for "Ruff and Reddy." By the fall of 1957, only months after the closing at MGM, Mitchell had commissioned them to produce the first five-minute trial segment of the proposed show.

At first, luck seemed to be against Hanna and Barbera. When part of the pencil test for "Ruff and Reddy" was

Left: Huck (center) and friends (left to right): Snagglepuss, Baba Looey, Quick Draw McGraw, Top Cat, Yogi, and Boo Boo.

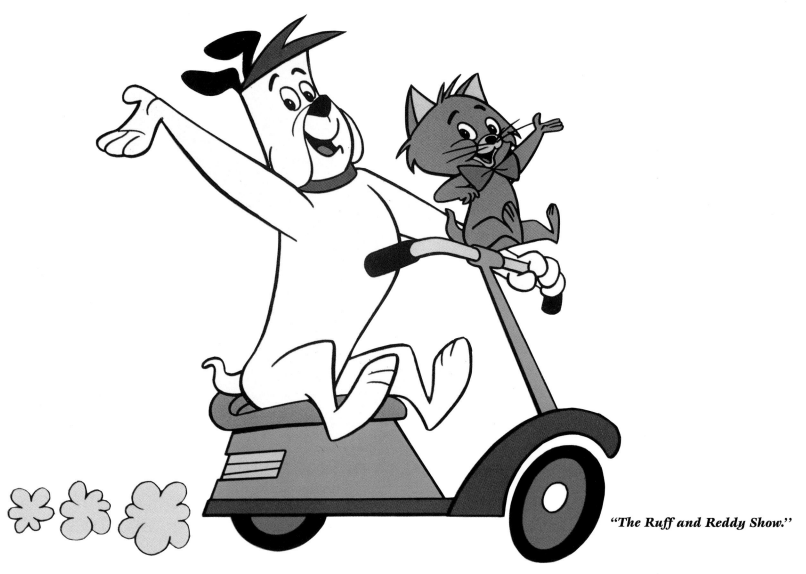

"The Ruff and Reddy Show."

shown to Harry Cohn, his reaction was swift and severe: "Get rid of them! Just drop the whole idea!" But almost at the same time as he was saying this, NBC had seen the test reel and had approved of John Mitchell's concept of using new "bookends" with the package of old theatrical cartoons. Hanna and Barbera were assigned to produce the first group of five-minute episodes of "Ruff and Reddy." Drawing on their own limited resources, plus the financial backing of Columbia (which would distribute their films) and director George Sidney,* Hanna and Barbera took

*George Sidney served as president during this initial period. Bill Hanna and Joe Barbera then alternated the position of president on an annual basis until the company was sold to Taft Broadcasting. Joe Barbera was president at the time and has remained so ever since. Bill Hanna assumed the office of senior vice president and remains in that position.

over Charlie Chaplin's old studio on Highland Avenue in Hollywood to create one of the first original cartoon series for television. There was one major stipulation, however: the cost of each cartoon was not to exceed three thousand dollars, roughly one tenth of the money usually required for a theatrical cartoon.

Obviously, an economical system of animation would be needed to put together the "Ruff and Reddy" cartoons. Drawing on and extending the same streamlined concept they had used to create the detailed pencil tests for "Tom and Jerry" at MGM, Hanna and Barbera turned to the technique of "planned," or "limited," animation, which had actually existed in very primitive form during the silent era. With this technique, far fewer drawings were

needed to complete a cartoon. As opposed to the intricate details of classical animation, a few moving parts of the principal characters were animated and then photocopied on to the cels to simulate talking or simple action. The character walks and other standard movements were codified and reused in cycles, while a single background could serve for entire sequences. With this system, a complete cartoon could be made and timed to its exact length in a much shorter period than before. Although a loss of lifelike and richly varied detail was inevitable, the savings in time and money were incalculable. Television animation on a massive scale became possible for the first time with these stripped-bare procedures.

Art Scott, a producer and director at Hanna-Barbera for many years, has described the procedure aptly: "Everyone had said that you can't make cartoons for television. So Hanna and Barbera took all the different systems that made up the total, from story to recording to layout and so on to final editing, and put them together in a system that would be all blocked out. At one time storyboards were huge, but Hanna and Barbera condensed them to the small size used today. Now you can make changes quickly and everyone can see what you're doing. It's like a blueprint for a house. They streamlined the system, made it possible to do cartoons for television." He adds, "In television, you have no option. You have to get the material out in time, or you're in trouble. What Hanna and Barbera did was to move everything into a rigid time frame. And it worked."

However, there was no way of knowing what lay ahead when Hanna and Barbera started out on July 7, 1957, in the musty studio on Highland Avenue. Occupying Charlie Chaplin's old studio, they were well aware of the Little Tramp's ghost that hovered in the halls, and the comic genius that permeated his movies. Nevertheless, they were fired up by the challenge of creating brand-new animated cartoons for a burgeoning medium. Hiring many of the talented people who had worked with them at MGM, they

turned to "Ruff and Reddy." They decided that the key to the series would not be the natural enmity of dog and cat; dimwitted Ruff and feisty Reddy would be friends who joined together to battle the forces of evil in a madcap world. Their antagonists, each of whom appeared in ten or more segments to make up a complete story, included such off-the-wall villains as the Mastermind of the planet Muni-Mula; the Chicken-Hearted Chickasaurus; Scary Harry Safari; Killer and Diller, the terrible twins from Texas; and the Goon of Glocca Morra. The titles of the episodes emphasized the sort of outrageous wordplay children enjoyed: "Asleep While a Creep Steals Sheep," "A Whale of a Tale of a Tail of a Whale," and so on. Premiering in December 1957 on NBC, "Ruff and Reddy" appeared as wrap-around segments for thirty minutes of old cartoons, hosted for the first three seasons by Jimmy Blaine and his puppet friends Rhubarb the Parrot and Jose the Tucan, and later by Captain Bob Cottle and his puppets Jasper, Gramps, and Mr. Answer.

The "Tom and Jerry" cartoons had been mostly silent; except for shrieks of fright and pain, the cat and mouse seldom spoke. (One memorable exception was "Mouse Trouble," in which a battered Tom, reading in the book *How to Catch a Mouse* that a "cornered mouse never fights," says in a sepulchral voice, "Don't . . . you . . . believe it!") In the past only incidental characters, such as Mammy Two-Shoes or Spike the bulldog, had any dialogue, but now Hanna and Barbera were confronted with a new challenge: to find the voices that would give added life and substance to the animated characters and would also compensate in large measure for the limited animation. They recognized from the start the singular importance of the voices. Years later, Joe Barbera noted, "Voices make or break your show. When I'm casting a voice, I close my eyes and listen. If you can't smile when you hear that voice, then you haven't got a hit."

For the voices of Ruff and Reddy, Hanna and Barbera chose two actors who would become durable and signifi-

cant mainstays of their operation: Don Messick (Ruff) and Daws Butler (Reddy). Both were seasoned players in radio and early television, and they fully understood the special skills required to provide the voices for cartoon characters. "You don't think of them as voices," Butler said. "You think of them as characters. You do it physically—nothing changes. You're an actor, except that all they're getting is the voice." Messick, reflecting on the way in which a character develops over a period of time, has said: "After the writer gets more fluid with the character, and the actor becomes more familiar with the character he is playing, the role takes on additional color and flavor. Usually it's a combination of the director and the actor." Daws Butler died in 1988, but today Don Messick is still actively employed by Hanna and Barbera, breathing life into animated creations with a remarkable variety of inflections and dialects.

Although the first two seasons of "Ruff and Reddy" were shown on television in black and white, Hanna and Barbera cagily prepared all the episodes in color. Hanna recalls, "It was one of the smartest things we did. We said, 'Color will be here soon. Cartoons last forever. Let's go ahead and do them in color, and we'll be a jump ahead of the game.'" The idea proved to be eminently sound when color entered the television scene in 1959. From its very first season, however, "Ruff and Reddy" had demonstrated that it was possible to create low-cost animation for television that would attract and please an audience of children. After the trauma of the MGM closing, Hanna and Barbera were under way.

The success of "Ruff and Reddy" prompted Hanna and Barbera to extend the idea of animation for television into new and more adventuresome areas. The time seemed ripe for the first all-animated half-hour program for television, and the team worked assiduously to create new and viable characters. By this time they

had been able to expand their staff with experienced people from other animation houses. Barbera recalls, "The lucky part of the whole disaster at MGM was that they had to release the best group of animators in the world, and we brought these people back into our studio. We had a ready-made army." Hanna adds, "We got the best story people from Leon Schlesinger. And artists from Disney. We simply took on the most talented people from all over."

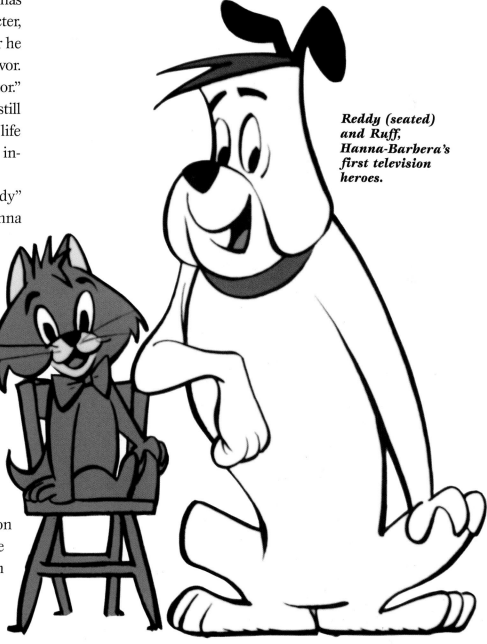

Reddy (seated) and Ruff, Hanna-Barbera's first television heroes.

Left: Daws Butler (left) and Don Messick at an early recording session.

Huck the snake charmer.

The first major character they introduced after "Ruff and Reddy" was a genial but none-too-smart dog who sang an off-key rendition of "Clementine" as he ambled, unruffled and oblivious, from one disastrous situation to another. Hanna and Barbera had created Huckleberry Hound after noting Daws Butler's ability to do a slow Southern drawl and also recalling the character of the sad-eyed dog named Droopy that Tex Avery had originated at MGM. (Joe Barbera remembers that many names were considered before deciding on the redoubtable Huckleberry; Alfalfa Hound, Cactus Hound, and Dingy Dog were among the contenders, but Huckleberry won because of its "kind of hayseed connotation.") To complete the half hour of cartoons, Hanna and Barbera added other new characters: Pixie and Dixie, two mischievous mice who constantly torment a cat named Mr. Jinx, and the soon-to-be-legendary Yogi Bear, the self-styled, smarter-than-the-average bear who joined with his bear cub pal Boo Boo to pilfer "pic-a-nic" baskets from the vacationers at Jellystone National Park. Several years later, when cartoon star Yogi was given his own show, Hanna-Barbera replaced "Yogi Bear" with "Hokey Wolf," concerning the adventures of an engaging con artist who resembled Phil Silvers's "Sergeant Bilko" television character.

Selling "Huckleberry Hound" and the component car-

toons to a sponsor proved to have its harrowing moments. Projected for the first time into the role of a sales person, Joe Barbera was obliged to present the show to the client (Kellogg's) and its agency (Leo Burnett). Standing before a group of cranky and hungry people, Barbera had only to press a button to start the film rolling. Unfortunately, after the film began he realized that the wrong sound track was being used — Pixie and Dixie were speaking in the voice of Yogi Bear. *We are dead*, he thought. *We are totally dead.* Quickly the sound tracks were switched and after fifteen agonizing minutes the film began again. "The audience rolled on the floor," Barbera recalls. "This was our first experience. But we sold the show!"

Launched on October 2, 1958, "The Huckleberry Hound Show" became an instant success, and the hound entered television annals as the first cartoon superstar. Noble and generous to a fault despite the many calamities heaped on his head, Huckleberry endeared himself to audiences with his corn pone voice — supplied, inimitably, by Daws Butler in his laid-back, unflappable style.[1] Each cartoon offered the hound in a different guise, with equally disastrous results. He would turn up as a lion hunter whose prey uses all sorts of outlandish tricks, from sneakers to radar, to elude him ("That lion will do anything for a laugh!"); an intrepid Mountie seeking to capture Powerful Pierre ("I got to declare Pierre's right smart for a criminal-type bad guy!"); or a brave knight in medieval times who rescues a damsel from the Fat Knight ("I double dare you to come out and fight, knight!"). Huck has an inappropriate remark for every occasion. When an escaped gorilla named Wee Willie eats his pistol and handcuffs, and then carries him to the top of a building under construction, the hound can only comment, "I guess I hurt his feelings."

Right: Huckleberry Hound strums a tune in his canoe.

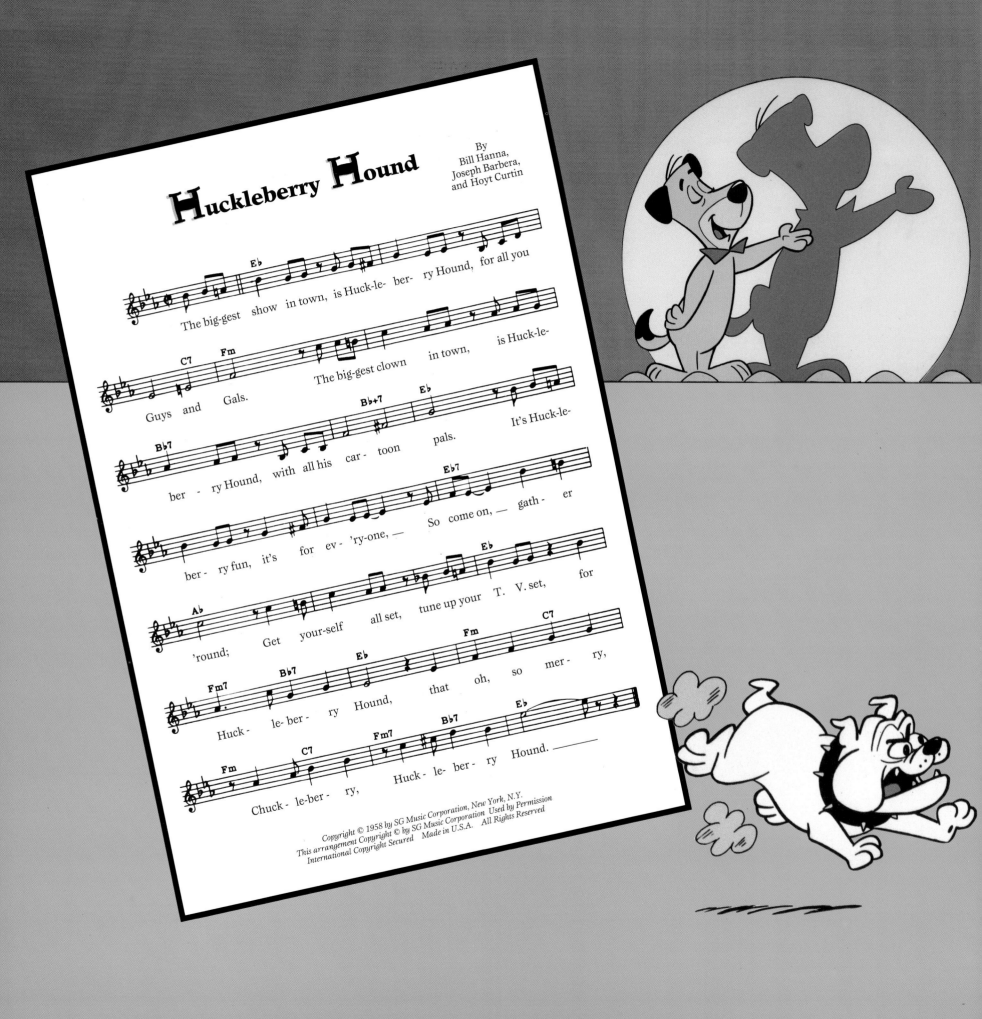

The episodes gave Huck the opportunity to assume many identities. At various times he was the swashbuckling Purple Pumpernickel, determined to oust a tyrant; a Scotland Yard inspector who grapples with a monstrous Jekyll-and-Hyde character named Schnitzel (he changes from scientist Wiener Schnitzel into Monster Schnitzel); and the last member of the Pennsyltucky Huckleberry family, engaged in a feud with the last survivor of the Doodleberry family. Written by Joe Barbera and later by Warren Foster, a gifted and prolific gag man who contributed importantly to the Warner Bros. cartoons of the forties and fifties, the "Huckleberry Hound" cartoons displayed not only a keen appreciation of the venerable art of slapstick but also a brash, impudent irreverence toward the standard genres of movies and television. In 1959 the television industry itself recognized the program's worth: "The Huckleberry Hound Show" became the first animated cartoon series to receive an Emmy Award for outstanding achievement in children's programming.[2]

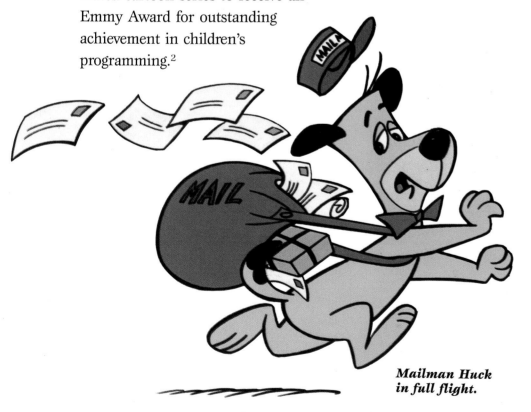

Mailman Huck in full flight.

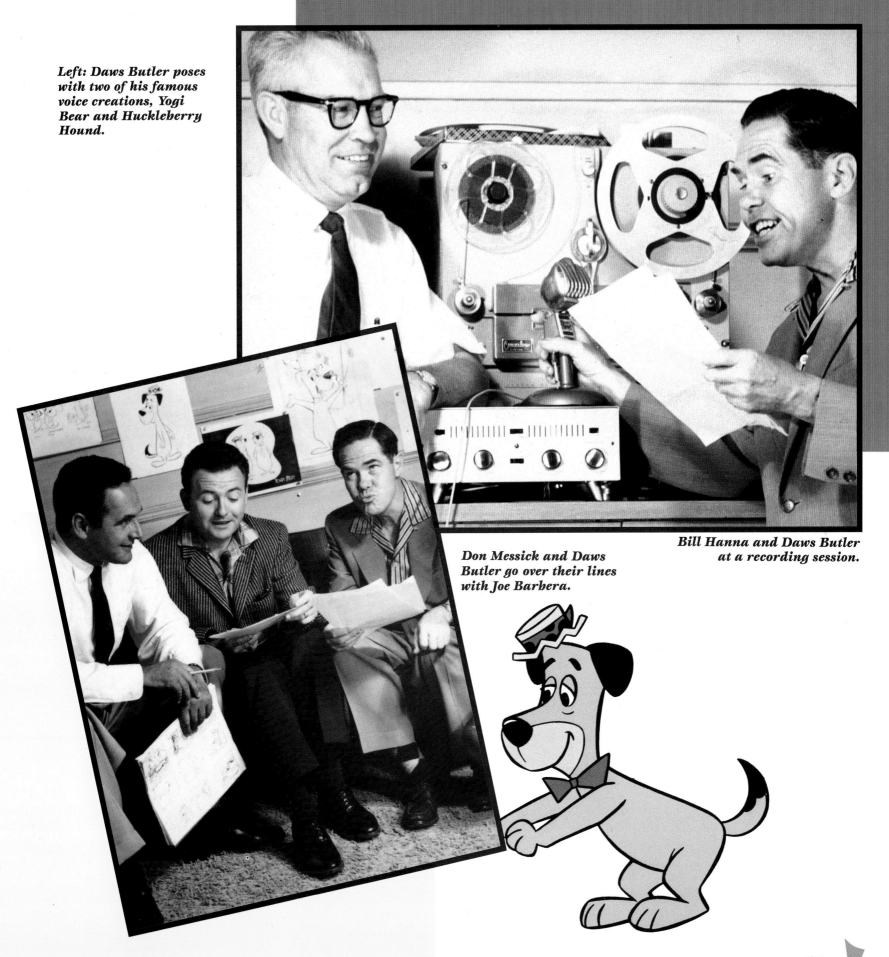

Left: Daws Butler poses with two of his famous voice creations, Yogi Bear and Huckleberry Hound.

Don Messick and Daws Butler go over their lines with Joe Barbera.

Bill Hanna and Daws Butler at a recording session.

The other segments of "The Huckleberry Hound Show," created to fill out thirty minutes of air time, contributed substantially to its popularity. In "Pixie and Dixie," a delightful variation on the perennial cat-chases-mouse theme, the raffish tomcat named Mr. Jinx (voiced by Daws Butler with what he described as "a loose, New York type of attitude") devoted his life to catching the jaunty, southern-accented mice Pixie (Don Messick) and Dixie (Butler). Of course the effort was sheer futility as the blue-bowtied Pixie and the red-vested Dixie outtrick and outmaneuvered Mr. Jinx on every occasion. Often the long-suffering cat was driven to utter, "I hate those meeces to pieces!" which became a popular catch phrase. In one typical episode, "Kit-Kat-Kit," Mr. Jinx, after a particularly exhausting runaround with Pixie and Dixie ("I'm too pooped to pant!"), decides to build "a better mousetrap." In fact, he tries several, all of which fail miserably. Finally, he uses a "Do-It-Yourself Kit-Kat-Kit" to construct an automatic Mice-Catcher. "This means war!" the mice shout after they have been captured. They retaliate by placing huge mouse ears on Mr. Jinx, causing the mechanized Mice-Catcher to pursue him relentlessly. The titles of the cartoons suggested the sort of genial, basic slapstick that made "Pixie and Dixie" a favorite with viewers: "Mouse Nappers," "Lend Lease Meece," "Missilebound Cat," "Price for Mice," and "Heavens to Jinksy."

The third segment of "The Huckleberry Hound Show" proved to be the most popular and durable of all.

From the moment he appeared on the television screen as a joint invention of Hanna and Barbera, Yogi Bear struck a resonant chord in viewers with his porkpie hat, his resourcefulness, and his indomitably cheery manner. Hanna and Barbera assert that it was not their intention to name Yogi after the famous baseball player Yogi Berra. Many names (including Yogi) were figuratively tossed into the hat — Huckleberry Bear, Yucca Bear, Yo-Yo Bear — before the

> **I hate those meeces to pieces!**
> —Mr. Jinx
>
> **This means war!**
> —Pixie and Dixie

Left: Pixie and Dixie flee from Mr. Jinx.

final decision. Also, as Barbera notes, "Yogi is a bear, after all. And he does not play baseball." Played by Daws Butler in a voice and style that resembled Art Carney's Ed Norton in "The Honeymooners," the artful bear had one overriding goal: to cadge food from the picnickers who swarmed into his home territory of Jellystone National Park. The pleasure was not so much in the eating as in the devious and ingenious ways he could devise to get the "pic-a-nic" basket and avoid being caught and punished by Ranger John Smith (Don Messick). If he was not actually "smarter than the average bear," as he was wont to exclaim repeatedly, Yogi was certainly smarter than his tolerant, simpleminded friend Boo Boo, the tiny bear cub also voiced by Don Messick. Messick remembers that the voice of Boo Boo "started out a little nasal — like he always had a cold. But gradually the director let me clear up his sinuses."

I'm smarter than the average bear!
—Yogi Bear

The first episode of "Yogi Bear," entitled "Pie Pirates," set the pattern for the others that followed: fleeing from a farmer who has caught them stealing, Yogi and Boo Boo come upon a succulent blueberry pie perched on a windowsill. One whiff, and Yogi is determined to filch the pie. Trouble takes the form of a large and vicious dog who guards the house. Yogi sets up a series of maneuvers to grab the pie, even resorting to a pair of stilts. ("That dopey dog thinks I'm Daddy-Dog-Legs!") Further trickery by Yogi, who is not above using little Boo Boo in his schemes, fails to win him the prize — he is invariably clobbered by the dog and at one point he is catapulted through a fence.

When the pie disappears, Yogi consoles a crying Boo Boo by telling him that he will prepare a "yummy Yogi special" of inner-tube minestrone soup.

The formula remained the same throughout the next few seasons: the genial, nonconformist Yogi, nervously abetted by faithful Boo Boo, concocted schemes for stealing picnic food in the park, making life a torment for Ranger Smith. Warnings and punishment were of no avail: Yogi would continue his ravenous pursuit in such episodes as "Yogi Bear's Big Break," "Show Biz Bear," and "Robin Hood Yogi." ("We'll rob tidbits from the rich and give them to the poor. Namely us.") In one episode, "Home, Sweet Jellystone," Ranger Smith inherits his uncle's estate and leaves Jellystone Park to live in lonely splendor in a mansion. At first Yogi expresses delight ("The pic-a-nic baskets are at my mercy!"), but he soon misses the conflict with his "worthy opponent," and as a ploy to get him back he pretends to go on a hunger strike. The dismayed ranger returns to the park to tend to Yogi ("I'd do the same thing for any dumb animal"), and the old disorder is happily restored.

Another episode, "Love-Bugged Bear," had Yogi struck by Cupid's arrow after denying Cupid's existence to Boo Boo. ("Do you think for one moment they would let a curly-headed kid in short shorts run around and shoot people with arrows?") A worried Ranger Smith thinks that Yogi is not love-smitten but undernourished and carries him off to be fed. Yogi's romance ends, however, when he sees his true love with another bear. "I didn't lose a

Right: Yogi Bear and his flirtatious girlfriend, Cindy Bear.

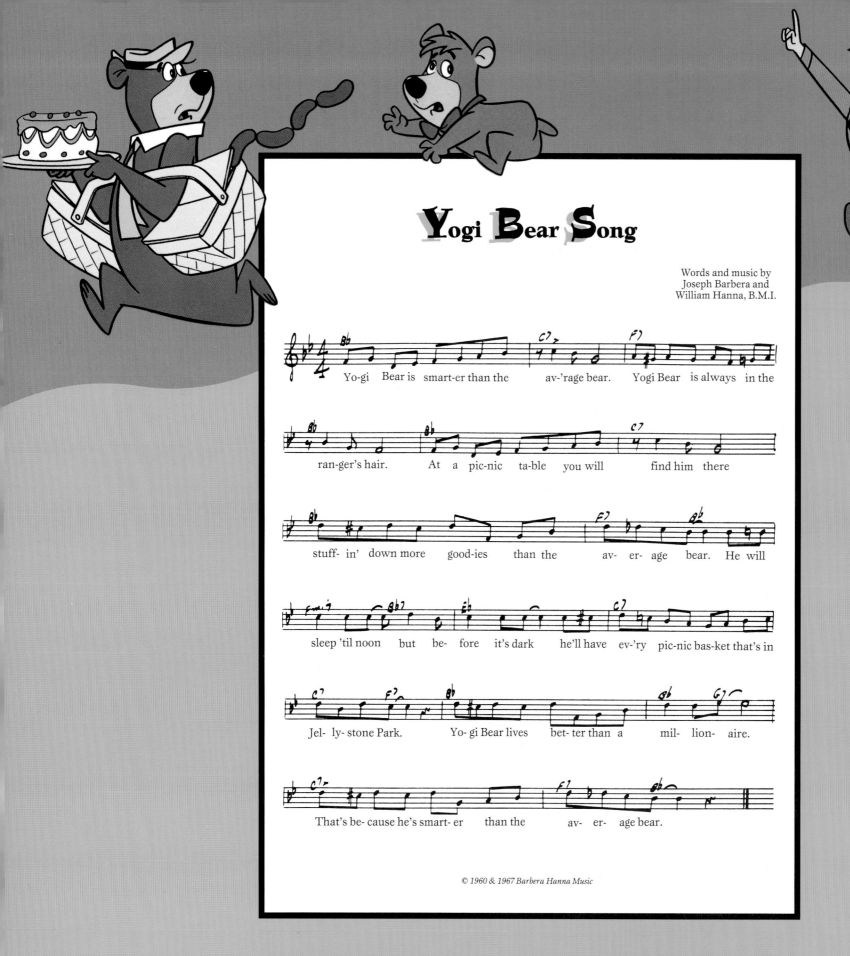

Yogi Bear Song

Words and music by
Joseph Barbera and
William Hanna, B.M.I.

Yo-gi Bear is smart-er than the av-'rage bear. Yogi Bear is always in the ran-ger's hair. At a pic-nic ta-ble you will find him there stuff-in' down more good-ies than the av-er-age bear. He will sleep 'til noon but be-fore it's dark he'll have ev-'ry pic-nic bas-ket that's in Jel-ly-stone Park. Yo-gi Bear lives bet-ter than a mil-lion-aire. That's be-cause he's smart-er than the av-er-age bear.

girl," he asserts, "I gained an appetite!" Actually, Yogi was given a recurring romantic attachment, however reluctant, in the person of a southern girlfriend, Cindy Bear (Julie Bennett), whose breathlessly girlish exclamation "Ah do declare!" became another expression widely imitated by viewers.

By 1960 Yogi and Boo Boo's antics in Jellystone Park had attracted enthusiastic viewers across the country, and stardom in their own show was inevitable. Early in 1961 Hanna and Barbera launched their third half-hour series, "The Yogi Bear Show," featuring the canny bear in further misadventures. From the beginning the program drew the sort of reviews that spell success. In its February 15, 1961, issue, *Variety* welcomed the show as "the funniest and most inspired of all the charming, contagious Bill Hanna–Joe Barbera cartoon characters." "The beauty of Yogi Bear," the review concluded, "as well as most of the other Hanna-Barbera creations, is that he can be appreciated wholeheartedly by adults as well as children. In the world of animated animals, he has no peer. . . . The wonderfully witty scripts of writers Warren Foster and Mike Maltese put the punch into Yogi and his companions."

Heavens to Murgatroyd! Exit stage left!
—Snagglepuss

In addition to new episodes of "Yogi Bear," the program offered two new series that became regular features. One was "Snagglepuss," focusing on a genial, orange-furred lion in a state of constant calamity. Clearly derived from Bert Lahr's memorable Cowardly Lion in *The Wizard of Oz*, Snagglepuss would constantly exclaim, "Heavens to

Left: The theme song for "The Yogi Bear Show."

Right: "Mischievous Little Yakky Doodle" and, top, Snagglepuss.

Above: A circus scene from "Hey There, It's Yogi Bear," 1964.

Murgatroyd!" or "Exit stage left . . . better yet, exit stage right!" as he sought to avoid capture by the pith-helmeted Hunter. Voiced by Daws Butler, Snagglepuss starred in such episodes as "Paws for Applause," "Remember Your Lions," "Jangled Jungle," and "Legal Eagle Lion." The third series, "Yakky Doodle," featured a garrulous, yellow-feathered duckling named Yakky (Jimmy Weldon), who is protected by a bulldog named Chopper (Vance Colvig). Their opponent was often a tricky con artist named Fibber Fox (Daws Butler), who looked on Yakky as a prospective delicious meal. Typical episodes included such titles as "Railroaded Duck," "Oh, Duck-ter!" "Foxy Friends," and "Duck Seasoning."

Yogi Bear's phenomenal popularity inevitably extended into merchandising, and throughout the sixties the jovial bear turned up in holiday parades, television commercials, comic books, and ice shows.

He also became the star of Hanna-Barbera's first feature-length cartoon, *Hey There, It's Yogi Bear*, released in 1964. Not fully animated, yet with much more animated detail than the television series, the movie was an ingratiating mixture of slapstick, sentiment, and music. It centers on the adventures of Yogi and Boo Boo as they search for Yogi's beloved Cindy Bear, who mistakenly believes he has been taken to the San Diego Zoo. Poor Cindy is forced to become a high-wire act in the tacky circus of the sneaky Chizzling Brothers (whose dog, Mugger, has a wonderfully nasty laugh), and Yogi and Boo Boo strive to rescue her.

Right: In "Hey There, It's Yogi Bear," Yogi, Boo Boo, and Cindy dream of being in Venice.

Left: The main title for "Yogi's First Christmas," 1980.

There are many setbacks, but Yogi's skill as the ultimate con artist stands him in good stead. Ultimately all of the characters converge on New York City, where Yogi becomes a celebrity. They return to Jellystone Park, where Ranger Smith, who has been searching frantically for Yogi, is rewarded for his devotion to duty.

Throughout their tribulations Yogi's optimism never deserts him ("We can't fail with Yogi Bear on the trail!"), and his good cheer and sassiness give *Hey There, It's Yogi Bear* a diverting, offhand appeal. The film also contains a generous amount of truly funny slapstick, as when Cindy Bear, distraught at finding herself on a wrong train, is befriended by a boxcar of madcap bears, or when Yogi, fleeing from the police, ends up at a raucous hillbilly barn dance, where he becomes a great sensation — until everyone notices that he's a bear. The sequence in New York, with Yogi and his friends racing into the subway and then being trapped in a building under construction, has an irresistible knockabout humor. The movie's lively, infectious songs include "Whistle Your Way Back Home," "I'm on a Go-Go Train," and "Ven-e, Ven-o, Ven-a," which is

featured in a beautifully animated sequence that has Yogi and his friends dreaming of being transported to a magical Venice. Young audiences responded to the movie's lighthearted charm, and ticket sales were brisk at the box office.

As the bear's fame continued into the seventies, Hanna and Barbera sought new ways to use the character. In 1973 they launched an hour-long series called "Yogi's Gang," in which Yogi and Boo Boo, alarmed by a variety of world problems that ranged from pollution to bigotry, decide to do something about them. Joined by other Hanna-Barbera characters, including Huckleberry Hound, Snagglepuss, and Magilla Gorilla, they traveled around the country in a balloon called the Ark Lark. The instructional nature of the series could be seen in the names of some of the adversaries they battled, such as Mr. Waste, Mr. Bigot, Lotta Litter, the Envy Brothers, and Mr. Cheater. Later, starting in 1978, NBC offered a ninety-minute series called "Yogi's Space Race," in which Yogi and an assortment of cartoon characters competed for an all-expenses-paid vacation on Mars. In these episodes Yogi and his copilot Scarebear (Joe

Besser) rocketed through space in their Supercharged Galactic Leader. Each week they would be challenged by characters from other Hanna-Barbera series, all driving bizarre vehicles. A principal villain was the fiendish Phantom Phink (Frank Welker), who, with his henchman Sinister Sludge (also Welker), used many disguises in a futile effort to outwit Yogi and win the race.

Other segments of "Yogi's Space Race" included "The Buford Files," involving the slow-witted dog Buford who solved mysteries with his teenage friends Woody and Cindy Mae; "Galloping Ghost," concerning an ectoplasmic horse named Nugget Nose who joined with his accomplices Rita and Wendy to battle villains in the Old West; and "The Galaxy Goof-Ups," the most popular segment, which offered Yogi, Scarebear, Huckleberry Hound, and Quack-Up (a daffier Daffy Duck) as lunatic interplanetary adventurers under the command of Captain Smerdley. "The Galaxy Goof-Ups" later earned its own half-hour time slot, as did "The Buford Files."

A television special, built around "Yogi's First Christmas," aired in 1980. While still falling short of the full animation used for theatrical features, the movie extended and refined the limited animation techniques to achieve some pleasing effects.

Once again, the goofy charm of Yogi and his friends was blended with knockabout slapstick and a brace of lilting tunes. The simple plot revolved around the efforts of Yogi and his cohorts, including Huckleberry Hound, Augie Doggie and Doggie Daddy, to keep the Jellystone Lodge from being torn down by its haughty owner, Mrs. Throckmorton. Their opposition comes from Mrs. Throckmorton's nasty nephew Snively and from the cantankerous local hermit named Herman, who are bent on ruining everyone's Christmas. In his amiable fashion Yogi, whose winter hibernation has been interrupted ("Aggrevatin' a hibernatin' bear is illegal"), bumbles his way to victory over Snively in winter sports contests and keeps getting promoted by Mrs. Throckmorton, who detests her nephew and admires Yogi's unconscious heroism.

A number of the songs in the movie involve exceptionally clever and funny animation: "Hope," engagingly sung by Boo Boo; "The Bear That Makes the Whole Thing Go," featuring Yogi on a wild ski run down the mountainside (he skis on both sides of a tree and tangles with a bewildered bird); "A Sprig of Mistletoe," sung by demure Cindy Bear to a painfully shy Yogi; and "I'm Mean," Herman the Hermit's paean to nastiness that manages some witty animation illustrating Herman's bad deeds. Naturally, the film includes the obligatory Christmas song ("We're Making a Big To-Do About This Christmas"), a wistful romantic ballad for Cindy Bear ("I've Been Kissed by Yogi Bear!"), and the arrival of the real Santa Claus. It all ends joyfully, with a torchlight parade and a heartfelt tribute to Yogi as "a dear sweet bear."

Above: Yogi and Boo Boo discover a treasure chest in "Yogi's Treasure Hunt," 1987.

Happily, the indestructible Yogi has continued to turn up in recent years. Since 1985, "Yogi's Treasure Hunt" has been the featured segment of the syndicated series "The Funtastic World of Hanna-Barbera," and two recent two-hour television specials have embroiled Yogi and his friends in new adventures. In "Yogi's Great Escape" (1987), the smarter-than-the-average bear and Boo Boo, joined by three abandoned cubs named Buzzy, Bopper, and Bitsy, flee Jellystone Park to avoid being captured and sent to the zoo. Their flight takes them first to the Wild West town of Ghost Gulch, where slow-on-the-uptake horse Quick Draw McGraw is the sheriff. They also tangle with Bandit Bear and Li'l Brother Bear, two outlaws whom they greatly resemble. Further adventures take them to an eerie "ghost ship" where cagey Wally Gator is the captain, and to a carnival run by the inimitable Snagglepuss. Somehow they end up in a hot-air balloon, caught on the sharp spire of New York's Empire State Building. When they learn the joyful news that Jellystone Park will not be closed after all, they return with Ranger Smith.

Left: "Yogi's Treasure Hunt."

Below: "Yogi's Great Escape," 1987.

How Can There Be Spring?

W. Hanna, B.M.I.
J. Barbera, B.M.I.
J. Debney, A.S.C.A.P.

A TEMPO

RIT.... How can there be spring when you are

OPT. SPOKEN

lone- ly — when your heart aches, spring flowers ne-ver bloom —— The

days are dull the birds don't sing — I try to smile but ev'- ry- thing that

should be glad — is gloom — How can there be spring when there is

no- one — to share a big full moon that shines a- bove —— with

just me there there's not a chance You can't have spring with-out ro-mance and

It still takes two to fall — in love ——————

Oh I know there is a spring-time but when we two are a- part I

just can't call it springtime when it's win- ter in my heart ___

How can there be spring I feel like cry- ing ___ I

choke back tears he's gone I don't know where _____ When

he comes home then we'll have spring — Flowers will bloom — birds will

sing ___ and I'll — have love to share ___ We'll
RIT.... A TEMPO RIT MOLTO

both have love to share _____

"Yogi and the Magical Flight of the Spruce Goose" (1987) found Yogi and his friends (most of them, amazingly, voiced by Daws Butler) launched into outer space when the Spruce Goose, the enormous cargo plane they are touring, suddenly takes off. At first their journey becomes a rescue mission when they save animals who have been stranded on an ice floe in the Antarctic, and they rescue the illegally trapped wild animals who have been abandoned on a ship adrift on the Zelman Sea. Their troubles really begin, however, when they land on a tropical island where their old nemesis the Dread Baron and his companion Mumbley have crash-landed. Fooled by the Baron's promise to reform if they are rescued, Yogi takes them aboard the Spruce Goose as crew members.

The Baron cannot change his nasty ways, and soon he has diverted the plane's course to the Isle of Moolah-Moolah, where he poses as the islanders' golden idol, Moolagoolah, to whom he bears a strong likeness. He orders the natives to bring him offerings of gold, which he loads into the Spruce Goose. His plan to take off with the

Left: The song "How Can There Be Spring?" from "Yogi's Great Escape."

Right: "Yogi and the Magical Flight of the Spruce Goose," 1987.

gold goes awry when a volcano erupts on the island, and the crew is forced to dump the gold to get the Spruce Goose off the ground. The Dread Baron and Mumbly leap out after their treasure, and the plane wings its way home. Although Yogi and his pals are not exactly welcomed as heroes, they are gratified to hear about the miraculous rescue of animals in the Antarctic and the Zelman Sea.

Loopy de Loop.

All this glittering superstardom for Yogi Bear was a distant dream, however, when he made his first appearance as one component of "The Huckleberry Hound Show," back in 1958. The success of that show sparked other series from Hanna-Barbera, bringing new animated characters to the fore. In 1959 the studio introduced its first series for theatrical release, built around an amusing character named Loopy de Loop. An eternally hopeful wolf with a French accent (spoken by Daws Butler), Loopy spent most of his time trying to convince the world that he was warm-hearted, friendly, helpful, and all things "good." Apparently, the world was not ready for a good wolf, as poor Loopy was chased, beaten, and otherwise persecuted in cartoons that extended until the mid-sixties. In a typical entry Loopy is pummeled by a mother bird after he has rescued her chick, and he is repeatedly clobbered by a watchdog after saving some farm animals from a predatory little wolf. ("Now there's an old pro," the little wolf

remarks. "Talked me right out of my chicken!") Throughout his ordeal Loopy regards himself as "kind, considerate, and charming."

One of the most delightful Hanna-Barbera creations around this time was a drawling mustang from New Mexico territory whose reputation as a sharpshooting gunslinger was not exactly warranted by the facts. Immensely stupid but also immensely likable, Quick Draw McGraw loped his way from one disaster to another, constantly ignoring the warnings of his tiny partner, the Mexican burro Baba Looey. (Both characters were voiced in exemplary fashion by Daws Butler.) Quick Draw's expressions soon became a permanent part of television lore: "Hold on thar!" he would shout, "I'll do all the thin'in' around here!" often adding a sonorous "And do-o-n't you forget it!" Or he would assert, "I'm gonna clean up this town!" never once acknowledging that, as one character remarks, he has "muscles to spare and a brain to match." Continuing characters in the series included a fickle filly named Sagebrush Sal (Julie Bennett) and a hilarious dog named Snuffles (Daws Butler again), who would be consumed with ecstasy every time he ate a dog biscuit. Squealing noisily, he would hug himself, leap into the air with joy, float down like a leaf, and finally heave a contented sigh. A two-faced hound not above turning on anyone who refuses him a biscuit, Snuffles was also fond of muttering foul-sounding imprecations under his breath.

Following pages: The eternally cheerful bumbler Quick Draw McGraw. Inset: Quick Draw tosses a biscuit to Snuffles.

Quick Draw McGraw.

Written by Michael Maltese and other top story men, "Quick Draw McGraw" drew a well-aimed bead on many of the conventions of the movie and television Western. Every clichéd situation was trotted out to be churned up in episodes that mixed slapstick and gags. ("Put the saddle on the stove, Mother, we're ridin' the range tonight!") Galloping into Bad Man's Territory after the ornery Tombstone Jones, Quick Draw and Baba Looey disguise themselves as a widow and her baby, with calamitous results. Tombstone gives Quick Draw the ultimate test of the West: "How fast can you draw a gun?" Obligingly, Quick Draw sketches a gun on a pad in record time. Later, Tombstone courts Quick Draw with such tender lines as "You remind me of my horse, you cute l'il' old cactus!" Hired by the Slinkerton Detective Agency to capture train robbers Durn and Gooden Meany, Quick Draw gets clobbered at every turn. Hurled through the entire length of the train when the brothers bring it to a sudden stop, the ever-hopeful Quick Draw exclaims, "Mighty fine brakes!" Boarding the riverboat the *Memphis Queen* to nab the sneaky gambler Bold Weevil, Quick Draw arms himself with more hidden gadgets than Agent 007, but they all backfire on him. "That's what I like about Quick Draw," Baba Looey remarks. "He's got a lot up here [pointing to his head]. No brains—just a vacant lot."

Occasionally, when he was not playing "the scourge of the outlaws," Quick Draw would disguise himself as a swashbuckling, Zorro-like masked avenger called El Kabong, who sang tunelessly with his guitar or used it as a weapon (a "kabonger") to smash over the heads of his enemies. ("I was overcome by a kabonging frenzy!") In a typical episode, "El Kabong Strikes Again," Quick Draw is sent to rout the villainous Tabasco, who is forcing a Mexican señorita to marry him unless she comes up with ten thousand "pestardos." The hilariously inept Quick Draw duels dashingly with Tabasco ("That smarts!" he yells, not for the first or last time, when Tabasco nicks him with his sword), and somehow finds himself in the bull ring, fight-

ing the nasty bull El Gorito, who uses a pencil sharpener on his horns. No fear: when the bull hears him sing, he runs screaming out of the ring, as does our heroine when El Kabong unmasks his face.

The "Quick Draw McGraw" series delighted in pitting the intrepid hero against the West's nastiest (and funniest) bandits. In one episode Quick Draw takes on Billy the Little Kid, who steals jelly beans; the ornery Wild Bill Hiccup, who (inevitably) suffers from a bad case of hiccups; and the dangerous damsel Texas Tillie, whom Quick Draw tries to capture by using his limited powers of seduction. Every ruse fails, until Quick Draw must call on his hard-bitten mother to bring in Tillie. In another episode, Quick Draw pursues the elusive Shadow Bandit whose secret hideout is a hole in the mountain he opens with the words "Open sesame!" This time it takes the biscuit-loving Snuffles to bring in the culprit. (He refuses to work unless he gets *three* biscuits.)

Other segments of the "Quick Draw McGraw" half hour drew their share of devoted viewers. "Snooper and Blabber" centered on a cat-and-mouse team of private investigators who stalk criminals and track down missing animals. The cat, named Super Snooper, and the mouse, amusingly called Blabber Mouse, worked out of the Super Snooper Detective Agency, where they were involved in such cases as "The Purloined Parrot," "Bronco Buster," and "Real Gone Ghosts." Blabber, who spoke as if his mouth was filled with marbles, provided the comic relief for straightman Snooper, who sounded much like Archie, the character created by actor Ed Gardner for the popular radio comedy show "Duffy's Tavern." (Both characters were voiced by

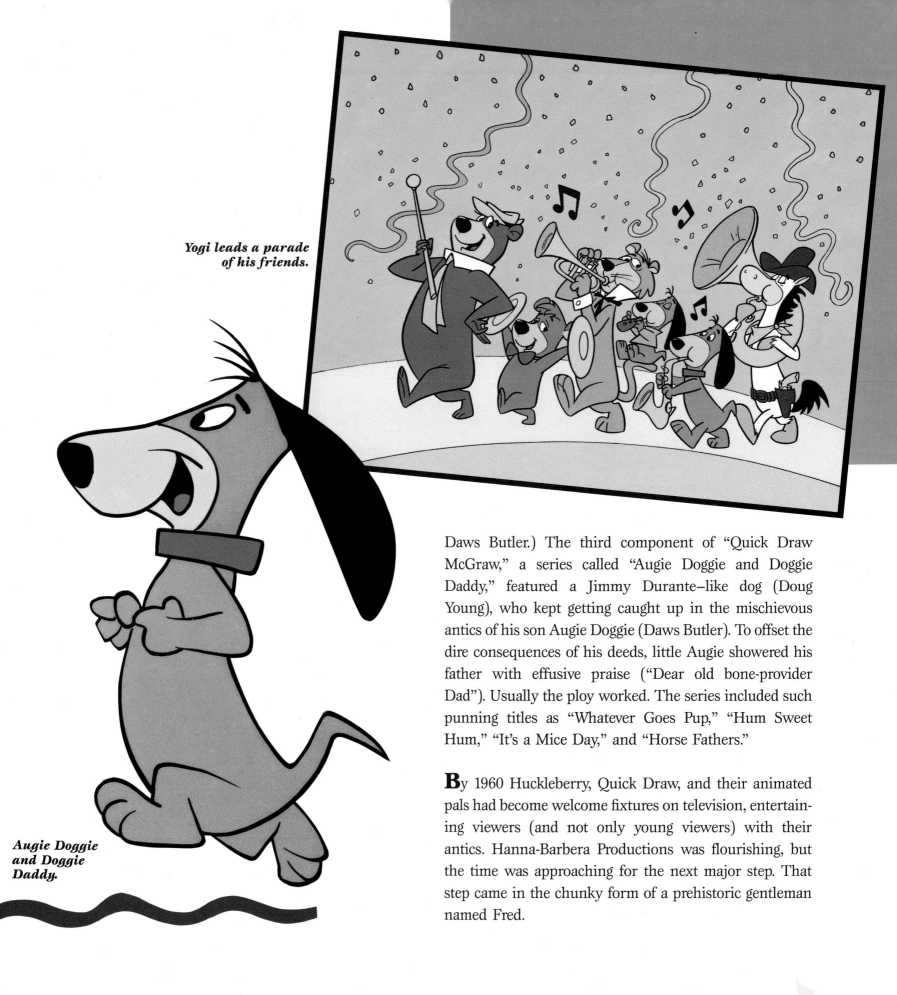

Yogi leads a parade of his friends.

Augie Doggie and Doggie Daddy.

Daws Butler.) The third component of "Quick Draw McGraw," a series called "Augie Doggie and Doggie Daddy," featured a Jimmy Durante–like dog (Doug Young), who kept getting caught up in the mischievous antics of his son Augie Doggie (Daws Butler). To offset the dire consequences of his deeds, little Augie showered his father with effusive praise ("Dear old bone-provider Dad"). Usually the ploy worked. The series included such punning titles as "Whatever Goes Pup," "Hum Sweet Hum," "It's a Mice Day," and "Horse Fathers."

By 1960 Huckleberry, Quick Draw, and their animated pals had become welcome fixtures on television, entertaining viewers (and not only young viewers) with their antics. Hanna-Barbera Productions was flourishing, but the time was approaching for the next major step. That step came in the chunky form of a prehistoric gentleman named Fred.

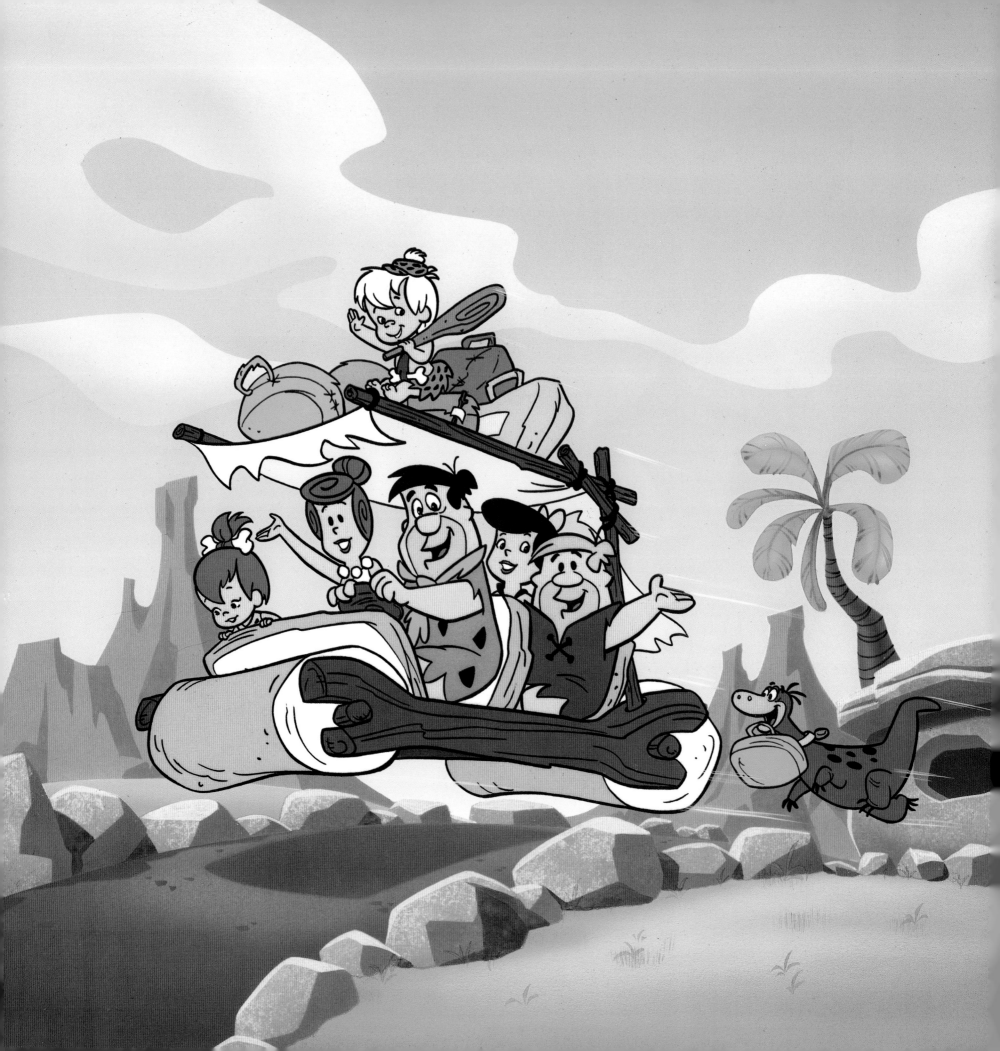

Meet the Flintstones

By 1960 Hanna and Barbera had proved conclusively (and profitably) that animation could work on television with carefully controlled guidelines and systems. "Huckleberry Hound" appeared on Monday, "Quick Draw McGraw" on Wednesday, and "Yogi Bear" on Friday, all under the sponsorship of Kellogg's. The shows were on over a hundred stations, and they were all flourishing in their time slots. They usually turned up in the early evening hours, which Hanna and Barbera considered prime time.

Then John Mitchell came to them and suggested that they conceive of an animated program for *true* prime time: a situation comedy with cartoon characters that would be aimed at adults as well as children. The idea was innovative and audacious; no company had ever created an animated half-hour series in which continuing characters were involved in the same antic escapades as their live counterparts. Hanna and Barbera decided to move ahead—but in what direction? They began to think along

> **T**he characters were dressed in loincloths. And they were playing a record on a phonograph—the old-fashioned kind—only the record needle was a bird with a long beak. Immediately, we could see the gag potential in that.
>
> **—Bill Hanna**

the lines of "The Honeymooners," the hugely successful comedy series that starred Jackie Gleason as blowhard bus driver Ralph Kramden, who tangles with his long-suffering wife, Alice, and their neighbor Ed Norton. Bill Hanna was especially delighted with the concept: "I used to watch 'The Honeymooners' and laugh until tears would run down my cheeks," he recalls.

Once it was decided that the animated series would revolve about characters similar to those in "The Honeymooners," the central questions were these: In which era would they live? What sort of people would they be? Bill Hanna remembers that "we dressed them as Pilgrims, as Indians. We had them as Romans, in togas." Sketching rapidly with his pencil, Barbera also tried contemporary figures: a man in overalls, or sports clothes, or hunting clothes, with his wife in similar costumes. Then one day an idea began to take root: Why not go back to Neanderthal days—the days when men used to run around in

*Left: The Flintstones and the Rubbles,
out for a prehistoric joyride.*

loincloths? Why not have the characters at work in the rocks, in some place that was part of the beginning of civilization? Soon Dan Gordon, a brilliant artist and storyboard man, turned up with a drawing in which the characters came out of the Stone Age, dressed in leopard skins. Suddenly it became possible to visualize all the splendid gag possibilities in sending a typical suburban family back into the dawn of history—to give them all the creature comforts (and problems) of any family, but with a prehistoric twist. And the gags began to flow: a house became a well-furnished cave, a car became a thatched-top convertible with stone wheels, and a telephone took the shape of a ram's horn.

Expanding on the concept, Hanna and Barbera went ahead to create the Flintstones. "Only they were originally called the Flagstones," Hanna recalls. "That is, until we received a letter from a cartoonist who already had comic-strip characters called the Flagstones. So, reluctantly, we changed the name to the Flintstones." Working assiduously, they conceived of a first episode—"the simplest story we could think of," Barbera says—in which Stone Age Fred Flintstone and his neighbor Barney Rubble scheme to get out of going to the opera with their wives, Wilma and Betty, and to go bowling instead. It was a plot that had done yeoman duty in many a television situation comedy, but placed in the prehistoric era, the possibilities for comedy and satire seemed virtually limitless.

From the very start Hanna and Barbera understood that the humor of "The Flintstones" resided primarily in reconstructing the familiar trappings of life in the mid-twentieth century—especially life in American suburbia—in terms of the Stone Age. Bowling, prehistoric fashion, became the central gag of the first episode. In the town of Bedrock, located 250 miles below sea level in Cobblestone County, the bowling alley has its very own style. Barbera remembers, "When Fred threw the ball, actually a large rock, it began to chip and break apart as it went down the alley, and by the time it got to the first pin, there was only a little pebble that would just go *plink* and knock over all ten pins. When we had a split, it was *really* a split. Fred threw the rock, which split in half, and each half went after a pin. We dreamed up many gimmicks like that."

With John Mitchell in frequent consultation, Hanna and Barbera completed the first two storyboards for "The Flintstones."[1] Very soon they discovered that selling the idea was a formidable task. Their credentials were impeccable—they had created the phenomenally popular "Tom and Jerry" cartoons for nearly two decades, and their television shows had spawned such well-loved cartoon characters as Huckleberry Hound and Yogi Bear. Yet now they were proposing an entirely new concept of animation for prime time, and the prospects for acceptance seemed dim at best.

Since John Mitchell was well known as a pioneer in the medium, he was able to set up a series of meetings with network executives and potential sponsors. Grueling and exhausting, the presentations required prodigious effort by Joe Barbera, who had already been involved in selling shows to Kellogg's. "It was a performance," he recalls. "By the time you give a preamble about what it's all about, go through two storyboards, and then watch their eyes and their reactions, to see if they're smiling or if they're falling asleep, you're worn out. I remember going to Chicago and pitching to some clients

Above: Fred tries to sneak away from Wilma for a bowling game.

of Foote, Cone & Belding. I remember flying to Saint Louis to do a pitch for Purina. These presentations took place every day."

The hardest struggle came in New York City, where most of the network and agency people tended to converge in those days. "We would meet in the Screen Gems office," Barbera remembers. "There would be anywhere from one to forty people waiting to see the presentation. The word had gotten out that this was *not* the usual presentation. I had to act out all the parts, jumping around and making all kinds of noises. That's what it took. Sometimes I had to do five presentations in one day. Then I'd walk back to my room at the Sherry Netherland Hotel and collapse until the next telephone call. Someone would say, 'They're all going to be here in ten minutes.' So I would get up and go back again. The pitch went on for eight long weeks."

From the beginning, there was no dispute about the bold originality of the concept. Most everyone liked the idea of the Stone Age suburbanites, and most everyone was laughing. Yet nobody wanted to take it on as a project. The idea of a prime-time animated program was too new, too much of an unknown factor. Jim Aubrey, the new president of CBS, turned it down. (Barbera recalls making the presentation in an office so dark he couldn't see the drawings.) NBC executives turned it down. Hanna and Barbera were about to give up when they met at the Screen Gems offices with top officials at ABC. Barbera began describing the show, as usual acting all the roles, and within fifteen minutes ABC had bought "The Flintstones." (He recalls that it happened on Saint Patrick's Day, when twice during the day he had to carry five-hundred storyboards through the giant parade from ABC to his hotel, and then back again.)

Now came the equally grueling job of selling "The Flintstones" to potential sponsors. Barbera retains vivid memories of pitching the program to executives of the Reynolds Tobacco Company in Winston-Salem: "We con-

verged on their beautiful conference room, with walls paneled in a rich wood. We couldn't put tacks into these walls, so we taped every drawing to the walls. We came back after a coffee break to find that all the drawings were on the floor, and we had to do it all over again in only two hours. We managed to make the presentation to all these southern gentlemen, but it seemed like a disaster. The chairman of the board wasn't smiling—he wasn't even chuckling. We learned later that he was in pain from the gout." To everyone's astonishment, Reynolds bought half of the show for Winston cigarettes.

The other half of "The Flintstones" was bought by Miles Laboratories for their One-a-Day Vitamins. Once again, the selling had its share of hair-raising experiences.

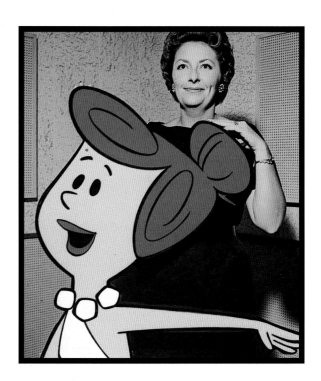

Above: Fred Flintstone and his alter ego, Alan Reed. Top right: Wilma Flintstone and Jean Vander Pyl, her voice for nearly three decades; right, Betty and Barney Rubble with their voice actors, Bea Benaderet and Mel Blanc.

Barbera remembers flying to Chicago with John Mitchell and ABC executive Ollie Treyz for a meeting with Miles. "We had all these boxes with the artwork. And we boarded an Electra—a two-propeller plane that flew to Chicago. These were the planes that turned out to have a fault—they began to disintegrate in the air. A few weeks later, there were two crashes. We arrived at midnight, after the wildest, bumpiest ride I have ever had. We got to their offices and pinned up all the drawings until my thumbs were bleeding. We finished at three in the morning and then came back again at eight to make the presentation. And lo and behold, they bought the other half. Now we were fully sponsored."

Selecting the right actors to play the Flintstones and the Rubbles proved to have its rewards and its pitfalls. The actors chosen to play Wilma Flintstone and Betty Rubble were eminently right for their parts. Jean Vander Pyl (Wilma), an experienced performer with substantial credits, brought a warmth and uncloying sweetness to the role, and Bea Benaderet (Betty), fondly recalled for her work in many programs, especially "The Burns and Allen Show" and "Petticoat Junction," made a spirited foil for Barney.[2] The problem centered on the roles of Fred Flintstone and Barney Rubble. The actors selected for these parts turned out to be unsuitable and had to be replaced at considerable expense. The newly recorded voices belonged to veteran actor Alan Reed (Fred), perhaps best known for his characterization of "poet" Falstaff Openshaw on Fred Allen's radio program, and to Mel Blanc (Barney), to this day the best-known and most versatile voice actor in the animation field. Blanc is still giving Barney a raffish charm that has never faded.[3] (He also voices the irrepressible sounds made by the Flintstones' pet, Dino.)

The first episode of "The Flintstones" had its premiere on ABC on September 30, 1960. Immediately the show assumed historic status as the first animated situation comedy on television, the first animated series to go beyond the six- or seven-minute cartoon format, and the first animated series to feature human characters. The reviews, however, were largely unfavorable and even hostile. Although *Time* magazine (October 1, 1960) noted that "the series has the sort of talent behind it that seldom fails," most of the major commentary did not welcome the Stone Age family. Jack Gould in the *New York Times* (October 1, 1960) called the program "an inked disaster," adding that "the masculine figures are notably unattractive, coarse, and gruff, and the women nondescript." "The humor," he concluded, "was of the boff-and-sock genre, nothing light and subtle." *Variety*'s review (October 5, 1960) was equally damning: "On the basis of the first episode, it doesn't seem to have the qualities that make for staying power." With the kind of certainty that later becomes an embarrassment, the reviewer prophesized that "Fred Flintstone isn't likely to garner the kind of popularity that Hanna-Barbera's Huck Hound or Yogi Bear have occasioned, since he's not a particularly likable kind of guy." Despite these adverse reviews, the program was given an Emmy nomination and received a Golden Globe Award as an Outstanding Achievement in International Television Cartoons. It was also voted the most original new series by *TV-Radio Mirror*, and it received the coveted Silver Plaque of the National Cartoonists Society for "the best in animation."

Ignoring the critical barbs, television viewers warmed quickly to "The Flintstones," and by the second season the reviewers had joined with the public in enthusiastic approval for the program. The *Variety* critic now seemed to feel that the program was destined for longevity rather than oblivion: "The satirical framework . . . seems plenty durable and of course it provides endless possibilities for sight gags" (October 2, 1961). The third season found the reviewer effusive with praise: "The whimsy, the satirical pokes, and the ingenuity of representing modernity in Stone Age terms are the distinguishing factors that have made Flintstones the only kidult cartoon series to cut the mustard in the prime heavyweight class. It's still a funny

show for viewers of all age levels" (September 30, 1962).[4]

By this time the Flintstones and the Rubbles had become welcome visitors in homes across the country, and it seemed appropriate that the program would come to the attention of critics outside the area of television. In an October 1963 column in the *New York Times*, the newspaper's eminent theater critic Brooks Atkinson offered the highest praise for "The Flintstones," hailing each weekly episode as "a remarkably fresh cartoon." He wrote: "William Hanna and Joseph Barbera, who invented the characters in 1960, lifted their cartoon out of mediocrity by setting it in the Stone Age. It is pure fantasy in the genre of *Alice in Wonderland*." He concluded by endorsing Fred and Barney as "they bounce through a grotesque landscape with superhuman speed and agility" or "luxuriate with superhuman gusto at the meetings of the Order of Water Buffaloes." "Thanks to the raciness of the cartoon medium," he wrote, "they are worth a hundred of the standard comedies, and they make actors look inept and anxious."

In truth, as a viewer comes freshly upon many of the 166 episodes in the original six-year run, the basis for Brooks Atkinson's enthusiasm becomes readily apparent. Aside from its qualifications as a "first" in many areas of television, the program created a form, or even a sub-genre of its very own: animated situation comedy laced with both fantasy and satire. It was a form that owed its success not only to the creative imagination of Hanna and Barbera but also to the inordinate skill of the writers. Hanna re-

members, "After Joe and I wrote the first script, I said, 'There's no way in the world that we can write all of these scripts. You're doing all of the recording, and I'm doing all of the directing, and we do a half hour every week.' So Warren Foster came in at this point, and for fifteen weeks straight, he wrote a one-half-hour story and did the storyboard too. That's a job that had never been done before—and has never been repeated since!" Barbera adds, "Warren fell into the job as if he was born for it. The guy was a genius." Over the initial run of "The Flintstones," many other talented writers made their contribution; they included Mike Maltese, R. Allen Saffian, Barry Blitzer, Tony Benedict, Herb Finn, Jack Raymond, Sydney Zelinka, Arthur Phillips, and Joanna Lee.

On a rudimentary level "The Flintstones" derives, of course, from the most familiar, most widely accepted situation comedies in television's history, especially "The Honeymooners." Like Ralph Kramden, Fred Flintstone is a well-meaning blowhard who fancies himself capable of carrying out get-rich schemes. Although he works as a crane operator in a gravel pit (where the crane happens to be a dinosaur), Fred has no compunction about passing himself off as everything from a song writer to a sportsman. Like Ralph, Fred has a long-suffering wife (Wilma) and neighbors (Barney and Betty Rubble) who become involved in his antics. Genial but none too bright, Barney, in the style of Ralph Kramden's neighbor Ed Norton, acts as a foil to Fred, often commenting wistfully on Fred's ability to get them both into deep trouble.

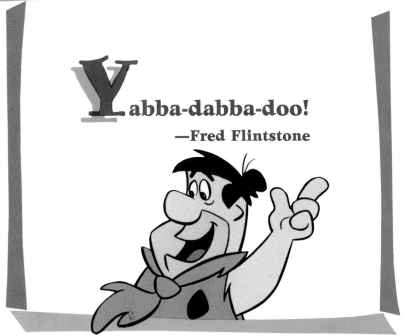

Yabba-dabba-doo!
—**Fred Flintstone**

Right: Theme song for "The Flintstones."

84

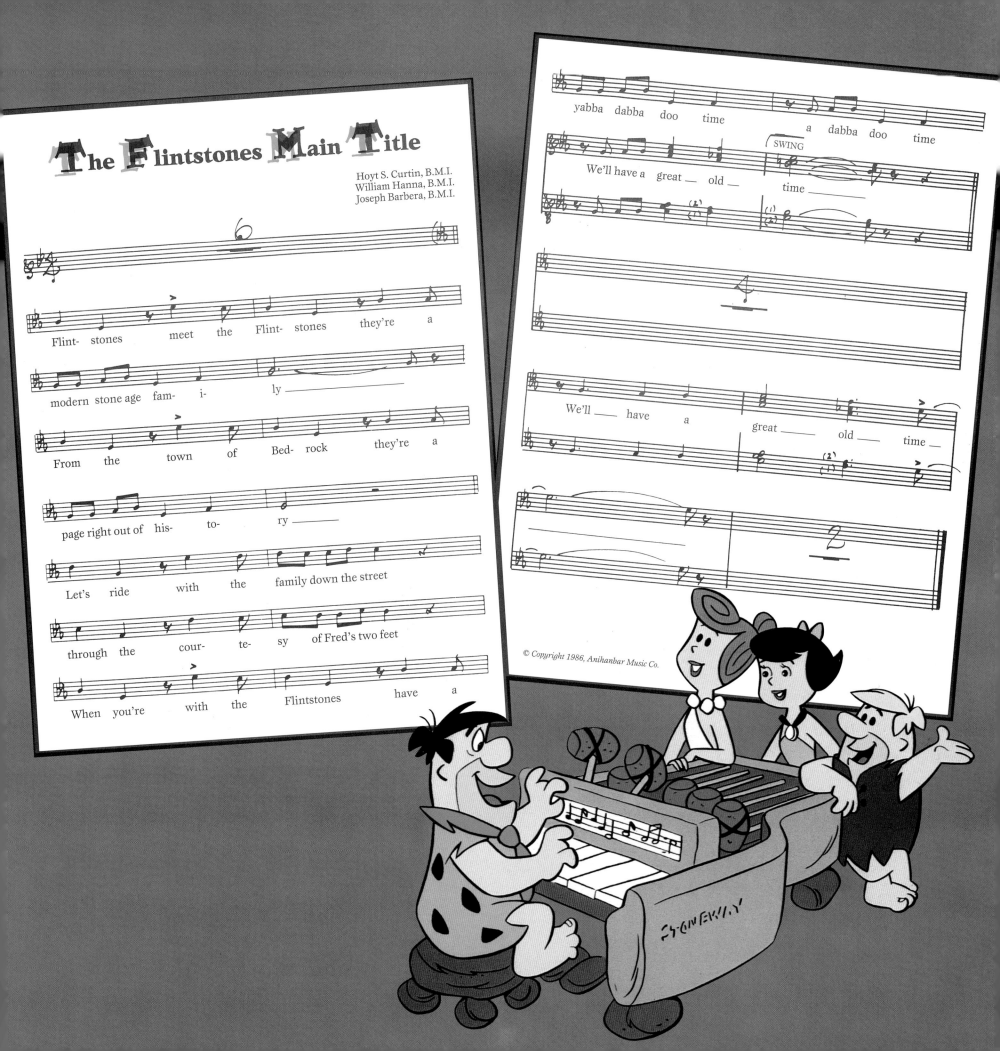

Pebbles and Bamm Bamm play in the snow, with Dino looking on.

From the beginning "The Flintstones" made no pretense about drawing on the basic situations of television comedy. In the footsteps of numerous comedy characters who have preceded him, Fred must endure an ogre for a boss (Mr. Slate or Mr. Rockhead), forgets his wedding anniversary, suffers from mother-in-law trouble, often decides to change occupations, and (later in the series) copes with the perils of fatherhood. Echoes of classic programs abound. Like "The Honeymooners," foolish misunderstandings wreak havoc—in one episode Fred finds an old love poem he wrote to Wilma and, forgetting that he is the author, suspects that Wilma has taken a lover. As in "I Love Lucy," many episodes depend on Fred and Barney getting caught up in embarrassing escapades. (When Wilma and Betty contract measles, Fred and Barney, dressed as women, must substitute for them in the Big Bake-Off Contest. Their entry is the Flint-Rubble Bubble Cake.)

Situations dear to the heart of comedy writers since the fifties surfaced continually on "The Flintstones." Chaos ensues when Fred is forced to secretly wine and dine a lady buyer, or when he suddenly decides to go for "class" and "culture" and ends up living on Snob Hill Estates with rich, freeloading neighbors. Inevitably the Flintstones and the Rubbles get to move away from their suburban caves in Bedrock for further adventures. In various episodes they find themselves out West (where Fred becomes sheriff for a day of Rocky Gulch), adrift at sea on a houseboat they win on a quiz show ("The Prize Is Priced"), and working on the staff of a resort hotel. In an entry gleaned directly from Abbott and Costello's movie *Buck Privates*, Fred and Barney are accidentally drafted into the army, where they become inept soldiers at Camp Millstone and also involuntary space travelers. Many of the episodes depended on the hangups television audiences had come to know and love: fear of going to the dentist (Barney gets too much gas and ends up floating in space), worry about failing eyesight (Fred gets the wrong glasses and bumps into everything, Mr. Magoo style), or the threat of being unemployed (Fred's scheme to get a raise backfires and he winds up jobless, then working as a short-order cook, a gas station attendant, and a circus performer!).

The birth of the Flintstones' daughter, Pebbles, in Bedrock's Rockapedic Hospital in February of 1963 (deciding on the infant's sex took two days of intensive, nerve-wracking meetings), sparked a number of new plot lines. In "I Love Lucy" fashion, the day of Pebbles's birth has Fred in a dithering uproar—he takes their pet, Dino, to the hospital instead of Wilma. Later episodes had Fred insisting on taking full charge of the baby after he fires a bossy nurse—naturally he becomes a nervous wreck, taking Pebbles to a wrestling match where she gets on television—and joining Daddies Anonymous, an organization that allows baby-sitting fathers some secret time for fun and games while their carriages await in the parking lot. Some time after the arrival of Pebbles, in the fall of 1963, the Rubbles adopted the baby found on their doorstep. Their little son, named Bamm Bamm, proved to have extraordinary strength that caused no end of complications for both families.

*The Flintstones
take a ride on Dino.*

If "The Flintstones" had merely offered a retread of established comedy plots or a recycling of threadbare comedy characters, it would hardly have warranted its durable place in television annals. What the program achieved was to take these basic situations and characters into the realm that Brooks Atkinson aptly calls "pure fantasy." Like the most successful fantasies, "The Flintstones" creates its own world where the most outlandish and preposterous events and characters can be accepted by viewers of all ages. Fred and Wilma may reside in a split-level cave in the town of Bedrock with the Rubbles as their best friends and next-door neighbors, but their everyday lives are as fanciful as anything Lewis Carroll could devise. They inhabit a Stone Age universe that only a team of gifted writers and animators could imagine, where familiar foods include brontosaurus cutlets, lizzard's gizzards, and swamp-root soufflé, where a lawn mower is a ravenous lobster; a car horn is a squeaky bird; and gasoline comes from an elephant

named Ethel. No limits are set on the uses of the animal kingdom: a doctor uses a porcupine quill as a needle, and at Fred's quarry, quitting time is signaled when a bird squawks after having its tail rudely pinched by the foreman. Can a suburban household exist without a coffee machine? Why not have a lizard scraping coffee beans into a pot? If an intercom is needed in Fred's construction company, satisfactory results can be obtained with a beehive and a squawking parrot. Even the advances of civilization can be accommodated in this prehistoric paradise — an airplane for Pterodactyl Airlines becomes a huge bird with goggles, and a space ship is a huge log with a sharp point at one end and rubber bands to provide liftoff. Occasionally "The Flintstones" ventured into the realm of pure fantasy with the recurring character of the Great Gazoo, a tiny creature from the planet Zetox (also called Ziltox), who grants Fred and Barney's wishes. Voiced by Harvey Korman, Gazoo claims to have been sent from his planet, where he was

*Left: The Flintstones and the
Rubbles enjoy a picnic.*

89

Fred and Wilma in their Cavemobile.

"head master scientist," to serve these two "prehistoric dumdums."

In addition to its ingenious Stone Age gadgetry, "The Flintstones" derived much of its humor from transforming modern-day characters and figures into their prehistoric equivalents. Sometimes the transformation was as simple as using variations of "rock," "stone," and "pebble" in the names: Fred's eye doctor is named Boulder Dome; Wilma visits her obstetrician, Dr. Rockpile; a lunatic psychiatrist (in situation comedy, are there any *sane* psychiatrists?) is named Dr. Stonewall; and Fred tangles with television director Norman Rockbind. The possibilities, of course, are endless;

Wilma and one of her Stone Age helpers.

among the characters are rocket scientist Professor von Pebbleschmidt, gas station attendant Mr. Quartz, and wrestler Broncho Cutrock, the Masked Mauler.

Occasionally latter-day personalities became grist for the mill: Leonard Bernstone conducts musical selections by (who else?) Rockmaninoff; boxer Floyd Patterstone fights Rocky Granite, who is unrelated to actor Cary Granite; Ed Sullystone hosts a television show; singer Ann-Margrock (played by actress Ann-Margret herself) hides out as a baby-sitter in the Flintstone household; and actor Stony Curtis (voiced by Tony Curtis) teaches Fred about the physical perils of being a movie star. If actual celebrities were used as direct models only occasionally, they would turn up in unmistakable voice impressions. An ample lady gangster named Dagmar the Peroxide Kid sounds very much like Mae West; a private eye has the vocal inflections of Cary Grant; even the snorkasaurus, a prehistoric animal hunted by Fred, speaks in the inimitable style of Phil Silvers's Sergeant Bilko, the memorable con artist he created on television. One voice imitated in more than one Flintstone episode belonged to Ed Wynn,

Right: Bedrock in the snow.

the masterly comedian of the foolish giggle and madcap antics. Wynn's unique delivery was also imitated for a later Hanna-Barbera character, Wally Gator.

While the fantastic elements of "The Flintstones" appealed to young viewers, the show also added a satirical note that widened its audience to include adults as well. If the satire never cut very deeply, it managed a lighthearted look at human foibles and attitudes in every era. Like their twentieth-century counterparts, the Flintstones and the Rubbles embrace the idea of conspicuous consumption — there is hardly any modern-day appliance, device, or gadget that cannot be converted to prehistoric times. Fred's shaver is a clam shell with a bee in it; for a vacuum cleaner, Wilma uses a baby mastodon with a long trunk; the garbage disposal unit is a famished, buzzardlike creature called the pigasaurus, which is kept caged beneath the sink. Best of all is their beloved Cavemobile (sometimes Flintmobile), which is propelled by having the passengers move it along with their feet.

Some of the show's satirical thrusts were aimed at television itself. In an episode in which Fred and Barney fancy themselves as song writers, their climactic rendition

of "Yabba-Dabba-Doo!" is accompanied by a parody of Lawrence Welk's "champagne" music, with a happy elephant dispensing bubbles that envelop the song-and-dance team of Flintstone and Rubble. In another segment Fred's involvement with a piano he has bought as a surprise gift for Wilma gets him into all kinds of trouble, including a hilarious "Dragnet"-style interrogation by the police when they think he is a wanted crook named 88-Fingers Louie. Yet another episode pokes gentle fun at television's less-than-genuine sincerity — as a budding new television "star" (if only in Fred's scheming mind), Wilma behaves with girlish effusiveness, whirling onto the set like Loretta Young and bidding farewell with an enthusiasm Dinah Shore might envy. "The Flintstones" also parodied the popular series "The Addams Family" (itself a parody of family sitcoms), bringing in bizarre new neighbors in Weirdly and Creepella Gruesome, who think that everyone in Bedrock is a bit strange.

The fantasy and satire of "The Flintstones" were often complemented by another ingredient: a surprising amount of sharp-edged sarcasm. In particular viewers relished the acerbic comments of the creatures who were required to work all the Stone Age gadgets and devices. They were not a happy lot, and in many an episode they were called upon to express their malcontent in blunt (and very funny) terms. Here is a sampling of their bitter banter:

- An angry porcupine, used as a dish dryer, complains, "I'm getting dishpan quills."

- An irritated dinosaur, charged with lifting the "STOP-GO" signs on the road, bellows: "Ding! Ding! Ding! And to think I studied public speaking!"

- A penguin, dispensing ice cubes from a refrigerator, sneezes and remarks, "When will people learn to close doors?"

- Two monkeys, whose tails are being used as playground swings, bemoan their fate. "You know, I used to have a very short tail," one remarks. "Me too," the other adds glumly.

- A bird, serving as a squawking alarm clock, mutters, "I'll be glad when real roosters develop. I'll be able to sleep in the morning!"

- A turtle is used as a gong at a wrestling match. When timekeeper strikes him, he turns to the audience and asks, "What did you expect — Westminster chimes?"

Left: Fred and Wilma dance to the music of a Stone Age phonograph.

- A mastodon whose trunk has become a fire hose moans, "I wish I could think of a better way to earn a living!"

Long-beaked birds have their very own Complaint Department in Bedrock. One bird whose beak is being used as a phonograph needle protests angrily when Fred handles it roughly: "Watch it, buster! I'm a precision instrument!" The beaks of two others become knitting needles for Wilma, prompting one to remark, "I'm gonna cry if she drops another stitch!" Still another serves as a clothespin for Wilma's laundry. When Betty Rubble greets Wilma as an "early bird," the grumpy creature snarls, "*She's* an early bird! What am I, chopped liver?"

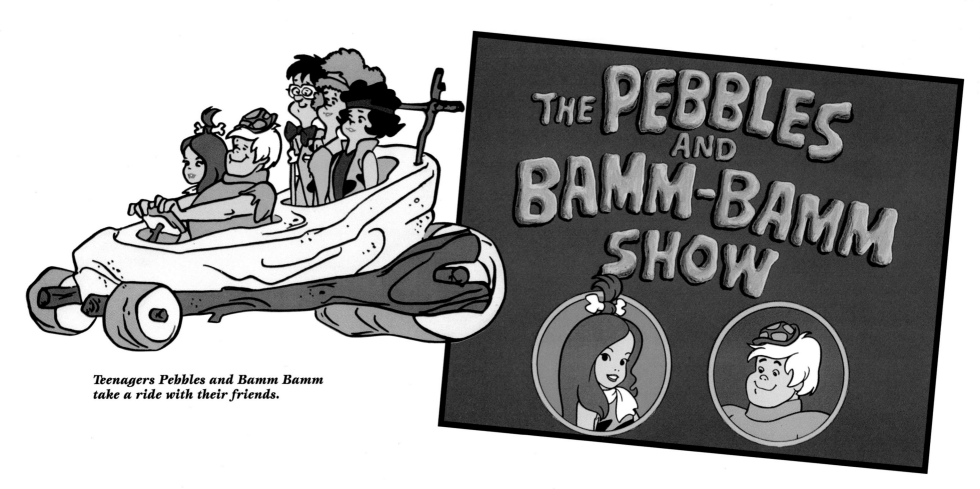

*Teenagers Pebbles and Bamm Bamm
take a ride with their friends.*

Due to the phenomenal popularity of "The Flintstones," the life of the Stone Age family extended far beyond the initial run on ABC from 1960 to 1966. After the original episodes were rerun on NBC from 1967 to 1970, Hanna and Barbera decided to create a spin-off, giving the Flintstone and Rubble offspring, Pebbles and Bamm Bamm, their very own show. Premiering in September 1971, "Pebbles and Bamm Bamm" accelerated the children's growth by turning them into lively teenagers who attended Bedrock High School with their friends. Pebbles, voiced first by future "All in the Family" co-star Sally Struthers and then by Mickey Stevens, and Bamm Bamm, played by former "Dennis the Menace" child actor Jay North, shared fun and adventure with such running characters as the bespectacled young inventor Moonrock (Lennie Weinrib) and Pebbles's two best friends, Penny (Mitzi McCall) and Wiggy (Gay Hartwig). Young viewers responded favorably to such episodes as "Pebbles's Big Boast," "Gridiron Girl Trouble," and other Stone Age vari-

ations on teenage life. Afterward, these original "Pebbles and Bamm Bamm" episodes were combined with new episodes and shown for a season and a half on CBS, first as "The Flintstones Comedy Hour" (1972–73) and then as "The Flintstones Show" (1973–74). Some new episodes featured a mournful, bad-luck omen named Schleprock (Don Messick) and a rowdy rock-cycle gang named the Bronto Bunch that challenged Bamm Bamm and Moonrock in an ongoing racing competition.

When NBC acquired the program in 1979, it redubbed thirteen of the original episodes of "The Flintstones," substituting Henry Corden as Fred for the late Alan Reed, and using Gay Autterson's voice for Betty in place of the late Bea Benaderet's. Entitled "The New Fred and Barney Show," the program was later expanded to an hour and renamed "Fred and Barney Meet the Thing," with a segment added that was modeled on "The Incredible Hulk" in which a high school student named Benjy Grimm (Wayne Norton) transforms himself into a rocklike super-

*Right: Pebbles and Bamm Bamm
rehearse with their rock band.*

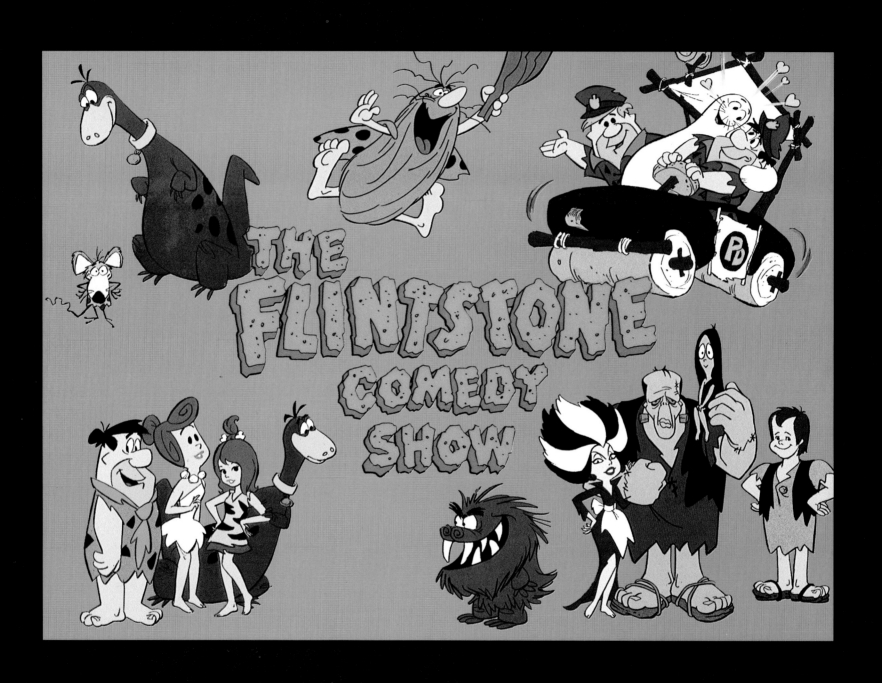

human called the Thing (voiced by Joe Baker as a Jimmy Durante sound-alike) and joins with other of his school friends in routing the bad guys. Expanded to ninety minutes in November 1979, the show added yet another segment, called "The New Shmoo," which had been introduced earlier as a separate program. The Shmoo was a creature that assumed different shapes and forms to help three young investigative reporters solve baffling mysteries.

During the eighties "The Flintstones" took on even more configurations. "The Flintstone Comedy Show," a ninety-minute program that started on Saturday mornings on NBC in the fall of 1980, mingled the Flintstone characters in adventures with other Hanna-Barbera creations. In various segments Fred and Wilma had to contend with some new neighbors, a strange family of monsters called the Frankenstones, who had been introduced in two earlier television specials; Wilma and Betty, as reporters for the *Bedrock Daily News* (edited by Lou Granite), joined with a madcap superhero called Captain Caveman to thwart assorted criminals.[5] Fred and Barney became "The Bedrock Cops," solving cases with Sergeant Boulder; and "Pebbles, Dino, and Bamm Bamm" involved the teenagers and their "dog" in unraveling

The Frankenstones play a tune on "The Flintstone Comedy Show."

mysteries. Most recently, Hanna and Barbera created "The Flintstone Kids," which turned Fred, Wilma, Barney, and Betty into precocious Bedrock preteens who share adventures with their friends.[6]

Apart from their appearances in (among other things) amusement parks, ice shows, and on vitamin bottles, the Flintstone characters have also turned up over the years on motion picture screens and in a number of television specials. A 1966 feature film entitled *The Man Called Flintstone* has Fred involved with an espionage gang headed by the mysterious Green Goose. A few lively songs ("When I've Grown Up," "Team Mates," and "Tickle Toddle") and a generous number of gags helped to keep the movie spinning merrily for young audiences. Television specials have included "A Flintstone Christmas" (1977), "The Flintstones' Little Big League" (1978), "Fred's Final Fling" (1980), "Jogging Fever" (1981), "Wind-Up Wilma" (1981) and "The Flintstones' 25th Anniversary Celebration" (1986).

Left: Main title for "The Flintstone Comedy Show."

The Flintstone Kids.

The Flintstones and the Rubbles get into the Christmas spirit in "A Flintstone Christmas," 1977.

*Two scenes from "The Flintstones'
Little Big League," 1978.*

Above: "Fred's Final Fling," 1980; left, from the invitation to the party celebrating the Flintstones twenty-fifth anniversary on television.

The enormous success of "The Flintstones" prompted Hanna and Barbera to create a new animated series that would swing the pendulum in an entirely opposite direction and take a typical suburban family into the future. ("It seemed a natural evolvement," Barbera says.) Premiering in September 1962, "The Jetsons" revolved around George Jetson, his wife Jane, and their children, Judy and Elroy, living in the fantastic and technologically advanced world of the twenty-first century. (The program's theme song, which even today can be rendered with brio by countless viewers, was written by Hanna and Barbera teamed with musical director Hoyt Curtin.) Their skypad apartment in Orbit City, which could be raised or lowered hydraulically to take advantage of good weather, contained a number of ingenious space age improvements, including a handy Food-a-Rac-a-Cycle that dispensed any kind of food on order (such as Martian meatballs) and a bathroom where shaving and grooming were mechanized. Voiced by George O'Hanlon, best known for his Joe McDoakes character in the "Behind the 8-Ball" movie short subjects, George Jetson worked as a computer "digital index operator" at Spacely Space Age Sprockets, while his family pursued their own interests: housewife Jane, played by Penny Singleton of "Blondie" fame, enjoyed the services of a wisecracking Brooklynese robot maid named Rosie (wryly voiced by Jean Vander Pyl), who was acquired from the U-Rent-a-Robot Maid Service; Judy (Janet Waldo) attended Orbit High School and swooned over teenage boys; and Elroy (Daws Butler) tinkered happily with his intergalactic radio set when he was not being carried in a pneumatic tube to the Little Dipper School, where the teachers were computerized robots.[7] Other running characters included the Jetson pet dog Astro (enthusiastically barked by Don Messick); George's snarling boss, Cosmo C. Spacely (Mel Blanc); and Spacely's snobbish wife, Stella (Jean Vander Pyl).[8]

Like "The Flintstones," "The Jetsons" drew its plot lines from the familiar situations of television comedy, deriving most of its humor from projecting its typical family into a futuristic environment. The episode "A Date with Jet Screamer" revolved around Judy's infatuation with rock star Jet Screamer, who sings and dances the "Swivel." When Judy wins a date with Jet, George decides to follow them around. Of course he gets caught up in all the futuristic teenage hangouts, including the Spaceburger Drive-In, the Swivel Lounge, where Sonny Solar and his band draw the crowds, and an amusement park where the big attraction is the Rocket Chute. In "Test Pilot," George becomes an unwilling guinea pig, testing the indestructible jacket invented by Professor Lunar for Spacely Space Age Sprockets. (At an insurance physical, he swallows "peek-a-boo probo capsules" to show pictures of his insides on a screen.) When Spacely's arch rival, Cogswell (of Cogswell's Cogs), also wants the jacket, poor George is made the point of contention between the two firms. (The jacket turns out to be unwashable.) Another episode, "The Space

Above: The Jetsons and their pets pose for a photograph; right, Jane Jetson prepares a meal for the family with her Food-a-Rac-a-Cycle.

The Jetsons Main Title

Words and music by
William Hanna, Joseph Barbera
and Hoyt S. Curtin

Meet George Jet-son,

Jane, his wife,

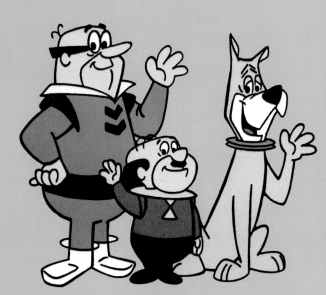

The theme song for "The Jetsons."

Left: "Astro and the Space Mutts."

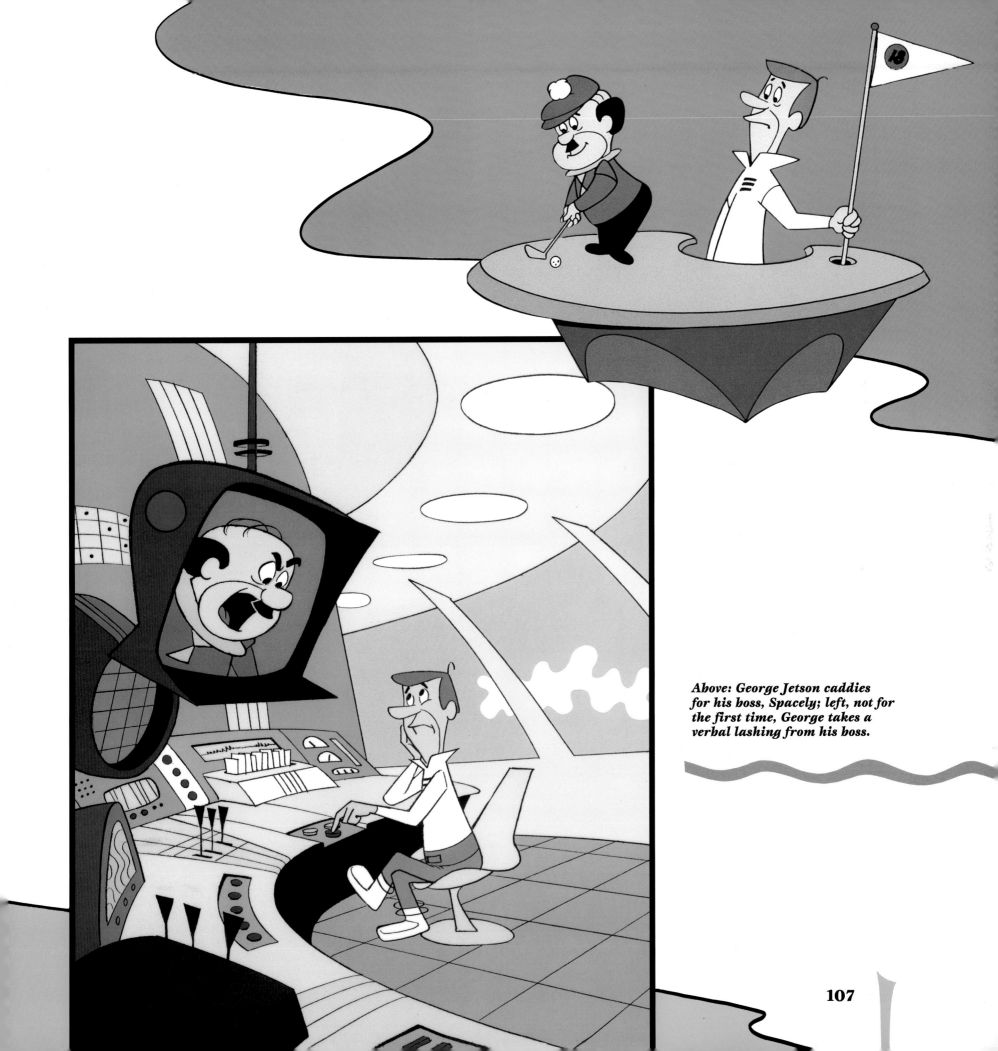

Above: George Jetson caddies for his boss, Spacely; left, not for the first time, George takes a verbal lashing from his boss.

107

George and Elroy watch Astro's television commercial.

Car," drew on the time-honored "wrong car" gambit; George inadvertently drives off with a car belonging to an escaped convict named Knuckles Nuclear, who has stashed his loot in the trunk. Naturally, George is mistaken for Knuckles, but all ends well and he becomes an unwitting hero. (At one point, he is stopped by the police for driving at 2,000 miles an hour in a 1,250-mile zone.)

Also emulating "The Flintstones," "The Jetsons" drew many of its laughs by altering familiar names and places to suit the era, in this case the twenty-first century. In one of the most amusing episodes, George and Jane take off for a vacation in Las Venus, a bustling metropolis where gambling flourishes. Staying at the Supersonic Sands, where the night club show stars Dean Martian, they enjoy the lavish

trappings and play the robot slot machines. (Other Las Venus hotels include the Sonic Sahara, the Riviera Satellite, and the Flamoongo.) Of course, George gets in trouble — at Mr. Spacely's insistence, he is obliged to take a client to dinner, and when the client turns out to be a sexy woman, George becomes unglued. A dinner conflict with Jane and the client provides much of the fun and confusion. (At one point he participates in a dance competition where the band leader is named Starence Welcome.)

Set in this futuristic universe, the episodes of "The Jetsons" maintained a fast pace that never lagged. An illusion of rapid movement was conveyed from the beginning of the series. "We had a rule about 'The Jetsons,'" Barbera remembers. "Nobody ever

Judy Jetson listens to the radio.

The Jetson entourage watches television.

walked. We used what we called 'people-movers' to propel the characters from place to place. Of course this was great for us — we had less animation to do. When George arrived and stepped on a people-mover, in a second he had Rosie the Robot waiting for him to take his coat or hat. The family dog Astro didn't have to be taken for a walk — he was just placed outside the house on a treadmill. That's how he got his exercise. The characters didn't even have to move to change their clothes — they would just stand in front of a cutout and in an instant, a new outfit would be superimposed on their bodies."

Slotted in prime time by ABC against two popular family shows, "Walt Disney's Wonderful World of Color" and "Dennis the Menace," "The Jetsons" initially met with disappointing results. (Barbera remarks, "When you have three family shows opposite each other, you're splitting your audience." Hanna adds, "We were perplexed and disappointed that it didn't do better in the ratings.") Yet, when the twenty-four episodes were repeated on Saturday mornings in the following season, the reception by young audiences was hugely favorable, and despite the moves from network to network, the program's popularity has remained unabated. In 1985 forty-one new episodes, introducing Orbitty, a tiny alien pet with spring-loaded legs and suction-cup feet, joined the original episodes in syndication, and ten more episodes were added in 1987.

Far right: George takes Astro for a twenty-first-century stroll.

Right: The Skypad apartments in Orbit City.

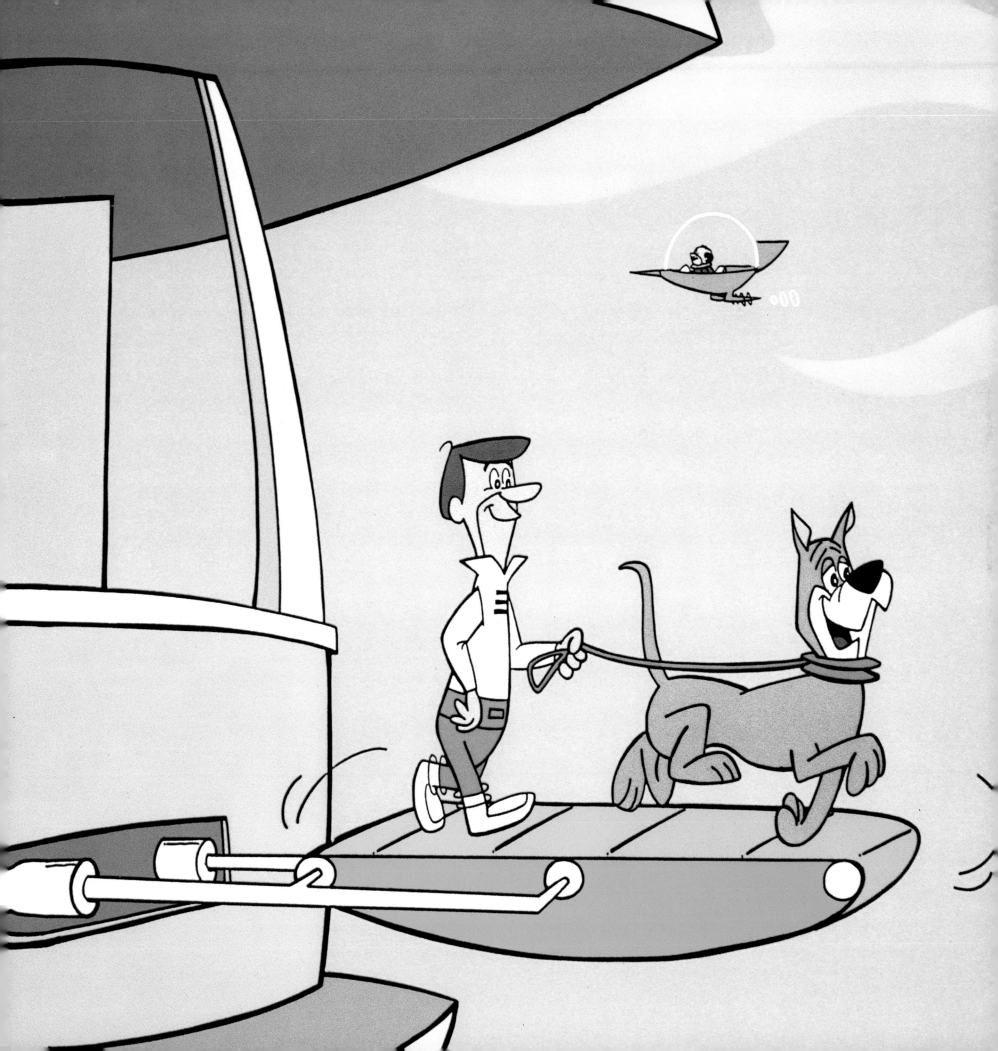

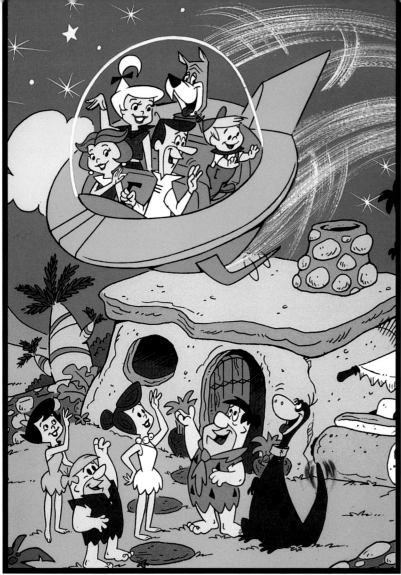

New movies, "The Flintstones Meet the Jetsons" and "Rockin' with Judy Jetson," appeared in syndication in 1987, and a live-action feature film is currently in preparation.

The new episodes continued to mine the vein of futuristic humor, plunging George Jetson into hot water while retaining the ingenious gimmickry. In "Boy George," striving to get into shape in order to compete with a new young go-getter at the factory, George goes to the Nuclear Nutrition Center, as advertised on television by Jock L. Rocket. One dose of a product called Rejuvenex and he reverts to being a boy. Complications ensue when George must behave as an adult while seeming to be a boy. (The antidote for Rejuvenex turns out to be water.) The episode "Judy's Elopement" also involved competition for George — this time with Mr. Spacely's nephew Sam. It turns out that Sam is actually more interested in eloping with the daughter of Spacely's chief rival, Cogswell, than in taking over George's job. When George comes to believe that Judy,

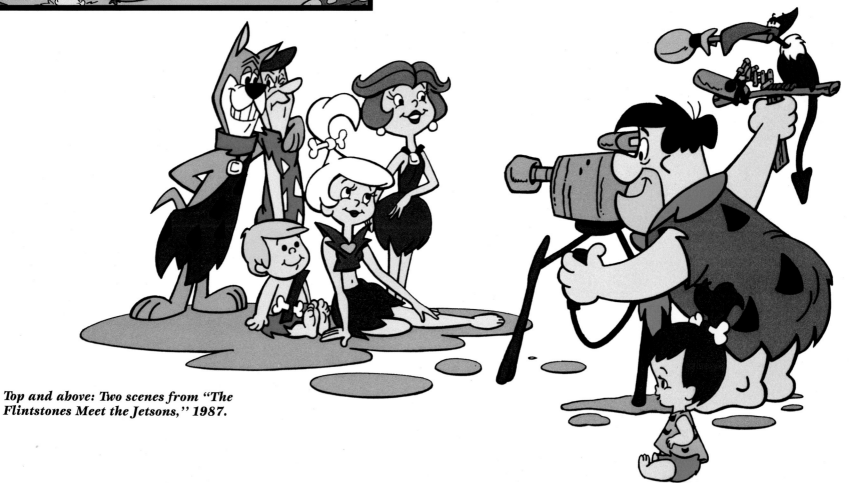

Top and above: Two scenes from "The Flintstones Meet the Jetsons," 1987.

rather than Cogswell's daughter, is the elopee, confusion reigns. In "The Century's Best," the Jetsons, attending the Galactic Expo, are chosen as the family that best represents the twenty-first century, and their life stories are placed in a time capsule for a thousand years. (This episode includes Elroy's computerized dream machine, which allows him to dial the dream of his choice — Rocket Ranger, Super Sports Star, or Jungle Hunter — when going to sleep.)

The continued enthusiasm for "The Jetsons" remains no mystery to Joe Barbera: "That show was ahead of its time. Recently, we received an article pointing out that many of the things we had in 'The Jetsons' exist today. And audiences loved the program. A survey group ran a test on the show and came back with these long rolls of paper, like a cardiogram, showing the laughs. The highest-rated laughs they had ever registered were for the program. It still is brilliantly conceived."

Astro and Orbitty asleep.

As the sixties got under way, Yogi Bear and his friends were regular visitors on television screens, and "The Flintstones" and "The Jetsons" had their loyal followings as they offered fantastic visions of the past and the future. For Hanna-Barbera Productions, the present bustled with excitement, and the decades ahead held the promise of new ventures and new ideas. It was a heady time, as a host of original animated creatures and characters poured forth from the Hanna-Barbera studios, to fill America's homes with the glorious sound of laughter.

George "exercises" with the television.

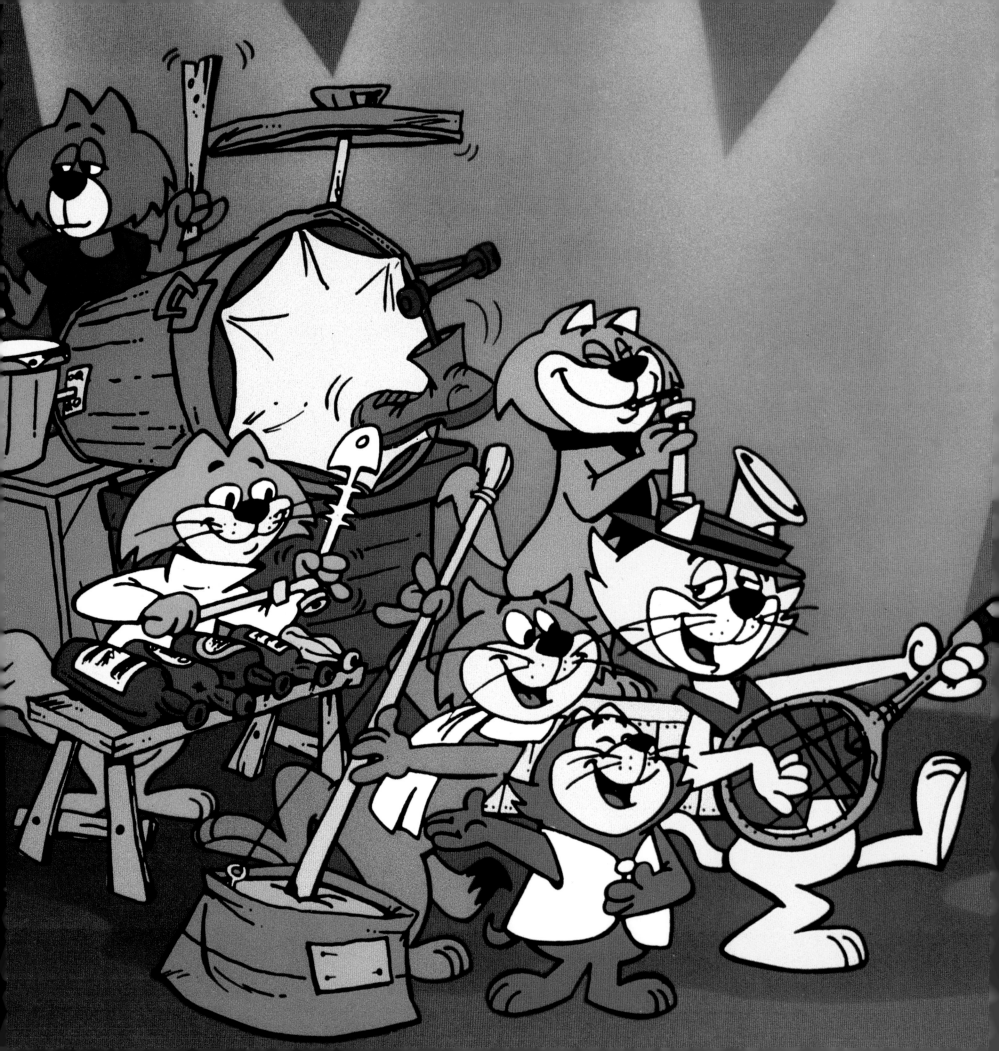

Reigning Cats and Dogs

Occasionally a new Hanna-Barbera series was inspired by a title and a single drawing. Riding high into the sixties with the success of "The Flintstones" and other top-rated shows, Hanna and Barbera continually sought fresh ideas to meet the insatiable demands of television. Barbera remembers, "One day, I happened to do just one drawing of this smart-aleck cat, and underneath the drawing was the name 'Top Cat.' He looked exactly the way he does today. Well, I walked into a meeting, laid the drawing down, and they bought it right from that drawing. Bill and I also provided a thumbnail description of Top Cat, living in an alley with his smart-aleck friends and making his way only by his wits and his instinctive ability to survive."

The irreverent and conniving "Top Cat" introduced a new setting to Hanna-Barbera's animated world. Whereas "Yogi Bear" and "Huckleberry Hound" had opted for the wide open spaces, "Top Cat" took place in the rapidly

> **When Joe and I had the freedom, and we didn't have all of the restrictions of program practices and the network rules to live by, we were able to create shows that were funnier and more sophisticated than those shows in which we had to eliminate all the slapstick.**
>
> **—Bill Hanna**

beating heart of a large city, where trash cans replaced cacti and where quick thinking was more essential than quick draws on a gun. Strongly influenced by the popular Phil Silvers army comedy show, "You'll Never Get Rich," which Barbera considered "a brilliant example of television comedy," "Top Cat" followed the raffish adventures of the enterprising T.C. and his alley cohorts as they bustled (and hustled) through the city streets. Played by veteran radio and television actor Arnold Stang, whose distinctive voice brought the right note of street-smart mockery to the role, Top Cat boasted an agile mind, a glib tongue, and a fertile imagination as he lorded it over his feline gang.[1]

Premiering on ABC in the fall of 1961, "Top Cat" immediately established characters that won audience and critical approval. In addition to T.C., the alley denizens of the Thirteenth Precinct, all with Damon Runyonesque names — included Benny the Ball (Maurice Gosfield), no

Left: The Top Cat band in "Top Cat and the Beverly Hills Cats," 1987.

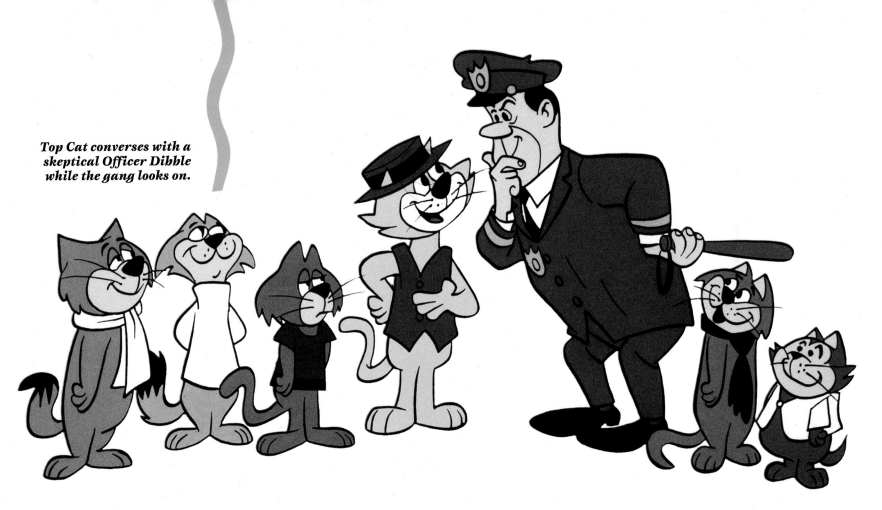

Top Cat converses with a skeptical Officer Dibble while the gang looks on.

mental giant but a valuable aide-de-camp and conscience to Top Cat — Gosfield's Private Dwayne Doberman on "You'll Never Get Rich" had been a hilarious portrait of amiable stupidity; Choo-Choo, the ever-eager errand runner voiced with the essence of New Yorkese by Marvin Kaplan; the genial but foolish "hip" cat called Spook (Leo De Lyon); the Brain (also De Lyon), whose minuscule thinking capacity belied his name; and Fancy-Fancy (John Stephenson), the ladies man whose leading fan was himself. (Today, Stephenson refers to him fondly as "the Cary Grant of Brooklyn.") Together, the gang schemed to avoid falling into the clutches or the bad graces of Officer Dibble, the cop on the beat. Dibble was voiced by Allen Jenkins, whose gallery of thugs, truck drivers, and hangers-on had been one of the constant pleasures of moviegoing in the thirties.

Down but never out, Top Cat and his pals made sure that their alley was never dreary or depressing. At the time of the show's release, Joe Barbera described their home

aptly: "T.C. has seen to it that it has all the comforts that a well-adjusted cat needs. There's a telephone on a nearby pole that's technically for police use, but T.C. doesn't let this discourage him from making free and frequent use of it. The group gets nourishment, with little effort, from bottles of milk left on neighboring doorsteps. T.C. lives in a magnificent trash can, but when bad weather makes it uncomfortable, he and the group congregate in the basement of a nearby delicatessen. Always anxious to improve their minds, the cat sextet studies the newspapers tossed on doorsteps."

In this environment, where the governing rule was to make the best of a bad situation, Top Cat was the ideal leader — street wise, sharp-tongued, and always able to come up with one more get-rich scheme. Even before the first episode was shown, Bill Hanna sensed the source of T.C.'s wide appeal: "Stray alley cats have real living problems with which viewers can easily identify. They're going to understand the gang's struggle for survival, and they're

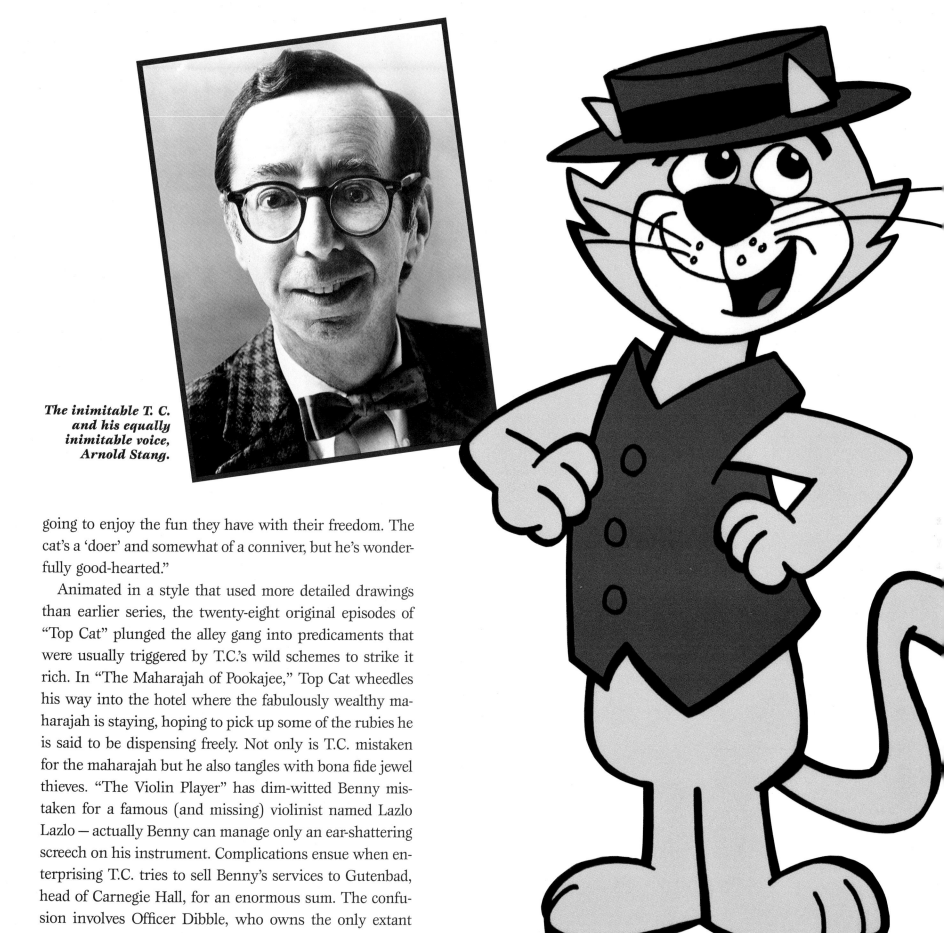

*The inimitable T. C.
and his equally
inimitable voice,
Arnold Stang.*

going to enjoy the fun they have with their freedom. The
cat's a 'doer' and somewhat of a conniver, but he's wonder-
fully good-hearted."

Animated in a style that used more detailed drawings
than earlier series, the twenty-eight original episodes of
"Top Cat" plunged the alley gang into predicaments that
were usually triggered by T.C.'s wild schemes to strike it
rich. In "The Maharajah of Pookajee," Top Cat wheedles
his way into the hotel where the fabulously wealthy ma-
harajah is staying, hoping to pick up some of the rubies he
is said to be dispensing freely. Not only is T.C. mistaken
for the maharajah but he also tangles with bona fide jewel
thieves. "The Violin Player" has dim-witted Benny mis-
taken for a famous (and missing) violinist named Lazlo
Lazlo — actually Benny can manage only an ear-shattering
screech on his instrument. Complications ensue when en-
terprising T.C. tries to sell Benny's services to Gutenbad,
head of Carnegie Hall, for an enormous sum. The confu-
sion involves Officer Dibble, who owns the only extant

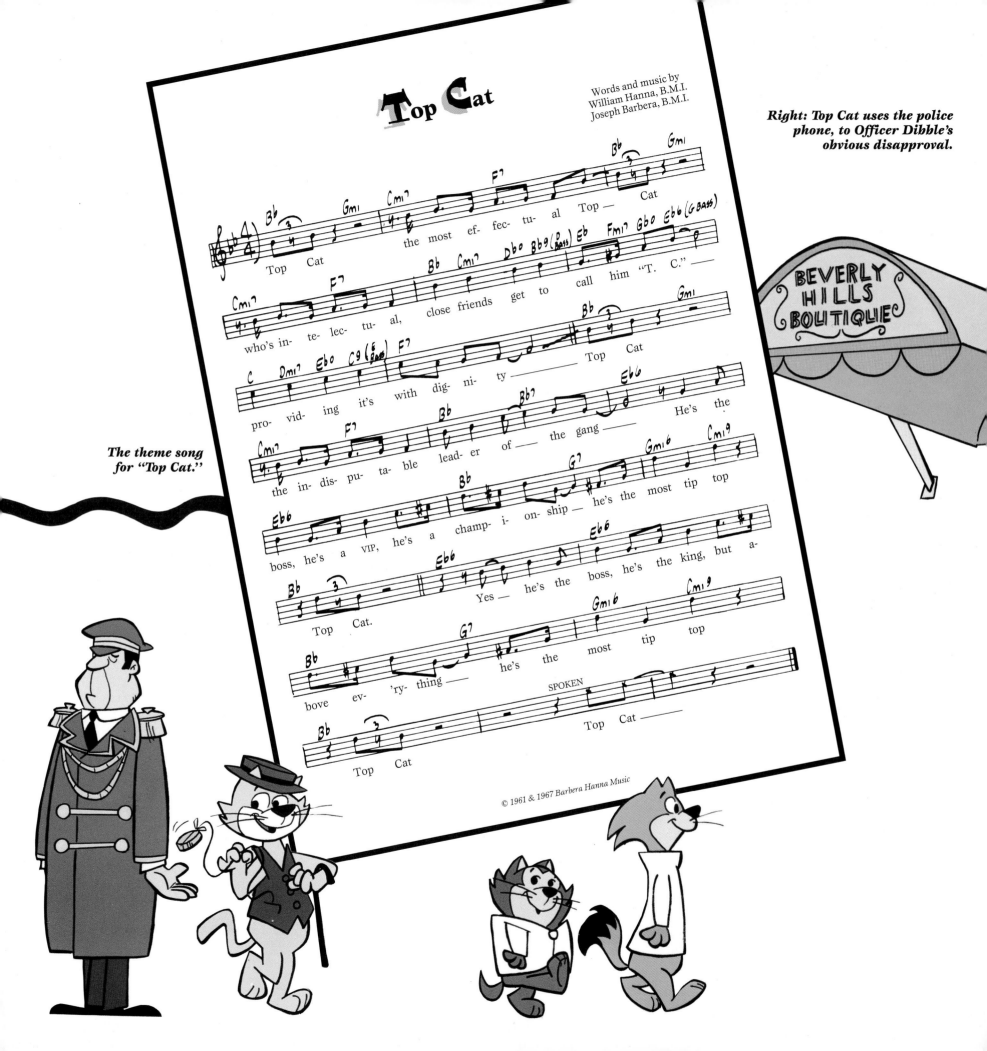

Right: Top Cat uses the police phone, to Officer Dibble's obvious disapproval.

The theme song for "Top Cat."

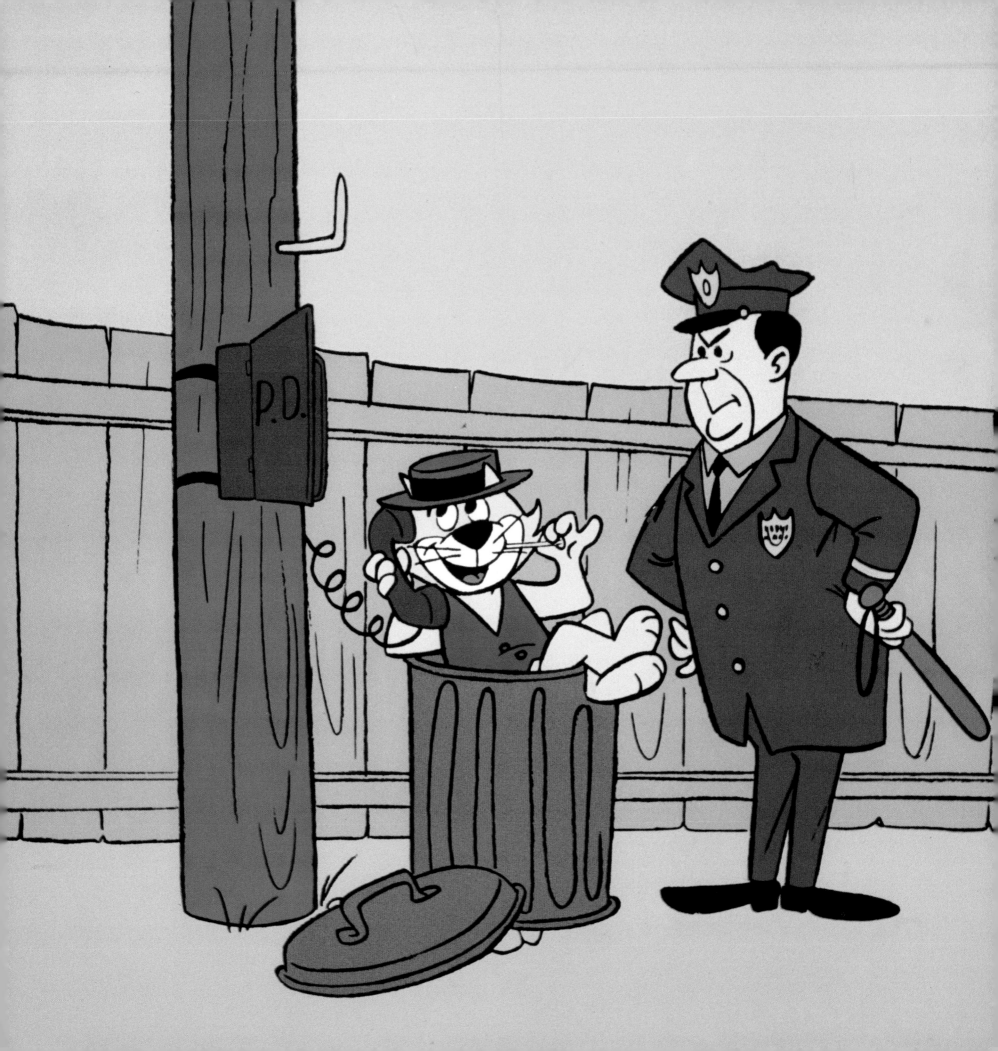

Lazlo Lazlo record, and the famous violinist himself, who turns up as a street cleaner. One of the most amusing episodes, "All That Jazz," centers on the efforts of a rakish cat named Jazz (full name All That Jazz) to take over Top Cat's alley domain. Jazz usurps T.C.'s money-making schemes, including a bingo party and a pinochle game, and even makes a play for T.C.'s girl, before being outsmarted by one of T.C.'s elaborate hoaxes.

As written by Barry Blitzer, the team of Harvey Bullock and Ray Allen, and others, the "Top Cat" series often managed a degree of sophistication that was rare in cartoon series, even among those intended for adults as well as children. Bill Hanna concurs. Today he says, " 'Top Cat' was one of the most sophisticated shows we had ever attempted. I enjoyed working on that show as much as any we've ever done." Top Cat's sly put-ons of his main target, Officer Dibble, were pitched at a higher level than the usual dialogue that served only to propel the story. In

T. C. in the television special "Top Cat and the Beverly Hills Cats," 1987.

"The Maharajah of Pookajee," for example, T.C. pretends to admire Dibble's many strong qualities: "I like the image you portray . . . incorruptible virtue . . . the picture of a true guardian of the people. . . . If they don't give you a promotion soon, the least they can give you is an Academy Award, Dibble. But they won't. You know why? Because they're jealous. Gregory Peck should be grateful that you have chosen the profession of civil servant instead of acting. Why, he'd be starving! Starving!"

Throughout the series T.C. exhorts his scruffy flock of felines or his unwitting victims with a barrage of words that suggest a mixture of Groucho Marx, Phil Silvers's Sergeant Bilko, and the M.C. at an old Catskills resort hotel. Shocked when he sees that his rival Jazz has cleaned up his beloved alley, T.C. exclaims, "The joint is a mess! It looks like a hospital!" When he is told that the "camel" he had shipped from Australia actually looks like a horse, he quips, "Two months on a boat. Who wouldn't?" Confronted by a moronic jewel thief, T.C. doesn't flinch for a second as he flatters the hapless man: "This is like the Peter Pistol program. That steely glint in your eyes! That strong jaw! You *are* Peter Pistol! You're joking. You *must* be Peter Pistol!"

Over the years Top Cat has continued to go his inimitably scheming way. As Arnold Stang points out, "I've done 'Top Cat' commercials for years — even whole campaigns. Would you believe he was the spokesman for the Royal Bank of Scotland? And for the last few years, T.C. has been a running character on 'The Funtastic World of Hanna-Barbera.' He's especially popular in England, where they have stores that sell 'Top Cat' memorabilia, including mugs, T-shirts, and hats. They call him 'Boss Cat' over there." Most recently Top Cat and his pals have been up to their old tricks in a television special called "Top Cat and the Beverly Hills Cats" (1987), in which Benny the Ball inherits the estate of an eccentric old woman and then joins with his alley friends in keeping it out of the hands of her scheming butler.

*The endlessly resourceful
Wally Gator.*

As a resourceful feline forever seeking the "main chance," Top Cat clearly follows in the paw prints of master con artist Yogi Bear, with only a street-smart cunning added to help him survive in the city jungle. However, other cartoon characters who emerged from Hanna-Barbera in the early sixties either continued the "Huckleberry Hound"–"Quick Draw" tradition of the amiable but dim-witted hero with a sidekick, or inaugurated traditions of their own. *The Hanna-Barbera New Cartoon Series*, a package of three different cartoons that premiered in the syndicated children's market a year after "Top Cat" (1962), offered characters from all sides of the spectrum.

The most durable of the three characters in this series proved to be Wally Gator, "a swinging alligator from the swamp" (as the theme song told us), who refused to be confined to his home in the zoo. To the endless chagrin of the zookeeper, Mr. Twiddles (Don Messick), the debonair and imperturbable Wally continually broke loose to enjoy

adventures in the outside world. Typically, in "California or Bust," he escapes by taking the place of a penguin being shipped to the San Diego Zoo, then finds himself in the middle of the Mojave Desert being pursued by a gun-totin' old westerner. "Ice Cube Boob" has Wally jumping into a freight truck bound for Paris, only to be dumped unceremoniously at the North Pole, where he tangles with a polar bear and a prehistoric ice age monster come to life. Wally, of course, is returned to Mr. Twiddles and the zoo. Sometimes the alligator had to cope with especially formidable obstacles, as in "The Escape Artist," where he tries and fails to outsmart a fierce schnauzer hired by Twiddles as a guard dog. (Nothing works, not hypnosis, or warm milk to make the dog sleepy, or pole-vaulting over the fence.) Voiced by Daws Butler in the style and inflections of comedian Ed Wynn, Wally Gator was one of Hanna-Barbera's most endearing creations of the period.

Other components of *The Hanna-Barbera New Cartoon*

Series echoed past successes and also had their share of cleverly wrought characters and situations. "Lippy the Lion," voiced by Daws Butler in a style suggesting the genial, wide-mouthed movie comedian Joe E. Brown, involved the constantly bragging con artist and his lugubrious hyena sidekick Hardy Har Har (Mel Blanc) in slapstick jungle adventures. The pun-riddled titles of the episodes included "Banks for Everything," "Horse and Waggin," "Witch Crafty," and "Legion Heirs." "Touché Turtle," the third component in the series, followed the well-established pattern of pitting a well-meaning but simple-minded champion of justice against a string of adversaries. Sounding very much like Droopy, the tiny basset hound he had created for Tex Avery's MGM series, actor Bill Thompson played Touché Turtle, an inept swashbuckler whose motto is "Hero work done cheap, all credit cards accepted." Helped by the slow-moving dog Dum Dum (Alan Reed), the turtle brandished his sword to the cry of "Touché and away!" in such tales as "Black Is the Knight," "Aladdin's Lampoon," and "Red Riding Hoodlum."

In 1964 Hanna and Barbera were ready to add another legendary character to their cartoon menagerie, but this time the character was even further removed from the traditional dog and cat than the "swingin' alligator from the swamp." Their latest animated hero wore a multi-colored derby,

Touché Turtle and Dum Dum.

green suspenders, and red shorts. Amiable and cheerful, although not exactly overburdened with gray matter, he resided in a pet shop owned by Mr. Peebles. He also happened to be a gorilla named Magilla.

The gorilla made his entrance into syndicated television in January 1964, as the centerpiece of a three-segment cartoon program called "The Magilla Gorilla Show." The premise was simple but highly workable: forever on display in the pet shop window, the ungainly Magilla (voiced by Allan Melvin, the seasoned actor best remembered for his character of Barney Hefner in "All in the Family" and "Archie Bunker's Place") could never find a permanent home. His only friend was the little neighborhood girl called Ogee (Jean Vander Pyl). The gorilla's life, however, was not without adventure. Stumbling into all sorts of fantastic incidents that took him far away from Peebles (Howard Morris) and the pet shop, or used by temporary masters with nefarious schemes, Magilla remained his amiable, imperturbable, and fun-loving self through every mad encounter.

Magilla's adventures often took him as far afield as a gorilla could go. In "Beau Jest," he finds himself in the

Lippy the Lion and his sidekick Hardy Har Har.

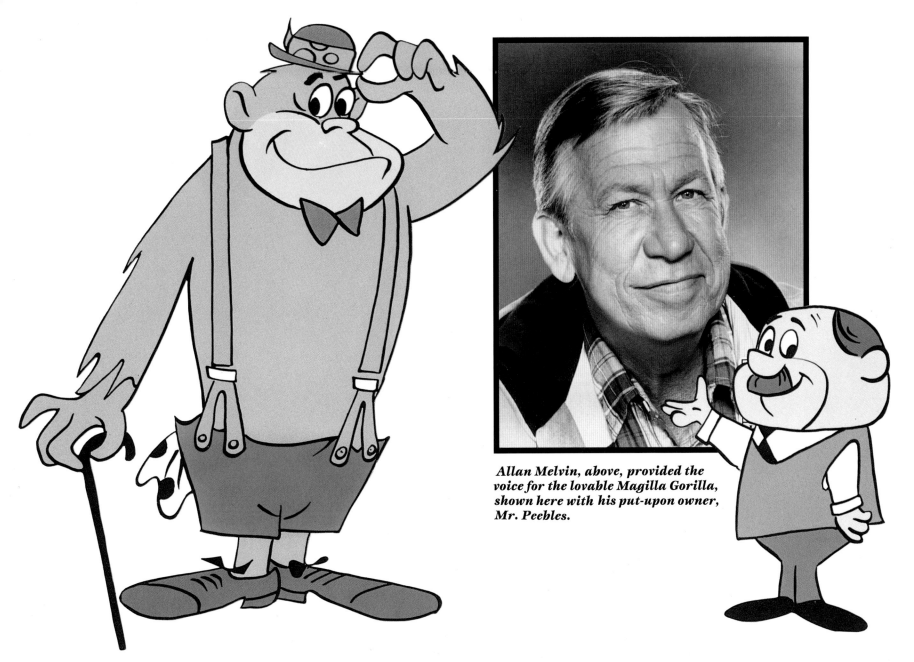

Allan Melvin, above, provided the voice for the lovable Magilla Gorilla, shown here with his put-upon owner, Mr. Peebles.

French Foreign Legion ("To think that the Furry Legion has gone ape!"), where he survives all sorts of tribulations, including a whirling sandstorm, in order to capture the villainous Abu Ben Hakim. In "Private Magilla," he is drafted by mistake into America's own army and sent to Camp Killkare, where he endures all the rugged training. ("Just what we need for guerrilla warfare," somebody remarks.) Somehow Magilla is chosen to make a moon shot, but he ends up parachuting back into Peebles's Pet Shop. More than once Magilla finds himself behind the wheel of an out-of-control vehicle. In "Wheelin' and Dealin'," he goes for a wild ride on the freeway with the police in hot pursuit. Soon he is driving in the wrong direction, careening through a car wash, and even moving under water — until he crashes into a police station. "High Fly Guy" has him flying a plane onto the set of Colossal Pictures' airborne epic, *Return of the Son of the Hero of Eagle Squadron*, where he causes chaos. Unable to land the plane, he flies through a control tower and into the toys section of a department store. As usual, he returns home to Mr. Peebles, who is secretly glad to have him back. Throughout every ordeal, Magilla remains a delightful creation, modest ("Somebody wants little old me?"), affectionate, and forever hopeful.

The second component of "The Magilla Gorilla Show" returned Hanna-Barbera to the Wild West setting of Quick Draw McGraw. "Ricochet Rabbit" (Don Messick) was a tenacious sheriff whose distinguishing characteristic was his ability to move at lightning speed. Ricocheting from one adversary to another to the cry of "ping, ping, ping," he is able to nab the desperadoes in such episodes as "Annie Hoaxley," "Itchy-Finger Gunslinger," "Cactus Ruckus," and "Big Town Show Down." Inevitably, Ricochet had to contend with a slow-moving deputy called Droop-a-Long (Mel Blanc).

The third component of the show focused on animal characters who were decidedly off the beaten track. Set at Camp Frostbite, an Alaskan army base, "Breezly and Sneezly" involved a foolish polar bear named Breezly (Howard Morris) and a more sober-minded arctic seal called Sneezly (Mel Blanc) who spent most of their time trying to infiltrate the camp, either to join the service or to cadge a decent meal. Their principal adversary was the camp commander, Colonel Fusby (John Stephenson), whose voice resembled that of Paul Ford, the blustery Colonel Hall in the Phil Silvers army comedy "You'll Never Get Rich." Breezly and Sneezly's efforts led them to adopting various guises in such episodes as "Furry Furlough," "Stars and Gripes," and "Noodnik of the North." In the fall of 1964 Hanna-Barbera replaced "Breezly and Sneezly" as one of the program's components with a new series called "Punkin Puss," in which a hillbilly cat (Allan Melvin) engaged in a nonstop feud with a rodent called Mush Mouse (Howard Morris) in a brash slapstick version of "The Hatfields and the McCoys."

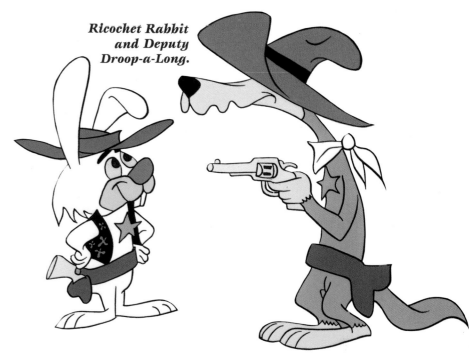

Ricochet Rabbit and Deputy Droop-a-Long.

The 1965 television season brought a new kind of character to Hanna-Barbera's animated menagerie. The resourceful, amiable con animals such as Yogi Bear, Top Cat, and Wally Gator were joined by creatures with much more urgent business on their minds than filching picnic baskets or outwitting the police. In a tradition that extended from the schoolboy pluckiness of Frank Merriwell and Tom Swift through the high-flying heroics of Superman to the spectacular adventures of superagent James Bond, the new characters on the block, called Atom Ant and Secret Squirrel, were concerned with such cosmic matters as saving the world from the doom plotted by nefarious villains. Yet Hanna and Barbera were not quite ready to take such matters seriously on a regular basis, and "The Atom Ant/Secret Squirrel Show," which premiered in October 1965 on ABC, adopted their characteristically tongue-in-cheek approach to the subject of superheroism. In an unusual format for cartoon programming, the hour-long show consisted of one episode apiece of "Atom Ant" and "Secret Squirrel," with each episode accompanied by two supporting series to fill the time slot.

A sly parody of the invincible superhero, "Atom Ant" stemmed from an idea that has never failed to appeal to animators: that of presenting the tiny ant as amazingly

Left: Magilla tries out a skateboard.

Atom Ant, the world's smallest superhero.

("Crankenshaft's Monster") or opposing a karate ant named Mr. Mooto ("Atom Ant Meets Karate Ant"), the small but mighty ant carried out his assignments with aplomb and a ready quip. (Capturing an escaped convict named Big Fats Domino in the episode "Up and Atom," our hero snaps, "It took an ant to make Big Fats say uncle!")[2] A recurring villain in the series was Ferocious Flea, who claimed to surpass Atom Ant as the world's strongest insect. The flea is used by various crooks to rob banks or, in "How Now Bow Wow," to steal a prize-winning dog, but Atom Ant perseveres and wins the day. In "Nobody's Fool," he even survives the seductive wiles of Anastasia Antnik, who tries to distract him while her crooks rob the Treasury Building.

The two series accompanying "Atom Ant" in its time period also had brashly funny aspects that set them apart from the merely "cute" animation intended for the youngest viewers. In "Precious Pupp" the focus was on a small dog, seemingly the essence of canine devotion and lovability, who lived with dear old Granny Sweet (Janet Waldo), the picture of old-fashioned benevolence. Looks, however, are deceiving. Precious Pupp, played by Don Messick with the inimitably wicked snicker he had perfected in other series, was actually a clever, mischievous dog who enjoyed wild adventures away from the house at 711 Pismo Place.[3] After demolishing his opponents with chortling glee, Precious would return to take his place as the soul of innocence. Granny herself was no apple-cheeked senior citizen but a feisty old biddy who loved to ride her motorcycle and go bowling.

A number of very funny episodes were constructed around this premise. In "Precious Jewels," the canny canine is asked to guard Granny's jewels while she goes out. A luckless burglar encounters the madly snickering Precious, who shortly has him falling down the cellar stairs, careening around the house on a single roller skate, and sitting on a hot stove. The burglar finally turns himself in

strong. (A cartoon would show a piano seemingly moving of its own free will, then move down to a close shot of a little ant holding it up with one hand.) As conceived by Hanna-Barbera, Atom Ant was the tiniest but most relentless defender of law and order on television. Endowed with superpower by a pair of atomized eyeglasses, he left his secret laboratory deep beneath the earth's surface to answer urgent cries for help or to solve cases too tough for the police. Armed with his *Crook Book*, which gave him the modus operandi of the world's villains, he would move into action with the ringing cry of "Up and at 'em, Atom Ant!" Whereas previous Hanna-Barbera characters stumbled into madcap adventures laced with slapstick action, the little ant was called on for continual acts of derring-do against a formidable array of evildoers.

Voiced first by Howard Morris and then by Don Messick, Atom Ant never faltered in his determination, whatever the odds. Whether battling the proverbial mad doctor who creates a bank-robbing monster called the Glob

The Hillbilly Bears whip up some backwoods music.

to the police. "Poodle Pandemonium," which matches some of the "Tom and Jerry" cartoons in inventive slapstick, has Precious and a vicious neighborhood bulldog in heated contention over a flirtatious French poodle. When the suitors grapple over a dropped handkerchief, Precious generously gives the bulldog first choice at picking it up, deftly managing to substitute a lighted firecracker for the handkerchief. The poodle finally chooses the bulldog, although in most episodes Precious is the gleefully cackling winner. On a number of occasions ("Bites and Gripes," "Doggone Dognapper") he escapes from dognappers simply by being his own irascible, sneaky self, although he always remembers to slather the duped Granny Sweet with fervent kisses.

The other series accompanying "Atom Ant" veered into the realm of pure farce, with often uproarious results. In the broad style reminiscent of Al Capp's legendary comic strip "Li'l Abner," "The Hillbilly Bears" concerned a backwoods family of bears called the Ruggs, headed by shiftless Paw (Henry Corden), who spent a good part of the time simply muttering under his breath. Maw (Jean Vander Pyl) was the matriarch, offering continual side comments on Paw's laziness ("He's harder to get up than a three-legged mule!"). Floral (also Jean Vander Pyl) and Shag (Don Messick) were their offspring. Much of the humor depended, on Paw's occasionally rousing himself from his stupor to do battle with intrusions from man or nature.

Like many a cartoon character before him, Paw Rugg finds the cards stacked against him. The entire episode of "Woodpecked" revolves around Paw's relentless but futile efforts to eradicate a pesky woodpecker—he even disguises himself as a tree. In utter desperation, he uses a flirtatious female woodpecker to distract his prey, only to have the happy couple return with their offspring and proceed to demolish the house! In "Anglers Aweigh" Paw insists on grappling with a dangerous catfish called Ol' Whiskers, then gets caught in every trap he devises. He finally ends up fighting him with boxing gloves in the water. Other episodes involved Paw's ongoing feud with the Hoppers, and especially his hatred of Floral's suitor Clod Hopper. In "Picnic Panicked," Paw persists in firing at Clod at the town picnic, but as usual he ends up more the victim than the victimizer. When he nearly drowns, Maw scolds him: "If I told you once, I told you a hundred times. Don't go near the water. 'Cause you float like a bucket of mud!"

"Secret Squirrel," featured in the second part of "The Atom Ant/Secret Squirrel Show," was unmistakably inspired by Ian Fleming's superagent James Bond and his dashing heroics. Like Atom Ant, Secret Squirrel (also known as Agent Zero-Zero-Zero) devoted himself to routing the forces of evil, but this furry hero stayed firmly rooted to earth. Dressed traditionally in a trench coat and a fedora, with eyes cut out of the brim, Secret (voiced by Mel Blanc) worked for the International Sneaky Service, headed by a man known only as Double Q. He was partnered with Morocco Mole (Paul Frees), a fez-wearing rodent with a voice that matched the oily, insinuating tones of actor Peter Lorre. Often given to remarks such as "I'll wait good. Like a faithful friend should," Morocco Mole assisted Secret Squirrel in destroying the villains who usually had such grandiose schemes as conquering the immediate world. A frequent bad guy called Yellow Pinkie (modeled on James Bond's archenemy, Goldfinger) had the girth and voice of portly actor Sydney Greenstreet.

Secret Squirrel.

Although the dauntless squirrel may have lacked Bond's debonair ways, he emulated Fleming's hero in his fondness for hi-tech devices that could assault or evade the enemy. His devices, however, were as funny as they were effective: a comic spoof of this sort of Bondian folderol. In "Masked Granny," in which a diabolical old lady with laser-beam knitting needles steals a secret bomber, Secret

Squirrel uses his Anti-Blowout Button to keep his car on the road, and when Granny unleashes her deadly Masked Mosquito, Secret retaliates with his Skeeter-Beater. In "Robin Hood and the Merry Muggs," when a gang of thieves in Robin Hood garb steals a million dollars, the squirrel relies on his Super-Atomic Neutralizer Bazooka to capture them.

Much of the fun in "Secret Squirrel" came from the frequent off-the-wall humor that surfaced in many episodes. In one of the most diverting segments, entitled "Wolf in Cheap Cheap Clothing," Secret takes on a tough-talking, sheep-smuggling wolf by using what he calls his

Red Riding Hood Trap. He dresses Mole as Red Riding Hood, creates an Instant Grandma Cottage by adding water to a dehydrated house, and disguises himself as Grandma. The wolf is not impressed. "What an ugly kid!" he remarks as he gazes at Mole in drag, adding, "They're sure not making Little Red Riding Hoods like they used to!" "Grandma" also gets the back of his paw: "This old crow is even homelier than her granddaughter!" When the cottage shrinks back to its original small size, Secret only has to deliver it to the police, with the wolf inside.

The two component series accompanying "Secret Squirrel" covered familiar territory. In the tradition of "Wally

*Furry superagent Secret Squirrel battled evil
with the help of his partner, Morocco Mole.*

Winsome Witch.

Squiddly Diddly, the star-struck octopus, becomes a one-man band.

Gator" and "Magilla Gorilla," Squiddly Diddly, a squid at an aquatic amusement park, constantly sought — and found — adventure outside his narrow little world. To the annoyance of Chief Winchley (John Stephenson), the star-struck Squiddly (Paul Frees) kept escaping from the park to take on a succession of new occupations, from clown to astronaut, in the hope of finding fame. The other series linked with "Secret Squirrel," entitled "Winsome Witch," involved a good-natured sorceress (Jean Vander Pyl) who helped people in distress without resorting to the usual witchlike ways. Winnie starred in such episodes as "Have Broom, Will Travel," "Schoolteacher Winnie," and "Wolf-craft Versus Witchcraft."

For Hanna and Barbera these programs were a joy to create, and the laughter they generated from viewers was a happy reward. By that time they had also earned a significant place in the field of animation by demonstrating that it was possible to turn out weekly series for television in which the wit, charm, and originality of the characters compensated amply for any necessary loss in animated detail. Their animated menagerie and Stone Age suburbanites had become welcome guests in American homes. Yet there were new challenges to face in the next few years, challenges that would take them far from mischievous cats and dogs and cunning cavemen to a new world of fantasy and adventure.

The Superheroes

6

At the same time that Atom Ant and Secret Squirrel were carrying out their own brand of tongue-in-cheek heroics, Planet Earth was experiencing a true-life adventure in which fantasy suddenly took on an astonishing reality. Since the late fifties and the first moon probes, scientists had begun to take giant strides toward realizing the centuries-old dream of exploring outer space. By the mid-sixties, despite failures and miscalculations, unmanned rockets had orbited close enough to the moon to take remarkable photographs. The public's imagination had been fired not only by the possibility of discovering new worlds beyond our own but also by the chance of coming upon new and extraordinary life forms in the vast stretches of space "out there." Science fiction began to seem more like science and less like fiction.

Each decade brings its own breed of true-life heroes, and as interest in actual space exploration heightened in the sixties, the new heroes appeared to be the pioneering men who had conquered space. While astronauts like Gor-

> **A**s kids, Bill and I had always loved the big heroic figures like Frank Merriwell and Tom Swift. Now it was our turn to create our own.
>
> **—Joe Barbera**

don Cooper, Alan Shepard, and John Glenn won public adulation, comic-book artists were using the remarkable advances in technology to create fantasy space heroes of their own. Reconstructed and vastly improved versions of Buck Rogers, Flash Gordon, and other futuristic heroes of the thirties began to find their way out of comic-book pages and into television. For Hanna and Barbera it was a new direction, a considerable distance from the lovable bears, dogs, cats, and mice that had dominated their work from the beginning.

Their first venture into the world of superheroes came in the fall of 1964 with the launching of "The Adventures of Jonny Quest" on Friday evenings over ABC. In a series of adventures mixing fantasy and science, the program focused on a quartet of characters who were constantly called on to unravel baffling mysteries and who, in the course of their investigations, were required to do battle with an assortment of bizarre villains. Heading the group was Dr. Benton Quest (voiced by John Stephenson in the

Left: The Fantastic Four set out on a mission.

133

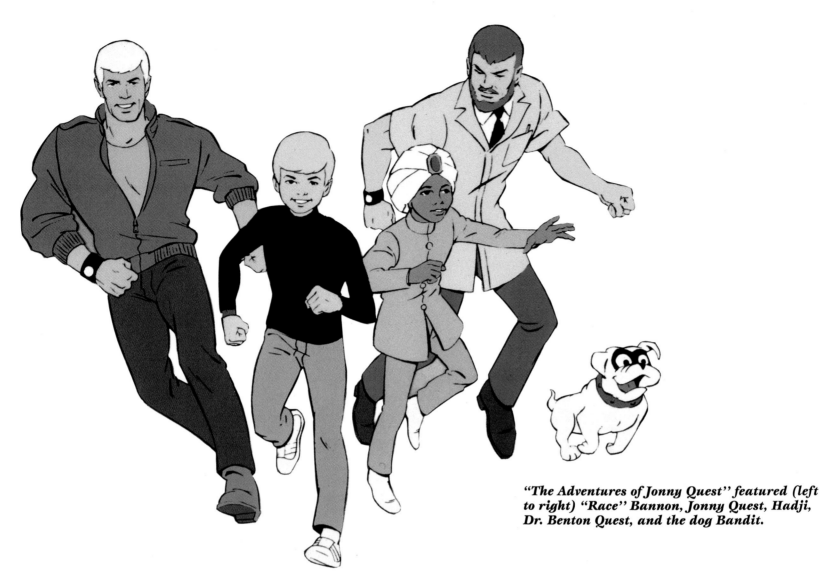

"The Adventures of Jonny Quest" featured (left to right) "Race" Bannon, Jonny Quest, Hadji, Dr. Benton Quest, and the dog Bandit.

first season and then by Don Messick), a bearded scientist usually working on secret experiments. For security reasons his spunky, tow-headed son, Jonny (Tim Matthieson), was guarded at all times by a handsome, rugged pilot named Roger ("Race") Bannon (Mike Road), who served as Jonny's "tutor, companion, and all-around watchdog." Completing the heroic group were Jonny's turbaned young East Indian friend Hadji (Danny Bravo) and a feisty black-eyed bulldog called Bandit. (Don Messick provided the barking.) Each episode contained some scientific or educational data, explained by Dr. Quest.[1]

Joe Barbera recalls the origins of "Jonny Quest": "It had always been one of my long-standing dreams to do an action-adventure series. We tossed around a lot of ideas at the time. Actually, the inspiration for the series was 'Terry

and the Pirates,' the longtime popular comic strip by Milton Caniff.[2] I had always liked and admired this strip which had a blonde, a good-looking hero like Race Bannon, and an adventurous young kid like Jonny Quest. They also operated all over the world, taking on exotic villains like the Dragon Lady. You could say that 'Terry and the Pirates' even influenced the artwork for 'Jonny Quest.' In fact, if you want to see a technique that's reminiscent of 'Jonny Quest,' just look at any strip of 'Terry and the Pirates,' at how the shadows are done and the way the characters are drawn."

Once the concept had been decided on, noted comic-book artist Doug Wildey was called on to design all the features for the show. Influenced by material he had read in such magazines as *Popular Mechanics* and *Scientific*

Right: Jonny Quest and his friend Hadji speed to the rescue, with Bandit in tow.

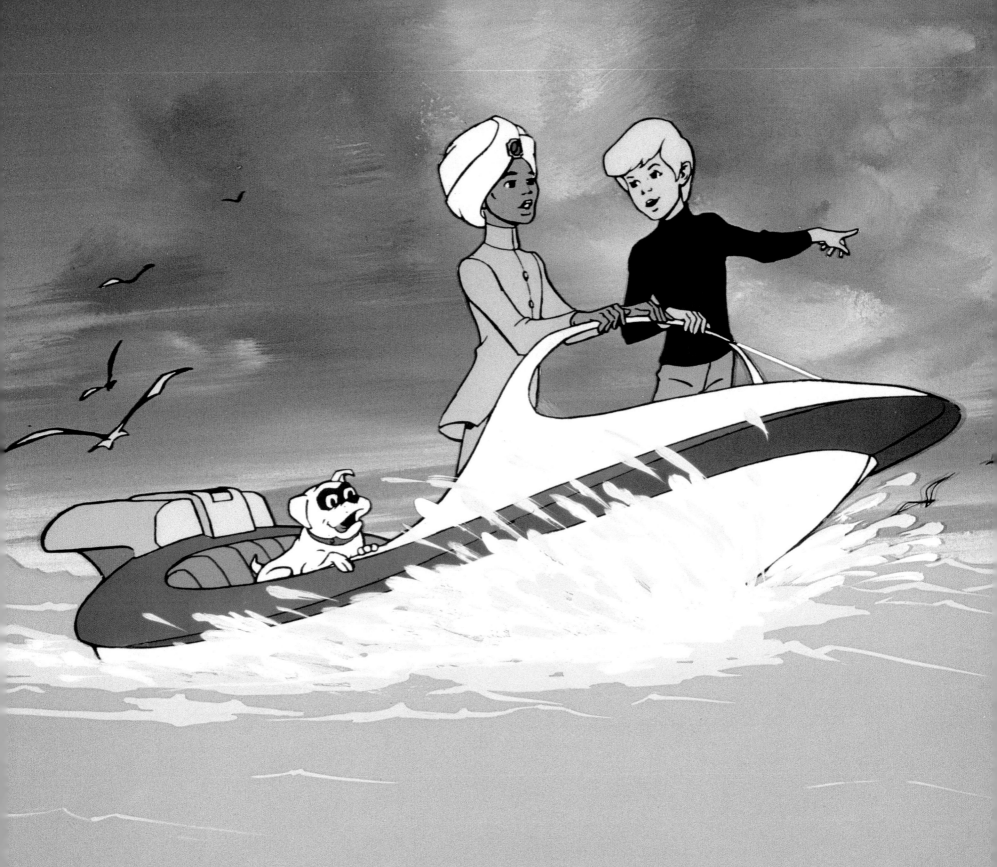

American, Wildey created the character models, the hardware, and the special ambience which gave "Jonny Quest" its air of authenticity. (He also provided the premises for many of the episodes.) Working long and arduous hours, Wildey joined with Hanna and Barbera to prepare and polish the short film that was used to sell the series. When the film was shown, according to Barbera, "it blew everyone out of the theater. It was a big departure for its day."

Today Doug Wildey remembers the beginnings of some of the popular characters: "Joe Barbera wanted to add a dog to the show, probably because the company was heavily into the licensing of characters for toys, and the dog could be a salable addition. So we added Bandit. I tried a lot of exotic animals, particularly a monkey, but I was overruled. Then we realized that we would be doing a show in which the young hero would have to talk to his dog. So we thought up another character, a young fellow with a magical, mysterious background. In this way, the kids would be talking to each other, and the audience could accept something like that. We added the character of Hadji, who was loosely modeled on the Indian actor Sabu."

With the characters in place, "The Adventures of Jonny Quest" made its debut with an episode entitled "The Mystery of the Lizard Men." Typically, the story line begins with an unexplained mystery: the sudden disappearance of ships in the Sargasso Sea, and moves to the adventures of Jonny and his friends as they try to unravel it. With the help of a futuristic computer called the Unitized Neutronic Information Center, Dr. Quest discovers that a power-hungry scientist, with the aid of an army of bizarre green "lizard men," has been destroying the ships with his laser gun and is now plotting his "final and most spectacular" experiment: shooting down the first space rocket headed for the moon. Jonny, Race, and Bandit are captured but manage to escape, and after a wild chase through the Sargasso Sea, Dr. Quest succeeds in destroying the mad scientist's ship before it can blow up the space rocket. (The "lizard men" turn out to be ordinary men in grotesque costumes designed to frighten their adversaries.)

Another typical episode, "The Curse of Anubis," involved the group in an Egyptian adventure. Here Dr. Quest is summoned to Egypt by his friend Dr. Karim, who claims to have made an amazing archaeological discovery. In truth Dr. Karim is a treacherous schemer who has stolen the sacred statue of Anubis. He plots to accuse "foreigners" Dr. Quest and Race of stealing the statue and thus unite the angry Arab nations under his leadership. Of course he fails to count on the youthful bravado of Jonny and Hadji, who finally succeed in rescuing Dr. Quest and Race from the catacombs. He also fails to acknowledge the "curse" of Anubis, through which a mummy emerges from its casket to exact revenge on whoever purloins the statue of Anubis. In the end, the ceiling of the catacombs collapses on Dr. Karim and the mummy, while the group escapes. Along the way to a happy conclusion, they have to deal with murderous thugs, poisonous adders, and a deadly scorpion.

Although not fully animated, "The Adventures of Jonny Quest" conveyed the illusion of full animation by using a large number of strikingly realistic drawings. Many of the episodes called for special effects that could not be rendered in the expedient shortcut style of limited animation. The climax of "The Mystery of the Lizard Men," for ex-

Above: Jonny Quest.

ample, draws its excitement from the rapid juxtaposition of vivid details: the churning water as Jonny and Race hurtle through the sea in their hydrofoil, with the lizard men in pursuit; the sea in flames as Race boldly drives the hydrofoil at top speed directly into the lizard men's boat, causing it to overturn, and the fierce explosion that demolishes the villain's home ship when Dr. Quest uses a mirror to divert a deadly laser ray back to its source. Animator Irven Spence, who worked on many episodes, remarks, "You can't cheat on these effects. You've got to make them full."

Space Ghost, with his friends Jayce and Jan and their pet monkey, Blip.

In the fall of 1966 Hanna and Barbera entered full throttle into the superhero genre. The surge of hard-action animated adventure series was actually inaugurated by Fred Silverman, the head of Daytime Programming for CBS. As someone who had always enjoyed Superman and his heroic ilk, and who also noted the excitement surrounding space exploration, Silverman was certain that the time was ripe for creating a new cycle of superheroes who would triumph over evil as they soared into a new era. Today Silverman says, "Everything up to that point was kind of soft. It was either live action or it was lots of little animals running around. This was a departure. I guess I projected what I liked into a brand-new schedule, what you might call a 'superhero morning.' " He turned to Hanna-Barbera and other animation studios for new concepts and ideas.

Hanna and Barbera were eager to move into this area but at first there was some difficulty. Ken Spears, who, with his partner Joe Ruby, wrote many of the stories in the superhero cycle and who later played a major role in conceiving "Scooby-Doo" and other shows, recalls the main problem: "Hanna and Barbera called us in and showed us a few of the series they were working on. They were having problems because until then they had worked only on funny cartoons, and the staff writers didn't grasp the action adventure, science fiction type of show. So Joe and Bill explained the series to us and we went out of there with two or three approved ideas. We wrote the first two scripts on spec and we delivered them under a mat at Joe's house. They were shipped to CBS, who thought they were terrific. From then on we wrote many of the scripts for the superhero series."

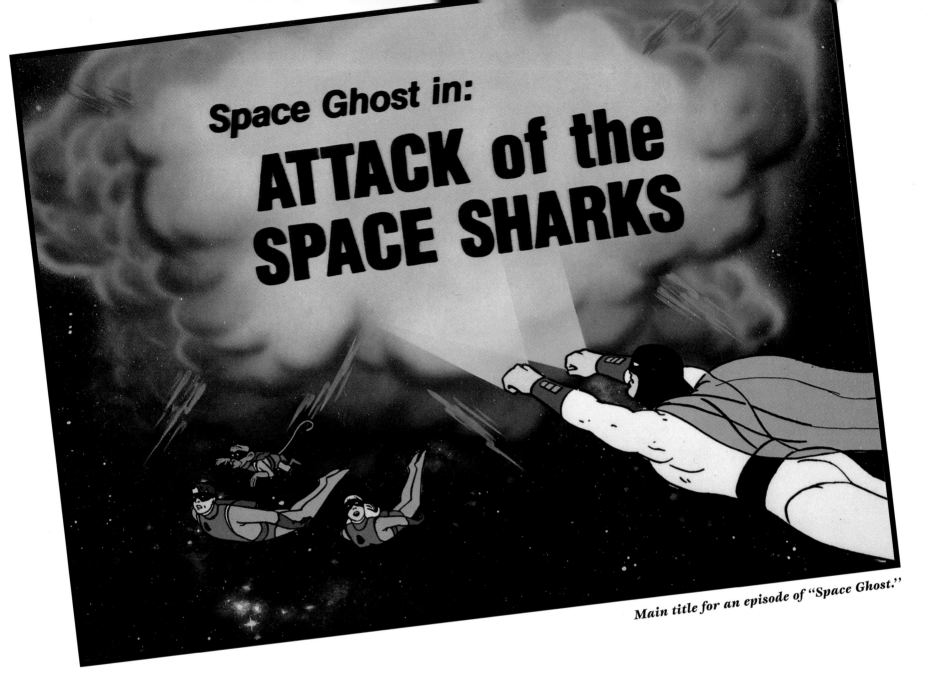

Space Ghost in:

ATTACK of the SPACE SHARKS

Main title for an episode of "Space Ghost."

The first series, "The Space Ghost and Dino Boy" (CBS, 1966), proved to be among the most popular. Designed by Alex Toth, a leading comic-book artist greatly admired by Hanna and Barbera, "The Space Ghost" centered on a black-hooded, yellow-caped interplanetary crusader who rocketed through space in his sleek *Phantom Cruiser*.[3] Given to shouting "Great Galaxies!" and armed with an array of powerful devices, especially his Invisi-belt, which made him invisible at will, Space Ghost (voiced by Gary Owens) was accompanied in his adventures by a pair of masked and caped teenagers named Jan (Ginny Tyler) and

Jayce (Tim Matthieson) and their lively pet monkey, Blip (Don Messick). Most of Space Ghost's time was spent in rescuing Jan and Jayce from the clutches of monstrous creatures or demonic aliens with such colorful names as Metallis, Iceman, Sorcerer, and Space Ghost's archenemy, the web-spinning Black Widow.

Imaginatively conceived and animated, "The Space Ghost" kept viewers enthralled with its tales of interplanetary adventure. Typical episodes found the cosmic crusader and his friends in conflict with such beings as the Heat Thing, a thirty-foot-tall monster that spewed lava

bombs at its victims; a diabolical Creature King who unleashed a giant green-eyed ape and huge bats in his quest for power; and a race of lizard people who kept an army of slaves under their control, until Space Ghost set them free with the aid of his Invisi-power. One segment had Space Ghost and Jayce brought to a Devilship where an evil wizard transforms them temporarily into gold-hungry fanatics. Jan saves the day by pushing the button that controls people's minds and releasing Space Ghost from the spell.

"Dino Boy," the series that accompanied "The Space Ghost" in its premiere, also involved a cleverly wrought premise, which had the young hero Tod (Johnny Carson)* parachuting into the midst of a strange Stone Age world. Rescued from predatory creatures by a caveman named Ugh (Mike Road), Tod, now called Dino Boy, became the central figure in a series of adventures with prehistoric creatures and people. Among his many adversaries were the Worm People, the Ant Warriors, the Rock Pygmies, and the Mighty Snow Creature. In a typical segment, Dino Boy and his pet brontosaurus named Bronto, are captured by the nasty Treemen, who want to sacrifice them to prehistoric vultures. The two are rescued by a stampede of mammoths, who knock the Treemen out of their leafy abodes and trample everything in sight.

*Not the Johnny Carson of "Tonight" fame.

Space Ghost and Dino Boy, with Dino's pet brontosaurus, Bronto.

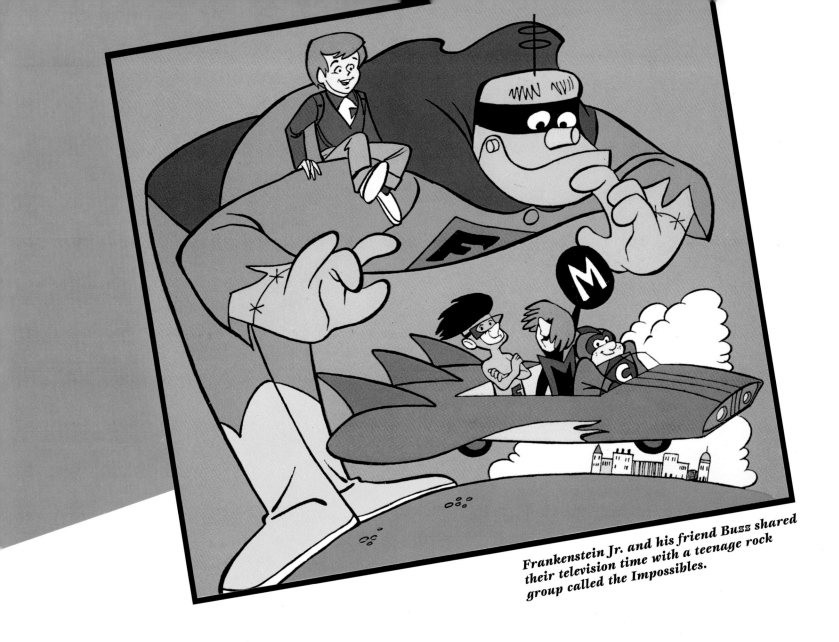

Frankenstein Jr. and his friend Buzz shared their television time with a teenage rock group called the Impossibles.

Artist Alex Toth, who also worked on "Dino Boy," has described the creative process at the time: "We would have long brainstorming sessions. With someone like Fred Silverman, who knew exactly what he wanted, there would be lively, round-the-table discussions, with everyone taking part. Joe Barbera and I would be doodling while Bill Hanna and Silverman were talking, thrashing out what a new character ought to look like. Very often it was that kind of mutual input. After my rough drawings were approved, I would give them a final trimming, running back and forth until they were right. It was hectic, but it was fun."

For other shows the studio had to prepare either elaborate full-color presentation art or a short but expensive pilot film, along with other material that would be used by Joe Barbera to pitch the show to network executives. With Fred Silverman the procedure was much simpler. Toth recalls, "Once we locked in the characters, we made as many designs as possible, to move the characters around and show how they would look, how they would interrelate with other characters, and what devices they would use, whether they required a special plane, a rocket ship, or a clever gadget. The approved model sheets would be distributed to the studio."

Drawing fully human figures for "Space Ghost" and other space-oriented series proved to be both a challenge and a boon for Hanna-Barbera. On the one hand, the

artists had to be certain that the proportions of each figure were correct and that they moved in reasonably realistic fashion. On the other hand, the use of human figures meant that less animation was required than for the series with animal characters. "You didn't have to move the human figures as much," Joe Barbera says. "One of the reasons you achieved a feeling of fluidity was that they were zooming through space a lot. If a character puts his arms out and he sails through the air at a terrific speed, you get the feeling of smoothness, but you have to realize that there's really no animation there. The character is not sitting or standing or scratching his nose—he's sailing through the air at great speed."

In addition to "The Space Ghost and Dino Boy," which may well have enjoyed the highest rating in the history of Saturday morning television, Hanna and Barbera were assigned to create other series for Fred Silverman's super-hero cycle on CBS. Released simultaneously with "The Space Ghost" in the fall of 1966, "Frankenstein Jr. and the Impossibles" concerned two separate groups of intrepid heroes who battled the perennial forces of evil, although with a lighter and more comic touch than in "The Space Ghost and Dino Boy." Frankenstein Jr. bore no resemblance to the obsessed scientist of Mary Shelley's novel or to the monster he created in his laboratory. Instead he was a masked and caped fifty-foot-tall computerized robot (voiced by Ted Cassidy) who could think and talk clearly. Created by plucky boy scientist Buzz Conroy (Dick Beals), the son of the eminent Professor Conroy (John Stephenson), Junior was activated by Buzz's radar ring. At Buzz's ringing cry of "Allakazoom!" the pair would blast off from Professor Conroy's mountaintop laboratory to destroy evil-doers. Armed with weapons that would make James Bond envious, unstoppable Junior and resolute young Buzz defeated such nasty characters as Dr. Spectro, who could duplicate ghosts with his Ghoulish Ghost Maker Machine, and Mr. Menace, who created the Pilfering Putty Monster to help him steal invaluable museum treasures.

The Impossibles had a secret identity as superheroes fighting for justice.

"The Impossibles," a teenage rock group with a secret identity as "the world's greatest fighters for justice," also carried their share of superhero action. The premise had the three young musicians summoned by their chief, Big D, by means of a tiny television set hidden in the crook of a guitar. Given another "impossible" assignment, the three would cry "Rally-ho!" and turn themselves into grotesque but heroic figures who traveled everywhere in their Impossicar. Coil Man (Hal Smith) would extend his legs like a huge spring; Multi Man (Don Messick) was able to duplicate himself many times over, and Fluid Man (Paul Frees) could turn himself into any form of liquid. In the comic-book tradition, their adversaries were an equally bizarre lot, bearing such names as the Fiendish Fiddler, the Terrible Twister, and the Diabolical Dauber. Sooner or later the villain would grumble, "Those Impossibles are impossible!"

A Hanna-Barbera series that was not part of Fred Silverman's superhero group at CBS premiered on NBC at the same time. Pitched to a younger audience than the several CBS series, "Space Kidettes" sent a quartet of prepubescent youngsters on extraterrestrial adventures in their space capsule clubhouse. Accompanied by their dog, Pupstar (Don Messick), the tiny explorers, named Scooter (Chris Allen), Snoopy (Lucille Bliss), Jenny (Janet Waldo), and Countdown (Don Messick), found themselves continually confronted with an assortment of sinister adversaries, both human and nonhuman. Ever ready to do battle, the staunch Kidettes used an arsenal of weapons to thwart such creatures as a laser-breathing Space Dragon, the Cosmic Condors, and the Moleman. Their most persistent opponent, however, was Captain Skyhook (Daws Butler), a blustering, cockney-accented braggart not unlike

Above and left: The Space Kidettes were pint-size heroes who fought such evildoers as Captain Skyhook and traveled with the dog Pupstar in tow.

In an episode of "The Herculoids," the creatures named Tundro, Zok, and Igoo help King Zandor and his son, Dorno, rescue Zandor's wife, Tara.

Captain Hook of *Peter Pan* who kept fretting about the Kidettes: "I can't get the best of them! They're just itty-bitty kids!"

Buoyed by the success of the superhero series in the 1966–67 season, CBS turned to Hanna-Barbera the following year for three additional Saturday morning series in the same vein. Premiering in the fall of 1967, "The Herculoids" took the superhero cycle several steps further into the grotesquerie of comic-book art. Instead of a caped and masked hero soaring through space, the program presented a group of bizarre creatures who inhabited the planet Quasar in a distant galaxy and whose principal task was to defend their king and his family from invaders. The Herculoids consisted of Zok, a flying dragon capable of firing powerful laser rays from his eyes and tail; Tundro the Tremendous, a ten-legged rhinoceros whose horn served as a cannon; and Igoo, a huge and incredibly strong gorilla. (All three characters were voiced by Mike Road.) Accompanying these strange animals were Gloop and Gleep (Don Messick), two bloblike, odd-voiced creatures

who could assume any shape or size.[4] Almost every episode called on the Herculoids to rescue King Zandor (Mike Road), his wife, Tara (Virginia Gregg), and their blond son, Dorno (Teddy Eccles), from the clutches of such deadly monsters as the Raider Apes, the Destroyer Ants, the Electrode Men, and the Faceless People.

Working closely with artist Alex Toth, Hanna and Barbera created the ultimate animated "beasties" in the Herculoids, fantastic in appearance, ferocious when provoked, and fiercely loyal to their master. In "The Purple Menace" they rescue Zandor, Tara, and Dorno from a monstrous plant that generates dangerous tentacle-like vines with an ominous purple glow. It turns out that the plant's bizarre behavior is controlled by "energy rocks" that cause the vines to mutate. In "The Firebird" the Herculoids must prevent a terrible volcano from erupting and destroying Quasar. The volcano cannot be sealed off, however, because it is being guarded by a firebird who is fiercely protecting her egg deep inside the volcano. Benign creatures despite their grotesque appearance, the Herculoids

help the firebird to retrieve the egg and fly away with her baby, before sealing off the volcano. (The episode ends with a moral: "No animal on earth is completely evil.")

"Shazzan," the second Hanna-Barbera series in the 1967 lineup of CBS Saturday morning programs, turned to the perennially popular device of time travel for its premise. The story line had the teenage twins Chuck (Jerry Dexter) and Nancy (Janet Waldo) coming upon a mysterious chest in a cave off the Maine coast. Inside the chest were two halves of a ring that, when put together, form the word Shazzan. Uttering the word, Chuck and Nancy were immediately transported back to the legendary land of the Arabian Nights, where fantastic adventures occurred at every turn. Shazzan turned out to be a 60-foot genie who

Shazzan, with his friends Nancy and Chuck and the flying camel named Kaboobie.

vowed to protect them from evil with his wizardry. The bald and bearded genie, voiced in appropriately deep tones by Barney Phillips, gave them a magical flying camel called Kaboobie (Don Messick), but his generosity did not extend to returning them to their own time. He was willing to send them home only after they have delivered the magical ring to its rightful owner.

From this starting point "Shazzan" moved into a succession of perilous encounters in which Chuck and Nancy are constantly pursued or captured by a variety of colorful villains until Shazzan came to their aid in a burst of electrical fury. Animated in often dazzling detail — the exotic Arabian Nights backgrounds have exceptional texture and color — the episodes also generated a good deal of narrative excitement. In "Master of the Thieves," Chuck and Nancy's rings are stolen by a master thief with unusual magical powers, who can turn people into toads, lizards, and other creatures. Before the twins can recover the rings, with Shazzan's help, they are pursued by demons conjured up by the master thief. "The Living Island" finds them on a mysterious island controlled by the Evil Hunter, who makes them his quarry. Soon Chuck and Nancy are being chased by dragon hounds (spawned from dragon seeds), carnivorous plants, a snarling leopard ringed with fire, and a flock of grotesque sky demons. Inevitably Shazzan defeats the Hunter and disintegrates his island and its treasures.

Despite its quality "Shazzan" proved to be disappointing, and today Fred Silverman recalls the problem it faced: "It was a very imaginative show, but we had a concept problem. The genie had no weaknesses. Once you summoned him, the story was over. It was a very difficult show to do, and very expensive." He comments further on what he calls "second-generation" shows, which follow in subsequent seasons on the heels of the great triumphs: "These shows are never as successful. Basically, they repeat the same idea in a different way. Derivations are never as successful as the originals."

Right: The 60-foot genie named Shazzan wreaks havoc on the enemy.

Moby Dick and his teenage pals Tom and Tub, and aquatic friend Scooby.

whirling into an underseas world controlled by a power-hungry tyrant, and keeping the boys out of the clutches of another madman who is using bizarre creatures to help him dominate the ocean's depths.[5]

For "The Mighty Mightor," Alex Toth designed a fanciful Stone Age environment bearing not the slightest resemblance to Fred Flintstone's prehistoric suburbia. The series focused on Tor (Bobby Diamond), a teenage cave dweller who lived with his father, Pondo (John Stephenson), sister, Sheera (Patsy Garrett), and young brother, Li'l Rok (Norma McMillan). The unusual family pets included Tor's winged dinosaur, named Tog, and Li'l Rok's bird Ork (both voiced by John Stephenson). The premise began when Tor rescued an old hermit, who gratefully gave him a magical club. When Tor raised it to the sky, he turned into Mightor, an extraordinarily strong, masked superhero with horns protruding from the sides of his cowl. His pet, Tog, became a fire-breathing dragon. In

"Moby Dick and the Mighty Mightor," the third 1967 series produced by Hanna-Barbera for CBS, involved two separate and disparate superheroes designed by Alex Toth. Taking only the name of Herman Melville's famous whale, "Moby Dick" concerned a much friendlier marine mammal. The story had him saving a pair of teenage boys from man-eating sharks and befriending them and their pet seal as they launch a series of fantastic adventures. The premiere episode gave the young heroes more travails than Indiana Jones: the boys, named Tom (Bobby Resnick) and Tub (Barry Balkin), find themselves trapped in an underwater earthquake, threatened by a giant sea spider, ensnared in a giant clam, entangled in man-eating seaweed, and surrounded by monstrous electric eels. At all times, loyal Moby swims to their rescue, emitting fierce growls as he takes on the enemy, and occasionally the seal, Scooby (Don Messick), provides some help. Other segments had Moby saving Tom and Tub from a vortex that sends them

"The New Adventures of Huckleberry Finn" sent Mark Twain's Huck, played by Michael Shea, into an animated fantasy world.

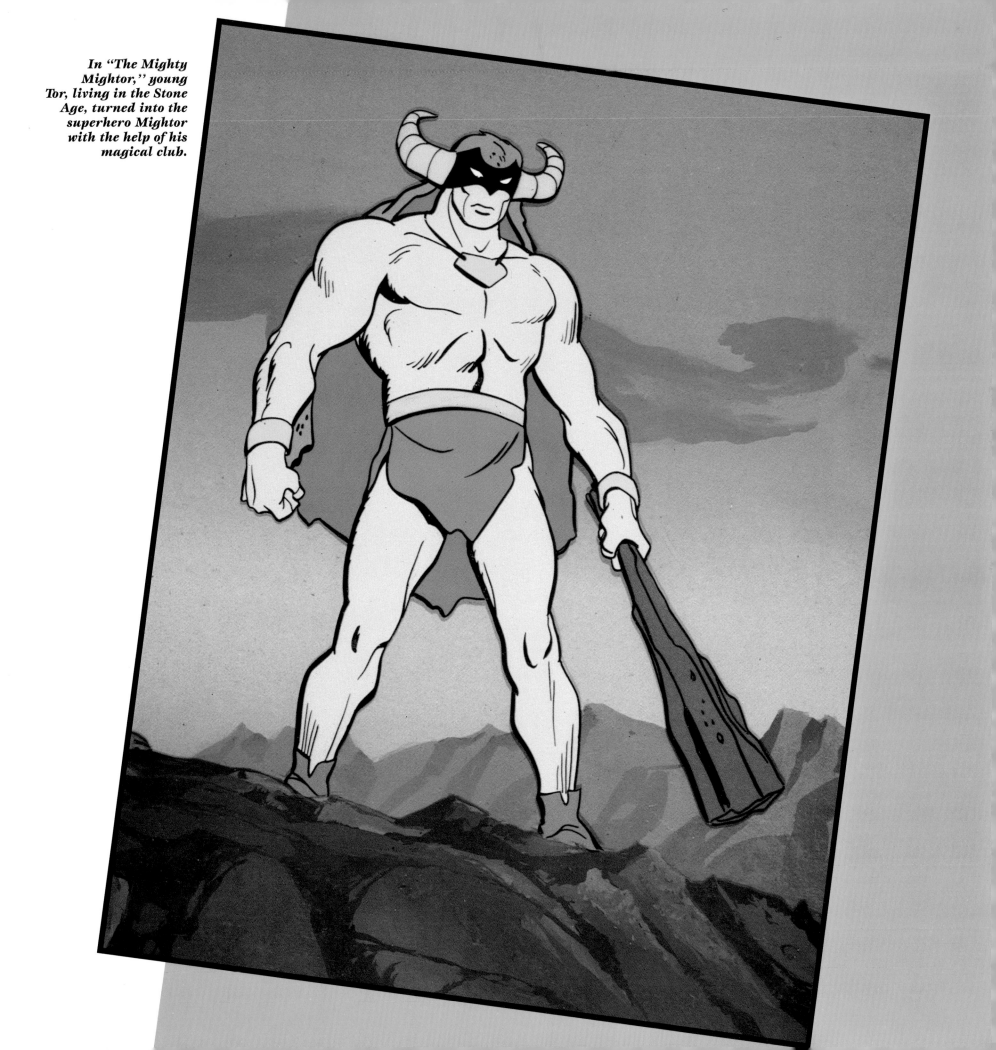

In "The Mighty Mightor," young Tor, living in the Stone Age, turned into the superhero Mightor with the help of his magical club.

subsequent episodes Mightor and the dragon battle such evil creatures as Numo and his Sea Slavers, who kidnap Sheera and other women of the tribe (to save the day, Mightor must destroy the ferocious sea serpent evoked by Numo), and the Plant People, a nasty tribe that controls acres of carnivorous greenery.

Not all of the programs in the superhero cycle emanated from Fred Silverman and CBS. In the enthusiasm for intrepid comic-book crusaders against crime and evil, other networks decided to offer their own contributions. On one very active Saturday morning in September 1967, at the very same time that "The Herculoids," "Shazzan," and "Moby Dick and the Mighty Mightor" were being launched on CBS, three other Hanna-Barbera productions were premiering on rival networks: "Samson and Goliath" and "Birdman and the Galaxy Trio" on NBC and "The Fantastic Four" on ABC.

"Samson and Goliath" played yet another variation on the popular transformation theme. In this instance, young Samson (Tim Matthieson) was (or seemed to be) an average teenager with a pet dog, Goliath. When trouble loomed, however, he raised his wrists, rubbed two gold bracelets together, and shouted, "I need Samson power!" In an instant he became the amazingly strong reincarnation of his legendary namesake, while Goliath turned into a ferocious lion. Together they set about defeating the usual assortment of grotesque villains, in such episodes as "The Colossal Coral Creature," "The Thing from the Black Mountains," and "The Terrible Dr. Desto."

Designed with imaginative detail by Alex Toth, "Bird-man and the Galaxy Trio" offered another group of superheroes with out-of-this-world capabilities. Drawing on the ancient Greek legend of Icarus, whose father, Daedalus, gave him wings, "Birdman" focused on Ray Randall (Keith Andes), who is saved from a fiery death by the sun god Ra and granted the power of flight. A striking figure in gold, with huge blue wings, a black mask, and a yellow helmet crested with a red-winged bird, Birdman was also given a formidable weapon in the Solar Ray Beams that emerge from his knuckles, melting everything in their path. A Solar Shield deflected the deadly rays and missiles from his many enemies. The premise had Birdman alerted

Above: Young Samson with Goliath, his dog-turned-lion.

to every diabolical scheme by his chief, Falcon 7 (Don Messick), and then soaring into action to the penetrating cry of "Bi-r-r-d Man!" A giant American eagle called Avenger accompanied Birdman on his missions and often saved his life when Birdman's energy, derived from the sun's rays, began to fade.

As a defender of freedom and a champion of mankind, Birdman was called upon to thwart demented scientists with bizarre schemes for world domination or elaborate plans for destroying their winged adversary. In "Morto the Marauder," the "evil genius" Morto escapes from prison to wreak revenge on Birdman and to seize control of the world's gold and silver supply. All his devices and weapons, however, turn out to be useless against the might of Birdman and

his faithful Avenger. ("Your stealing days are over, Morto!") In "The Quake Threat," a nasty professor plots to destroy the world by sending shock rays into the fluid layers of the earth. Eventually Birdman defeats him but not before saving Avenger from the mad professor's Metal Men ("Drop that bird, you bucket of bolts").

While Birdman soared through the stratosphere, the group called "The Galaxy Trio," sharing his Saturday morning time slot, relied on their special skills to carry them through their adventures. In the venerable comic-book tradition, the Trio consisted of three people with the power to transform themselves into otherworldly creatures. Vapor Man (Don Messick) could take on any gaseous or mistlike form; Galaxy Girl (Virginia Eiler) was

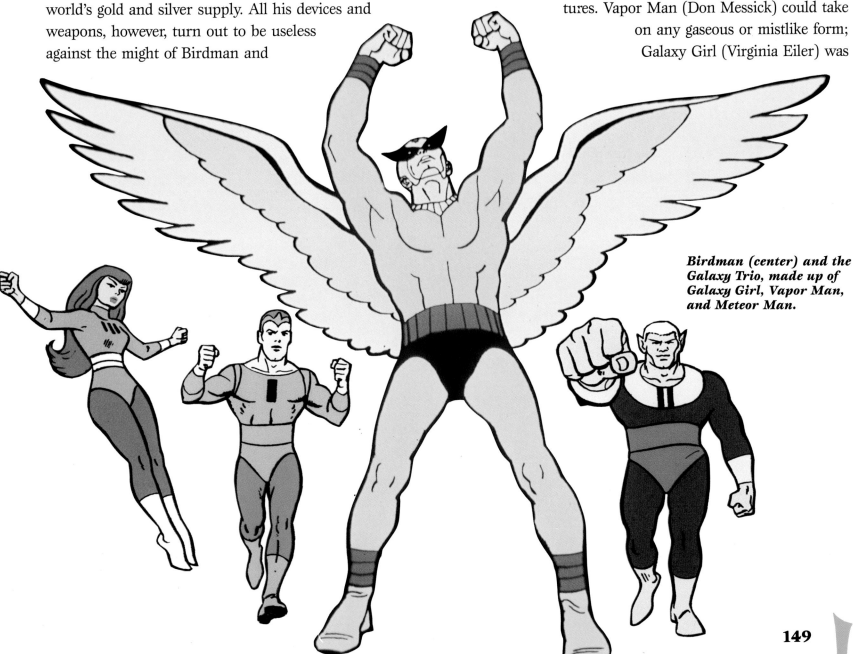

Birdman (center) and the Galaxy Trio, made up of Galaxy Girl, Vapor Man, and Meteor Man.

able to defy the law of gravity by soaring through space at will; and burly, hulking Meteor Man (Ted Cassidy) boasted superhuman strength. (He also had pointed ears, resembling those of Dr. Spock in "Star Trek.") Roaming the universe in their spaceship *Condor I*, the Trio was constantly being ordered by Intergalactic Security to investigate trouble on what appeared to be a limitless number of alien planets.

Adapted from the comic-book heroes created in 1961 by Stan Lee and Jack Kirby, "The Fantastic Four" carried the concept of transformation to even further reaches of fantasy than "The Galaxy Trio." In the establishing premise, a rocket ship was attacked by mysterious cosmic rays, and its four passengers were altered forever after a crash landing. Scientist Reed Richards (Gerald Mohr) discovered that his skin has become plastic and that he could move as flexibly as a rubber band. He took the name Mr. Fantastic. His wife, Sue (Jo Ann Pflug), had the power to vanish, and she became the Invisible Girl. Sue's brother, Johnny Storm (Jack Flounders), could burst into flame at will, and he became the Human Torch. And the family friend Ben Grimm (Paul Frees) was transformed into a grotesque

rocklike creature called the Thing. Over the course of the series, the Fantastic Four used their individual powers to destroy such evildoers as the Mole Man, an undersea ruler bent on conquering the earth; the iron-masked Dr. Doom; and Diablo, a wicked alchemist who gets free after a century of entombment.[6]

For the 1968–69 television season Hanna-Barbera was still introducing adventure series: "The Adventures of Gulliver," ABC; "The Arabian Knights," NBC; "The Three Musketeers," NBC. Yet their reception was somewhat less than enthusiastic, and the cycle of superhero programs had seemed to run its course. At the same time that the ratings were falling, a swell of protest began to rise against what was perceived as the excessive violence in many of the series, and especially against the proliferation of commercials for expensive toys and sugar-coated cereals. "Watchdog" groups started to make their voices heard, sparked by a group that called itself Action for Children's Television. Formed in 1968 by a Massachusetts

In "The Adventures of Gulliver," Gary Gulliver finds himself in the land of Lilliput.

The Arabian Knights.

housewife named Peggy Charren and a few of her neighbors, ACT urged Congress and the Federal Communications Commission to initiate reform in the area of children's programming. Eventually, in response to this pressure, the networks reduced the advertising quotas in children's shows to 9.5 minutes per hour, strengthened the advertising code, and reduced the violence content in the programs.

Joe Barbera recalls traveling to Boston and Concord for friendly talks with Peggy Charren and ACT: "The industry met with her and listened to her side of the story. She made a loud enough noise so that the producers began to wonder what they were doing. From then on there was an excessive amount of fear and terror from advertisers and network people." On the other hand, Fred Silverman maintains that the slipping ratings of the shows played a much larger role in decision making than any watchdog group: "Actually the numbers influenced us more than anything else. They just weren't good enough. You can bet your life that if the shows' ratings were as high as the first year, Peggy Charren or not, we would have continued. Her voice was only an added factor."

In any case, it became abundantly clear that a basic change in both approach and format was in order. The time seemed right for a new type of show, lighter and more humorous in content than the superhero series, but one which continued to preserve the spirit of mystery and adventure that viewers appeared to enjoy. Soon the concept of combining comedy and action would converge in a new and popular array of Hanna-Barbera cartoon stars, led by an overgrown, none-too-brave dog named Scooby-Doo.

Scooby-Doo and Friends

The first Hanna-Barbera show to signal a change in approach and format arrived on CBS in the fall of 1968. Drawing to some extent on two elaborate 1965 movie comedies, *The Great Race* and *Those Magnificent Men in Their Flying Machines*, "The Wacky Races" involved a madcap cross-country racing competition in which eleven drivers competed for the title "The World's Wackiest Racer." Driving their bizarre but workable vehicles, all brilliantly designed by Iwao Takamoto, the racers not only had to compete with each other but also with the nasty machinations of the "double-dealing do-badder" Dick Dastardly (voiced by Paul Winchell), who used an array of Rube Goldberg–like contraptions to sabotage the other drivers. Invariably Dastardly failed in his diabolical mission, earning yet another nasty snicker from his canine accomplice Muttley (Don Messick). The drivers were a colorful lot, ranging from the tried-and-true Peter Perfect (Daws Butler) in his Turbo Terrific to hillbillies Luke and Blubber Bear (John Stephenson) in their Arkan-

I don't think it means a darn thing to kids whether I put in 40,000 drawings or 4,000, as long as the entertainment is there.

—Joe Barbera

sas Chugabug, from glamorous southern belle Penelope Pitstop (Janet Waldo) in her Compact Pussycat to Clyde (Paul Winchell) and the Ant Hill Mob in their Bulletproof Bomb.[1] The humor had a zany, even lunatic, quality that made good use of inventive sight gags, outrageous puns, and unabashed slapstick.

The popularity of "The Wacky Races" — it was an enormous success — sparked several spin-offs from its band of globe-trotting adventurers. At Fred Silverman's suggestion, a few of the characters in the marathon racing competition were given their very own shows in the 1969–70 season. One pair of characters was almost an inevitable choice: the despicable Dick Dastardly and his snickering, less-than-trustworthy dog Muttley had endeared themselves to viewers with their single-minded (and hopeless) attempts to wreck the other racing vehicles. Turned into a World War I flying ace, under orders from the General (heard only as a sputtering telephone voice) to intercept the message of the American courier Yankee

Left: "Scooby's Midnight Ride."

153

Dastardly waits for the General's call, with
Muttley, Zilly, and Klunk looking on.

Nasty Dick Dastardly and
his snickering canine,
Muttley, participate in
"The Wacky Races."

Doodle Pigeon, Dick Dastardly became the centerpiece of a hilarious new CBS series, "Dastardly and Muttley in Their Flying Machines." It premiered in September 1969.[2]

The concept never changed: shouting "Drat!" "Double drat!" or even "Triple drat!" whenever he failed to achieve his mission (which was always), Dastardly (again Paul Winchell) was abetted — or, more often, hindered — by the double-dealing Muttley (again Don Messick), who either muttered such unintelligible curses as "snackle-razzle-futzal-crazz" whenever he was denied a medal, or kissed Dastardly's hand to keep in his good favor. Dastardly was also plagued with two wildly incompetent mechanics, the bizarre Klunk (Don Messick), who spoke in a barrage of whistles, gurgles, and sputters that had to be interpreted by the perennially terrified Zilly (also Messick). Constantly done in by their weird and ramshackle aircraft, the inept foursome barely survived from one episode to another, while the unflappable Yankee Doodle Pigeon went on his merry way, occasionally sounding a triumphant "Charge!" on his bugle.

At their best, the "Dastardly and Muttley" episodes contained inspired sequences equal to any live-action comedy. In "Fur Out Furlough," told by the General that a thirty-day furlough awaits whoever nabs the pigeon, the four characters battle among themselves for the prize. At one point in the mad confusion, Dastardly stands poised on the wing of his plane with an outstretched net to catch the pigeon. Determined to stop him, Klunk and Zilly drop a piano — your basic flying piano — into the net. As Dastardly plummets to earth, he cries, "*Do* something!" to Muttley (not for the first or last time), whereupon the sneaky dog starts to play the piano. Dastardly, of course, hits the ground as Muttley emits his dirty laugh. In "Follow That Feather" Klunk invents a feather-seeking

Dastardly and crew pursue Yankee Doodle Pigeon.

homing missile to catch the pigeon, but when the pigeon loses a feather in his efforts to avoid the missile, it floats into Dastardly's plane. The frantic four inside blow the feather from one to the other until it lands on Dastardly. "There's nobody here but us pigeons," he says with a weak smile, whereupon the plane explodes.

Wide-eyed blond racer Penelope Pitstop also took a turn at her own show, joining "Dastardly and Muttley" in the

Penelope Pitstop in her racing car, the Compact Pussycat.

Saturday morning lineup on CBS. Strongly suggested by the silent film serial "The Perils of Pauline," in which resolute Pearl White endured any number of hairbreadth escapes, "The Perils of Penelope Pitstop" had heiress Penelope (again Janet Waldo) driving her racing car, the Compact Pussycat, around the world in international competition, while constantly evading the machinations of the cloaked and masked Hooded Claw, otherwise known as Sylvester Sneekly (Paul Lynde). Aided by his clumsy henchmen, the Bully Brothers (Mel Blanc), Sneekly created ingenious ways to destroy Penelope and inherit her fortune, all of which backfire. Her protective godfathers (also alumni from "The Wacky Races") were the seven frisky members of the Ant Hill Mob, each of whom has his own distinct personality. Driving around in their Chugaboom, a limousine that could instantly be con-

verted in many useful ways, the Mob — Clyde, Dum Dum, Zippy, Pockets, Snoozy, Softly, and Yak Yak[3] — could always be counted on to save Penelope from Sneekly's nasty schemes.

Written largely by Mike Maltese and the team of Ken Spears and Joe Ruby, and narrated in tongue-in-cheek fashion by Gary Owens, "The Perils of Penelope Pitstop" kept the heroine constantly busy extricating herself from near-fatal dilemmas. Often she had the assistance of the Ant Hill Mob, but she also had her own resources — tied to a runaway trolley, she uses a handy nail file to cut the rope — and she is never at a loss for an apt response to an inane question. Strapped to a torpedo, she is asked by Sneekly, "Are you comfy?" "Not very," she replies. (Sneekly is sending her to China, where she will be "the biggest bang of the Chinese New Year.")

Left: Penelope Pitstop is trapped at the cliff's edge by the Hooded Claw; at the top are her friends The Ant Hill Mob.

Another globe-circling comedy adventure series from Hanna-Barbera (not a spin-off of "The Wacky Races") made its debut on ABC about the same time. Loosely adapted from Jules Verne's classic 1873 novel, *Around the World in Eighty Days*, the series, called "Around the World in 79 Days," concerned the stalwart young Phileas Fogg, Jr. (Bruce Watson), the son of Verne's famous hero, whose dream was to travel around the world in a period of time one day shorter than his father's. Bent on thwarting him at every turn were the villainous Crumden (Daws Butler) and his lackey Bumbler (Allan Melvin). Phileas, however, had friends who accompanied him on his journey: his cat, Smirky (Don Messick); young Jenny Trent (Janet Waldo); and her frisky dog, Happy (Don Messick). The group's adventures took them to far-flung corners of the globe in such episodes as "Arabian Daze," "The Argentiney Meany," and "Saucy Aussie." Under the umbrella title "The Cattanooga Cats," which used actors dressed as cats as hosts for the cartoons, "Around the World in 79 Days" appeared in tandem with two other new series, "It's the

Wolf" and "Autocat and Motormouse," as part of ABC's Saturday morning lineup in September 1969.

That month and year proved propitious for Hanna-Barbera, with the arrival of one of its most durable programs and most popular animated characters. Premiering directly after "The Perils of Penelope Pitstop" on CBS, "Scooby-Doo, Where Are You?" not only turned out to have extraordinary staying powers of its own but also inspired a number of similar programs, not all of them from Hanna-Barbera's studio. The origin of the perpetually terrified dog can be traced to Fred Silverman, who, as head of Daytime Programming for CBS, was looking for another show that would lead the network out of the superhero cycle and into the more acceptable realm of comedy adventure. Apparently Silverman liked the idea of a series that would combine elements of "I Love a Mystery," Carleton E. Morse's popular radio program of the forties, in which three detectives roamed the world solving crimes, with aspects of "The Many Loves of Dobie Gillis," the television sitcom about a scatterbrained teenager and

Above: Globe-circling Phileas Fogg, with his friends Hoppy and Jenny, in "Around the World in 79 Days."

his friends, which had appeared on CBS from 1959 to 1963.

The concept was brought to Hanna-Barbera, who assigned writers Ken Spears and Joe Ruby to create the characters, the basic situation, and many of the story lines. At the beginning the show revolved almost entirely around four teenage detectives who roamed the country in their van, the Mystery Machine, solving supernatural mysteries and extricating themselves from dangerous situations. They were accompanied by a Great Dane who took part in the action but was not an especially prominent character. First known as "Mysteries Five" and then as "Who's Scared?" the program was presented to CBS's president Frank Stanton and the top CBS management as the centerpiece of an entirely new Saturday morning schedule for the fall of 1969.

Fred Silverman recalls what happened: "I went to pre-sent the whole schedule, and we finally got to this show. It turned out that the artwork was actually very frightening. Stanton looked at it and said, 'We can't put that on the air.' We were in trouble. We had placed this show at 10:30, right in the middle of the schedule, and without this show we wouldn't *have* a schedule. 'Well,' I said, 'let me see what I can do.' Flying back to Los Angeles that night, I happened to have the earphones on and was listening to Frank Sinatra singing 'Strangers in the Night.' I was struck by the phrase 'Scooby-dooby-doo.' I went back and said, 'We'll call the show "Scooby-Doo, Where Are You?" and we'll make the dog the star of the show.' It was the same basic show, except that we brought the dog up front, and all the other characters supported him."

The revised premise turned out to be eminently work-able. Now Scooby-Doo, the goofy, ungainly Great Dane with the unique scratchy voice and foolish laugh (courtesy

Terrified as usual, Scooby-Doo slinks away from friends Shaggy, Velma, Daphne, and Freddy.

Scooby-Doo and Shaggy.

of Don Messick) became the center of each story, making the emphasis more comic than mysterious. Unkempt, brown-haired Shaggy (Casey Kasem),* the teenager in a constant state of panic and terror, served as Scooby's principal foil, sharing not only his cowardice but also his ravenous appetite—while stalwart blond Freddy (Frank Welker), brainy, bespectacled Velma (Nicole Jaffe), and trouble-prone, red-headed Daphne (Heather North) were charged with searching for clues and unraveling the mysteries.

From the time of its premiere in September 1969, "Scooby-Doo, Where Are You?" enjoyed wide popularity. Although the pattern seldom veered from the first episode, the situations devised for the teenage detectives were inventive and funny, and the characters of Scooby and Shaggy, forever quaking in fright or searching for edibles, endeared themselves to viewers. In a typical episode, "Mine Your Own Business," the gang arrives in a western ghost town that apparently has a real ghost—a specter called the Miner Forty-Niner is frightening visitors away from a nearby resort hotel. Investigating what Shaggy calls "this creepy, creepy place," they come upon a mysterious

Now a popular radio personality.

160

old miner hiding deep inside a deserted mine—petrified Scooby, of course, is the only one to see him at first. A climactic chase through a maze of secret passages ends in the unmasking of the true villain. While the mystery is cleverly contrived, the emphasis—as in all the "Scooby" episodes—is largely on the comic reactions and antics of Shaggy and Scooby at every scary turn of events. Other episodes in the initial 1969–70 series had such colorful titles as "Decoy for a Dognapper," "A Gaggle of Galloping Ghosts," and "Which Witch Is Which?"

During its first two seasons "Scooby-Doo, Where Are You?" earned exceptionally high ratings in its Saturday morning time slot. Scooby became a nationally popular character as new episodes were added to run with the original episodes. By 1972 time for a change in format seemed to have arrived, and for two successive years the program was known as "The New Scooby-Doo Comedy Movies." The gang remained intact, driving the Mystery Machine to new adventures, but now the episodes incorporated the voices and likenesses of such guest stars as Phyllis Diller, Tim Conway, Jonathan Winters, and Laurel and Hardy, whose trademarked slapstick antics were used as part of the story. One segment had the teenagers becoming unlikely "housekeepers" in the spooky mansion occupied by the decidedly weird Addams family, who had been dispensing their macabre humor on television since 1964.

Scooby and his harebrained cousin Scooby-Dum.

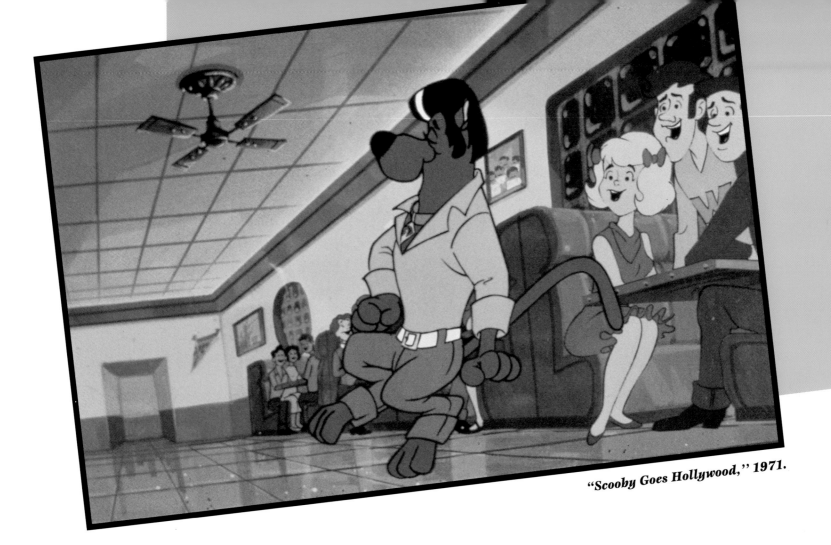

"Scooby Goes Hollywood," 1971.

After a seven-year run on CBS, Scooby and his friends moved to ABC, first as part of the 90-minute "Scooby-Doo/ Dynomutt Hour" launched in the fall.* Although the characters remained intact, two new canine cohorts were added to the team: Scooby's clumsy rustic cousin, Scooby-Dum, and the flirtatious female Scooby-Dear. Scooby's new adventures involved him and his sidekicks with a suitably grotesque assortment of demons, specters, and monsters, including the Gator Ghoul, the No-Face Zombie, and the Headless Horseman of Halloween. The following year Scooby headlined the hugely successful "Scooby's All-Star Laff-a-lympics," the first two-hour Saturday morning cartoon show in network history, bringing together episodes of "Scooby-Doo," "Dynomutt," and a new series called "Captain Caveman and the Teen An-

gels."* In 1978 still more episodes of "Scooby-Doo" were added to a trimmed version of "Laff-a-lympics," now entitled "Scooby's All-Stars."

The year 1979 was a banner year for the quaking canine, with the premiere of his first television special, "Scooby Goes Hollywood." Combining slapstick and parody with a sprinkling of music, the special centered on Scooby's all-out invasion of the movie and television world. As he goes about inadvertently wrecking everything in his path, his fantasies run rampant. We see him as a *High Noon*–type sheriff, gunning for a showdown with outlaw Jesse Rotten; as a "hip" variation of Fonzie in "Happy Days," creating havoc with his motorcycle; as an improbable Superman; and as half of a teenage singing team called "Scooby and Cherie." Along the way there are

*See pages 173–75 for more on "Dynomutt, Dog Wonder."

*See page 170 for more on "Captain Caveman and the Teen Angels."

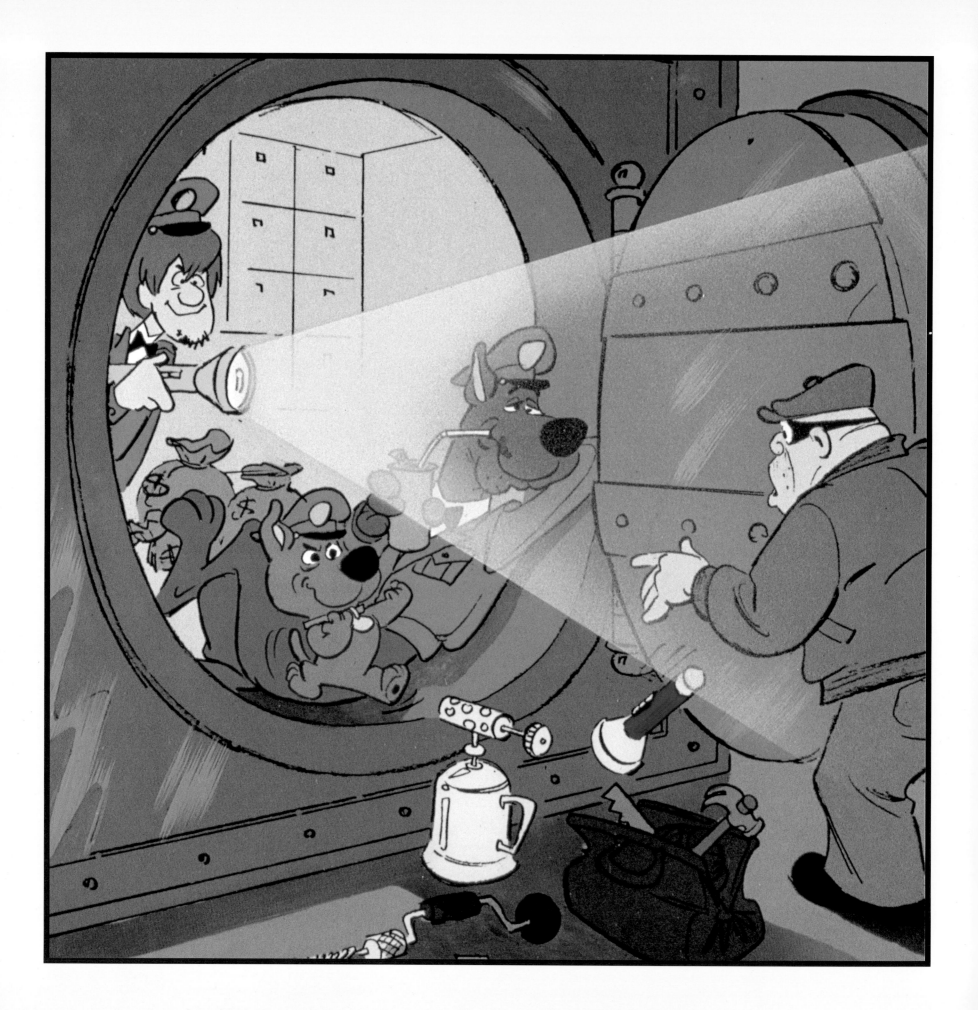

flashbacks to fondly remembered sequences in the Scooby cartoons, a wisp of a plot about Scooby wanting to become a superstar, and several songs.

Another Scooby-Doo event took place in 1979, with the addition to the cast of the hound's aptly named, feisty little nephew Scrappy-Doo (Casey Kasem). In the new series called "Scooby and Scrappy-Doo," little Scrappy contributed to the comic mayhem with his unqualified, if misguided, devotion to his uncle ("You show 'em, Uncle Scooby!") and the ringing cry of "Puppy Power!" with which he went into action against the enemy. In "Shiver and Shake, That Demon's a Snake!" an episode that takes them from Haiti to New Orleans, the group tangles with the sinister Snake Demon, a creature who pursues them (and of course terrifies Shaggy and Scooby) for his own nefarious ends. Shaggy and Scooby admit to being members of the American Cowards Association, but Scrappy never gives up the fight. ("I may be small, but I'm tough!") In "The Scary Sky Skeleton" they investigate a mysterious flying skeleton that is disrupting a sky circus where their friend is a pilot. In setting one of his Scrappy-traps, the unstoppable pup causes more trouble for Scooby and Shaggy, eventually landing them inside the Sky Skeleton's out-of-control plane. Throughout the eighties the well-loved Scooby and his pals continued to turn up in various combinations, including the addition of a new character, Scooby's Wild West cousin Yabba-Doo.[4]

What is the reason for Scooby-Doo's continuing popularity? Don Messick, who has voiced the character from the beginning, may well have the answer: "I've loved Scooby from the inception, and so has everyone else. I think it's because he embraces a lot of human foibles. He's not the perfect dog. In fact you might say he's a coward. Yet with everything he does, he seems to land on his four feet. He comes out of every situation unscathed. I think the audience — kids and more mature people as well — can identify with Scooby's character and a lot of his imperfections."

Inevitably, the success of "Scooby-Doo" prompted many more animated series involving spunky teenagers and their comic and often unusual sidekicks.

Left: Shaggy, Scrappy, and Scooby surprise a burglar.

163

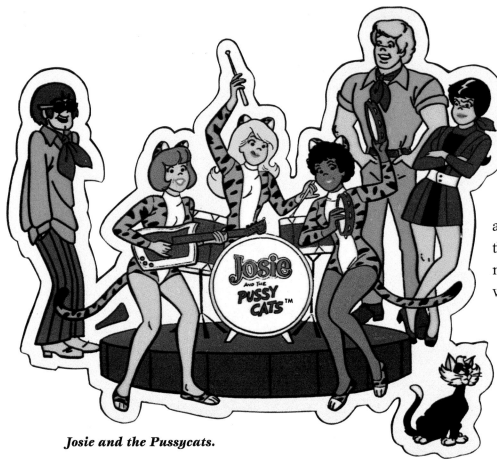

Josie and the Pussycats.

The networks and Hanna-Barbera recognized that young viewers responded favorably to the mix of comedy and mystery, especially if the comedy portions were given over to the sort of zany slapstick characters they most enjoyed. A sprinkling of rock music could also do well as an active ingredient.

One program that successfully combined all of these elements turned up in the fall of 1970 on CBS. Suggested by Fred Silverman and designed by artists John and Richard Goldwater, "Josie and the Pussycats" concerned an all-girl teenage rock group that traveled around the world on a concert tour and inadvertently became entangled in comedy-laced adventures.[5] Pert red-headed Josie (voiced by Janet Waldo) was the leader; Valerie (Barbara Pariot), a smart, sensible black girl with the distinction of being the first minority heroine in animated cartoons, and Melody (Jackie Joseph), a featherbrained blonde whose ears wiggled whenever there was danger, were the other Pussycats. Other major characters were Alex-

ander Cabot III (Casey Kasem), the group's constantly quaking manager; his smart-alecky sister, Alexandra (Sherry Alberoni); their muscular blond friend Alan (Jerry Dexter); and Alexandra's cat, Sebastian (meowed by Don Messick). In addition to the inevitable entanglements with nasty villains, episodes in the series invariably included a lively chase sequence accompanied by rock music. Two seasons later, starting in the fall of 1972, Josie and the Pussycats set off on brand-new adventures that propelled them into outer space, where they battled a new assortment of power-hungry schemers.

Among the many teenage-oriented series that turned up from Hanna-Barbera after the enormous success of "Scooby-Doo," some followed the "Scooby" pattern of kids-with-a-comic-sidekick, with the premise sufficiently altered to prevent the program from becoming a clone. "The Funky Phantom" (ABC, 1971), for example, substituted a jittery ghost for the quaking dog, taking for its central character a New Englander named Jonathan Muddlemore (Daws Butler) who, fleeing from the Red-

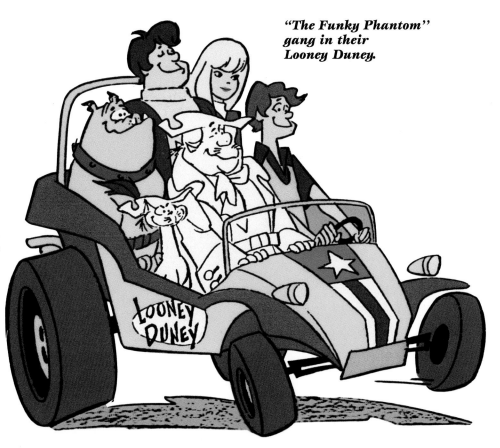

"The Funky Phantom" gang in their Looney Duney.

coats in 1776, became entrapped in a grandfather clock for nearly two centuries. When three traveling teenagers named Skip (Mickey Dolenz), Augie (Tommy Cook), and April (Tina Holland) reset the clock hands to twelve, Jonathan's ghost emerged and became their faithful friend. Along for the ride were Muddy's cat, Boo, and Skip's bulldog, Elmo. The series had the four driving around the country in a vehicle called the Looney, solving mysteries and sharing adventures.[6] Another series, called "Butch Cassidy and the Sun Dance Kids" (NBC, 1971, and no relation to the 1969 movie), took a leaf from "Josie" (also "The Impossibles") by focusing on a teenage rock group that worked in secret as undercover agents, exposing a hornet's nest of spies and scoundrels. Of course they paused occasionally to deliver a rock song, and of course they had a mischievous dog, here named Elvis.

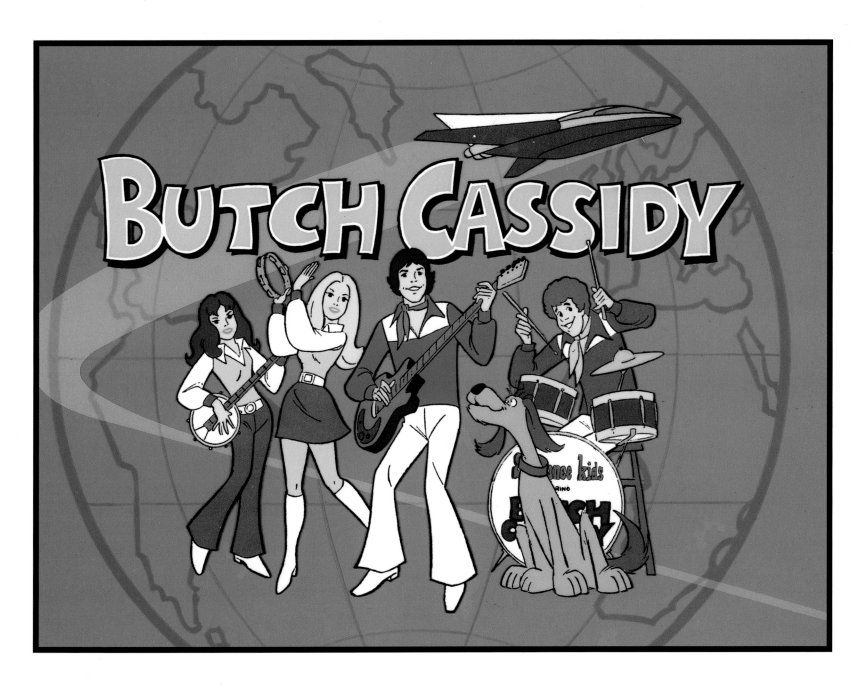

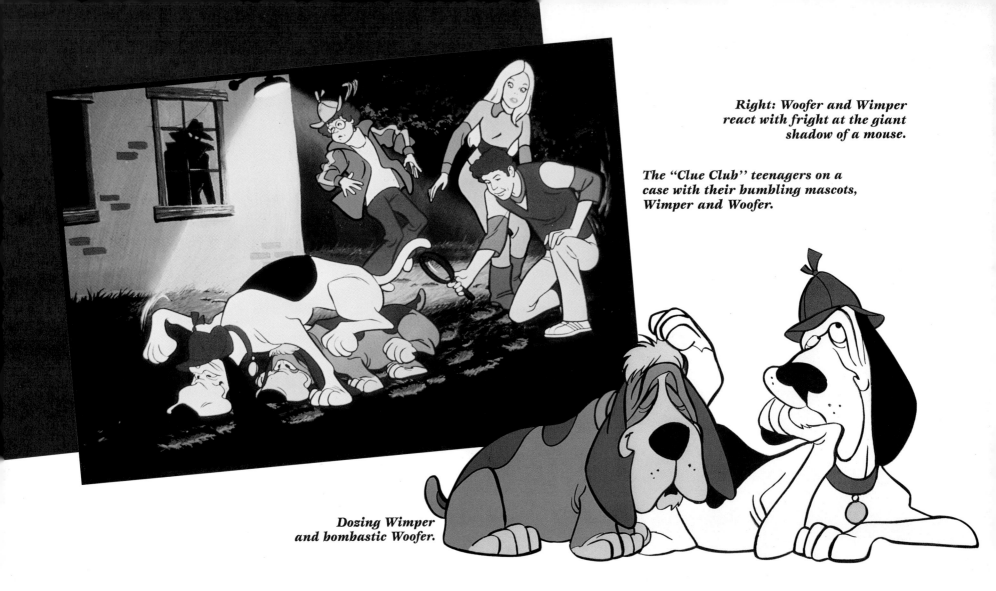

Right: Woofer and Wimper react with fright at the giant shadow of a mouse.

The "Clue Club" teenagers on a case with their bumbling mascots, Wimper and Woofer.

Dozing Wimper and bombastic Woofer.

Another series with unmistakable Scooby-like elements appeared on CBS starting in August 1976. "Clue Club" involved a quartet of clever teenagers who spent their time solving puzzling mysteries instead of cramming for exams. The members were the club's leader, Larry (David Joliffe), pert blonde Pepper (Patricia Stich), red-headed and be-spectacled D.D. (Bob Hastings), and Dotty (Tara Talboy), a thirteen-year-old computer wizard who stayed in the clubhouse garage, dispensing valuable information at the touch of her fingers. In the "Scooby" tradition, the club's mascots, Woofer (Paul Winchell) and Wimper (Jim McGeorge), provided the comic relief, sometimes acciden-tally helping the group to uncover clues. Bloodhounds with a southern drawl, the dogs dominated the series with their hilarious antics. Woofer, a grandiloquent blowhard

wearing a Sherlockian hat, had delusions of being a great detective, and delighted in quoting his "grandpappy" on every occasion, while the lethargic Wimper simply slept as often as possible.

Although the plot lines were conventional (recovering stolen diamonds, a secret formula, or a prize pig), the characters of Woofer and Wimper remained genuine origi-nals. Woofer, in particular, delighted with his continual — and unjustified — bragging. "I've got Kung Fu paws!" he tells Wimper, and when the Clue Club is summoned on a case, he remarks haughtily, "It's about time. They could use a professional nose!" A week after ending its initial run, "Clue Club" returned briefly to the schedule as "Woofer and Wimper, Dog Detectives," then resumed un-der its original name for another season's run.

a rock band called the Neptunes. (His favorite expression, borrowed from comedian Rodney Dangerfield, was "I don't get no respect!") Living in an underseas environment in the year 2076, the Neptunes consisted of leader Biff (Tommy Cook), the bubble-headed Bubbles (Julie McWhirter), the haughty Shelly (Pat Parris), and Clam-Head (Barry Gordon), a very Shaggy-like character given to crying "Woweee, wow, wow, wow!" when excited. Traveling to underseas cities in their Aquacar, the Neptunes encountered — and dealt with — the usual formidable as-

Above: The goofy Jabberjaw and, right, Jabberjaw and the Neptunes.

Although set in the future, "Jabberjaw," a 1976 series on ABC, also resembled "Scooby-Doo" in its format. (The resemblance was not incidental — Fred Silverman was now president of ABC Entertainment, and writers Ken Spears and Joe Ruby, who had worked on "Scooby-Doo," were not only influential in establishing the premise and the characters of "Jabberjaw" but also wrote most of the stories.) In this instance, Jabberjaw, voiced by Frank Welker in a style that recalled the moronic Curly of the Three Stooges, was a goofy shark who played the drums in

Main title for "Inch High, Private Eye."

sortment of comic-book villains. Jabber, of course, was always around to provide help, run interference, or simply offer a few wisecracks.

In addition to know-it-all automobiles, bumbling dog detectives, and lightheaded sharks, the teenager-oriented series created by Hanna-Barbera in the seventies included their share of human (or reasonably human or even once-human) characters. One diverting series, entitled "Inch High, Private Eye" (NBC, 1973), adapted the premise of "Get Smart," the prime-time series that spoofed the spy genre in the late sixties, but gave it an unusual twist. The inept agent Maxwell Smart, played by Don Adams, was now a minuscule detective named Inch High (Lennie Weinrib, using a Don Adams–like voice), who solved crimes with the aid of his normal-size teenage niece Lori (Kathi Gori); her Gomer Pyle–like boyfriend, Gator (Bob Luttell); and his misnamed dog, Braveheart. (The brandy cask on the dog's collar held Inch's supply of weapons and disguises.) In the "Get Smart" tradition, the "World's Biggest Little Detective" usually stumbled into success, but not before driving Mr. Finkerton (John Stephenson), head of the Finkerton Detective Agency, to hair-pulling despair.

Inevitably many of the jokes in "Inch High" depended on his Lilliputian size. On an assignment to capture Mr. Midas, the villain who is spreading counterfeit money around the city, Inch gets caught up in the money-making machinery at the U.S. Mint, where he is bounced about like a loose pebble. At a party where he is investigating a series of fur thefts, he somehow manages to get inside the olive in a martini in order to eavesdrop. Trying to snare a Sydney Greenstreet–like art thief, Inch sneaks into the museum and glues himself to a painting to observe the activities. In all episodes, whether riding in his silent Hushmobile to his next assignment or shouting "Geronimo!" as he moved in for the "kill," Inch exuded a totally unjustified confidence.

*Captain Caveman
on the loose.*

An even odder foil for intrepid teenage investigators made his entrance in "Captain Caveman and the Teen Angels," a 1977 ABC series sparked by Fred Silverman. A prehistoric cutup and clown set free from a glacier, Captain Caveman (or Cavey, as he was affectionately called) became the protector of a trio of girls known as the Teen Angels. As they went about solving mysteries, Cavey, their wacky, pint-size Stone Age companion who spoke a variation of pidgin English, came to their rescue wielding his magic club and emitting an ear-shattering cry of "Captain Caveman-n-n-n!" Suggested by the girls in ABC's hit series "Charlie's Angels,"[7] which had started its successful five-year run the year before, the Teen Angels consisted of vivacious Dee Dee (Vernee Watson); the perpetually frightened Taffy (Laurel Page); and Brenda (Marilyn Schreffler), a black girl who was clearly the smartest of the three. Together they sifted through clues and exposed crooks and thieves with Cavey's help. ("Go get 'em, Cavey!")

Voiced by Mel Blanc, Captain Caveman was a genuine original with a bottomless bag of magical tricks and an antic disposition. The Angels were involved in the plots—

uncovering the mystery behind the disappearance of a famous ice skater, or a prize car, or some precious gold calendars—but Cavey provided most of the fun as he tangled with modern civilization. In an episode called "Cavey's Crazy Car Caper," he finds himself on a car assembly line ("Me make wrong turn") and gobbles up auto parts at a nearby junkyard. ("Me love junk food.") Another episode had Cavey and the Angels invading a movie studio, where they unmask the Phantom who is mysteriously turning the beautiful leading ladies into wrinkled hags. Before the Phantom can be exposed, Cavey succeeds in wrecking a set ("Hunga-munga, me bring house down!").

Not all of Hanna-Barbera's series in the seventies involved nervy teenagers in far-flung or mysterious comedy adventures. Some new series returned to the older tradition of having a dull-witted or goofy animal hero with a comic sidekick involved in escapades. The tone of these series, however, was brasher and more broadly satirical than in "Huckleberry Hound" or "Yogi Bear," aiming, on the whole, to poke good-natured fun at the concept of the invincible superhero. "Hong Kong Phooey," for example, spoofed the idea of Superman as a meek non-entity transformed into a champion of justice, but added another, more recent target: the "Kung Fu" craze that had briefly swept the country in wake of the popular television series suggested by China's ancient martial art.

*Hong Kong Phooey
confronts a fly.*

Premiering in the fall of 1974 on ABC, "Hong Kong Phooey" centered on mild-mannered Penrod ("Penry") Pooch (voiced by veteran black actor Scatman Crothers), who worked at a police station as an inept janitor and was the bane of existence for tough Sergeant Flint (Joe E. Ross). Penry had a secret: whenever trouble loomed, he would leap into a file cabinet concealed in a secret room and emerge as Hong Kong Phooey, the Mutt of Steel. Accompanied by Spot (Don Messick), his snickering feline companion, he set about defeating a variety of villains, often by accident or the intervention of Spot. (Many of Hong Kong's ideas came from his *Hong Kong Kung Fu Book of Tricks*.) Every episode had him returning as Penry to the police station, where his sole friend was Rosemary (Kathi Gori), the switchboard operator.

"Hong Kong Phooey" won many of its laughs from the hero's bumbling antics and the disbelieving, amused reactions of Spot. (He continually smacks his forehead in exasperation.) The villains, as usual, were a colorful lot, ranging from the benevolent-seeming Grandma Goody to the Malevolent Magician, from the Batty Bank Mob to Dr. Disguiso. In "The Great Choo Choo Robbery," Hong Kong tangles with Rhinestone Jim Shady, who makes entire trains vanish in an instant, and in "Patty Cake, Patty Cake, Bakery Man," he finally succeeds in foiling Mr. Pattycake, an original-minded jewel thief who hides his loot in gingerbread cookies. It takes a cynical Spot to finally trap Mr. Pattycake and his band of baker thieves in their own dough.

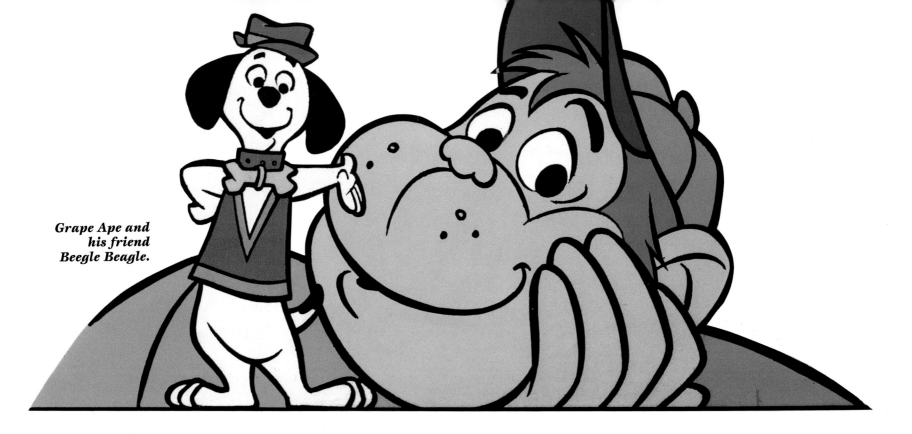

*Grape Ape and
his friend
Beegle Beagle.*

The animal-hero-with-sidekick pattern continued in the 1975–76 season with the introduction of one of Hanna-Barbera's most likable creations, a forty-foot, purple-colored ape with limited mental powers, who stumbled from one adventure to another with his companion, a jaunty carnival hustler named Beegle Beagle (Marty Ingels). Voiced in a deep bass monotone by Bob Holt, Grape Ape, as he is called, was prone to mutter "Sorr-ee!" whenever he sparked yet another disaster with his gargantuan size. His tremendous strength, however, could also be used to help his friend "Beegily Beagily" out of any dilemma. Asked to perform a heroic deed or a feat of strength, he invariably replied, "Okey dokey!"

Starting in the fall of 1975 in tandem with a new group of Tom and Jerry cartoons, "Grape Ape" involved the thick-skulled but sweet-natured ape in stories that ran the gamut from broad spoofing to way-out fantasy. Traditional army comedy was sent up hilariously when Beegle and Grape Ape are drafted into the service by mistake. In basic training, Grape Ape goes through the roof when he stands at attention, demolishes a barrack when his reflexes are tested, and passes the intelligence test by throwing pens at

the right answers. Another episode poked fun at the Robin Hood variety of swashbuckler by having Grape Ape pretend to be the Purple Avenger, rescuing the beleaguered people of Dumpnograd from the nasty tyrant Baron Nogoodnik.

Occasionally the satire in "Grape Ape" moved close to the edge of happy lunacy. In one of the funniest entries, Grape Ape and Beegle have become stalwart Canadian Mounties. Spoofing the hard-breathing gaslight melodramas of the turn of the century, the story has the duo rescuing the blonde heroine Rosie O'Lady from the machinations of Bart Blackheart, owner of the Cross-Canada Railroad, who wants to build the railroad through Rosie's house. A familiar plot line, but this heroine is decidedly strange: tied to a railroad track in the path of an oncoming train, Rosie calmly continues her knitting. Helplessly floating down the river in the direction of a waterfall, she deplores the villain's using "the old waterfall routine." And she refuses to be locked out of her own home, at least "not when my favorite soap opera is on!" Meanwhile, the luckless Blackheart gets clobbered at every turn; "Drat and double drat!" he exclaims; "The villain always gets it," as

Grape Ape entangles him in the railroad track ("Coiled again!") or catapults him into the train's smokestack ("Soiled again!").[8]

"Superman," "Batman," and their heroic ilk also came in for genial spoofing, in "Dynomutt," a Hanna-Barbera series that was introduced in the fall of 1976 on ABC, along with new episodes of "Scooby-Doo." Ultimately known as "Dynomutt, Dog Wonder," when he was given his own show nearly two years later, the goofy canine was actually a robot teamed with Blue Falcon (Gary Owens), a red-caped, blue-cowled superhero, in a continual fight against crime. Working for the mayor of Big City, they sped about in their Falcon Car, taking on evildo-ers. There was a catch, however: comically inept and bumbling, the feather-brained Dynomutt (voiced by Frank Welker) constantly interfered with B. F. (as he called him) and often turned a heroic deed into a disaster. Yet he would frequently help the Falcon out of dangerous predicaments, extending his paws by means of a system of miniaturized transistors. The Blue Falcon himself had an array of superhero gimmicks and devices.

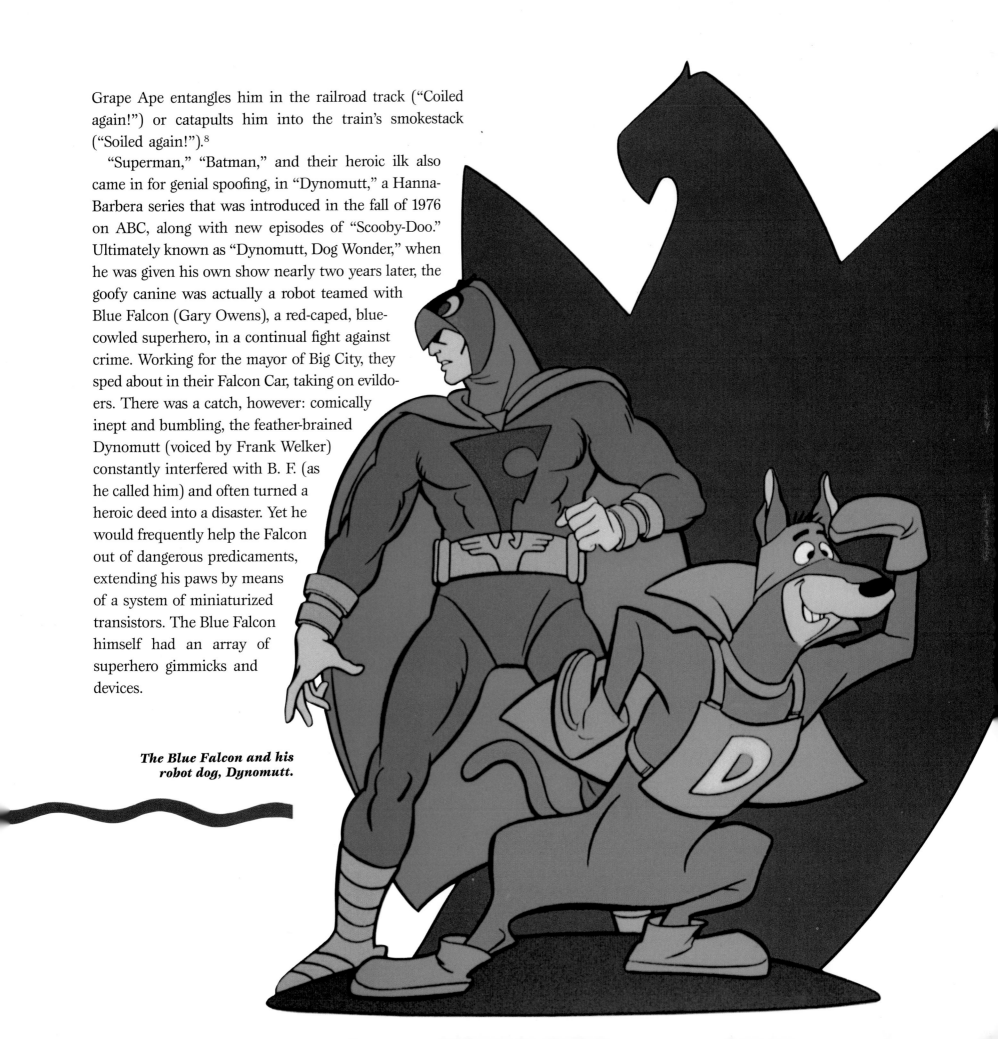

The Blue Falcon and his robot dog, Dynomutt.

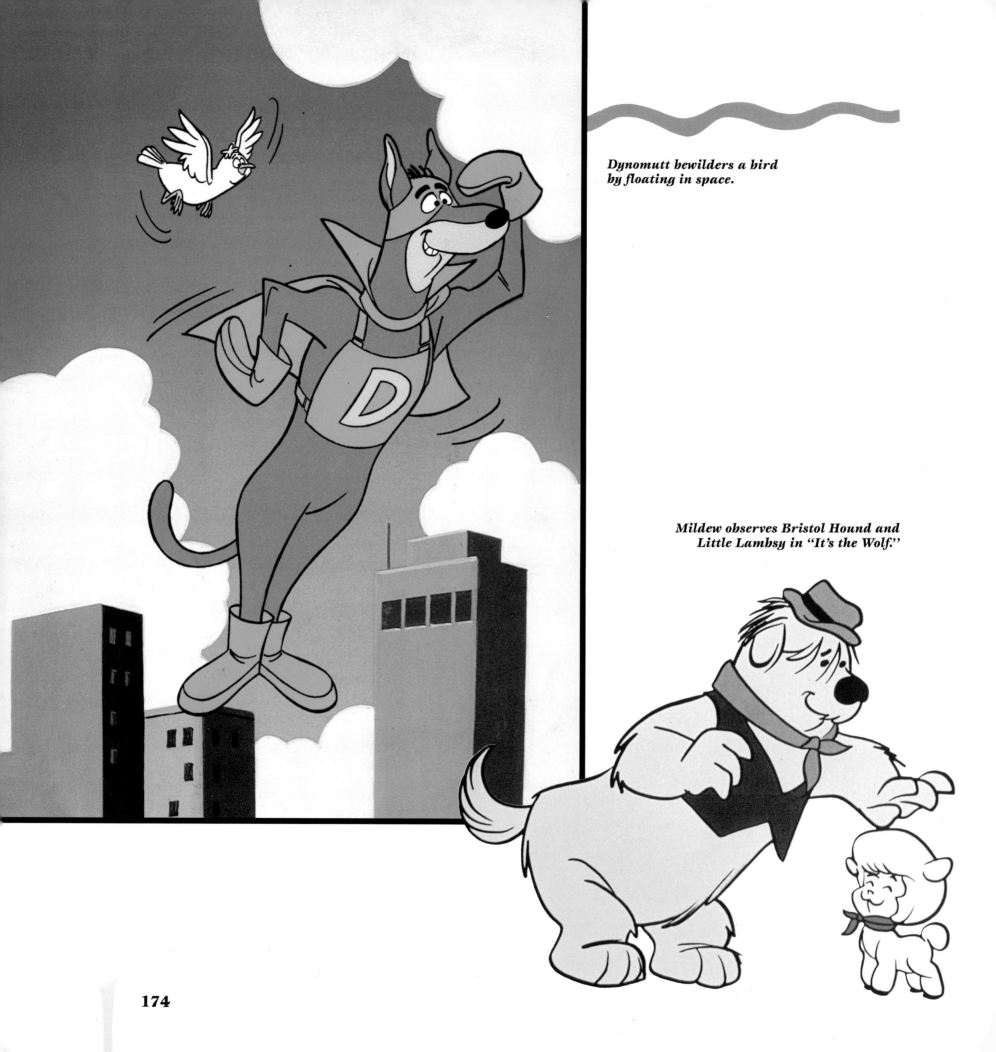

Dynomutt bewilders a bird by floating in space.

Mildew observes Bristol Hound and Little Lambsy in "It's the Wolf."

174

Written with flair and a sharp sense of humor, largely by Joe Ruby and Ken Spears, "Dynomutt" was a mix of comic-book adventure and a generous dose of slapstick. The concept of a clownish robot in league with a superhero resulted in many amusing episodes. Typically, one episode had the Blue Falcon and Dynomutt rushing from their home, the Falcon's Lair, to do battle with the arch-villain Fishface, who not only plots "the sea crime of the century" — robbing all the passengers on the S.S. *Gigantic* — but also schemes to control Big City by taking over its oil supply. (Told to be alert, Dynomutt quips, "I'll be as alert as a long-tailed cat in a rocking chair factory!") Before they can defeat Fishface, the Falcon must call on such devices as his Instant Ice-Cube Maker, which freezes the water in a shark-infested pool. For his part, Dynomutt has to use his extenders to reach unreachable places. ("Nothing like an old hand around the house," he claims.) Another criminal, known as "the Blimp, evil genius of the air waves," schemes to take over the world's supply of helium and give everyone his own enormous girth (he will "blimpify" them). Riding to save the day, the Falcon and that endearing dim-wit Dynomutt pull out their full array of gimmicks, including a Dyno-Helium Sniffer and Instant Costume Capsules that change their appearance immediately. Dynomutt, of course, continually trips over his own amiable stupidity. (Blue Falcon: "When will that dog ever learn?")[9] Occasionally the shades of "Tom and Jerry" turned up in a series to remind viewers that animals still enjoyed

Motormouse and Autocat.

outwitting or demolishing each other in a nonstop game of cat and mouse. "Autocat and Motormouse," which was part of the "Cattanooga Cats" cartoon sequence, offered a "revved-up" variation of the old Tom and Jerry show, featuring energetic Autocat (Marty Ingels) as a feline sports car fanatic determined to beat little Motormouse (Dick Curtis) in a continual series of frenetic races. It came as no surprise when the mouse always triumphed over the cat. Another series in the same hour time slot presented an amusing variation on the Tom and Jerry theme of futile pursuit. In "It's the Wolf" the tireless Mildew Wolf (voiced inimitably by Paul Lynde) tried to devour sweet little Lambsy (Daws Butler), only to be thwarted at every turn by an English sheepdog named Bristol Hound (Allan Melvin). ("Bristol Hound's my name, and saving sheep's my game!")

Chopper and his gang look down on Wheelie and his loving girlfriend, Rota Ree, in "Wheelie and the Chopper Bunch."

One 1974 series on NBC featured a mechanized version of the same theme. "Wheelie and the Chopper Bunch" was set in the automotive world, where Wheelie, a champion stunt-racing car, continually had to fend off the efforts of a sneaky motorcycle gang called the Chopper Bunch to destroy him or humiliate him before the eyes of his rotary-engined girlfriend Rota Ree (Judy Strangis). The Bunch was a colorful lot, headed by the ferocious, bullying Chopper (Frank Welker), who punctuated his speech with a hilarious assortment of automotive shrieks, whistles, and sputters; his cronies were the excitable Scrambles (Don Messick); the giggling Revs (Paul Winchell), who sounded like movie comedian Hugh Herbert; and the moronic Hi-Riser (Lennie Weinrib). Wheelie himself (Frank Welker) communicated only with an expressive horn. The lively episodes had Chopper continually trying and failing to wreck Wheelie — in the Tom and Jerry tradition, all his schemes end in ruin for him and the Bunch. ("I told ya! I told ya!," Scrambles shouts after every setback or disaster.)

A few years later Hanna-Barbera tried another motorized hero, with the series "Wonder Wheels" (CBS, 1977), in which a high school journalist named Willie (Mickey Dolenz) used his extraordinary supermotorcycle called Wonder Wheels to capture criminals.

While the idea of animal antagonists could always be counted on to provide the basis for a series, the opposite premise of a friendly gang of animals, banded together to pursue adventure or the common good, was also sure to turn up in a Hanna-Barbera series of the seventies. One such series, "Help! It's the Hair Bear Bunch!" (CBS, 1971) followed the example of "Wally Gator" by focusing on a trio of zoo bears who spent their time trying to elude or outsmart their keeper. Living in Cave Block Number 9 at the Wonderland Zoo were the leader, Hair Bear (Daws Butler), a crafty con artist with a full head of wavy hair; Bubi Bear (Paul Winchell), his level-headed friend; and Square Bear (Bill Callaway), their dim-witted crony. Hair's game, with the aid of Bubi and Square, was to win conces-

Right: A typical moment of comic chaos from "Help! It's the Hair Bear Bunch!"

"These Are the Days."

"The Roman Holidays."

sions from the testy keeper Mr. Peevely (John Stephenson), who tried to keep order with the help of his harebrained assistant Botch (Joe E. Ross).[10] Laced with the same sort of flip, sophisticated dialogue that characterized "Top Cat," "Help! It's the Hair Bear Bunch!" had an impudent knockabout charm that kept the program on the air for several seasons. The title was changed to "The Yo Yo Bears" when the show entered syndication in 1974.

Occasionally a Hanna-Barbera series of the seventies could trace its lineage to one previous success. "Roman Holidays," premiering in the fall of 1972, clearly took a leaf from "The Flintstones" by placing an ordinary family in a long-vanished period of history and giving them the same problems and hang-ups of a contemporary American fam-

ily. In this instance, the setting was ancient Rome, circa A.D. 63, and the family was the Holidays: father Gus (Dave Willock); mother Laurie (Shirley Mitchell); their daughter, Precocia (Pamelyn Ferdin); and their son, Happius, nicknamed "Happy" (Stanley Livingston). Living in their apartment in the Venus de Milo Arms in Pastafasullo, Rome, with their pet lion, Brutus (Daws Butler), the Holidays endured the familiar frustrations of big city life, many of them brought about by their unpleasant landlord, Mr. Evictus (Dom DeLuise).[11] As in "The Flintstones," the humor in many of the episodes stemmed from transposing modern-day concerns and objects to ancient Roman times. (Gus subscribes to *Chariot and Driver* magazine, and Laurie prepares Caesar's salad for supper — "I think I'll be patriotic.")

A few of the seventies series from Hanna-Barbera offered animated variations on the sort of family-oriented live-action programs that were prevalent during the decade. "Where's Huddles?" (CBS, 1970) centered on Ed Huddles (Cliff Norton), a professional football star, and the hectic life with his wife, Marge (Jean Vander Pyl), and their best friends Bubba and Penny McCoy (Mel Blanc and Marie Wilson). As in "The Honeymooners," many of the situations were provoked by Ed and Bubba's attempts to supplement their income. Another series, "Wait Till

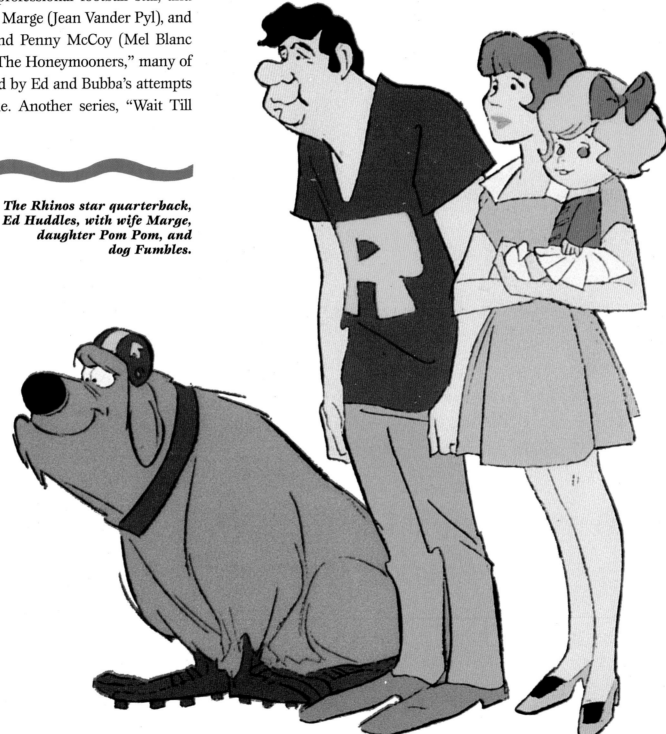

The Rhinos star quarterback, Ed Huddles, with wife Marge, daughter Pom Pom, and dog Fumbles.

"The Partridge Family: 2200 A.D."

Below: Shirley Partridge and Orbit, from
"The Partridge Family: 2200 A.D."

Your Father Gets Home" (syndicated, 1972), echoed "All in the Family" in its story of the Boyle family and the generational conflict between old-fashioned father Harry (Tom Bosley) and his more modern children. The small-town warmth and nostalgia of "The Waltons" were evoked in the series "These Are the Days" (ABC, 1974), which concerned the everyday joys and tribulations of the Day family in the cozy town of Elmsville.

Several times a popular live-action family series was simply adapted to animation with little change, or was lifted bodily into another era. "The Addams Family" (NBC, 1973) revolved around the grotesque family of eccentrics and crackpots that had amused audiences in the mid-sixties on ABC. Based on Charles Addams's *New Yorker* cartoons, the ghoulish group, headed by the decidedly weird Gomez (Lennie Weinrib) and his somberly beautiful wife, Morticia (Janet Waldo), toured the country in a recreational vehicle, which was actually a traveling haunted house complete with bats. Several members of the original live-action cast (Jackie Coogan, Ted Cassidy) repeated their roles. "The Partridge Family: 2200 A.D." (CBS, 1974) announced its premise in the title. Drawing on the popular series that had run for four years (1970–74) on ABC, the show projected the singing Partridges — a widowed mother and her children — into the next century so they could enjoy many futuristic adventures.

Right: Harry Boyle clearly is not enjoying the impromptu
concert in "Wait Till Your Father Gets Home."

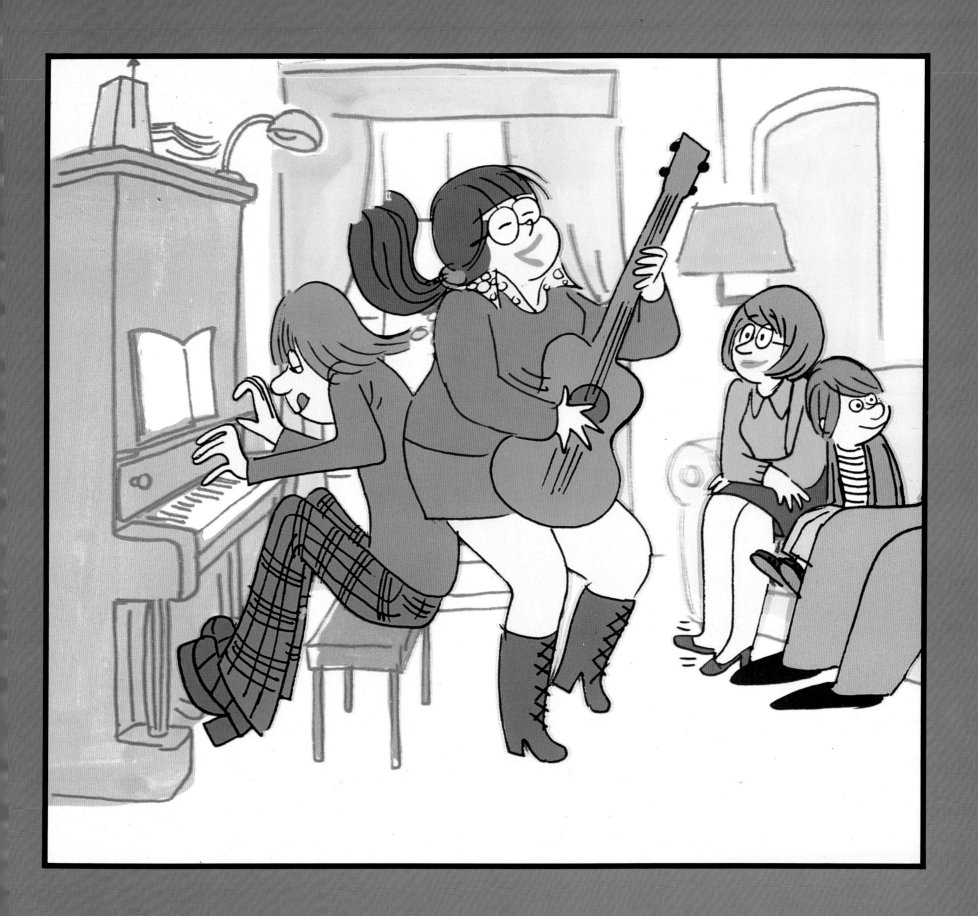

Ernie Devlin performs a daredevil stunt in "Devlin," with the help of sister Sandy.

When Hanna-Barbera did turn back to straight-action animation in the seventies, it was in a style considerably removed from the flamboyant comic-book animation of the late sixties.[12] Even in a futuristic environment, as in "Sealab 2020" (NBC, 1972), the tone was curiously muted and sober. Set in the twenty-first century, the series was centered on a self-contained city on the ocean floor where Dr. Paul Williams (Ross Martin), a Chinook Indian with extensive knowledge of oceanography, headed a team engaged in high-level scientific research. Dr. Williams drew on the help of three young astronauts and also took on a number of passengers from a floundering ship into Sealab 2020, where they joined the others in underseas adventures with scientific underpinnings. Another action series, entitled "Devlin" (ABC, 1974), was moored closer to earth, dealing with three orphaned young people, aged eleven to twenty, who performed as a daredevil motorcycle team with a small traveling circus. The series had them working out their domestic problems or coping with problems involving the circus while they dispensed an occasional safety tip.

Bobby Murphy rides a porpoise in "Sealab 2020."

Left: A scene from "Sealab 2020."

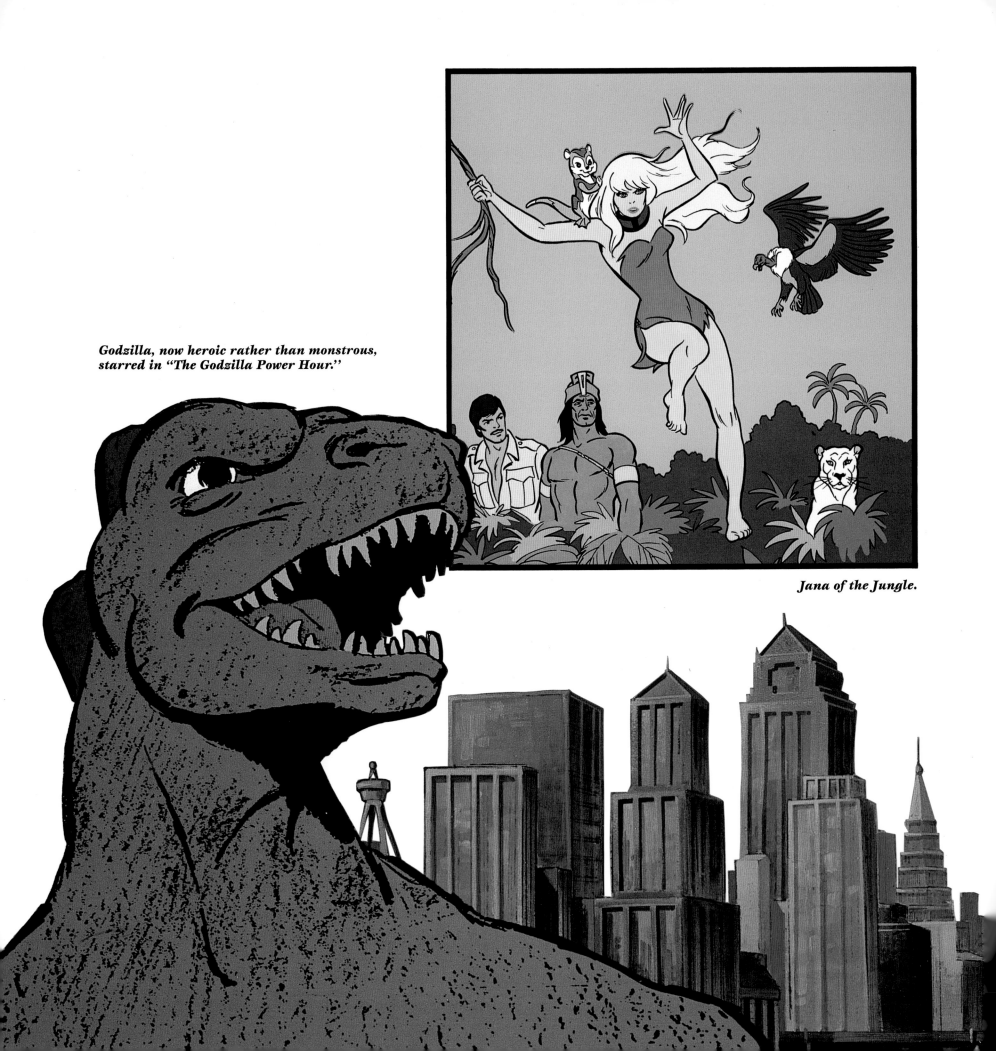

Godzilla, now heroic rather than monstrous, starred in "The Godzilla Power Hour."

Jana of the Jungle.

Later in the decade, in the fall of 1978, two new fantasy adventure series were paired for a Saturday morning program on NBC with the umbrella title "The Godzilla Power Hour." The Godzilla of the title bore no resemblance to the giant lizard that had made his debut in 1954 (1956 in the United States) in a surprisingly successful Japanese science fiction movie called *Godzilla: King of the Monsters*. Here, Godzilla (Ted Cassidy) became a 400-foot-tall amphibian who attached himself to a research ship's crew after they rescue his little relative, a cheerful green dragon named Godzooky (Don Messick). The ship's passengers, headed by Captain Carl Majors (Jeff David) and a scientist named Dr. Quinn Darien (Brenda Thomson), faced perilous adventures as they investigated mysterious phenomena all over the world. Inevitably Godzilla emerged from the ocean's depths to rescue them. The second series on "The Godzilla Power Hour," entitled "Jana of the Jungle," was centered on a Sheena-like young girl (B. J. Ward) who spent most of her time searching for her lost father, accompanied by her pet animals and by a friendly Indian chief (Ted Cassidy) who carried a magical "staff of power." Jana herself had a necklace holding a disc she could detach and hurl at her enemies.

The seventies had witnessed a rich and wide assortment of animated programs from Hanna-Barbera, as well as the birth of many new characters who would find a permanent place in cartoon lore. More than three decades after Bill Hanna and Joe Barbera had created the first "Tom and Jerry" cartoon, the sense of cheerful irreverence, the penchant for inspired slapstick that had permeated their work from the beginning, persisted in such shows as "The Wacky Races" and "Scooby-Doo, Where Are You?" To these qualities Hanna and Barbera had added a well-honed skill at creating high-flying animated adventure, as well as increasingly inventive and detailed animation techniques.

The seventies had been a heady time for Hanna and Barbera. And new challenges lay ahead.

Animated Specials and Features

I enjoy seeing a well-animated feature where the animator truly brings out the character of the drawing—with the proper voice and with the character really acting to bring out the emotions.

—Bill Hanna

Over the years Hanna and Barbera have occasionally moved outside the orbit of the weekly series to produce special films for television and theaters. Many of these films have drawn on familiar characters (the Flintstones, Yogi Bear), placing them in more complicated situations and giving them the advantage of more detailed animation. Others have been derived from celebrated stories that lend themselves well to the animator's art. Most of these films display skilled techniques that lie somewhere between the economical style of limited animation and the much more expensive requirements of full animation. Still other films have been live-action features with no animation whatsoever.*

Throughout the sixties and seventies the studio presented (frequently in co-production) animated versions of many of the best-loved children's stories, from *Alice in Wonderland* (ABC, 1966) to *Gulliver's Travels* (CBS, 1979). The stories ranged far afield, from the swashbuckling adventure of *The Count of Monte Cristo* (syndicated, 1973) and the fantasy of *Twenty Thousand Leagues Under the Sea* (syndicated, 1973) and *Five Weeks in a Balloon* (CBS, 1977) to the rugged Americana of *Last of the Mohicans* and *Davey Crockett on the Mississippi* (both syndicated in 1975). On one occasion, Hanna-Barbera adapted Anna Sewell's classic novel *Black Beauty*, with pleasing results. The perennially popular (and often filmed) tale of a horse's tribulations in nineteenth-century England contained many affecting sequences in which Black Beauty "sinks to the bottom of man's ugly world," until he finally comes to understand the meaning of his mother's words, " 'Twill all come right. Some day or night." The horse's relationships with his friends Ginger and Merrylegs, and with the humans who treat him with kindness or cruelty, were depicted expertly in animation.

One show, produced for NBC in 1966, combined animation and live action in a diverting musical adaptation of

*See page 257 for a full listing of Hanna-Barbera's live-action productions.

Left: Heidi and her animal friends.

"Last of the Mohicans," 1975.

"Davy Crockett on the Mississippi," 1975.

Beauty is trapped in a fire in "Black Beauty," 1978.

the perennial children's story *Jack and the Beanstalk*.[1] A fanciful twist was given to the tale by having young Jack (Bobby Riha) meet a jovial man-of-all-trades named Jeremy Keen (the inimitable Gene Kelly), who persuades him to trade his mother's cow for a handful of "magic" beans. When the beanstalk sprouts to the skies, Jack and Jeremy climb it to the kingdom ruled by the Giant, where they experience many colorful adventures. In particular, Jeremy meets and falls in love with the beautiful Princess Serena, whom he rescues from the Giant's lair. The songs by Sammy Cahn and Jimmy Van Heusen, including "Half-Past April and a Quarter to May," "It's Been Nice," and "What Does a Woggle Bird Do?," were agreeable, but the film's most charming sequences depended on the juxtaposition of real and animated characters, as when Jeremy performs a delightful dance and close order drill with a group of mice or when he dances with the animated Princess Serena to the song "One Starry Moment." The film received an Emmy as the year's Outstanding Children's Special.

Following pages: Jack (Bobby Riha) and Jeremy (Gene Kelly) try to flee from the Giant's clutches in "Jack and the Beanstalk," 1966.

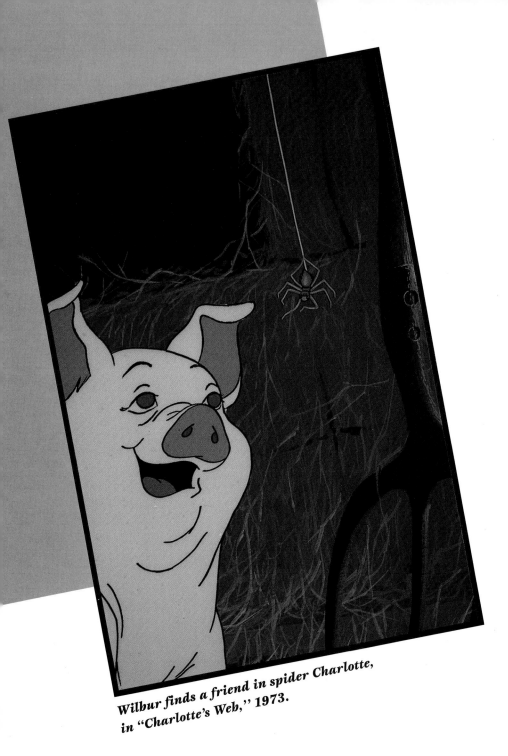

Wilbur finds a friend in spider Charlotte, in "Charlotte's Web," 1973.

In 1973 Hanna and Barbera were ready to bring another favorite story to the larger screen of the movie houses. Until then, their theatrical features had been confined to the few that drew on their most popular animated characters. Now they were assigned to create a musical adaptation of a book that had no relation whatsoever to any of their previous work. Since its publication in 1952, E. B. White's *Charlotte's Web* had enchanted readers of all ages with its story of Wilbur the pig, his barnyard friends, and especially Charlotte, the wise spider who saves his life in an unusual way. Edgar Bronfman, the president of Seagram's and an active figure in Hollywood, had acquired the rights to the book and now turned to Hanna-Barbera to produce a musical version of White's elegantly simple and moving parable about life's verities. White himself had described *Charlotte's Web* as "a tale of friendship and salvation, a story of miracles — the miracle of birth, the miracle of friendship, the miracle of death." Hanna and Barbera and their creative teams worked diligently to do justice to the story, and the result was a lovely film.

Beginning with beautiful images of a farm in springtime, where "life is good and busy and brand-new," *Charlotte's Web* quickly establishes the friendship between Fern Arable (Pamelyn Ferdin), the farmer's young daughter, and sweet, naive Wilbur (Henry Gibson). (She sings "Me and You" to him.) His very unpiglike behavior — terrified by a nighttime thunderstorm, he rushes into the house and knocks over Farmer Arable — causes him to be sold to Fern's uncle Homer Zuckerman. In the new barnyard, he learns to speak ("I Can Talk!" he sings, exulting "Isn't it great/That I can articulate!"). He also meets the very proper Goose (Agnes Moorehead); the gluttonous, ill-tempered rat named Templeton (Paul Lynde); and a ram who gives him terrible news: when he reaches maturity, Wilbur will be killed to make smoked ham and bacon for the household! Enter Charlotte the spider (Debbie Reynolds), who urges Wilbur to remain hopeful. "Chin Up!" she sings, in a tune that has more than enough sunny uplift to spare.

Right: Charlotte talks to Wilbur's farm friends about a new word for her web.

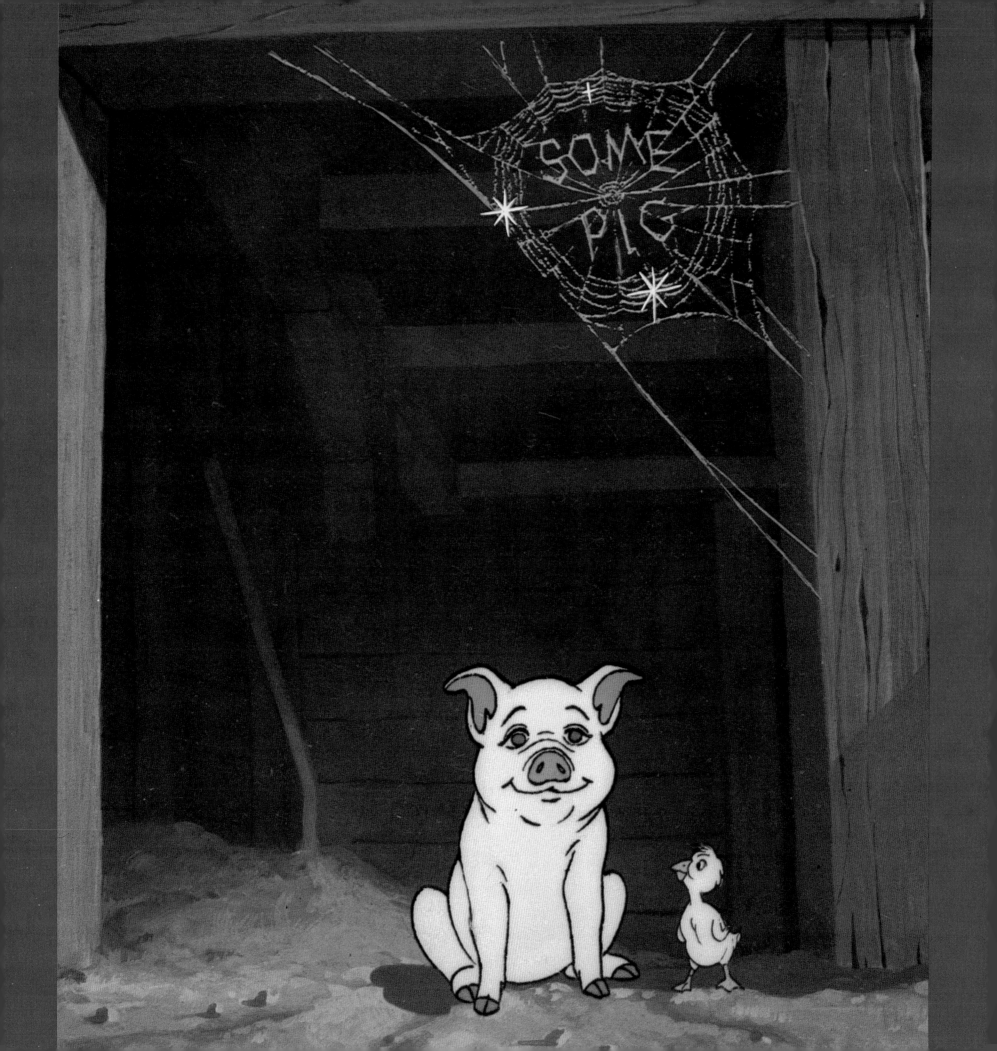

Charlotte, who proves to be "a true friend and a good writer."

While Wilbur makes more friends in the barnyard, singing "We've Got a Lot in Common" to an undersized gosling in an engaging sequence, Charlotte reflects on ways to save Wilbur's life. She also sings the title song, which is animated by many sparkling, shimmering images. ("Sometimes when somebody loves you, miracles somehow appear.") Finally, she gets an inspired idea: on her web she clearly spins out the words SOME PIG. Suddenly Wilbur is a local celebrity, attracting crowds who are anxious to see the miraculous pig. Charlotte keeps the curious coming by spinning out another message: TERRIFIC. When the novelty starts to wear off, Templeton brings her pieces of discarded boxes so that she can find new words to describe Wilbur. Her next message, taken from a box of soap flakes, reads RADIANT, and the amazement continues.

Egg-laying time for Charlotte is accompanied by one of the film's most exquisite sequences, an animated display of the earth's natural wonders — trees bursting with leaves, floating dandelions, shimmering butterflies — all animated to the song "Mother Earth and Father Time." At a joyful county fair in the fall, Wilbur wins a medal and is lionized as "Zuckerman's Famous Pig." But things are changing: Fern Arable no longer has any interest in

Left: Charlotte makes Wilbur famous by spinning the words SOME PIG.

Wilbur, and worst of all, Charlotte's life span is ending, although in one final burst of glory, she lays no less than 514 eggs! She manages to spin one final word: HUMBLE. At the same time, in the film's most memorable sequence, Templeton discovers that the fair is "a rat's paradise!" Singing "A Veritable Smorgasbord," the rascally rat gorges himself on leftovers, including apple cores, banana peels, bits of cheese, corn cobs, and half-eaten sandwiches.

Wilbur and gosling Jeffrey.

"Terrific" Wilbur is the sensation of the farm community; below, he poses for a photograph with Zuckerman's farmhand.

Templeton breakfasts on a discarded doughnut.

At the county fair.

199

The death of Charlotte forms the poignant climax of the film as the spider tries to reassure the desolate Wilbur. "You have been my friend," she tells him. "By helping you, perhaps I was trying to lift up my own life a trifle." After she dies, Wilbur guards her egg sac through the snowy winter, and then as life renews itself in the spring, the sac hatches, sending Charlotte's offspring into the world to make names for themselves. The three smallest, who stay behind and are too small to fly, are named Joy, Arania, and Nellie. Charlotte's virtues are sounded by Wilbur — "She was in a class by herself. She was brilliant, beautiful, and loyal to the end." But it is the narrator who speaks her memorable epitaph: "It's not often that someone comes along who is a true friend and a good writer. Charlotte was both." Without undue strain, *Charlotte's Web* touches memorably on universal themes: the continuing cycle of birth, growth, and death; the special joys and rewards of friendship; and even the power of the written word.

Released by Paramount in February 1973, *Charlotte's Web* drew admiring reviews in which the critics praised the film for retaining the book's charm and simple eloquence. *Variety* called it "heartwarming entertainment," while Arthur Cooper in *Newsweek* wrote that "the subtle, pastel movie animation fully captures the story's mood and charm. . . . Unlike so many children's films, this one leaves you with a warm afterglow and without the feeling that your wallet has been lifted by midgets." Clark Whelton, in New York's *Village Voice*, hailed *Charlotte's Web* as "a terrific animated musical movie," adding that "the tough, funny, non-sentimental E. B. White dialogue has been left intact, the color and animation are excellent, and the voice casting is right on the mark."

Fern pets Wilbur, now Zuckerman's Famous Pig.

Right: Sadly, Wilbur watches Fern and her friend Henry.

Heidi's Song, Hanna-Barbera's next major adaptation of a famous story, arrived in 1982 after years of intensive and exacting preparation. For a long time the studio had searched for another suitable property, aware that most of the classic stories had already been made by Disney. Although Johanna Spyri's enduring novel *Heidi* had been filmed several times before, it seemed to offer fresh potential as a musical feature. Joe Barbera remembers, "We knew that *Heidi* was still a great story, a tear-jerking story that everyone loved. But it had never been done as a musical. When we added the songs, we were able to give it an entirely new approach. We felt that it was a marvelous story that would live forever."

To create *Heidi's Song*, Hanna and Barbera brought together a number of exemplary talents. Sammy Cahn and Burton Lane were assigned to write the score for an adaptation of the story by Joe Barbera, Jameson Brewer, and Robert Taylor; Lorne Greene, Sammy Davis, Jr., and Margery Grey (as Heidi) were cast as principal voices. Under Robert Taylor's direction, the studio's most skilled team of layout artists, background artists, and animators were charged with providing the extensive animation required for a theatrical feature. The result was a thoroughly engaging movie, with a number of delightful sequences.

Heidi is taken to her grandfather's home in the Swiss Alps in "Heidi's Song," 1982.

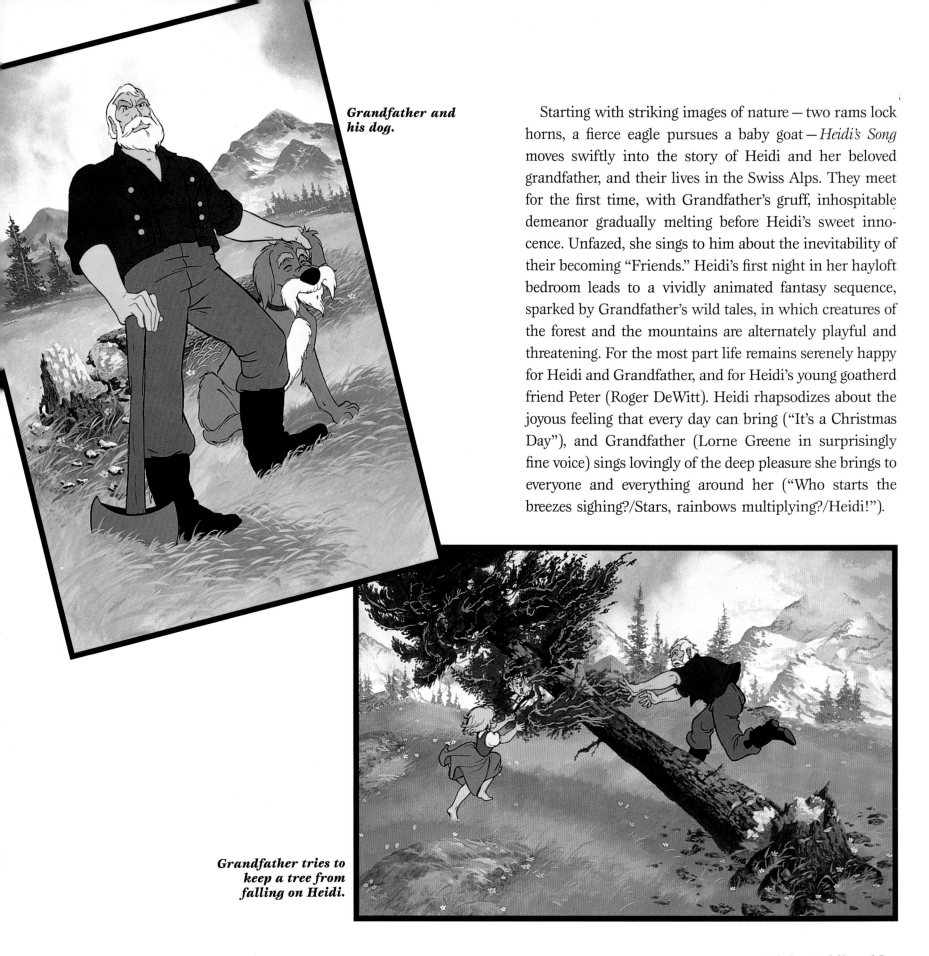

Grandfather and his dog.

Starting with striking images of nature — two rams lock horns, a fierce eagle pursues a baby goat — *Heidi's Song* moves swiftly into the story of Heidi and her beloved grandfather, and their lives in the Swiss Alps. They meet for the first time, with Grandfather's gruff, inhospitable demeanor gradually melting before Heidi's sweet innocence. Unfazed, she sings to him about the inevitability of their becoming "Friends." Heidi's first night in her hayloft bedroom leads to a vividly animated fantasy sequence, sparked by Grandfather's wild tales, in which creatures of the forest and the mountains are alternately playful and threatening. For the most part life remains serenely happy for Heidi and Grandfather, and for Heidi's young goatherd friend Peter (Roger DeWitt). Heidi rhapsodizes about the joyous feeling that every day can bring ("It's a Christmas Day"), and Grandfather (Lorne Greene in surprisingly fine voice) sings lovingly of the deep pleasure she brings to everyone and everything around her ("Who starts the breezes sighing?/Stars, rainbows multiplying?/Heidi!").

Grandfather tries to keep a tree from falling on Heidi.

Right: Heidi and her friend Peter.

204

A sad Heidi arrives in Frankfurt, where she meets Clara, Fräulein Rottenmeier, and Sebastian.

Clara, Heidi, and kittens.

Heidi's Song follows the Spyri story by having Heidi separated from her beloved grandfather and forced to live in Frankfurt as a companion to the wealthy crippled girl Clara (Pamelyn Ferdin). (As Grandfather repeats the title song tearfully, there is a wonderful shot of Heidi sadly crossing the bridge away from her haven in the mountains.) In a nicely detailed Frankfurt, the plot thickens with the introduction of Fräulein Rottenmeier (Joan Gerber), Clara's mean-spirited governess, who detests Heidi on sight. ("She will never do for a cultured girl like Clara," she asserts, leading to her furious song, "She's a Nothing!") Heidi makes a few friends, including the blonde maid Tinette (Janet Waldo) and her shy coalman admirer Willie (Michael Bell). As usual in a Hanna-Barbera film, dogs, especially Fräulein Rottenmeier's comically nasty dog Schnoodle, provide comic relief.

Heidi's "disruptive" influence in the house—among other things, she gives Clara four cuddly kittens that cause a slapstick uproar—further alienates Fräulein Rottenmeier ("She is a bad influence!"). Nevertheless, Clara adores Heidi, and her spirits brighten. In a lavish se-

Heidi is frightened
by Head Ratte.

"You're Not Rat Enough to Be a Rat."

quence to the song "Can You Imagine," Clara imagines herself waltzing through an idyllic world with all her friends and a dashing Prince Charming. Heidi, however, is locked in the cellar as punishment, where she sings about the worst thing of all — "An Unkind Word" — while Hooty the Owl supplies some welcome comic contrast to the saccharine lyrics. In the movie's most remarkable sequence (not in the book), a group of raffish rats emerges to sing gleefully about their nasty ways. "You're Not Rat Enough to Be a Rat!" Head Ratte (Sammy Davis, Jr.) exclaims in song, and soon the screen is filled with kaleidoscopic and even phantasmagoric images bursting with light and color. Told by Hooty about Heidi's plight, Peter and his animal friends arrive in Frankfurt to save her from the rats in a comic free-for-all. Fräulein Rottenmeier gets her comeuppance from Clara's returning father; Tinette and Willie will marry; and best of all, Heidi goes back to her home in the mountains, to be reunited with Grandfather and her friends. There is even a happy ending with Clara, who forces herself to walk again when she has to save her kitten from an attacking eagle.

Despite the high quality of the production, *Heidi's Song* did not fare as well as expected at the box office. Today Bill Hanna feels that the fault for the disappointing business may well have been the title: "There had been so many *Heidi*s made that we probably should have given the film another title. Everyone worked so hard on it. I can remember going over the film at the end — Joe and I looked at it frame by frame, making final decisions and touches, and many minor corrections in animation." Joe Barbera also remembers that "a lot of love was involved in the movie." But he attributes the weak returns to the inept, even disastrous distribution, which had the film released simultaneously with two other animated features. This "cartoon glut" forced the reviewers and the moviegoers to choose among them. Barbera adds, "I also wanted to give the film a new title, but I was told it was too late. The distributors just threw it to the wolves."

A joyful moment for Heidi and the people she loves.

While theatrical animated releases were few and far between due to their enormous expense, Hanna-Barbera did turn out a number of animated television specials throughout the seventies. There were seasonal films (*The Thanksgiving That Almost Wasn't* and *A Christmas Story*, both syndicated in 1971); lively variations on legendary or literary characters (*Robin Hoodnik*, ABC, 1972; *Oliver Twist and the Artful Dodger*, ABC, 1972); and animated versions of popular live-action television series (*Gidget Makes the Wrong Connection*, ABC, 1972; *Lost in Space*, ABC, 1973). Hanna-Barbera even offered its own animated version of Edmond Rostand's celebrated play *Cyrano de Bergerac*, for which José Ferrer repeated his award-winning stage and screen role. Entitled simply *Cyrano*, it was shown on ABC in 1974.

Left: Clara falls out of her wheelchair, trying to keep her kitten from the clutches of an eagle.

One of Hanna-Barbera's finest animated films, *The Last of the Curlews*, appeared in October 1972 as an ABC Afternoon Special. Based on a book by Fred Bodsworth, this moving and beautifully wrought film dramatized the life of a lonely migrating bird and the dangers of extinction. Without even a hint of anthropomorphic "cuteness," it focused on a single Eskimo curlew, the last of his rapidly vanishing breed, who hesitates making his annual yearly flight to South America in the hope that a mate will finally appear. Reluctantly he begins his lonely trek, eventually joining a flock of golden plovers who must overcome extraordinary difficulties to make it safely to the fields and mountains of Venezuela and Argentina. To his joy, he discovers a mate, but their brief, happy life together is shattered tragically when she is killed by a hunter's bullet. The frantic curlew flies off alone to his winter home.

Exquisitely animated, and with a lovely musical score by Hoyt Curtin, *The Last of the Curlews* contains many striking images and sequences that convey a lyrical sense of the curlew's plight. We can sense his fleeting moments

Sadly, Mark holds the dead body of the curlew's mate in "The Last of the Curlews," 1972.

The curlew leads a flock of migrating plovers.

of pleasure — he soars straight into the sky when he joins the migrating plovers, and he performs a ritualistic dance of joy when he finds his mate. We can also feel the terror of the birds at being caught in a raging storm and the curlew's anguish when his mate is fatally wounded. Desperately he tries to feed her a worm, then rushes about squealing in despair when he realizes she is dead.

The Last of the Curlews falters only when it interjects an instructional note about hunting into the scenario. Incidental footage is given over to a hunter and his young son, who is taught the basic rules of hunting by his father and who is given a small lecture on the hunter's role in the scheme of things. "We just keep nature in balance," he tells the boy. The film also contains one song, "Golden Wings," which would be expendable if not for the beautiful images accompanying it. A memorable film with an important message, *The Last of the Curlews* received an Emmy Award as the Outstanding Achievement in Children's Programming.

Over the past decade Hanna and Barbera have continued to offer animated television specials featuring some of the world's most beloved characters, both new and old. The cost of every special may be high, and each production may require the prodigious effort of an army of people, working at top form. There is also the undeniable risk of giving shape and form to the people and creatures who have existed for decades only in the vivid imagination of readers. Yet the rewards of breathing life into a well-loved story are great indeed, and the exciting promise of bringing one of these stories to the world of animation is one that never fades.

Left: the last curlew.

Present Tense, Future Tense: The Eighties and Beyond

Hanna-Barbera moved confidently into the eighties with new programs and concepts that expanded their worldwide enterprises. In addition to the many variations on such perennially popular shows as "The Flintstones" and "Scooby-Doo," there were new series that continued the studio's tradition for creating original and laugh-provoking animated characters. Other series followed the successful seventies pattern of involving a group of intrepid teenagers in comic-book adventures laced with humor.

One such series, premiering in the fall of 1980 on CBS, took a leaf from CBS's live-action 1978 series, "The Incredible Hulk." "Drak Pack" centered on three seemingly normal teenage boys named Drak, Jr. (Jerry Dexter), Frankie (Bill Callaway), and Howler (also Bill Callaway). However, Drak, Jr., happened to be the great-grandson of that favorite fang-baring creature Dracula, and all three boys had extraordinary powers. Clasping their right hands together and uttering the word "Wacko!" they were trans-

We never stop planning. We never stop dreaming.

—**Bill Hanna and Joe Barbera**

formed into Dracula, the Frankenstein monster, and a werewolf, though not the fearsome demons of legend but fighters against evil and injustice. Summoned by greatgrandad Big D (Alan Oppenheimer) to a TV screen, the Drak Pack was assigned in each episode to thwart the plans of O.G.R.E. (Organization of Generally Rotten Enterprises). Heading the organization was the brilliant but mad Dr. Dred (Hans Conried), who roamed the earth in his Dredgible with his wicked henchpersons Toad (Don Messick), Fly (also Messick), Mummy Man (Chuck McCann), and Vampira (Julie McWhirter).

Another 1980 series from Hanna-Barbera drew on already established teenage characters, placing them in an entirely new environment. Launched on ABC in November, "Fonz and the Happy Days Gang" used animated versions of the happy-go-lucky teenagers who had achieved wide popularity in the situation comedy "Happy Days" since 1974. Set in the 1950s, the series originally focused on young Richie Cunningham[1] (Ron Howard)

Left: "My Smurfy Valentine," 1983.

215

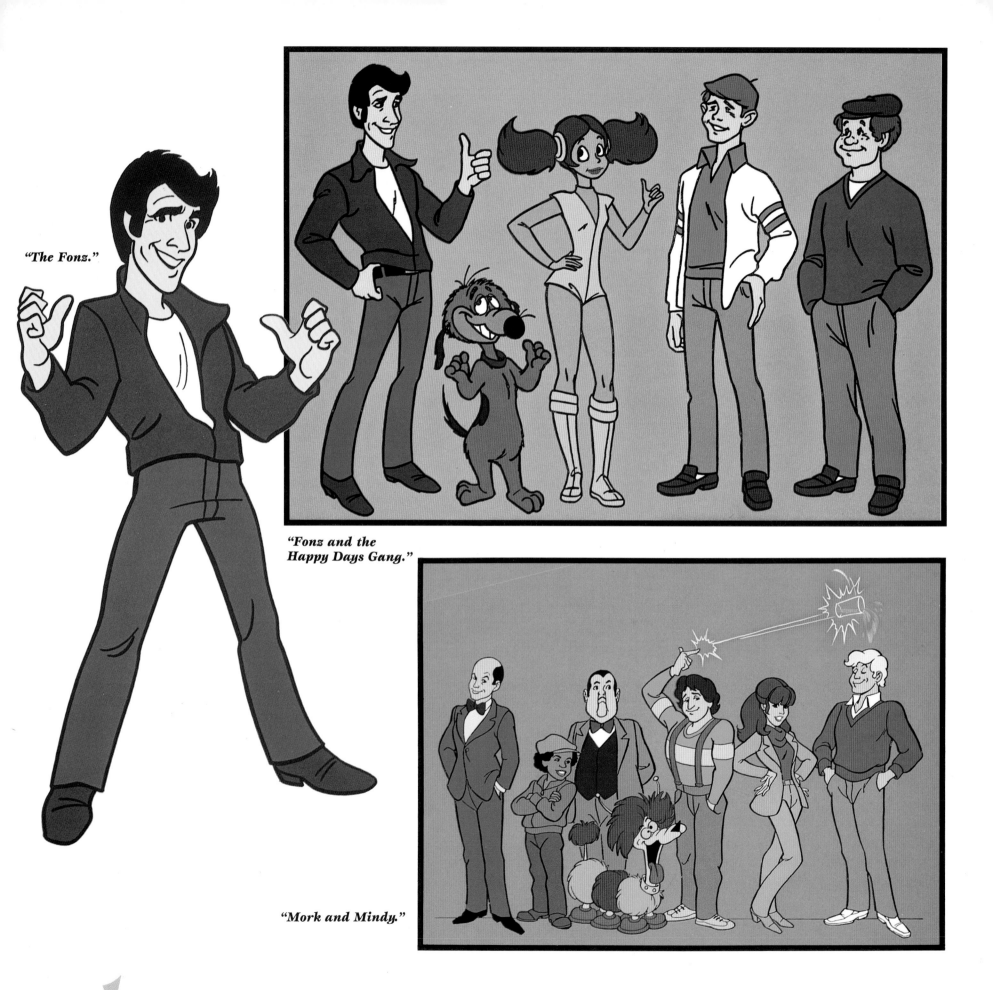

"The Fonz."

"Fonz and the
Happy Days Gang."

"Mork and Mindy."

216

Kwicky Koala.

"*The Kwicky Koala Show.*"

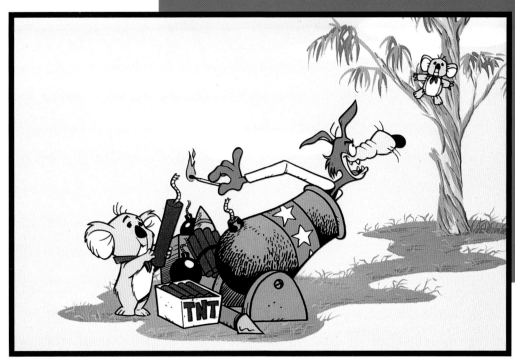

and his family, but the emphasis soon shifted to his "cool," take-charge friend Arthur ("the Fonz") Fonzarelli (Henry Winkler), who became a cult figure. Hanna-Barbera retained only the two characters (plus pal Ralph Malph, played by Danny Most), projecting them out of 1957 Milwaukee into different times and locales. The Fonz's job as unflappable leader was to get his friend out of a variety of fantastic dilemmas. Other popular sitcom characters receiving animated treatment from Hanna-Barbera included "Laverne and Shirley" (ABC, 1981) and "Mork and Mindy" (ABC, 1982).

As always, the ever-reliable cats and dogs could be counted on to provide colorful characters for Hanna-Barbera cartoons. A new group of feline and canine faces turned up on the Saturday morning schedules of the networks during the first half of the eighties. In the fall of 1981 CBS brought several of them together in the same time slot under the title "The Kwicky Koala Show." Brash, impudent, and above all, uproariously funny, they all carried unmistakable echoes of celebrated animator Tex Avery. Not long before his death in 1980, Avery had prepared a brief pilot film of "Kwicky Koala" for Hanna-Barbera, and although the animators who followed him

were unable to duplicate his style, there were Avery influences in the steady stream of wisecracks by leading characters, the almost surrealistic humor of many of the gags, and the continual chases that had one character in endless, futile pursuit of the other. "Tex Avery's timing was wonderful," Joe Barbera has said. "He was faster than the eye."

The title show, "Kwicky Koala," was typical of Avery's approach. Kwicky (Robert Allen Ogle), adorable, innocent-seeming, but actually sly in the honored tradition of Jerry the mouse and Tweetybird, continually eluded the grasp of Wilfred Wolf (John Stephenson), who went to extraordinary lengths to catch him. When "Kwicky Goes West," the wolf even goes to the trouble of quickly erecting an entire western town and assumes various disguises to nab Kwicky, including "Limpalong Louie, the smartest figure in the West," and the stoic Indian "Cast-Iron Eyes." Frustrated to the point of madness, he creates his own "koala catcher" in the form of a stagecoach. Of course everything goes wrong: he gets thrown by a horse, his tail gets caught in the roller of a player piano, and he rides off a cliff. As disaster beckons at every turn, Wilfred can only shout a plaintive and doom-laden "Oh, no!"

Howard Cossell, pretends to be a doctor ("I am Dr. Dirty, M.D., P.D., R.S.V.P., A.S.A.P., and C.O.D.," he tells everyone). One segment had Dirty wooing a French poodle, not with romance on his mind but with the thoughts of the delicious meals she can dispense. Dirty and his friends end up in a restaurant, where they gorge themselves, then give the bill to a bewildered Officer Bullhorn.

"Crazy Claws," the third component of "The Kwicky Koala Show," may well have been the funniest. A wise-cracking cat with a quip, or show-business "schtik," for every occasion, Crazy (Jim McGeorge) was the perennial target of Rawhide Clyde (Robert Allen Ogle), a short, ill-tempered mountain man with a beard and coonskin cap, who was always accompanied by his dog, Bristletooth (Peter Cullen). Bristletooth was the latest in Hanna-Barbera's parade of untrustworthy hounds who would do anything for a prize, here a piece of beef jerky. Often on hand was the perennially nervous and worried Ranger Rangerfield (Michael Bell). Fast-paced and hilarious, the "Crazy Claws" episodes had the quipping cat forever getting the best of the calamity-prone Clyde. In one segment, "Bearly Asleep," Crazy deliberately leads Clyde into the lair of a hibernating bear. While chasing Crazy, poor Clyde tries desperately to keep the bear from waking up. Of course he fails, not once but often. Caught up in the mayhem, jittery Ranger Rangerfield remarks, "I should have gone into an easier line of work. Like wrestling sharks." Other eighties series from Hanna-Barbera continued

Other components of "The Kwicky Koala Show" shared the same flip, nose-thumbing attitude that made them irresistibly funny. "Dirty Dawg" (Frank Welker) and his scruffy pal Ratso (Marshall Efron) emulated other Hanna-Barbera characters in their daily hand-to-mouth existence that had them concocting elaborate schemes merely to find food and shelter. As usual, the police remained relentlessly on their trail. Various episodes had them as stowaways on a cruise ship, where their nemesis, Officer Bullhorn (Matthew Faison), is driven nearly mad as they take on different roles to elude him, or in a hospital where Dirty, who sounds like Groucho Marx crossed with

*Right: Dirty Dawg and Ratso.
Far right: Crazy Claws is about to land a tree
on Rawhide Clyde and his dog, Bristle Tooth.*

the established pattern of banding animals together for lighthearted adventures. One such series, called "Shirt Tales" (NBC, 1982), copied "Help! It's the Hair Bear Bunch" by centering on creatures, here a number of park animals, who are in frequent conflict with authority, represented in this case by the park superintendent, named Dinkle (Herb Vigran). Suggested by a popular line of greeting cards that depicted cuddly animals, "Shirt Tales" involved the escapades of Rick the raccoon, Pammy the panda, Digger the mole, Bogey the orangutan (who sounded like Humphrey Bogart), and Tyg the tiger. A sixth animal, Kip the kangaroo, joined them in later segments.[2] All of the animals wore shirts on which words from the show's dialogue often materialized. Many episodes took

them out of the park, where a cry of "It's shirttail time!" triggered the next battle or another altercation with the exasperated Mr. Dinkle.

Later series involving clever animals included "The Biskitts" (CBS, 1983), about a group of miniature dogs who guarded their late king's crown jewels from the greedy grasp of his brother Max; "The Pink Panther and Sons" (NBC, 1984), only vaguely suggested by the debonair animated panther in the hit film series; and "Foofur" (NBC, 1986), about a blue dog with a number of rowdy friends who shared in his wild adventures. For younger viewers Hanna-Barbera adapted "Pound Puppies," a popular stuffed toy, for a 1985 syndicated series about some lovable puppies with an eye for mischief.

Foofur.

"Shirt Tales."

***Main title for
"Pound Puppies."***

Spanky and the Little Rascals.

Main title for "The Dukes."

Still other eighties series attempted (as others had in the past) to present popular personalities or characters in new animated formats or situations. Olive Oyl, Popeye's gangly, screechy girlfriend for half a century, was given her own show on CBS in 1981, in which as "Private Olive Oyl" (Marilyn Schreffler) she endured comic army predicaments as the target of the bellowing drill sergeant Bertha Blast (Jo Anne Worley). "The Gary Coleman Show" (NBC, 1982) cast the diminutive star of "Diff'rent Strokes" as Andy LeBeau, a mischievous apprentice angel who was sent to earth in the guise of a normal teenager. Another series, "The Little Rascals" (ABC, 1983), animated the escapades of Spanky (Scott Menville) and his happy-go-

lucky band of kids who had pleased young audiences since the thirties. And drawing on a more recent source, "The Dukes" (CBS, 1983) took off on the daredevil driving and down-home country humor that had attracted television audiences to the live-action "Dukes of Hazzard" (CBS, 1982).

If the interplanetary or futuristic adventure series of the late sixties no longer remained in the forefront at Hanna-Barbera, they continued to turn up occasionally in the eighties, still imaginative and still animated with careful attention to colorful detail. "Challenge of the GoBots" (syndicated, 1984) created a distant, scientifically advanced world in which a race of noble robots called Guardian GoBots, residents of the high-tech planet

GoBotron, engaged in fierce battle with the evil Renegade Robots, who were plotting to rule the planet. In "Galtar and the Golden Lance" (syndicated, 1985, and winner of a 1988 Golden Reel Award for Animation and Sound Editing), the staunch hero Galtar (Lou Richards) roamed an exotic planet, experiencing fanciful adventures as he searched for the evil Tormack (Brock Peters), whose minions had killed his parents. Another futuristic conflict of good and evil took place in "Sky Commanders" (syndicated, 1987), in which Mike Summit (Bob Ridgely) and a crew of renegade soldiers in the late twenty-first century fought the evil General Plague (Bernard Erhard), a monstrous villain bent on world domination, in a treacherous new continent called the High Frontier.

"Wildfire," a Hanna-Barbera series in the realm of pure fantasy, was shown on CBS in the fall of 1986. The story revolved around Sara (Georgi Irene), a spunky twelve-year-old Montana girl, whose life was changed dramatically when a beautiful horse named Wildfire (John Vernon) appeared to take her on an adventure to Dar-Shan, a magical fairy-tale land in another dimension. On Dar-Shan, Sara learned that she was really a princess who, at birth, was sent by her mother to the mortal world to protect her from the dark forces of evil. Now, back in her birthplace, Sara was the target of an evil sorceress named Diabolyn (Jessica Walter), who sought to seize control of Dar-Shan by stealing the amulet around Sara's neck. The series recounted Sara's adventures as she rallied a motley band of companions to fight Diabolyn in the mountains and plains of Dar-Shan.

Sara rides the magical horse called Wildfire in the series of the same name.

Main title for "Challenge of the GoBots."

Following pages: Galtar battles Tormack in "Galtar and the Golden Lance."

Papa Smurf.

Fantasy — the sort of fantasy that creates a special world of its own — also figured importantly in the creation of a race of little blue people who have remained among the most durable and best loved of Hanna-Barbera characters. By now the benign and cheerful Smurfs have moved from animated figures to popular legend and beyond popular legend to a thriving industry. But before their television introduction in the fall of 1981, the tiny humanoids had been known for nearly a quarter century as the brain children of a Belgian cartoonist named Peyo Culliford. By the late seventies, various Smurf toys had already been licensed in the United States. By the sort of fortuitous circumstance that makes television history, some of these toys found their way into a shop in Aspen, Colorado, in 1979, which Fred Silverman, then NBC's president, was visiting with his young daughter during a break from an industry meeting. Silverman remembers, "I had never seen them before. I was so taken with them that I went back to Hanna-Barbera and said, 'Get the rights to the Smurfs, and you have an on-the-air commitment.' The rest, as they say, is history."

Making its debut as a sixty-minute show, "The Smurfs" became an immediate and huge success, expanding to ninety minutes in the following season and winning Emmy awards in two consecutive years (1982 and 1983) as the Outstanding Children's Entertainment Series. Young viewers were delighted with the tales of the lovable creatures — only "three apples high" — who enjoyed positively "smurfy" lives in a peaceful forest — "smurfy," that is, until the appearance of their archenemy, Gargamel (Paul Winchell), who, with the aid of his *Great Book of Spells*, tried in vain to capture them. ("So many uncast spells! So many uncaught Smurfs!") At his beck and call were his scheming assistant, Scruple (Brenda Vaccaro), and his wicked cat, Azriel (Don Messick). Guided and protected by wise Papa Smurf (Don Messick), the Smurfs, like the Seven Dwarfs, had names that characterized them immediately: bookish, intellectual Brainy

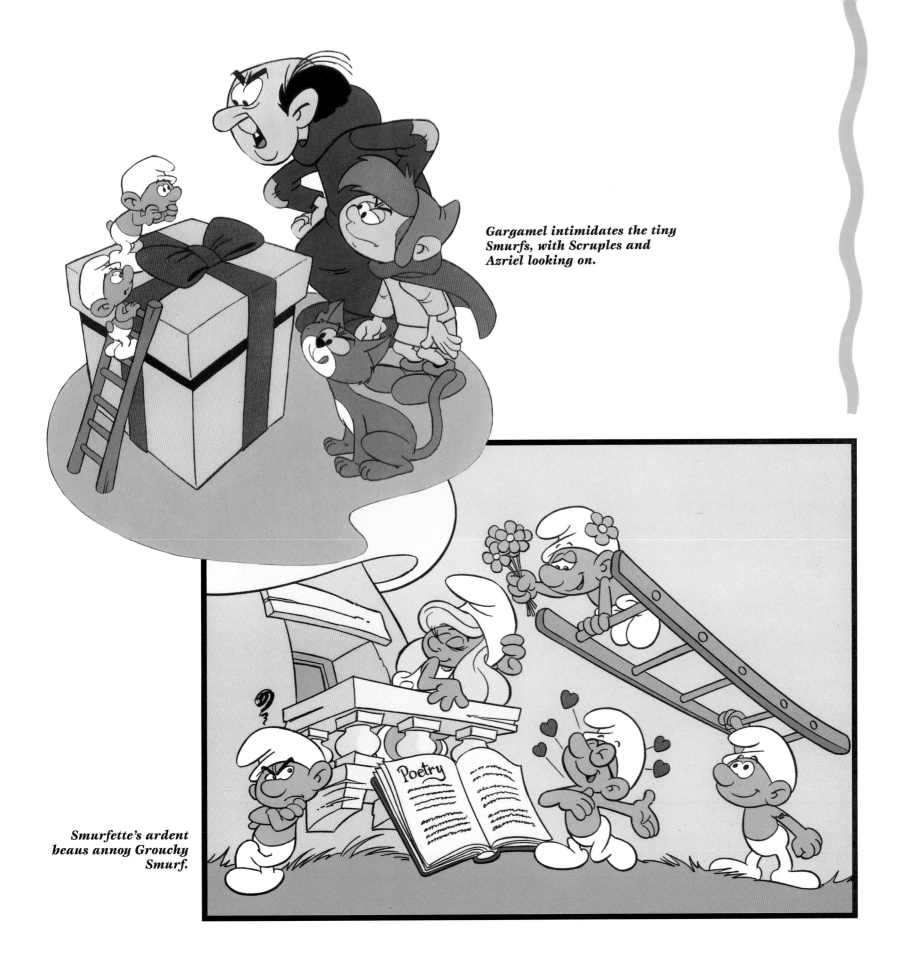

Gargamel intimidates the tiny Smurfs, with Scruples and Azriel looking on.

Smurfette's ardent beaus annoy Grouchy Smurf.

(Danny Goldman); strongman Hefty (Frank Welker); jack-of-all-trades Handy (Michael Bell); the greedy Greedy (Hamilton Camp); the vain Vanity (Alan Oppenheimer); the bad-tempered Grouch (Michael Bell); the vivacious Smurfette (Lucille Bliss); and others.

Typical episodes had Gargamel, undaunted by continual failure, inventing new ways to trap the elusive Smurfs. In "To Coin a Smurf," he creates a machine that will turn the little blue people into gold coins. (The machine uses six tons of smurfberry blossoms to make six drops of deadly potion.) When several Smurfs are caught looking for blossoms for the Smurfberry Blossom Festival and are turned into coins, Papa Smurf must devise a way to restore them. "Timber Smurf" had Gargamel stirring up a storm that threatens to destroy Smurf Village. When the storm blows a hole in the dam, the Smurfs send out Timber Smurf to cut down trees for wood. The problem is that Timber Smurf insists on talking to the trees before chopping them down, leaving Gargamel time to capture some Smurfs. Timber manages to save the day — and the wood — for a happy ending. In the clever episode "Smurfette Unmade," the Smurfs must contend with a Smurfette who has two personalities — one her usual sweet self, the other a nasty sort created by one of Gargamel's spells. The dual personalities cause confusion and trouble until the good Smurfette prevails.

"My Smurfy Valentine."

Left: A romantic moment onstage with Smurfette and Poet Smurf.

The Smurfs rescue their friends from Gargamel's machinations.

Following pages: Papa Smurf gives his blessing to Laconia and Woody in "Smurfily Ever After," 1985.

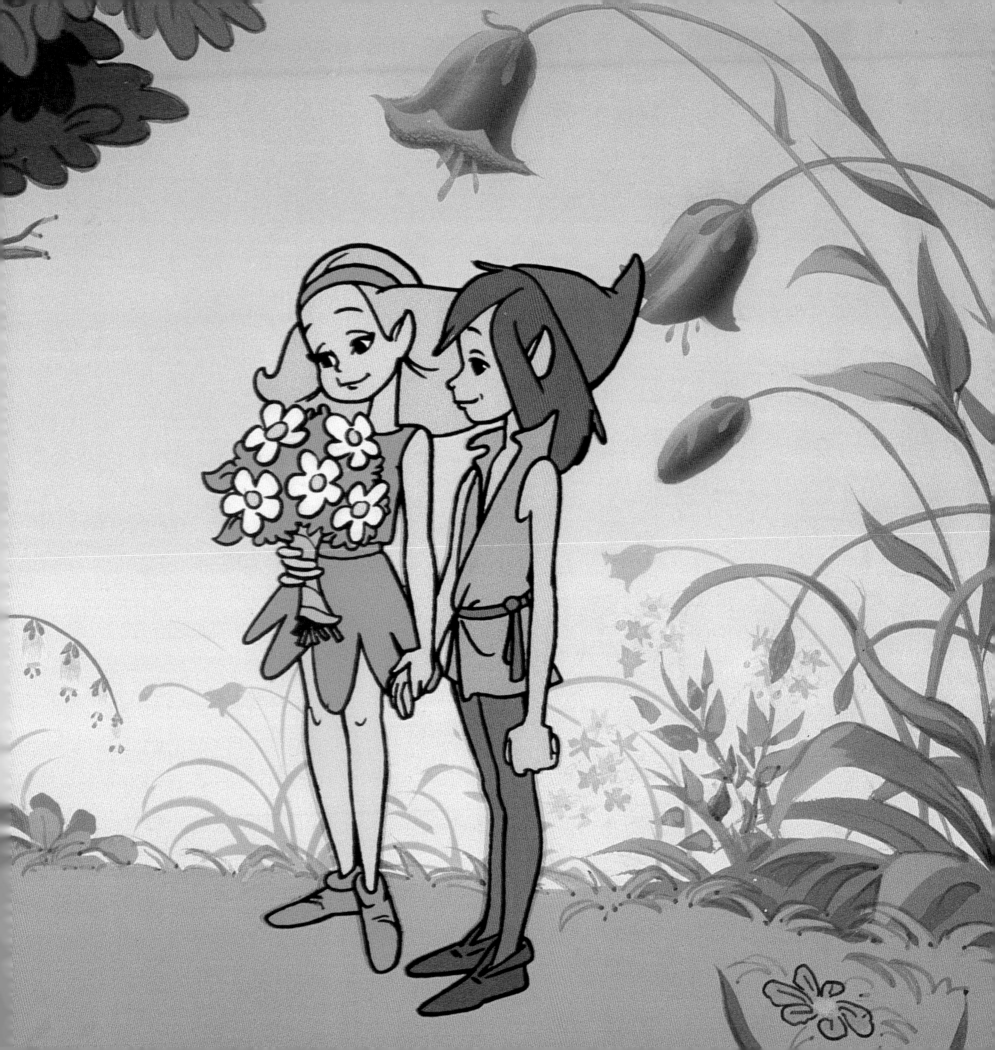

"The Smurfs Springtime Special," 1982.

"The Smurfs Springtime Special."

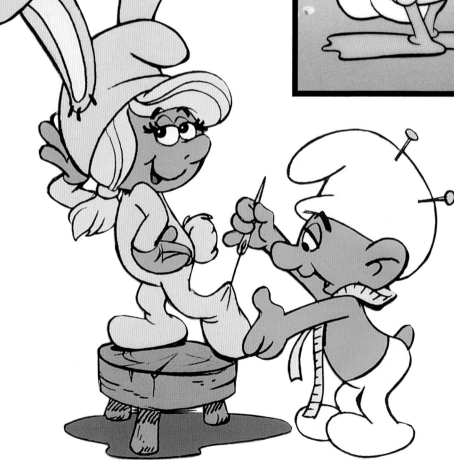

In recent years the Smurfs have starred in television specials that have earned them further acclaim and continued affection. Appearing in 1982 on NBC, "The Smurfs Springtime Special" received the Bronze Award as the Best Children's Special in the International Film and TV Festival of New York, as did "The Smurfic Games" in 1984. ("The Smurfs Springtime Special" also won a 1982 Golden Reel Award for Animation Sound Editing.) Other smurfy television specials, all on NBC, include "The Smurfs Christmas Special" (1982), "My Smurfy Valentine" (1983), "Smurfily Ever After" (1985), and " 'Tis the Season to Be Smurfy" (1987). The latter seasonal special had the Smurfs bringing hope to a kindly toy maker and his ailing wife, encouraging thieves to reform, and in general spreading holiday cheer wherever they go.

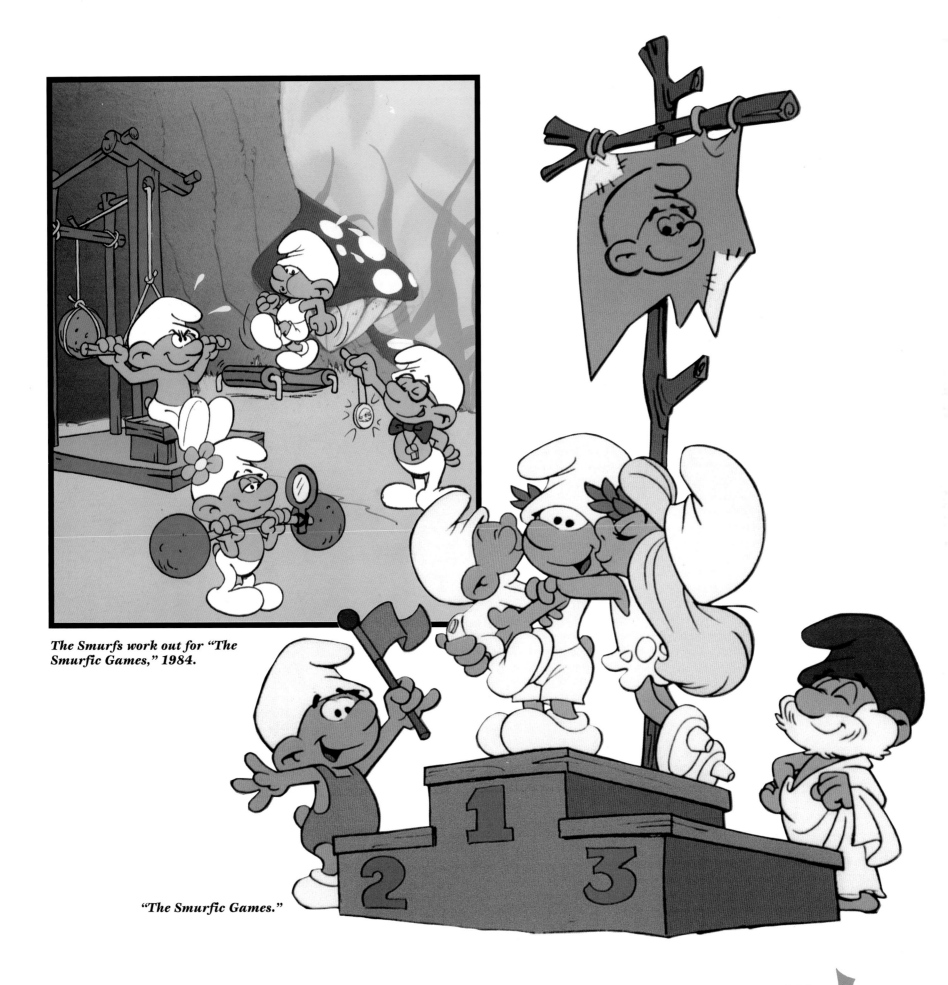

The Smurfs work out for "The Smurfic Games," 1984.

"The Smurfic Games."

The Smurfs hang up their Christmas stockings in "The Smurfs Christmas Special," 1982.

"'Tis the Season to Be Smurfy," 1987.

Far right: Harmony Smurf serenades Smurfette.

Main title for an episode of "Pac-Man."

The huge success of "The Smurfs" triggered other Hanna-Barbera series in which fantasy creatures, living happily in their own environment, were menaced by outside forces. "Pac-Man" (ABC, 1982) derived from the popular video game that had little yellow figures chomping away at other figures, while trying to avoid being chomped themselves. The television adaptation, set in Pac-Land, had hero Pac-Man, or "Pakky" (Marty Ingels), engaged in continual conflict with the nasty Ghost Monsters, whose singleminded goal was to destroy all Pac-Men. A 1983 series called "Monchhichis" also gave its tiny characters their very own habitat, here the woodsy kingdom of Monchia, where the happy Monchhichis lived under the rule of a benign wizard. Their idyllic life was continually threatened by the gloomy Grumplins of nearby Grumplor, whose evil leader, Horrg (Sidney Miller), enjoyed being called "your loathsomeness" and "your nastiness." The most endearing character in the series was little Thumkii

The Trollkins
of Trolltown.

236

The Snorks in Snorkland, their underwater home.

(Hank Saroyan), who, in a state of endless excitement, never seemed able to finish a sentence.

One 1981 series on CBS created a fantasy world with its own special kind of lunacy. The tiny "Trollkins" of Trolltown resembled off-the-wall hillbillies whose adventures defied all logic or reason. Trading in rowdy slapstick rather than sweet whimsy, the Trollkins never seemed daunted by anything that came their way, whether it was a giant moth determined to eat their town, an out-of-control robot that wanted to arrest everyone, or a prehistoric creature called the trollosaurus. The principal characters were a colorful lot, including the excitable Mayor Lumpkin (Paul Winchell), who spoke in spoonerisms; trouble-prone Sheriff Pudge Trollsom (Alan Oppenheimer) and his bumbling DepuTroll Flake (Marshall Efron); and the enterprising

dog Flooky (Frank Welker). Also involved in the comic escapades were the mayor's son, Blitz (Steve Spears), and the sheriff's daughter, Pixlee (Jennifer Darling).

A more direct line to "The Smurfs" turned up in the fall of 1984 with the premiere of "The Snorks" on NBC. Originally created by Freddy Monnickendam for a Belgian comic book, "The Snorks" took place in Snorkland, an underwater domain where the tiny, colorful Snorks lived in an environment that allowed them every modern comfort. All Snorks were equipped with snorkles, protruding gills that propelled them swiftly through the water. When a Snork became excited, his gill made a "snork" sound. The leading characters were bright and handsome Allstar (Michael Bell): his pretty blond girlfriend Casey (B. J. Ward), and friends Dimmy (Brian Cummings) and Tooter (Frank Welker), whose serene lives were always being hampered by Snorkland's nasty governor (Frank Nelson) and his obnoxious son, Junior (Barry Gordon), a chip off the old snorkle.

The happy Monchhichis.

237

Noah brings bears into the Ark in "Noah's Ark."

In the summer of 1986 the studio launched the first group in a continuing series of animated videocassettes called *The Greatest Adventure: Stories from the Bible*. Each cassette, developed with an advisory board of a Catholic priest, a rabbi, and a Protestant minister, dramatizes a story from the Bible in terms that are both appealing and accessible to viewers of all ages. Through the eyes of three contemporary teenagers — two young archaeologists named Margo and Derek and their nomad friend Mokey — we are thrust back into Biblical times, to witness at first hand the well-loved tales of conflict, betrayal, and salvation. Dramatic moments that capture the eternal truths of the Bible abound in every cassette: David confronting the giant Goliath with a slingshot and his "purity of soul"; Joshua marching his army around the walled city of Jericho;

Noah and his family, caught up in the flood that threatens to destroy the earth; Daniel tossed into the lion's den, where he is protected by an angel of the Lord — and many others. The characters are voiced by such well-known actors as James Whitmore, Vincent Price, James Earl Jones, Edward Asner, Robby Benson, Lorne Greene, and Gavin MacLeod. *The Greatest Adventure* has been certified as the most successful original animated videocassette series for children. To date it has sold well over one million copies of the first seven titles. In addition, it has received a number of awards, including the 1986 Gold Angel Award from Religion in Media; the 1987 Distinguished Service Award from National Religious Broadcasters; and both the 1987 and 1988 Award of Excellence from the Film Advisory Board.

Left: "David and Goliath."

Right: "Joshua and the
Battle of Jericho."

"Samson and Delilah."

"The Creation."

As Bill Hanna and Joe Barbera reach the half-century mark of their creative partnership, new plans and projects, designed for both theaters and television, continue to emerge from their studio. As of this writing, a feature-length film starring the legendary Tom and Jerry, slated for theatrical release, is in the planning stages, as is an elaborate animated version of the long-running stage musical *Cats*. Composer Andrew Lloyd Webber is working closely with Hanna-Barbera to create a remarkable merging of animation and live action. Also under way is an innovative new version of *The Wizard of Oz*, which will take advantage of a newly developed form of animation in which the faces of live actors are incorporated into animated torsos and backgrounds. In addition, Hanna-Barbera's ability to create co-venture and partnership relationships, both in America and abroad, has led to exciting new projects. The studio has entered into a new relationship with Steven Spielberg's Amblin Productions, to develop multi-media properties, and it is also working with Booker, an English company that owns the rights to all of the Agatha Christie and James Bond properties. An animated prime-time series built around a character called James Bond, Jr., is projected at this time. Nor are Hanna-Barbera's most celebrated characters being neglected. Live-action theatrical features of the Flintstones and the Jetsons are in the planning stages, as is a Broadway musical based on the Flintstones.

Starting from its historic base, Hanna-Barbera is working to expand and enrich that base for the decade ahead. New characters and projects drawing on the talents of some of today's most popular and gifted performers are being planned. Two new ventures with comedian Rodney Dangerfield are in development: one a mixed-media series called "Rodney," dealing with his life as a boy, the other named "Rover Dangerfield," an animated theatrical feature about a dog raised by Las Vegas showgirls, who, finding himself on the run, takes refuge on a farm. A mostly animated show using Lily Tomlin's special gifts is also being developed, featuring her popular characters of little Edith Ann and telephone operator Ernestine. In addition, Hanna-Barbera is producing an NBC series with Martin Short entitled "The Completely Mental Misadventures of Ed Grimley," which highlights the decidedly weird character created by Short on "Saturday Night Live." Short is being joined by Fellow Alumni of the Second City Television comedy group, including Andrea Martin and Catherine O'Hara. Also involved in a developing Hanna-Barbera project is comedian-actress Whoopi Goldberg.

Personally Hanna and Barbera enjoy richly fulfilling lives, Hanna with his wife, Violet, son David, daughter Bonnie, and seven grandchildren, Barbera with his wife, Sheila, children Jayne, Neal, and Lynn, two grandchildren, and two great grandchildren. They have reaped

Above: On August 28, 1988, Joseph Barbera and William Hanna received the prestigious Governors Award from the Academy of Television Arts and Sciences.

numerous awards, topped in 1988 by the prestigious Governors Award bestowed on them by the National Academy of Television Arts and Sciences. (They also received the 1988 Iris Award as Men of the Year from the National Association of Television Production Executives.) Both men have been honored many times for their charitable and philanthropic activities. They are particularly proud of the "Laugh Rooms," the special rooms for hospitalized children they are creating in hospitals across the country. In 1985 Bill Hanna was awarded the honor of Distinguished Eagle Scout for his six decades of service and support to the Boy Scouts of America, and in the same year Barbera was given the Columbian Award by the Federated Italo-Americans of Southern California "for achievement in the entertainment world and support of Italian-American concerns." (In 1982 Barbera was thrilled to receive the Award of Commendatore from the President of Italy.)

Joe Barbera in one of Hanna-Barbera's "Laugh Rooms" for hospitalized children.

The 1985 award given to Bill Hanna for his six decades of service and support to the Boy Scouts of America.

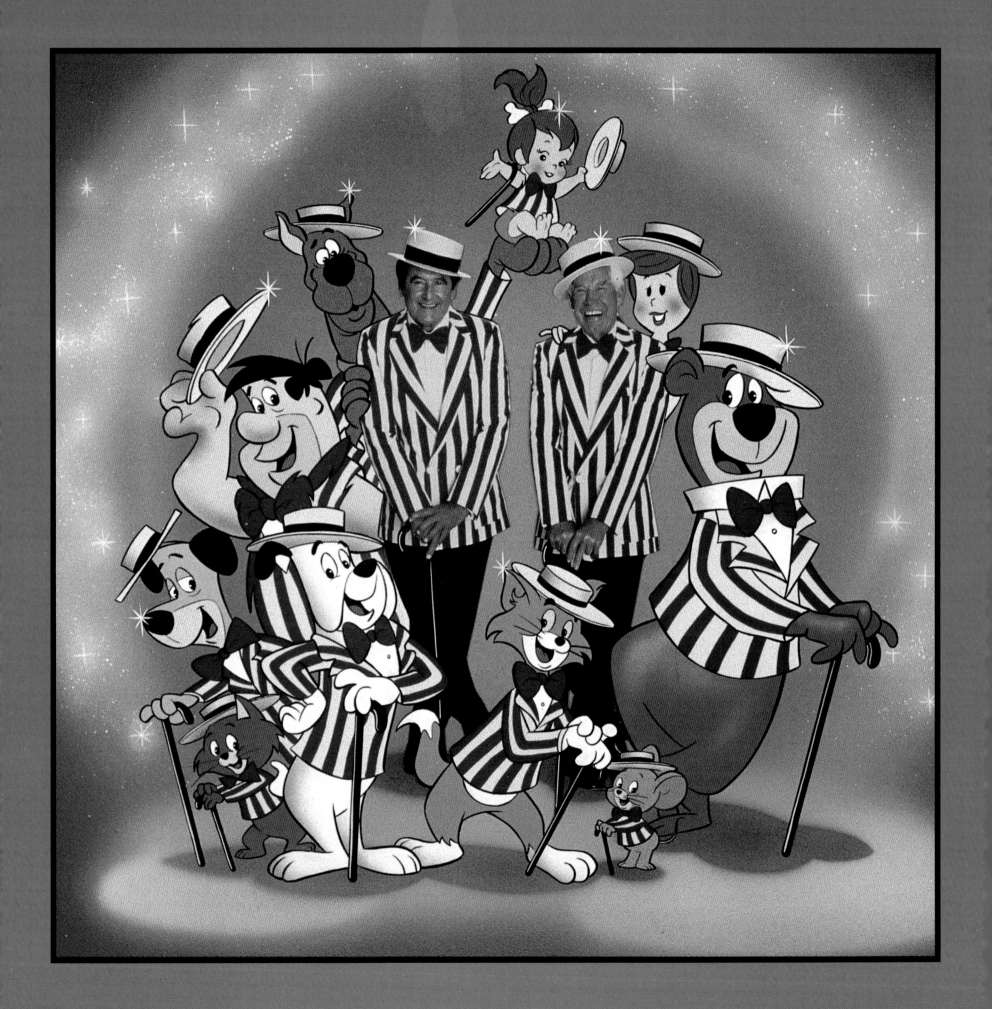

Today, as their work continues to thrive and grow, Bill Hanna and Joe Barbera can look back with pride and pleasure on a lifetime of achievement. Hanna feels most proud when people tell him "how much pleasure we've brought them through our years on television." He says, "I get the biggest thrill when I hear about the joy and the fun that we've given everyone who grew up on our cartoons." Barbera concurs enthusiastically and adds, "I think our greatest achievement may be our fifty-year association. Nobody else in the entertainment field has ever stayed together that long. We're asked: how do we do it? We don't get into each other's area. I concentrate on working with the story people, and he gets the production going. We still have a lot to do. We are ready to start the next fifty years."

As both men would say, "It has all turned out just fine." Together Bill Hanna and Joe Barbera forged an animation empire that is now moving beyond animation to creative new areas. Together they gave life to a host of animated characters who are now an enduring part of American folklore.

Together they happily bestowed on all of us the generous gifts of magic and laughter.

Joseph Barbera and William Hanna, ready for "the next fifty years."

Left: The Hanna-Barbera family of favorites.

Chronology of Hanna-Barbera Animated Series

The title of each series is followed by the network on which the series first appeared; its first year of production; and the principal characters and voice actors. (Syn.) indicates that the series started in syndication.

The Ruff and Reddy Show (NBC, 1957). Ruff: Don Messick. Reddy: Daws Butler.

Huckleberry Hound (Syn., 1958). Huckleberry Hound: Daws Butler.

Pixie and Dixie (Syn., 1958). Pixie: Don Messick. Dixie: Daws Butler.

Augie Doggie and Doggie Daddy (Syn., 1959). Augie Doggie: Daws Butler. Doggie Daddy: Doug Young.

Quick Draw McGraw (Syn., 1959). Quick Draw: Daws Butler. Baba Looey: Daws Butler.

Snooper and Blabber (Syn., 1959). Snooper: Daws Butler. Blabber: Daws Butler.

Yakky Doodle (Syn., 1960). Yakky Doodle: Jimmy Weldon. Chopper: Vance Colvig.

Yogi Bear (Syn., 1960). Yogi: Daws Butler. Boo Boo: Don Messick. Ranger Smith: Don Messick.

The Flintstones (ABC, 1960). Fred Flintstone: Alan Reed and Henry Corden. Wilma: Jean Vander Pyl. Barney Rubble: Mel Blanc. Betty Rubble: Bea Benaderet, Gerry Johnson, Gay Hartwick, and Gay Autterson.

Hokey Wolf (Syn., 1960). Hokey: Daws Butler. Ding-a-Ling: Doug Young.

Snagglepuss (Syn., 1960). Snagglepuss: Daws Butler.

Top Cat (ABC, 1961). Top Cat: Arnold Stang. Benny the Ball: Maurice Gosfield. Officer Dibble: Allen Jenkins. Choo Choo: Marvin Kaplan. The Brain: Leo de Lyon. Fancy-Fancy: John Stephenson.

Lippy the Lion (Syn., 1962). Lippy: Daws Butler. Hardy Har Har: Mel Blanc.

Touché Turtle (Syn., 1962). Touché Turtle: Bill Thompson. Dum Dum: Alan Reed.

Wally Gator (Syn., 1962). Wally: Daws Butler. Twiddles: Don Messick.

The Jetsons (ABC, 1962). George Jetson: George O'Hanlon. Jane: Penny Singleton. Judy: Janet Waldo. Elroy: Daws Butler. Astro: Don Messick. Spacely: Mel Blanc. Rosie: Jean Vander Pyl.

Magilla Gorilla (Syn., 1964). Magilla Gorilla: Allan Melvin. Mr. Peebles: Howard Morris. Ogee: Jean Vander Pyl.

Peter Potamus and His Magic Flying Balloon (Syn., 1964). Peter Potamus: Daws Butler. So So: Don Messick.

Ricochet Rabbit (Syn., 1964). Ricochet Rabbit: Don Messick.

Breezly and Sneezly (Syn., 1964). Breezly: Howard Morris. Sneezly: Mel Blanc. Colonel Fusby: John Stephenson.

Punkin Puss (Syn., 1964). Punkin Puss: Allan Melvin. Mush Mouse: Howard Morris.

Yippee, Yappee, and Yahooey (Syn., 1964). Yippee: Doug Young. Yappee: Hal Smith. Yahooey: Daws Butler.

Adventures of Jonny Quest (ABC, 1964). Jonny: Tim Matthieson. Dr. Quest: John Stephenson and Don Messick. "Race" Bannon: Mike Road. Hadji: Danny Bravo. Bandit: Don Messick.

Precious Pupp (NBC, 1965). Granny Sweet: Janet Waldo. Precious Pupp: Don Messick.

The Hillbilly Bears (NBC, 1965). Paw Rugg: Henry Corden. Maw Rugg: Jean Vander Pyl. Floral: Jean Vander Pyl. Shag: Don Messick.

Secret Squirrel (NBC, 1965). Secret: Mel Blanc. Morocco Mole: Paul Frees.

Squiddly Diddly (NBC, 1965). Squiddly: Paul Frees. Chief Winchley: John Stephenson.

Winsome Witch (NBC, 1965). Winsome Witch: Jean Vander Pyl.

Sinbad, Jr. (Distributed by AIT, 1965). Sinbad, Jr.: Tim Matthieson. Salty: Mel Blanc.

Laurel and Hardy (Distributed by Wolper Productions, 1965). Stan Laurel: Jim McGeorge. Oliver Hardy: Larry Harmon.

Space Kidettes (Syn., 1966). Scooter: Chris Allen. Snoopy: Lucille Bliss. Jenny: Janet Waldo. Countdown: Don Messick. Captain Skyhook: Daws Butler. Pupstar: Don Messick.

The Space Ghost (CBS, 1966). Space Ghost: Gary Owens. Jayce: Tim Matthieson. Jan: Ginny Tyler. Blip: Don Messick.

Dino Boy (CBS, 1966). Dino Boy: Johnny Carson. Ugh: Mike Road. Bronto: Don Messick.

Frankenstein, Jr. (CBS, 1966). Frankenstein, Jr.: Ted Cassidy. Buzz Conroy: Dick Beals. Professor Conroy: John Stephenson.

The Impossibles (CBS, 1966). Multi Man: Don Messick. Fluid Man: Paul Frees. Coil Man: Hal Smith.

Abbott and Costello (Distributed by RKO-Jomar, 1967). Bud Abbott: Bud Abbott. Lou Costello: Stan Irwin.

The Herculoids (CBS, 1967). Zandor/Zak/Igoo/Tundro: Mike Road. Tara: Virginia Gregg. Dorno: Teddy Eccles. Gloop/Gleep: Don Messick.

Samson and Goliath (NBC, 1967). Young Samson: Tim Matthieson.

The Fantastic Four (ABC, 1967). Reed Richards/Mr. Fantastic: Gerald Mohr. Sue Richards/Invisible Girl: Jo Ann Pflug. Ben Grimm/The Thing: Paul Frees. Johnny Storm/The Human Torch: Jack Flounders. (Returned as **The New Fantastic Four**, NBC, 1978, with new cast and addition of robot H.E.R.B., voiced by Frank Welker.)

Moby Dick (CBS, 1967). Tom: Bobby Resnick. Tub: Barry Balkin. Scooby: Don Messick.

The Mighty Mightor (CBS, 1967). Mightor: Paul Stewart. Tor: Bobby Diamond. Sheera: Patsy Garrett. Pondo/Ork/Tog/Rollo: John Stephenson. Li'l Rok: Norma McMillan.

Birdman (NBC, 1967). Ray Randall/Birdman: Keith Andes. Birdboy: Dick Beals.

The Galaxy Trio (NBC, 1967). Falcon 7/Vapor Man: Don Messick. Meteor Man: Ted Cassidy. Galaxy Girl: Virginia Eiler.

Shazzan (CBS, 1967). Shazzan: Barney Phillips. Nancy: Janet Waldo. Chuck: Jerry Dexter. Kaboobie: Don Messick.

The Three Musketeers (NBC, 1968). D'Artagnan: Bruce Watson. Porthos: Barney Phillips. Aramis: Don Messick. Athos: Jonathan Harris. Tooly: Teddy Eccles. Queen Anne/Constance: Julie Bennett.

The Arabian Knights (NBC, 1968). Bez: Henry Corden. Fariik: John Stephenson. Raseem: Frank Gerstle. Prince Turhan: Jay North. Princess Nida: Shari Lewis. Evil Vangore: Paul Frees.

The Micro Ventures (NBC, 1968). Professor Carter: Don Messick. Jill Carter: Patsy Garrett. Mike Carter: Tommy Cook.

The Adventures of Gulliver (ABC, 1968). Gary Gulliver: Jerry Dexter. Tagg: Herb Vigran. Thomas Gulliver/Captain Leech/King Pomp: John Stephenson. Flirtacia: Ginny Tyler. Bunko: Allan Melvin. Egger/Glumm: Don Messick.

The Wacky Races (CBS, 1968). Peter Perfect/Sergeant/Big Gruesome/Red Max/Rufus Ruffcut/Rock and Gravel Slag: Daws Butler. Dick Dastardly/Clyde/Private Pinkley: Paul Winchell. Muttley/Sawtooth/Professor Pat Pending/"Ring-a-Ding Convert-a-Car"/Little Gruesome: Don Messick. Penelope Pitstop: Janet Waldo. Luke and Blubber Bear/General: John Stephenson.

The Perils of Penelope Pitstop (CBS, 1969). Penelope Pitstop: Janet Waldo. Sylvester Sneekly/The Hooked Claw: Paul Lynde. Bully Brothers/Yak Yak/"Chugaboom": Mel Blanc. Clyde/Softly: Paul Winchell. Zippy/Pockets/Dum Dum/Snoozy: Don Messick.

The Cattanooga Cats (ABC, 1969). Country: Bill Callaway. Groovey: Casey Kasem. Scoots: Jim Begg. Kitty-Jo/Chessie: Julie Bennett.

Motormouse and Autocat (ABC, 1969). Motormouse: Dick Curtis. Autocat: Marty Ingels.

It's the Wolf (ABC, 1969). Mildew Wolf: Paul Lynde. Lambsy: Daws Butler. Bristol Hound: Allan Melvin.

Scooby-Doo, Where Are You? (CBS, 1969). Scooby-Doo: Don Messick. Shaggy: Casey Kasem. Freddy: Frank Welker. Daphne: Heather North. Velma: Nicole Jaffe, Patricia Stevens, and Maria Frumkin. Scrappy-Doo: Lennie Weinrib. Scooby-Dum: Daws Butler.

The phenomenally popular dog starred in a number of subsequent series, including **The New Scooby-Doo Movies** (CBS, 1972); **Scooby-Doo's All-Star Laff-a-lympics** (ABC, 1977); **Scooby's All-Stars** (ABC, 1978); **Scooby and Scrappy-Doo** (ABC, 1979); **Scooby, Scrappy, and Yabba-Doo** (ABC, 1982); **The New Scooby-Doo Mysteries** (ABC, 1984); and **The Thirteen Ghosts of Scooby-Doo** (ABC, 1985).

Dastardly and Muttley in Their Flying Machines (CBS, 1969). Dick Dastardly/The General: Paul Winchell. Muttley/Yankee Doodle/Klunk/Zilly: Don Messick.

Around the World in 79 Days (ABC, 1969). Phileas Fogg: Bruce Watson. Jenny Trent: Janet Waldo. Happy/Smirky: Don Messick. Crumden: Daws Butler. Bumbler: Allan Melvin.

Where's Huddles? (CBS, 1970). Ed Huddles: Cliff Norton. Marge Huddles: Jean Vander Pyl. Bubba McCoy: Mel Blanc. Penny McCoy: Marie Wilson. Claude Pertwee: Paul Lynde. Mad Dog Maloney: Alan Reed.

The Harlem Globetrotters (CBS, 1970). Freddy "Curly" Neal: Stu Gilliam. Geese Ausbie: John Williams. Meadowlark Lemon: Scatman Crothers. Gip: Richard Elkins. Bobby Joe Mason: Eddie Anderson.

Josie and the Pussycats (CBS, 1970). Josie: Janet Waldo. Melody: Jackie Joseph. Valerie: Barbara Pariot. Alan: Jerry Dexter. Alexander Cabot III: Casey Kasem. Alexandra Cabot: Sherry Alberoni. Sebastian: Don Messick. (Returned as **Josie and the Pussycats in Outer Space**, CBS, 1972, with addition of Don Messick as Bleep.)

Pebbles and Bamm Bamm (CBS, 1971). Pebbles Flintstone: Sally Struthers and Mickey Stevens. Bamm Bamm: Jay North. Moonrock: Lennie Weinrib. Penny: Mitzi McCall. Wiggy/Cindy: Gay Hartwig. Fabian: Carl Esser.

Help! It's the Hair Bear Bunch! (CBS, 1971). Hair Bear: Daws Butler. Bubi Bear: Paul Winchell. Square Bear: Bill Callaway. Mr. Peevely: John Stephenson. Botch: Joe E. Ross.

The Funky Phantom (ABC, 1971). Jonathan Muddlemore: Daws Butler. Skip: Mickey Dolenz. Augie: Tommy Cook. April: Tina Holland.

Sealab 2020 (NBC, 1972). Dr. Paul Williams: Ross Martin. Captain Mike Murphy: John Stephenson. Bobby Murphy: Josh Albee. Sallie Murphy: Pamelyn Ferdin. Sparks: Bill Callaway. Hal: Jerry Dexter. Gail: Ann Jillian.

Roman Holidays (NBC, 1972). Gus Holiday: Dave Willock. Laurie Holiday: Shirley Mitchell. Precocia Holiday: Pamelyn Ferdin. Happius Holiday: Stanley Livingston. Mr. Evictus: Dom DeLuise.

Amazing Chan and the Chan Clan (CBS, 1972). Charlie Chan: Keye Luke. Henry Chan: Bob Ito. Alan Chan: Brian Tochi. Stanley Chan: Stephen Wong and Lennie Weinrib.

Wait Till Your Father Gets Home (NBC, 1972). Harry Boyle: Tom Bosley. Irma Boyle: Joan Gerber. Chet Boyle: Lennie Weinrib. Alice Boyle: Tina Holland. Jamie Boyle: Jackie Haley. Ralph: Jack Burns.

Jeannie (CBS, 1973). Jeannie: Julie McWhirter. Babu: Joe Besser. Corry Anders: Mark Hamill. Henry Glopp: Bob Hastings.

Speed Buggy (CBS, 1973). Speed Buggy: Mel Blanc. Tinker: Phil Luther, Jr. Debbie: Arlene Golonka. Mark: Mike Bell.

The Addams Family (NBC, 1973). Gomez Addams: Lennie Weinrib. Morticia Addams/Granny Addams: Janet Waldo. Uncle Fester: Jackie Coogan. Lurch: Ted Cassidy. Pugsley Addams: Jodie Foster. Wednesday Addams: Cindy Henderson.

Goober and the Ghost Chasers (ABC, 1973). Goober: Paul Winchell. Gilly: Ronnie Schell. Ted: Jerry Dexter. Tina: Jo Anne Harris.

Inch High, Private Eye (NBC, 1973). Inch High: Lennie Weinrib. Lori: Kathi Gori. Gator: Bob Luttell. Mr. Finkerton: John Stephenson.

Butch Cassidy and the Sun Dance Kids (NBC, 1973). Butch Cassidy: Chip Hand. Merilee: Judy Strangis. Harvey: Mickey Dolenz. Steffy: Tina Holland.

Superfriends (ABC, 1973). Superman: Danny Dark. Batman: Olan Soulé. Robin: Casey Kasem. Wonder Woman: Shannon Farnon. Aquaman: Norman Alden and Bill Callaway.

Peter Puck (NBC, 1973). Peter Puck: Ronnie Schell.

Hong Kong Phooey (ABC, 1974). Penrod Pooch/Hong Kong Phooey: Scatman Crothers. Sergeant Flint: Joe E. Ross. Rosemary: Kathi Gori. Spot: Don Messick.

These Are the Days (ABC, 1974). Martha Day: June Lockhart. Kathy Day: Pamelyn Ferdin. Ben Day: Andrew Parks. Danny Day: Jackie Haley. Grandpa Jeff Day: Henry Jones. Homer: Frank Cady.

Devlin (ABC, 1974). Ernie Devlin: Mike Bell. Tod Devlin: Mickey Dolenz. Sandy Devlin: Michele Robinson. Hank: Norman Alden.

Valley of the Dinosaurs (CBS, 1974). John Butler: Mike Road. Kim Butler: Shannon Farnon. Katie Butler: Margene Fudenna. Greg Butler: Jackie Haley. Gorok: Alan Oppenheimer. Gara: Joan Gardner. Tana: Melanie Baker. Lok: Steacy Bertheau.

Wheelie and the Chopper Bunch (NBC, 1974). Wheelie/Chopper: Frank Welker. Rota Ree: Judy Strangis. Scrambles: Don Messick. Revs: Paul Winchell. Hi-Riser: Lennie Weinrib.

Partridge Family: 2200 A.D. (CBS, 1974). Connie Partridge: Joan Gerber. Keith Partridge: Chuck McClendon. Laurie Partridge: Susan Dey. Danny Partridge: Danny Bonaduce. Christopher Partridge: Brian Forster. Tracy Partridge: Suzanne Crough. Reuben Kinkaid: David Madden. Marion: Julie McWhirter. Veenie: Frank Welker.

The Great Grape Ape (ABC, 1975). Grape Ape: Bob Holt. Beegle Beagle: Marty Ingels.

Dynomutt, Dog Wonder (ABC, 1976). Dynomutt: Frank Welker. Blue Falcon: Gary Owens. Mayor: Larry McCormick.

Jabberjaw (ABC, 1976). Jabberjaw: Frank Welker. Clam-Head: Barry Gordon. Bubbles: Julie McWhirter. Shelly: Pat Parris. Biff: Tommy Cook.

Mumbly (ABC, 1976). Mumbly: Don Messick. Shnooker: John Stephenson.

Clue Club (CBS, 1976). Larry: David Joliffe. D. D.: Bob Hastings. Pepper: Patricia Stich. Dotty: Tara Talboy. Woofer: Paul Winchell. Wimper: Jim McGeorge. Sheriff Bagley: John Stephenson. (Returned in 1977 as **Woofer and Wimper, Dog Detectives**.)

The C. B. Bears (NBC, 1977). Hustle: Daws Butler. Bump: Henry Corden. Boogie: Chuck McCann. Charlie (voice only): Susan Davis.

Shake, Rattle and Roll (NBC, 1977). Shake: Paul Winchell. Rattle: Lennie Weinrib. Roll: Joe E. Ross. Sidney Merciless: Alan Oppenheimer.

Undercover Elephant (NBC, 1977). Undercover Elephant: Daws Butler. Loud Mouse: Bob Hastings. Chief: Mike Bell.

Heyyyyy, It's the King (NBC, 1977). The King/Yukayuka: Lennie Weinrib. Big H: Sheldon Allman. Skids: Marvin Kaplan. Clyde: Don Messick. Zelda: Susan Silo. Shenna: Ginny McSwain.

Posse Impossible (NBC, 1977). Big Duke/Stick: Daws Butler. Blubber: Chuck McCann. Sheriff: Bill Woodson.

Wonder Wheels (CBS, 1977). Willie Sheeler: Mickey Dolenz. Dooley Lawrence: Susan Davis.

The Three Robonic Stooges (CBS, 1978). Moe: Paul Winchell. Larry: Joe Baker. Curly: Frank Welker. Triple 0: Ross Martin.

Blast Off Buzzard (NBC, 1977). No speaking voices.

Captain Caveman and the Teen Angels (ABC, 1977). Captain Caveman: Mel Blanc. Dee Dee: Vernée Watson. Brenda: Marilyn Schreffler. Taffy: Laurel Page.

The Galaxy Goof-Ups (NBC, 1978). Officers Yogi Bear/Huckleberry Hound: Daws Butler. Officer Scarebear: Joe Besser. Officer Quack-Up: Mel Blanc. Captain Snerdly/General Blaster Blowhard: John Stephenson.

The Galloping Ghost (NBC, 1978). Nugget Nose: Frank Welker. Rita: Pat Parris. Wendy: Marilyn Schreffler.

The Buford Files (NBC, 1978). Buford Bloodhound: Frank Welker. Cindy Mae: Pat Parris. Woody: Dave Landsburg.

Godzilla (NBC, 1978). Godzilla: Ted Cassidy. Godzooky: Don Messick. Captain Carl Majors: Jeff David. Dr. Quinn

Darien: Brenda Thomson. Pete: Al Eiseman. Brock: Hilly Hicks.

Jana of the Jungle (NBC, 1978). Jana: B. J. Ward. Montaro: Ted Cassidy. Dr. Ben Cooper: Mike Bell.

The All-New Popeye Hour (CBS, 1978). Popeye: Jack Mercer. Olive Oyl: Marilyn Schreffler. Bluto: Allan Melvin. J. Wellington Wimpy: Daws Butler.

Dinky Dog (CBS, 1978). Dinky: Frank Welker. Sandy: Jackie Joseph. Monica: Julie Bennett. Uncle Dudley: Frank Nelson.

The New Shmoo (NBC, 1979). Shmoo: Frank Welker. Nita: Dolores Cantu-Primo. Billy Joe: Chuck McCann. Mickey: Bill Edelson.

The Super Globetrotters (NBC, 1979). Freddy "Curly" Neal/Sphere Man: Stu Gilliam. Geese Ausie/Multi Man: John Williams. Sweet Lou Dunbar/Gismo Man: Adam Wade. Nate Branch/Fluid Man: Scatman Crothers.

Casper and the Angels (NBC, 1979). Casper: Julie McWhirter. Minnie: Laurel Page. Maxi: Diane McCannon. Hairy Scary/Commander: John Stephenson.

The Thing (NBC, 1979). The Thing: Joe Baker. Benjy Grimm: Wayne Norton. Kelly: Noelle North. Betty/Miss Twilly: Marilyn Schreffler. Ronald Radford: John Erwin. Dr. Harkness/Stretch: John Stephenson. Spike: Art Metrano. Turkey: Michael Sheehan.

Scooby and Scrappy-Doo (ABC, 1979). Scooby-Doo: Don Messick. Shaggy: Casey Kasem. Scrappy-Doo: Lennie Weinrib.

Drak Pack (CBS, 1980). Drak, Jr.: Jerry Dexter. Frankie Howler: Bill Callaway. Big D: Alan Oppenheimer. Dr. Dred: Hans Conried. Vampira: Julie McWhirter.

Fonz and the Happy Days Gang (ABC, 1980). Arthur ("the Fonz") Fonzarelli: Henry Winkler. Richie Cunningham: Ron Howard. Ralph Malph: Danny Most. Mr. Cool: Frank Welker. Cupcake: Didi Conn.

Richie Rich (ABC, 1980). Richie: Sparky Marcus. Irona/Mrs. Rich: Joan Gerber.

Astro and the Space Mutts (NBC, 1981). Astro: Don Messick. Cosmo: Frank Welker. Dipper: Lennie Weinrib. Space Ace: Mike Bell.

Teen Force (NBC, 1981). Kid Comet: Daryl Hickman. Moleculad: David Hubbard. Elektra: B. J. Ward. Plutem: Mike Winslow. Uglor: Alan Lurie.

Crazy Claws (CBS, 1981). Crazy Claws: Jim McGeorge. Rawhide Clyde: Robert Allen Ogle. Bristletooth: Peter Cullen. Ranger Rangerfield: Michael Bell.

Kwicky Koala (CBS, 1981). Kwicky: Robert Allen Ogle. Wilfred Wolf: John Stephenson.

Dirty Dawg (CBS, 1981). Dirty Dawg: Frank Welker. Ratso: Marshall Efron. Officer Bullhorn: Matthew Faison.

The Bungle Brothers (CBS, 1981). George: Michael Bell. Joey: Allan Melvin.

The Smurfs (NBC, 1981). Papa Smurf: Don Messick. Smurfette: Lucille Bliss. Brainy: Danny Goldman. Hefty: Frank Welker. Handy: Michael Bell. Greedy: Hamilton Camp. Vanity: Alan Oppenheimer. Gargamel: Paul Winchell. Scruple: Brenda Vaccaro.

Laverne and Shirley (ABC, 1981). Laverne: Penny Marshall. Shirley: Lynn Marie Stewart. Sergeant Turnbuckle: Kenneth Mars. Squeely: Ron Palillo. Mr. Cool: Frank Welker. Special Guest Star: Henry Winkler as the Fonz.

Private Olive Oyl (CBS, 1981). Olive: Marilyn Schreffler. Sergeant Blast: Jo Anne Worley. Alice the Goon: Marilyn Schreffler. Colonel Crumb: Hal Smith.

The Trollkins (CBS, 1981). Sheriff Pudge Trollsom: Alan Oppenheimer. Pixlee Trollsom: Jennifer Darling. Blitz Plumkin: Steve Spears. Flooky: Frank Welker. Grubb Trollmaine: Michael Bell. Mayor Lumpkin: Paul Winchell. DepuTroll Flake: Marshall Efron. DepuTroll Dolly: Jennifer Darling.

Mork and Mindy (ABC, 1982). Mork: Robin Williams. Mindy: Pam Dawber. Doing: Frank Welker. Mr. Caruthers: Stanley Jones. Eugene: Shavar Ross. Orson: Ralph James.

The Little Rascals (ABC, 1982). Pete/Officer Ed: Peter Cullen. Spanky: Scott Menville. Buckwheat: Shavar Ross. Alfalfa/Porky/Woim: Julie McWhirter Dees. Darla: Patty Maloney. Waldo/Butch: B. J. Ward.

Pac-Man (ABC, 1982). Pac-Man: Marty Ingels. Ms. Pac: Barbara Minkus. Baby Pac: Russi Taylor. Chomp Chomp: Frank Welker. Sour Puss: Peter Cullen. Mezmaron: Alan Lurie. Sue Monster: Susan Silo. Inky Monster: Barry Gordon. Clyde Monster: Neilson Ross. Blinky and Pinky Monsters: Chuck McCann.

Shirt Tales (NBC, 1982). Rick: Ronnie Schell. Pammy: Pat Parris. Digger: Robert Allan Ogle. Bogey: Fred Travalena. Tyg: Steve Schatzberg. Kip: Nancy Cartwright.

The Gary Coleman Show (NBC, 1982). Andy LeBeau: Gary Coleman. Angelica: Jennifer Darling. Hornswoggle: Sidney Miller. Spence: Calvin Mason. Tina: La Shana Dendy. Bartholomew: Jerry Houser. Chris: Lauren Anders.

The Dukes (CBS, 1983). Boss Hogg: Sorrell Booke. Bo: John Schneider. Luke: Tom Wopat. Uncle Jesse: Denver Pyle. Daisy: Catherine Bach. Rosco: James Best.

Monchhichis (ABC, 1983). Moncho: Bobby Morse. Kyla: Laurel Page. Tootoo: Ellen Gerstell. Patchitt: Frank Welker. Thumkii: Hank Saroyan. Horrg: Sidney Miller. Wizzar: Frank Nelson. Snogs: Bob Argogast. Shreeker/Snitchitt/Gonker: Peter Cullen. Yabbot/Fasit/Scumgor: Laurie Faso.

The Biskitts (CBS, 1983). Waggs: Darryl Hickman. Lady: B. J. Ward. Scat: Dick Beals. Sweets: Kathleen Helppie. Spinner/Bump/Flip: Bob Holt. Shecky: Kip King. Shiner: Jerry Houser. Scratch/Fang/Dog Foot: Peter Cullen. King Max/Fetch/Snarl: Kenneth Mars.

The Snorks (NBC, 1984). Allstar/Elder #4: Michael Bell. Tooter/Occy: Frank Welker. Dimmy: Brian Cummings. Governor Wetworth: Frank Nelson. Junior Wetworth: Barry Gordon. Casey: B. J. Ward.

The Pink Panther and Sons (NBC, 1984). Pinky: Billy Bowles. Panky/Punkin: B. J. Ward. Chatta: Sherry Lynn. Howl: Marshall Efron. Anney/Liona: Jeannie Elias. Finko/Rocko: Frank Welker.

Challenge of the GoBots (Syn., 1984). Leader 1: Lou Richards. Turbo: Arthur Burghardt. Scooter: Frank Welker. Cy-Kill: Bernard Erhard. Cop-Tur: Bob Holt. Crasher: Marilyn Lightstone. Matt Hunter: Morgan Paull. A. J. Foster: Leslie Speights. Nick Burns: Sparky Marcus. Dr. Braxis: Rene Auberjonois.

Paw Paws (Syn., 1985). Princess Paw Paw: Susan Blu. Brave Paw: Thom Pinto. Pupooch: Don Messick. Mighty Paw: Bob Ridgely. Laughing Paw: Stanley Stoddart.

Galtar and the Golden Lance (Syn., 1985). Galtar: Lou

Richards. Goleeta: Mary McDonald Lewis. Tormack: Brock Peters. Ither: Bob Arbogast. Krimm: Barry Dennen. Otar: George Dicenzo. Pandat: Don Messick.

Pound Puppies (ABC, 1986). Cooler: Dan Gilvezan. Nose Marie: Ruth Buzzi. Howler: Bobby Morse. Brighteyes: Nancy Cartwright. Whopper: B. J. Ward. Holly: Ame Foster. Katrina Stoneheart: Pat Carroll. Nabbit/Cat Gut: Frank Welker. Brattina: Adrienne Alexander.

Wildfire (CBS, 1986). Sara: Georgi Irene. Wildfire: John Vernon. John: David Ackroyd. Diabolyn: Jessica Walter. Alvinar: Rene Auberjonois. Dorin: Bobby Jacoby. Ellen: Lilly Moon. Dweedle: Billy Barty. Brutus: Susan Blu.

Foofur (NBC, 1986). Foofur: Frank Welker. Rocki: Christina Lange. Annabell: Susan Tolsky. Hazel: Pat Carroll. Pepe: Don Messick. Chucky: Allan Melvin. Dolly: Susan Blu. Mel: David Doyle. Harvey: Michael Bell. Mrs. Escrow: Susan Silo. Fritz-Carlos: Jonathan Schmock. Louis: Dick Gautier. Sam: Chick Vennera. Baby: Peter Cullen. Burt: Bill Callaway. Fencer: Eugene Williams.

Sky Commanders (Syn., 1987). Mike Summit: Bob Ridgely. Cutter Kling: William Windom. R. J. Scott: Darryl Hickman. Red McCullough: Lauren Tewes. General Plague: Bernard Erhard. Books Baxter: Richard Boyle. Jim Stryker: Dorian Harewood. Spider Reilly: Triston Rogers. Mordax: Dick Gautier.

The Flintstone Kids (ABC, 1987). Fred: Scott Menville. Barney: Hamilton Camp. Wilma: Elizabeth Lyn Fraser. Betty: B. J. Ward. Nate: Frank Welker. Dreamchip: Susan Blu. Dino: Mel Blanc. Doris Slaghoople: Jean Vander Pyl. Ed, Edna Flintstone: Henry Corden. Flo Rubble/Rocky: Marilyn Schreffler.

Flintstone Lore: A Glossary of Names, Places, and Phrases

Since its inception in 1960, *The Flintstones* has accumulated its very own body of lore: names, places, phrases, and words that are associated with the program. The following is a partial list — loyal *Flintstone* fans will have to supply the missing entries themselves.

Family and Friends

The town in which the Flintstones and the Rubbles live: Bedrock

Population of Bedrock: 2,500

The Flintstone address: Fred and Wilma have been given a number of addresses over the years, including 342 Greasepit Terrace, 342 Gravel Pit Terrace, 55 Cobblestone Road, 34 Cobblestone Road, 201 Cobblestone Way, and 323 Cobblestone Lane. (Bedrock is in Cobblestone County.)

The Rubbles' address: 345 Stone Cave Road (previously 142 Boulder Avenue, Graniteville)

The Flintstones' daughter: Pebbles

The Rubbles' son: Bamm Bamm

Wilma Flintstone's maiden name: Slaghoople

Betty Rubble's maiden name: McBricker

Wilma's mother: Mrs. Slaghoople

Betty's nephew: Marblehead Sandstone, Jr. ("Sandy")

The Flintstones' pet: Dino, a doglike runtasaurus (also Baby Puss, a saber-toothed tiger)

The Rubbles' pet: Hoppy (also Hoppitty), a hopperoo

The Flintstones' car: Flintmobile

The Flintstones' license plate number: XYZ 643

Favorite Flintstone foods: brontosaurus burgers, dinosaur burgers, chopped pterodactyl liver, deviled dodo eggs, steakasaurus ribs, mastodon chow mein, creamed seaweed, baked cactus apples, gravelberry pie.

 Also: brontosaurus Stroganoff, sweet and sour pterodactyl, roast loin of Rockenschpeel, fillet of soleasaurus, deli cactus sauce, nestlerock pie, rockshore pudding, and many others (Fred *loves* to eat!).

Fred's favorite ice-cream flavors: Ripple Rocky Road Sherbet, Mastodon Ripple

Fred's favorite drinks: Cactus Cola, saber-toothed tiger's milk, Coconut Koola

Dino's favorite dog food: Shlump

Newspapers in Bedrock: *Bedrock Bugle, Bedrock Chronicle, Bedrock Daily Slate, Bedrock Gazette, Bedrock Press, Daily Granite, Daily Slate*

The Flintstones' paper boy: Arnold

Neighbors of the Flintstones: Joe and Rita Rockhead (he is head of Bedrock's Volunteer Fire Department)

The Flintstones' mailman: Mr. Featherspine

The Flintstones' baby sitter: Mrs. Fitzstone

Gas station attendant: Mr. Quartz

Fred's favorite television show: "Bowling for Lizards"

Fred's favorite quiz show: "The Prize Is Priced"

Fred's camera: Polarock

The Flintstone piano: Stoneway

Town in which Wilma's sister and her husband live: Gravelton

Outer space visitor to the Flintstones: the Great Gazoo

The Great Gazoo's home planet: Zetox (a.k.a. Ziltox)

The Great Gazoo's boss: Gazaam

Fred's favorite expression: "Yabba dabba doo!" (What else?)

Business and Pleasure

Fred's place of business: Bedrock Slate and Gravel Company (also Rockhead and Quarry Cave Construction Company — "Own your own cave and be secure")

Fred's boss: Mr. Slate (also Mr. Granite or Mr. Rockhead)

Barney's place of business: Pebble Rock and Travel Company

Barney's boss: Mr. Pebble (also Mr. Slate or Mr. Granite)

Fred's occupation: Dinosaur crane operator

Fred's dinosaur at work: Rocky or Hugo

Fred and Barney's lodge: Royal Order of Water Buffaloes (sometimes called the Loyal Order of Dinosaurs or the Royal Order of Water Buffalo)

The lodge's meeting place: Water Buffalo Lodge or Water Buffalo Hall

Leader of the lodge: the Grand Poobah (also King Buffalo)

The proper way to address the Grand Poobah: Grand Exalted Imperial Poobah

The entertainment capital of the area: Hollyrock

Bedrock's leading nightclub: the Copacave

Bedrock's most exclusive country club: the Stonyside Country Club (which Fred and Wilma are erroneously asked to join)

Vacation resort: Rockapulco (the Flintstones and the Rubbles enjoy an adventurous vacation there)

Popular gambling resort: Rock Vegas

Popular board game: Rockopoly

Bedrock's new amusement park: Bedrockland

Airline at Bedrock Airport: Pterodactyl Airlines

Boss Slate's yacht: S.S. *Mogulrock* (which Fred is obliged to paint)

Bedrock college: Princestone

Flintstone People

Following are the names of some of the characters, places, and companies with which Fred and Barney became involved in their endless and hopeless search for the good things in life:

Sonny Dempstone: boxer whom Fred takes on to prove to Wilma that he's not a coward

Brick Boulders: runs Bedrock Health Club

Bronto Crushrock: wrestler whom Fred and Barney go to see

Roberto Rockalino: TV Italian lover who has Wilma and Betty in a dither, and whom Fred tries to emulate

"Slats" von Rictoven: fly-by-night songwriter who writes music to Fred's lyrics

Ben Boulder: Fred's rival in a golf tournament

A. A. Carborundum: owner of a fleet of school buses (Fred drives one for a day)

Gina Lolabricks: sexy girl from Bedrock High School, now a movie star

Mortimer Stoneface: owner of Bedrock Costume Shop

Reggie Van Slayton III: Fred's snobbish, freeloading, but very temporary neighbor on Snob Hill

Ann Margrock: glamorous film star whom Fred unwittingly hires as a baby-sitter (played by Ann-Margret)

Gus Gravel: a friend of Fred's and the owner of a seashore hotel, who cons Fred into working for him

Smiley Molar: dentist to dinosaurs

Dr. Stonewall: Bedrock psychiatrist

Dagmar the Peroxide Kid: sexy blond bank robber who uses "detectives" Fred and Barney as foils for staging a robbery

Greta Gravel: important buyer whom Fred must take to dinner, causing all sorts of complications

Norman Rockbind: television impresario who tries to turn Wilma into an actress

Grandma Dynamite: bank-robbing granny who holes up at the Flintstones' house, posing as a housekeeper

The Slatery Brothers: desperadoes who return to Rocky Gulch to kill a sheriff (guess who becomes sheriff for a day)

Uncle Tex Flintstone: Fred's rich uncle from Texarock, who has trouble with an outlaw called Billy the Kidder (he likes to play practical jokes)

Raffles Gravel, a.k.a. Lightfingers Leo: international jewel thief with whom Fred gets involved when he buys a birthday present for Wilma

Sassie: television dog star adored by Dino

The Flint-Rubble Bubble Cake: the cake Wilma and Betty enter in the Tasty Pastry Contest

Missing Link Fence Company: builds a fence for Fred during one of his frequent spats with Barney

Nau-Sea: the name of the houseboat Barney wins on "The Prize Is Priced"

Rocktopus: creature with eight legs, used as a baby-sitter at Bedrock's World's Fair

"Go Go" Ravine: producer "on the cheap" who hires Fred to play "Hercurock" in a movie

Fiendish Films: fly-by-night movie company making *Son of Rockzilla* — gets Fred to don gorilla suit for publicity stunt

J. Giggles Flintstone: Fred's late wealthy uncle who leaves him his estate (provided he can spend one night in the spooky mansion)

Wilbur Terwilligerock: Wilma's handsome old schoolmate, who makes Fred jealous

Honeyrock Hotel: the hotel where Fred and Barney once worked as bellboys, and Wilma and Betty worked as waitresses (they each thought the other was rich)

Eppy Brianstone: rock impresario, who represents a group called "The Termites"

Chronology of Hanna-Barbera Live-Action Features and Series

The following covers the live-action features and series produced by Hanna-Barbera. Entries are arranged chronologically, in order of release. The pilot films for projected television series are not included.

Features

Hardcase (ABC, 1972)
Directed by John Llewelyn Moxey. Screenplay by Sam Rolfe and Harold Jack Bloom. Stars Clint Walker, Stefanie Powers, Pedro Armendariz, Jr., Alex Karras.

An American soldier of fortune (Walker) comes to Mexico in search of his wife (Powers), who took off with his share of their ranch money. He finds her in an armed rebel camp with the camp's noble leader (Armendariz). A bitter "hardcase," the soldier of fortune abducts the rebel leader, and they are soon joined by the wife and a sly American mercenary (Karras). The relationships of the four people continue to shift until the final showdown.

The Runaways (ABC, 1974)
Directed by John Florea. Written by Clyde Ware. Stars Belinda Balaski, Claudio Martinez.

Cindy (Balaski), a diabetic teenager upset by her mother's remarriage, runs away from home and moves into the shabby, dangerous street life in Hollywood. She meets Francis (Martinez), a streetwise eleven-year-old runaway, who teaches her "the ropes." When she loses her vital insulin in fleeing from the police, Francis tries to steal some for her and is arrested. He finally reveals where Cindy is hiding out, and they get to her as she lies unconscious in insulin shock. Cindy recovers and is reunited with her family, which now includes Francis. Winner of an Emmy as Outstanding Informational Children's Special.

Shoot-Out in a One Dog Town (ABC, 1974)
Directed by Burt Kennedy. Screenplay by Larry Cohen and Dick Nelson, from a story by Larry Cohen. Stars Richard Crenna, Stefanie Powers, Arthur O'Connell, Jack Elam, Michael Ansara, Dub Taylor, Richard Egan.

In yet another clone of Fred Zinnemann's 1952 classic Western *High Noon*, a principled banker (Crenna) in a small Arizona town finds himself forced to protect the $200,000 in cash left in his keeping from a gang of thieves bent on stealing the money. Inevitably he stands proudly alone at the end ("Law and order gotta start somewhere in this territory. It might as well start here"), while his apprehensive wife (Powers) waits in the wings for the sound of gunfire.

The Phantom Rebel (NBC, 1976)
Directed by Herman Hoffman. Written by Fred Freiberger. Stars Sandy McPeak, Elizabeth Cheshire, Lance Kerwin, Gordon Jump, Dran Hamilton, Liam Sullivan, Milton Selzer.

Set during the turbulent days of the American Revolution, the story centers on ten-year-old David Prescott (Kerwin) and

The cast of "The Gathering," 1977.

his younger sister Hetty (Cheshire), who set out boldly to serve the revolutionary cause, although they live with their British Loyalist aunt (Hamilton). They learn that the town's soft-spoken cobbler Emory Porter (McPeak) is actually the dashing Phantom Rebel, the revolutionary who plagues British General Smythe (Sullivan) and his troops with his maneuvers. (He always leaves behind a hollow pumpkin head.) General Smythe and Tory traitor Harley Wilton (Selzer) try repeatedly to capture Emory, but with David and Hetty's courageous help, he manages to elude his captors and obtain valuable information.

The Gathering (ABC, 1977)
Directed by Randal Kleiser. Written by James Poe. Stars Edward Asner, Maureen Stapleton, Lawrence Pressman, Stephanie Zimbalist, Bruce Davison, Veronica Hamel, Gregory Harrison, John Randolph, Gail Strickland.

Learning that he is fatally ill, Adam Thornton (Asner), who deserted his wife, Kate (Stapleton), and family four years earlier, seeks to bring them together for a squaring of accounts at one last Christmas reunion. With Kate's help, he gathers the clan at their home. Each member of the family has his or her own hang-ups, regrets, and long-smoldering resentments, and in a series of confrontations they manage to come to terms with the past. Finally at peace with himself, Adam can face whatever will come. In addition to the Emmy Award as Best Drama or Comedy Special, *The Gathering* was honored by the Christophers, an ecumenical mass media organization, for its contribution to the portrayal of "the highest values of the human spirit." Eastman Kodak also received an award from the American Council for Better Broadcasts for sponsoring the play.

It Isn't Easy Being a Teenage Millionaire (ABC, 1978)
Directed by Richard Bennett. Written by Jim Inman, based on the novel by Joan Oppenheimer. Stars Victoria Meyerink, Chris Dekker, Bob Hastings, Karen Hurley, Laurie Hendler.

Fourteen-year-old Melissa Cunningham (Meyerink) has a pleasant but conventional teenage life — until she wins one million dollars in the lottery! Although she cannot receive the

money until she is eighteen, her humdrum existence picks up considerably. She becomes an overnight celebrity, but friends begin to ignore her when the money starts going to her head. At a prom with her "Mr. Wonderful," Melissa overhears some painful truths about herself and reverts to the old ways of closeness with family and friends.

The Beasts Are on the Streets (NBC, 1978)
Directed by Peter Hunt. Written by Laurence Heath, from a story by Frederic Lewis Fox. Stars Dale Robinette, Carol Lynley, Billy Green Bush, Philip Michael Thomas.

Disaster threatens when a truck driver, stricken with a heart attack, crashes into a wildlife park and frees all the animals. The park's head ranger (Robinette) and the local veterinarian (Lynley) work frantically to retrieve the animals and prevent them from being killed, while the town reacts in various ways, mainly terror. The climax takes place in a hospital, where a lion has wandered in search of her cub.

Kiss Meets the Phantom of the Park (ABC, 1978)
Directed by Gordon Hessler. Written by Don Buday and Jan-Michael Sherman. Starring KISS (Ace Frehley, Gene Simmons, Paul Stanley, and Peter Criss), Anthony Zerbe, Deborah Ryan, Carmine Caridi.

KISS, the grotesquely costumed rock group extremely popular at the time, made its acting debut in this film. As the star attraction at an amusement park, the group finds itself involved with battling a mad scientist named Abner Devereaux (Zerbe), who is bent on destroying their careers by making robot replicas of the group and turning them loose to create havoc in the park. They also rescue a young park worker who has been turned into an android by the scientist.

C.H.O.M.P.S. (A Hanna-Barbera-American International Production, 1979)
Directed by Don Chaffey. Written by Dick Robbins, Duane Poole, and Joe Barbera, from a story by Joe Barbera. Stars Wesley Eure, Valerie Bertinelli, Conrad Bain, Jim Backus, Red Buttons, Chuck McCann.

A theatrical release, C.H.O.M.P.S. (acronym for Canine Home Protection System) centers on a computerized electronic watchdog invented by a young would-be security wizard named Brian Foster (Eure). Constantly searching for the foolproof computer system, Brian creates C.H.O.M.P.S. in the exact image of his own dog Rascal. His goal is to get the dog accepted by Norton Security Systems, headed by the father (Bain) of his loyal girlfriend Casey (Bertinelli). Norton's chief rival, Gibbs (Backus), uses underhanded tricks to get C.H.O.M.P.S. for his own company. After much confusion, it all converges on a crucial demonstration test in which Rascal is accidentally substituted for C.H.O.M.P.S. C.H.O.M.P.S., however, wins the day, Gibbs is thwarted, and everything ends happily for Brian and Casey.

The Gathering: Part II (CBS, 1979)
Directed by Charles S. Dubin. Written by Harry and Renee Longstreet. Stars Maureen Stapleton, Efrem Zimbalist, Jr., Jameson Parker, Bruce Davison, Lawrence Pressman, Gail Strickland, Veronica Hamel.

A sequel to *The Gathering*. Several years after Adam Thornton's death, Kate Thornton (Stapleton) is being courted by a wealthy industrialist (Zimbalist), but her children suspect his intentions (does he want to buy the family business?), and Kate herself wonders whether she is too old for romance. Once again the children have their own hangups, which are finally resolved.

Belle Starr (CBS, 1980)
An Entheous Unlimited Production in Association with Hanna-Barbera. Directed by John A. Alonzo. Written by James Lee Barrett. Stars Elizabeth Montgomery, Cliff Potts, Michael Cavanaugh, Fred Ward, Jesse Vint, Allan Vint.

Another whitewashed, softened version of the life of the notorious Western bandit queen, played earlier by such actresses as Gene Tierney and Jane Russell. The film views Belle with a 1980s sensibility, turning her into a strong-minded pre-feminist who defies the priggish moralists. Her young son, however, feeling ashamed and neglected, informs on her gang, and in the film's final moment he shoots her down.

The Great Gilly Hopkins (CBS, 1981)
Directed by Jeffrey Hayden. Written by Charles Pratt, Jr., from the National Book Award–winning novel by Katherine Paterson. Stars Tricia Cast, Conchata Ferrell, Rick Slyter, Tyne Daly, Joel Fluellen, Edith Atwater.

Gilly Hopkins (Cast), a troublesome twelve-year-old public ward, lives in the foster home of good-natured Mrs. Trotter (Ferrell). Mrs. Trotter also cares for another foster child, six-year-old W. E. (Slyter), and for Mr. Randolph (Fluellen), a blind, elderly black man who is her neighbor. Gilly's nasty temperament alienates everyone but Mrs. Trotter, who is a match for her. Finally, after stealing some money from Mr. Randolph, Gilly runs away to find her true mother. Instead, she learns a painful lesson about rejecting friendships.

P. K. and the Kid (A Hanna-Barbera-Castlehill Production, 1986)
Directed by Lou Lombardo. Written by Neal Barbera. Stars Paul LeMat, Molly Ringwald, Alex Rocco, Esther Rolle, Charles Hallohan.

Kid Kane (LeMat), a Denver produce worker, has the dream of winning the arm wrestling championship of the world in Petaluma, California. Accompanied by P. K. Bayette (Ringwald), a fourteen-year-old runaway trying to get away from her abusive stepfather, Kid travels to the West Coast. The story builds to a climactic arm wrestling match, and to Kid's confrontation with P. K.'s stepfather.

The Stone Fox (NBC, 1987)
Co-produced by Hanna-Barbera Productions, Allarcom Limited, and Taft Entertainment Television. Directed by Harvey Hart. Written by Walter Halsey Davis, from the book by John Reynolds Gardiner. Stars Buddy Ebsen, Joey Cramer, Belinda Montgomery, Gordon Tootoosis.

During a rugged Wyoming winter in 1905, twelve-year-old Willy (Cramer) must face the challenge of running a ranch by himself when his beloved grandfather (Ebsen) suffers a stroke. To earn money, he enters his dog, Morgan, in a grueling sled race. His only competition is Stone Fox (Tootoosis), a Shoshone Indian with a deep resentment of whites, who has the best sled dogs. Morgan appears to be winning but his heart bursts from the strain before the end. In a moment of compassion and understanding, Stone Fox allows Willy to carry his dog's body over the finish line. And when he returns home grief stricken, Willy learns that Stone Fox has left him a new puppy.

Series

"Korg — 70,000 B.C." (ABC, 1974)
Stars Jim Malinda, Bill Ewing, Naomi Pollack, Christopher Man, Charles Morteo, Janelle Pransky.

A Neanderthal family struggles to survive in a primitive world. The family consists of patriarch Korg; his mate, Mara; his younger brother Bok; and Korg's three children, Tane, Tor, and Ree. Together they experience a series of adventures as they learn human needs and values.

"Mystery Island" (CBS, 1977)
Stars Stephen Parr, Lynn Marie Johnston, Larry Volk, Michael Kermoyan.

A comedy adventure series relating the escapades of three people who are stranded on a mysterious island after their jet is forced down by an evil scientist. The pilot, Chuck Kelly, is the adopted brother of fifteen-year-old Sandy and his sister, Sue. The three strive to keep a highly developed computer named P.O.P.S. (Peace Oriented Protective System), created by Sandy and Sue's scientist father, from the scheming Dr. Strange.

"Benji, Zax, and the Alien Prince" (CBS, 1983)
Stars Benji, Chris Burton, Rick Spiegel.

In his own television series, the famous and lovable canine Benji befriends Prince Yubi, a young alien prince sent to the earth to reclaim his throne from evil forces. Benji loyally accompanies Prince Yubi as he learns about the earth and experiences various adventures while trying to protect his identity.

"Going Bananas" (NBC, 1984)
Stars J. R., Tim Topper, Emily Moultrie, Marie Denn.

The adventures of Roxanna Banana, an orangutan with superhuman powers. With the help of her adoptive brother and sister, James and Louise Cole, and their grandmother, Roxanna uses her powers to right wrongs and fight injustice.

Notes

2. The Tom and Jerry Years

1. Eugene Slafer, "A Conversation with Bill Hanna," *The American Animated Cartoon*, edited by Gerald and Danny Peary, p. 258.

2. Eugene Slafer, *op. cit.*, p. 258.

3. John Culhane, "The Man Behind Dastardly and Muttley," *New York Times Magazine*, November 23, 1969, p. 129.

4. Tom and Jerry later reappeared by way of MGM — first in a series of twelve cartoons made in the early sixties by animator Gene Deitch working with a Czech team and then, in redesigned form, in the series created for the studio by Chuck Jones. When Hanna and Barbera revived the characters for television in the mid-seventies, the tamer, milder adaptation of MGM's sassy, frenetic cat and mouse failed to attract an audience.

3. Enter Huckleberry, Quick Draw, Yogi, and Friends

1. Many years later Butler recalled that the hardest thing he had to do was give Huck an appropriate laugh: "I just couldn't imagine him laughing for some reason. I finally gave him a snicker that followed the line, 'I'm gonna sneak up on him from behind that tree, *hee hee hee*.' " "Daws Butler, the Master's Voice," by Brian Lowry, *Starlog*, March 1987, p. 60.

2. A 1987 syndicated television special, "The Good, the Bad, and the Huckleberry," starred the dauntless hound in new adventures. Huckleberry lives!

4. Meet the Flintstones

1. The final model for the characters was made by Ed Benedict, who had also worked on the models for many of the earlier Hanna-Barbera creations.

2. Bea Benaderet died in 1964 and was replaced by Gerry Johnson (1964–66), Gay Hartwig (1972–74), and Gay Autterson (1979 on). Jean Vander Pyl, a good friend of Benaderet's from their early radio days together, recalls that, in the casual manner of the time, they both auditioned for the two roles and were asked to choose which they wanted to play. For a while, both actresses played *all* the female voices on the show.

3. Hanna and Barbera credit Alan Reed with first using the immortal cry of "Yabba-dabba-doo!" At a recording session, given the exclamation "Yahoo!" Reed asked if he could use "Yabba-dabba-doo!" instead. The director agreed, and the expression entered our folklore. Reed died in 1977 and was replaced by Henry Corden.

4. To this day, "all age levels" are adept at singing the program's famous theme song ("Flintstones! Meet the Flintstones! They're the modern Stone Age family"). Written by

Hoyt Curtin, Hanna-Barbera's musical director, with lyrics by Hanna and Barbera, it was actually introduced later in the series, replacing Curtin's original song, which he has called "a big, booming show-opener." At first the theme song was written for the timpani alone, to suggest "cave music," but words (by Bill Hanna) were added.

5. Here, Cavey was the alter-identity of a meek copyboy named Chester. Three years earlier Cavey, sans Chester, had starred as the comic superhero of "Captain Caveman and the Teen Angels." (See Chapter Seven.)

6. In 1988 the Humanitas Award for effectively communicating human values was awarded to Mary Jo Ludin (teleplay) and Lane Raichert (story) for "Rock's Rocky Road," an episode of "The Flintstone Kids." In addition, a live-action version of "The Flintstones" is in preparation at this writing.

7. Years later Butler commented, "Everyone always assumed Elroy was really a kid. For me, it's like self-hypnosis. You must convince yourself that you're nine years old again, let the feeling go through your entire body."

8. Messick remembers a particularly grueling session in which back-to-back episodes were recorded over a two-day period. Astro had an unusually heavy role to play, and Messick lost his voice for two weeks. Some years later, for a brief period, he played Astro again in "Astro and the Space Mutts" (NBC, 1981), in which the canine joined two other dogs to be trained in interstellar police work.

5. Reigning Cats and Dogs

1. Today Arnold Stang recalls that the show was so clearly influenced by "You'll Never Get Rich" that he started to sound more and more like Phil Silvers: "After the first few episodes were recorded, the sponsor said, 'It doesn't sound enough like Arnold Stang. We want a little more of Arnold Stang in there.' I had to go back and redo parts of it. I worked so long to develop the Sergeant Bilko–type of character that I would have to pull back a little and bring more of myself."

2. Hanna and Barbera have always understood the kind of jokes young viewers enjoy. Asked why he used a laundry truck to escape from prison, Big Fats replies, "I wanted to make a clean break."

3. Today, Janet Waldo offers this observation on Don Messick's Precious Pupp: "He was, in a way, different from any of Don's snickering dogs. Precious was genuinely two-faced — on the one hand he was Granny's 'little darling' — she thought he was 'perfection' — but he was also a devil!"

6. The Superheroes

1. Today Don Messick affirms that Dr. Quest was one of his favorite characters from that decade: "It gave me the opportunity to do a straight character for a change. I took over the role when they decided that there was a vocal conflict between the actors playing Dr. Quest and Race Bannon. Until then I was doing only the yipping and yapping of little Bandit."

2. "Terry and the Pirates" started in 1934 at the request of Joseph Patterson, publisher of the New York *Daily News*, who wanted a series to compete with "Flash Gordon" and other adventure strips. Caniff drew the strip until 1946, when George Wunder took over.

3. Joe Barbera remembers that they had trouble deciding on the colors for Space Ghost's costume: "We made at least twenty different color schemes. We put all twenty drawings on the floor, and Fred Silverman walked around them, trying to decide on the colors. We also had trouble deciding on a name, but we finally settled on Space Ghost."

4. Today, speaking of Gloop and Gleep, Don Messick says, "I applied a voice I had developed back in my early teens when I had my own radio show in Maryland. It's just a sound I produce that I've never heard anyone else do. It's a kind of vibrato coming from the back or middle part of my tongue."

5. Moby Dick was not the only classic literary character to lend his name (and nothing else) to Hanna-Barbera. "The New Adventures of Huckleberry Finn" (NBC, 1968) left Mark Twain behind, with the new Huck (Michael Shea) and Tom Sawyer (Kevin Schultz) tripping through time in a series of fanciful adventures.

6. In 1978 "The Fantastic Four" returned to television as "The New Fantastic Four." Now on NBC, the series eliminated Johnny Storm and substituted a wisecracking robot named H.E.R.B. (Humanoid Electronic Robot, B model). The group now rode in a streamlined flying automobile called the Fantasticar, but their job of fighting evil remained the same.

7. Scooby-Doo and Friends

1. For the record, the other drivers were Professor Pat Pending (Don Messick) in his Ring-a-Ding Convert-a-Car, Rufus Ruffcut (Daws Butler) and Sawtooth (Don Messick) in their Buzz Wagon, the General (John Stephenson), the Sergeant (Daws Butler), and Private Pinkley (Paul Winchell) in their Army Surplus Special, Rock and Gravel Slag (Daws Butler) in their Boulder Mobile, Red Max (Daws Butler) in his Crimson Haybailer, and the Gruesome Twosome (Don Messick and Daws Butler) in their Creepy Coupe.

2. The show's theme song, "Stop That Pigeon!" written by Hoyt Curtin and Bill Hanna, was the original name of the series.

3. Zippy, Pockets, Dum Dum, and Snoozy were voiced by Don Messick; Paul Winchell played Clyde and Softly; and Mel Blanc did the voice of Yak Yak and the "chug" of Chugaboom. Janet Waldo's Penelope was one of her favorite voices: "I loved doing Penelope. She always took things in stride."

4. In 1987 Hanna-Barbera released three television specials involving Scooby: "Ghoul School," "Scooby and the Reluctant Werewolf," and "Scooby and the Boo Brothers." Addi-

tional segments of "Scooby-Doo" are continually being planned.

5. The Pussycats' voices were dubbed by a real music group, consisting of Cathy Douglas, Patricia Holloway, and Cherie Moore (later known as Cheryl Ladd).

6. Spirits and specters were frequently recurring characters in Hanna-Barbera series of the seventies. "Jeannie" (CBS, 1973) was a loose adaptation of the long-running series about a beautiful genie who emerges from a bottle after 2,000 years to savor life in modern-day California. "Shake, Rattle, and Roll" (NBC, 1977) concerned a trio of ghosts who run an inn for their fellow spirits. Even long-popular Casper the Friendly Ghost turned up in a futuristic variation called "Casper and the Angels" (NBC, 1979).

7. Simultaneously on NBC, Hanna-Barbera offered another animated variation on "Charlie's Angels," called "C. B. Bears." Here, three trouble-shooting bears took dangerous, way-out assignments dispensed by the unseen Charlie, in this case a sexy-voiced lady.

8. "Grape Ape" and "Tom and Jerry" were joined by "Mumbly," a detective dog, for a few months in the fall of 1976, then "Grape Ape" starred on his own for a year, starting in the fall of 1977.

9. The tradition of the dull-witted dog, or what might be called the Quick Draw McGraw school of heroism, continued with "Posse Impossible," a series that surfaced briefly in September 1977 on NBC. This time, a trio of clumsy cowboys — Big Duke (Daws Butler), Blubber (Chuck McCann), and Stick (Daws Butler again) — served as deputies to the sheriff (Bill Woodson) of a town called Saddle Sore.

10. John Stephenson sounded very much like Joe Flynn, the actor best remembered for his role as the crochety Captain Binghamton in "McHale's Navy" (1962–66). Stephenson recalls that Joe Barbera asked him, "Can you do Joe Flynn?" He answered, "Get Joe Flynn," and Barbera retorted, "We did. And he didn't sound right."

11. Amusingly, Butler's Brutus expressed his pleasure or displeasure by enunciating the words *snarl* or *growl* in a voice that resembled that of Bert Lahr's immortal Cowardly Lion in *The Wizard of Oz*.

12. Only one seventies series, "Superfriends" (ABC, 1973), reverted to comic-book origins. Bringing together Superman, Batman, and other popular heroes, it had them fighting the villains either singly or together. Various configurations of "Superfriends" continued virtually every season on television, with one variation appearing as late as 1985.

8. Animated Specials and Features

1. Experiments in combining animation and live action had started as early as the silent era with Max Fleischer and his "Out of the Inkwell" series and also with Walt Disney in his silent "Alice" series. In the forties Disney combined them in *The Three Caballeros* (1945), refined the technique further in *Song of the South* (1946), and finally achieved outstanding results in *Mary Poppins* (1964). Hanna and Barbera, of course, had Gene Kelly dancing nimbly with Jerry the Mouse in *Anchors Aweigh!* (1945), and with other animated characters in *Invitation to the Dance* (1953). Most recently Robert Zemeckis's *Who Framed Roger Rabbit?* (1988) marked a notable advance in this area.

9. Present Tense, Future Tense: the Eighties and Beyond

1. Another Richie, named Richie Rich, turned up on ABC's November 1980 schedule, directly after "Fonz and the Happy Days Gang." The world's richest boy, tow-headed Richie (Sparky Marcus) spent his time getting into trouble or solving problems with the aid of a robot maid named Irona (Joan Gerber), who, in a crisis, could turn herself into anything she chose.

2. For the record, Rick was played by Ronnie Schell, Pammy by Pat Parris, Digger by Robert Allen Ogle, Bogey by Fred Travalena, and Tyg by Steve Schatzberg. Nancy Cartwright voiced Kip Kangaroo.

Selected Bibliography

Brooks, Tim, and Earl Marsh. *The Complete Directory to Prime Time Network TV Shows, 1946–Present*. New York: Ballantine Books, 1979.

Culhane, John. "Hanna-Barbera: 25 Years." New York: The Museum of Broadcasting, 1982.

———. "The Man Behind Dastardly and Muttley," *New York Times Magazine*, November 23, 1969, pp. 56ff.

Diehl, Digby. "Joe Barbera," *People*, March 16, 1987, pp. 69ff.

Gansberg, Alan L. "Hanna-Barbera: 30 Years of Drawing Power," *The Hollywood Reporter*, December 11, 1987, pp. S-4ff.

Kausler, Mark. "Tom and Jerry: The Aesthetics of Violence," *Film Fan Monthly*, November 1968, pp. 15ff.

Kendrick, Walter. "Famous Long Ago," *Village Voice*, December 10, 1985, pp. 47–48.

Lowry, Brian. "Daws Butler, The Master's Voice," *Starlog*, March 1987, pp. 58–61.

McNeil, Alex. *Total Television: A Comprehensive Guide to Programming from 1948 to the Present*. New York: Penguin Books, 1980.

Maltin, Leonard. *Of Mice and Magic: A History of American Animated Cartoons*. New York: McGraw-Hill Book Company, 1980.

Mariani, John. "Hanna-Barbera: The Cartoonists Who Own Saturday Morning," *Saturday Review*, November 24, 1979, pp. 24ff.

Peary, Gerald, and Danny Peary, eds. *The American Animated Cartoon*. Westport, Conn.: Arlington House Publishers, 1981.

Slifkin, Irv. "The Wonderful World of Joseph Barbera," *Starlog*, December 1987, pp. 58ff.

Speranza, Ken. "Hanna-Barbera: From Cavemen to Computers," *Video*, November 1984, pp. 112ff.

Wetanson, Burton. "Smarter Than Your Average Barbera," *Attenzione*, March 1986, pp. 45ff.

Woolery, George W. *Children's Television: The First Thirty-Five Years, 1946–1981*. Metuchen, N.J., and London: The Scarecrow Press, 1983.

Index

The text of this book was set by Trufont Typographers, Inc., of Hicksville, New York, in ITC Esprit, designed by Jovica Veljović in 1985. The color separations, printing, and binding were done by the Dai Nippon Printing Company of Tokyo, Japan. The book and its jacket were printed on 106-pound New Age Matte, manufactured by the Kanzaki Paper Company.